ART AND BUSINESS

ART AND BUSINESS

An International Perspective
on Sponsorship

Edited by
ROSANNE MARTORELLA

PRAEGER

Westport, Connecticut
London

Library of Congress Cataloging-in-Publication Data

Art and business : an international perspective on sponsorship /
 edited by Rosanne Martorella.
 p. cm.
 Includes bibliographical references and index.
 ISBN 0–275–95000–X (alk. paper)
 1. Corporate sponsorship—Case studies. 2. Art patronage—Case
studies. I. Martorella, Rosanne.
 HD59.35.A78 1996
 306.4'7—dc20 95–40583

British Library Cataloguing in Publication Data is available.

Library of Congress Catalog Card Number: 95–40583
ISBN: 0–275–95000–X

First published in 1996

Praeger Publishers, 88 Post Road West, Westport, CT 06881
An imprint of Greenwood Publishing Group, Inc.

Printed in the United States of America

The paper used in this book complies with the
Permanent Paper Standard issued by the National
Information Standards Organization (Z39.48–1984).

10 9 8 7 6 5 4 3 2 1

To AMICI MIEI

Contents

III. The European Community

IV. Asia and the Pacific

Illustrations

FIGURES

Preface

The unprecedented corporate growth of the late 1970s and 1980s is over, and little has been written on its impact on the visual and performing arts. Despite the enormous attention given to government and state subsidies, and the continuing debate over the impact of such relationships, both the academic and art communities continue to require analyses of private art patronage. Indeed, often at times, the data are insufficient and inconclusive. However, the authors herein have attempted to conduct small surveys and interviews, and to gather statistical evidence wherever possible. I commend them for their efforts and insights. They have entered a fertile area of research, and their preliminary investigations will serve future scholars, art administrators, and artists alike.

As editor, I have expanded my knowledge of the global scene. My world has narrowed as I grappled with the diversity of languages, cultures, and writing styles. I express my gratitude to the contributing authors, especially to Völker Kirchberg who helped organize a session at the World Congress of Sociology in Bielefeld, Germany, in which some of the contributors presented early drafts of their papers, and who networked to recruit other submissions as well.

A special thanks to Joan FitzGerald who typed the manuscript, offered encouragement, and insisted on excellence. Anna Squatritti provided a skillful Italian translation, and Elizabeth M. Murphy, editor at Greenwood, provided encouragement early on in this project. Precise and diligent editorial work was provided by Mary Brohammer, and Lori Blackwell and Marsha Havers of Greenwood. A grant from the Assigned Research Time and a sabbatical from William Paterson College provided the necessary time to complete this book. Students like Jen and Deepa make teaching worth it. Louis and our children, Andrew and Bianca, provide continuing optimism.

I would like to provide a note on the dedication of this book: AMICI MIEI (friends here and abroad, especially in Italy). They have made me a better sociologist enhancing my skill at observation, and assisted in the unending search of the self, including a need to contribute to the community, and a *passione del'arte*.

Rosanne Martorella, Ph.D.

PART I

Introduction

Art and Business:
An International Approach
on Sponsorship

Rosanne Martorella

INTRODUCTION

The association of art and business, private companies supporting artistic work, is a relatively new phenomenon that originated, for the most part, in the 1960s. This was a time, indeed, of unprecedented corporate growth worldwide; and along with the profits from transnational companies came an increased consciousness of corporate responsibility and a public-relations role. Similar to the patrons of the Renaissance, these modern "princes"—Corporate Medicis—gave monies to mount museum exhibits, commission sculpture, and host artists-in-residence at corporate headquarters. They began to collect treasures, and lent support to dance, theater, music, and opera companies as well. Depending on a company's location, age, clientele, national cultural heritage, and its corporate culture, businessmen acted quasi-independently of government incentives to fund the arts—conscious, however, of the social status realized by arts patronage.

The business community came to realize that cultural organizations influence the economy: by employing artists and ancillary personnel, by providing indirect income and employment benefits that, in turn, produce direct expenditures which reverberate throughout the economy. They serve as a catalyst for economic development, enhance the aesthetics of a community, attract a well-educated public, and increase property values. The need to introduce products to new and foreign, sometimes reluctant, communities motivated executives to help local community programs, including cultural events. It was easy to assess, therefore, that the arts were good for business. These are the economic, political, and social aspects contributing to corporate arts sponsorship,[1] and these facts came to justify corporate philanthropy.

The significance of these new Medicis should come of no surprise to the historian in that the development of Western culture has been intrinsically tied

to those who have had the economic and political power to support and encourage an artistic milieu. However, this form of patronage has occurred alongside government subsidies and has predominantly supported, with the exception of Japan and Italy, the works of contemporary artists. In some cases, government cultural policy encourages private support by providing tax incentives and by legitimating particular art forms, in essence establishing an "official" culture. In many countries, especially in Europe and the United States, the concept of civic responsibility is gaining importance. As most large cities around the globe face increasing problems of poverty, violence, and unemployment, and at the same time major budget cutbacks and economic recession, government officials are looking particularly to the business community to offset budgetary restraints and assist in these problems. While this attitude has helped foster support to the arts, it has placed increasing competition on corporate philanthropy—a large potential source of funding at a time when government subsidies are retracting.

With the onset of the lagging economy in 1989, private companies have decreased their support, but they still continue to give and have found new and interesting ways to support the arts. Businesses have come to give direct subsidies through their contributions and their public-relations and advertising departments, or in a more formalized way through their foundations. Other forms of support include services by employees to art groups; art collecting and exhibiting works of art in their lobbies, galleries, and offices; sponsoring midday poetry readings or live performances; offering employees discounts to museums and concerts; commissioning artists to design buildings or products; restoring art treasures, etc.

Unlike in the United States, in most countries around the world, the government became the most important source of income for the nonprofit visual and performing arts. The government's role has mushroomed—assisting young artists' careers, sponsoring major museum exhibits, developing new cultural centers both in inner cities and in remote regions, and preserving the cultural heritage of nations. It has done so throughout history, and in modern times, it has come to mean an investment ensuring the economic stability of cities, encouraging tourism and urban renewal.

In countries where the governments have been characterized as industrial democracies, especially in the postwar era, the government's role has been achieved with the assistance of private business—a partnership for arts support. After all, cultural centers and high-powered industrial cities go hand in hand, and this fact has been clearly documented in a number of economic-impact studies. (For example, tourism represents a $9 billion industry in New York City.) This partnership has been seen as essential, and the conservative governments facilitated this trend—for example, the Republican Reagan era in the United States and the Thatcher regime in Great Britain.

The cultural policy and laws established by the constitutions of various nations provide incentives for businesses to give monies to the arts. Laws, for example, dictate maximum dollar amounts for contributions to philanthropic causes, and zoning requirements can, and have, dictated the use of outdoor

sculptures, gardens, and atriums at new corporate headquarters. Some govern-
ments go much further in dictating the "official" culture that businesses have to
support. There are numerous examples of situations in which inner cities work
closely with local businesses to rejuvenate decaying downtown areas—as in the
case of Berlin.

Since the 1960s, private foundations, corporations, and the private individual
have come to share in this form of philanthropy. A worldwide economic boom
generated huge profits that allowed extended grants to artistic projects besides
the usually funded programs in health, education, and welfare. Not since the
prewar era had the Western world realized the significance of private patrons.
The social tastes of these new patrons, dictated by corporate lifestyles, included
the appreciation of serious music. Leisure time not only increased for the
general population, but also incorporated a rapidly growing elderly population
eager to consume the arts.

The growth of mass communications and of transnational corporations, has
decreased the differences among nations. Undoubtedly, political and economic
situations dictate a proclivity toward the extent of and nature of corporate
involvement—including the nation's traditions, motivations, and cultural diversi-
ties. Italy, for example, is unique in its artistic patrimony, and its banks have
supported numerous and significant restorations of its art treasures and palaces.
Austria's pride in its musical heritage has dictated extensive sponsorship of its
music festivals. Moreover, Western and Eastern Europe continue to have a more
important role for government support of the arts than other countries repre-
sented in this book.

OUTLINE OF THE BOOK

In focusing on the modern corporation as a patron of the arts, this book
explores the relationship between the economy and artistic work and styles—a
major concern for sociologists who study the arts. Most studies on patronage
have focused on the role of government subsidies, utilizing the careful and
methodical guidelines of the granting process and actual dollar amounts for
analyses. Only a number of brief articles on the corporate patron have appeared
in newspapers and magazines, which is surprising given the newsworthiness of
the skyrocketing prices of artworks, or of a performance that supports an inner-
city project, tourism, or urban renewal. Only to this extent have we come to
understand the role of the modern corporation. This book, however, is a more
vigorous attempt to detail some of the modern corporations' efforts around the
world. Employing both quantitative and qualitative data, the authors present their
analyses here for the first time in publication form. Given the fact that data on
corporations are often private and that decisions are haphazardly made, their
efforts offer long awaited for and significant analyses.

Questions addressed herein include the following: Why do private companies
become interested in supporting the arts? What conditions (economic, political,
and social) facilitate their involvement? Do corporations show preferences for

particular artists, art styles, or performing-art organizations, and, if so, why? Who in the company has the power to decide? What are the motives behind such support? How do companies justify their philanthropy to stockholders and their community? What are the differences, if any, between corporate support in Western and Eastern Europe, Japan, Canada, South America, etc.? How has the international market of art been affected by corporate buying? Do transnational corporations show similar trends in philanthropy worldwide?

These questions form a sociological interpretation of art patronage, and in analyzing artistic culture in terms of the influence of its patrons, art is seen as a social product that is specific and responsive to its environment—an external environment made up of corporate executives, worldwide organizations, profit earning, product marketability, and the like.

Companies who compete to collect art treasures (for example, Japanese executives and Italian bankers) do so with the intent to invest their assets. Most, however, justify their purchases and support artistic activities because their involvement raises the prestige and status of their firms, giving them higher visibility and ultimately a greater market share. These motives seem to justify their philanthropy, and in such a global and competitive marketplace even appear to be a bargain, given the outcome.

While the diversity of cultures will become evident as the authors outline the nature and role of support in each country, the implications of such patronage need to be addressed to the extent that they influence artistic styles, the careers of artists, the restorations of cultural heritage, and the legitimation of official culture. The contributions of authors from North and South America, Western and Eastern Europe, Asia, and the Pacific are an attempt to present comparisons, and develop a typology on the nature of corporate philanthropy. However, the development of a global culture seems evident by the data presented, especially by the "Americanization" of corporations worldwide, and the increasing privatization of nonprofit cultural institutions.

NORTH AND SOUTH AMERICA

Although one can highlight some specific cases of corporate donations to the arts prior to 1945, corporate philanthropy is basically a postwar phenomenon, and since the late 1960s, has been formalized by the increasing number of corporate foundations. In 1955 the Conference Board in the United States reported that 180 companies gave 3.2% of their donations dollar to "civic and cultural causes." By 1965, art contributions were listed separately, and the level of art contributions peaked in 1991 with over $7 billion in total corporate contributions. With the arts garnering approximately 12% of all contributions, the arts now receive over $500 million annually.

The chapter on the United States reviews actual dollar amounts in detail, highlighting the fact that contributions are directly related to income levels. After a brief history of corporate involvement, the author outlines the motives for sponsorship. Over time, corporate departments came to justify and formalize

their grants. Encouraging such expenditures through tax incentives, the government legitimated the arts as a form of civic responsibility; in so doing, a consistent pattern of contributions was realized with the initiation of the National Endowment for the Arts in 1965. Most corporate donations occur through their contributions departments, with some through indirect subsidies and projects from advertising budgets. Foundation activity accounts for about $35 million annually (but this figure appears to be a low estimate).

In Canada, a pioneer study, Corporate Giving in Canada, was published in 1953, but listed art with recreation. From 1971 to 1987, donations to the arts have more than doubled, from over 5 cents of the donations dollar to nearly 13 cents, and were reported to be approximately $250 million in 1987. Generally, for Canadian performing-arts organizations, public subsidies are substantial, but it is primarily the box office that provides most of their income. However, for museums unearned income—almost 80%—is subsidized by the federal government, and to a lesser degree by the provincial governments. As in other countries around the world, Canadian cultural institutions are hoping for more private support as government subsidies decline.

The chapter on Canada, "Corporate Involvement in the Arts and the Reproduction of Power," by Gerald Kenyon, shows how senior executives play a role in the production of high culture. He finds a strong link between the boards of directors of private businesses and those of major cultural institutions, suggesting that business executives play a major role—as network links—in the reproduction of existing ideologies.

Businesses in other countries in the North American hemisphere, probably as a consequence of American domination, report similar reasons for their involvement in the arts, including competition among companies in industries with a high profile—food, beverage, tobacco, and petroleum products reap high profits and, hence, are competitive. Controversial products often gain in status and recognition by their companies' arts support. (This theme is especially entertained in several chapters in this volume.) Consequently, corporations like to sponsor the more popular, highly recognized performing arts, and they prefer to mount blockbuster museum exhibitions (see chapter 19). Because of the "bang for their buck" accrued from these activities, they can justify their donations, as well as high advertising budgets allocated to publicize these events. For the researcher in this area, however, it is difficult to ascertain just how much money is being allocated to artistic events through the marketing and public-affairs departments whose budgets are often larger than their foundations. A growing number of cultural organizations report receiving monies as donations, but also as "sponsorship" (that is, the promotion and advertising of a company's support).

No doubt, corporations have come to rely on the public-relations role to offset the anticorporate stance taken by groups resisting the import of American products, or those products invasive and detrimental to the environment. In countries where government bureaucracies are strong, corporations have come to realize that giving to the community benefits their own objectives, and this

form of "shadow government" serves them well (for example, companies often need new zoning laws to conduct their business). In some cases, governments have insisted that parent companies allocate monies through their subsidiaries in host or foreign countries to support local cultural events, and they are coerced into this philanthropy.

Along with the diversity in national traditions, companies display their own unique cultures as well. Consequently, there are often a complex set of motives, along with a decision-making process particular to the company and the leading executives of the firm. Throughout this book, authors address how organizational structures affect the recruitment of personnel to manage art programs, and how they determine the behavior styles of executives. Chapter 2, for example, attempts to delineate those conditions which dictate selections that are "external" and "internal" to the organization, alluding to many of the subtle yet significant ways decisions are made.

The two chapters by authors from South America, Argentina and Brazil, offer insight into the influence of politics on the arts. These countries are unique in the sense that private companies are controlled by a small number of elite families who produce and disseminate "official" culture. However, as immigrants, they have neglected indigenous cultures and acting from personal interests, reinforce their power through the use of culture.

Rodolfo Gonçebate and Margo Hajduk conducted a survey on the amount of corporate involvement, and motives for support, in Argentina. They found a similar pattern to that in the United States, and included in their survey many subsidiaries of American companies. It is not surprising, therefore, that these foreign subsidiaries are almost exact duplicates of parent companies in the United States. In order to offset the negative responses to their products, most American companies were eager to lend monies to cultural events for the good publicity realized. This chapter includes analysis of the first survey of its kind in Argentina, and addresses the present economic recession's effect on arts support.

José Carlos Durand's chapter, "Business and Culture in Brazil," reveals how immigrant families, in gaining economic and political power, set the pace and nature for arts patronage. Focusing on postwar São Paulo, he shows how a few families used the arts for self-aggrandizement. His analysis of Chateaubriand, Ciccillo, his uncle, Francisco Matarazzo (funder of IRFM), and his son, Francisco Matarazzo, Jr., gives insight into how the press regulated business, politics, and the state government, as well. This small group controlled all aspects of culture, purchased art for its museums, while advertising themselves in the press, and managing the political machinery of the state. He concludes that along with a devastating recession, and a meager attempt to help artists, cultural sponsorship has been discontinuous and haphazard. Recent regulations are attempting to curtail graft and abuse in arts funding, and a democratization of the country is in progress. He hopes that the democratization of cultural policy, made possible by American corporate philanthropy operating in Brazil, will occur.

THE EUROPEAN COMMUNITY

Comparative research has revealed that European companies have always and consistently supported the arts, but in the form of "sponsorship"—that is, in the sense of using the company logo/name in promoting or advertising the artistic event. This form of sponsorship has come to mean advertising the company on concert programs, flags announcing museum exhibitions, listing company names and products in newspapers, etc. Most European-based companies (including American subsidiaries) have accepted support as part of their advertising and marketing strategies. Although American companies have become more obvious and outspoken about these indirect benefits, their European counterparts have, from the beginning, given dollars in areas which are directly related to public relations.

The second significant characteristic among European companies has been their relatively new role alongside government patronage. Public spending has been taken for granted in most European countries, given their strong sense of national heritage and long history of cultural policy. Several chapters in this section take this into account in their discussions, and offer insightful analyses on the changing role of the state and the need to increase privatization of arts funding. Given its cultural heritage, the state's role has been obligatory and assumed. Consequently, the partnership between businessmen and artists has often been distrustful. It is not surprising, therefore, that European businessmen, at least at first, almost exclusively justified their support in terms of public relations, and artists have been complacent in applying for funding, assuming government funds will be provided. This form of "aesthetic welfare" has left many problems and created a crisis for the artistic communities of former communist countries.

Over the past few years, we have witnessed severe budgetary cutbacks in the huge socialized state bureaucracies of Western Europe. Coupled with a world-wide recession, government has increasingly looked to private businesses to lend a hand in areas once reserved for state governments. The preservation of national treasures is a case in point, and the chapters on Italy by Stefano Piperno and Patrizia Zambianchi show how Italian banks are at the forefront of art restoration in the major cities and in smaller regions in the north. These bankers participate and see it as their duty, and they like the prestige it gives them.

The first chapter in the European section by Ann Vanhaeverbeke outlines the role of CEREC—a European network of government and business agencies who support the arts. She emphasizes the public-relations role of most European companies, and addresses the role of sponsorship as advertising and the decentralization of the arts.

Most Western countries followed the leadership of the Association for Business Sponsorship of the Arts (ABSA) of Great Britain and initiated similar societies. These associations exist to promote and encourage partnerships between the private sector and the arts, and do so by sponsoring awards,

publicizing important contributions made by business, and lobbying government agencies or the media to provide incentives.

ABSA reports that in 1993-1994, sponsorship amounted to approximately $100 million in Great Britain. Other interesting findings of this survey reveal that London remains the largest region in terms of cash sponsorship, but a dramatic increase occurred in the south west; music, opera, museums, and theater are the four biggest art forms in terms of cash sponsorship and represent respectively 18.9%, 17.7%, 11.96%, and 10.9%; museums and festivals received over 15% of "in kind" sponsorship. ABSA plays a significant role in the cultural life of England and, particularly, London when one considers that the economic vitality of London is contingent on its tourist trade—London accounts for 50% of tourists to England, 20% of Oxford Street's turnover, 25% of all taxi fares, and 40% of all theater tickets. Tourism in 1992 earned about £5 billion for London, employed approximately 200,000 people, and represented the country's third largest industry.

Chin-tao Wu's chapter presents the major factors of corporate support in Britain, and continues to analyze art collections and the nature of these organizations and their executives. She traces the rise of corporate giving by law and accountancy firms to the increasing need to publicize their services and maintain an "enlightened" corporate image. Attempts to attract a new and expanding clientele are behind their support. At a time when competition was keen, manufacturing firms sought to collect, as well to gain, recognition for the company name, especially in their somewhat anonymous product sector. Similar to firms in the United States, these companies predominantly support the work of young artists, and their collections overwhelmingly include contemporary art.

The Austrian Business Committee for the Arts was begun in 1987, and reports that businesses spent 400 million schillings in 1993. Brigitte Kössner argues the significance of the art/culture and tourist industries for the economic sector—representing 17% of the gross national product! She analyzes what art organizations get support, and the effectiveness of the arts as a marketing and communications tool. Several music festivals and their sponsors are also discussed.

As a response to severe budgetary restraints, and national pride, the independent, privately sponsored foundations in Germany grew to 7,000 to support specific cultural institutions and events. Despite a long and strong history of government influence, these foundations allocated approximately 100 million DM. Virginia Glasmacher and Rupert Strachwitz report that approximately 14 billion DM were allocated for the arts by the government, with 60% of this provided by local governments. They claim a turning point occurred between 1990 and 1994 when the Federal Republic of Germany sought to assist the cultural institutions of East Germany during the period following the demise of communist Europe. Their chapter continues to analyze these foundations in detail listing actual dollar contributions and specific areas of support. They found that 450 foundations operate musical events and about two-thirds of all German foundations function to manage specific nonprofit agencies. Ten leading

foundations and their assets are presented, and since 1989 these private foundations have helped young artists and musicians find a voice and expression in the new Federation of Germany—without ANY communist controls.

Völker Kirchberg's chapter on Potsdam addresses this very point. As the capital of the new federal state of Brandenburg, which surrounds Berlin, Potsdam is being restored, and government and private funds have formed a partnership for this restoration. He presents a case study on the restoration of the monuments, including that of the Sanssouci Estate, a major museum that houses important art treasures.

Erik Hitters of the Netherlands offers a case study of the city of Rotterdam. He observes a somewhat distrustful relationship between artists and businessmen—whose support has been less for goodwill than to capitalize on marketable strategies—and the revitalization of the city. He raises an important dilemma confronting businessmen influenced by a historical tradition of national pride who unexpectedly find themselves competing in an ever-changing international marketplace. He worries that this development may act to inhibit their support of local culture.

Chapters by Stefano Piperno and Patrizia Zambianchi present the unique situation in Italy—privatization in a country with a tremendously important artistic legacy, and one wrought with continuous economic and political crises. Within this backdrop the relationship between corporations and the arts evolved, and began to show harmony in the 1980s. By 1989, it has been estimated that the private sector spent 200 billion lire on the arts—the highest of any country in Europe. Both the decline of the social tensions of the 1970s and the strong economic period of the 1980s facilitated this trend.

Despite the lack of any formal association or government regulations in this direction, Italian bankers have been willing to sponsor the restoration of great treasures, collect important art, and help restore well-known palaces and public monuments (within the limits of 2% of taxpayers' revenue set by a 1985 law). They have even acted on their own without any incentives—as was the case with Fiat's purchase and restoration, at a cost of $15 million, of the Palazzo Grazzi on the Grand Canal in Venice.

The chapter by Zambianchi, "Art Patronage Among Banks in Italy," highlights the role bankers play in collecting and restoring art treasures—thereby preserving the importance of regional cultures. It is not uncommon, for example, to visit a famous museum and observe a plaque beneath a Fra Angelico reminding the visitor that a local savings bank in the Tuscany region contributed to its restoration. She discusses numerous museum exhibitions and art collections maintained by regional and national banks throughout Italy.

Piperno's chapter, in focusing on the industrial and prosperous regions of the north, including two of the ten richest regions in Europe, Piemonte and Lombardia, stresses the political clout and popularity of local cultural commissioners who mount important cultural events. Taken together, these chapters show that privatization has acted to decentralize the structure of cultural organizations as business takes a leadership role in arts patronage.

There is no doubt that Italian bankers and high-technology manufacturers were eager to establish themselves worldwide. They realized early on that their support of internationally recognized art located in their very regions, and the consequent publicity of such support, would gain them unparalleled prestige, status, and visibility worldwide, as well as a competitive edge with their clients.

ASIA AND THE PACIFIC

Australia and Japan, the two countries represented in this section, attest to the pervasive influence of corporatism in the global economy. The description of corporate art collections in Australia and the several chapters on Japan show clearly a westernized approach to arts patronage.

Annette Van den Bosch focuses on the nature of art collecting in Australia since 1960, and outlines both the more noteworthy earlier collections of the Reserve Bank and I.C.I. (a chemical company) as well as other less significant collections. The bank began collecting earlier and was able to make good financial investments in significant Australian artists of the 1960s who became internationally known. The author addresses the major problems of the art scene including the exclusion of women artists (although she cites a positive example of regional Aboriginal artifacts in corporate art collections); the heavy financial losses resulting from the recent recession that began in 1989; the less empathetic new executives who are more concerned with company logos and profits than arts support; and the absence of a national cultural policy which has encouraged competition rather than harmony between the various needy art agencies in Australia.

Kenichi Kawasaki's chapter, "Art and Cultural Policy in Japan," presents an overview of the cultural scene, distinguishing between the minor role of government-sponsored activities, the extensive private support of cultural centers and art exhibitions, and the enormously profitable commercial music, video, and high-technology industries. He shows that despite the long tradition of classical Japanese painting and art crafts, the upwardly mobile middle class emulates the lifestyle and tastes of Western Europe (predominantly France and Italy). This duality of culture explains the dilettante musical and performance activity among the Japanese, and their high attendance at corporate art galleries and exhibitions.

The following chapter consists of a White Paper published by the Association for Corporate Support of the Arts in Japan. This 1992 survey details actual dollar amounts, areas of support, and the extent of support throughout Japan. With a total of over $200 million by 186 companies, contributions continue despite the economy's downfall.

However, in no other country has the economy impacted art patronage as profoundly as in Japan. Since 1969 one can trace this relationship quite consistently. The chapter on art collecting by major Japanese industrialists takes this theme and presents data. It reviews some of the newsworthy purchases of French Impressionist works at Sotheby's and Christie's auction houses, and their

Table 1.1
Defining Characteristics of Corporate Patronage/Sponsorship

Prototype	Characteristics	Art Activity
Corporate Medici	Long cultural patrimony and national heritage Art for art's sake ⎤ Business leader ⎬ France Great Britain Strong economy ⎦	Art Collection ⎤ Italy Art Restoration ⎦
Popular Corporation	Insecure or new culture Need to justify Lack of indigenous culture or official culture Proof of cost effectiveness Related to marketing Emulation of Western culture ⎬ Japan	Advertising ⎤ U.S. Blockbuster museum shows ⎦ ⎬ S. America Greece
Civic-minded Corporation	Insecure or new culture Humanitarian or welfare goals Government as leader Fluctuating economy "Civic responsibility"	Employee benefits ⎤ Artist-in-residence ⎬ U.S. Partnership for the arts ⎦

display in the department stores of Tokyo which attract hundreds of thousands of visitors each year.

SOME IMPLICATIONS OF SPONSORSHIP

The last section of this book presents three somewhat different chapters, each dealing in some way with the impact of business decision making on the arts—museum exhibitions sponsored by corporations, opera repertory decisions made by impresarios, and rational models of decision making within nonprofit arts organizations.

Victoria Alexander's chapter on museums exhibitions mounted by large American art museums between 1960 and 1986 shows how and why corporations favor sponsoring popular blockbuster exhibits and theme shows that attract millions of visitors. These shows enable companies to reach their public-relations goals. These goals also impact on the types of art styles shown in their exhibitions—they tend to sponsor more of the commercial art shows than those that are traditional or historically significant. Throughout her chapter, she

compares foundation and government preferences with corporately sponsored exhibitions.

The chapter by Patricia Adkins Chiti draws upon her own experience as a professional opera singer and her keen knowledge of opera history. The dynamic world of the impresario is presented, highlighting the keen marketing and business sense of many throughout music history. In her professional capacity, she has witnessed the complications arising from reliance upon the huge state bureaucracies that fund arts today throughout Eastern and Western Europe; Chiti offers insight and suggestions.

Drawing from years of experience in nonprofit organizations that fund the arts and his degree in economics, Roland Kushner identifies five measures of managerial interest which contribute to the decision to donate. He argues that support of arts organizations is both practical and rationally positive for the corporate patron.

TOWARD A THEORETICAL MODEL OF PRIVATE SPONSORSHIP

As we can see from this discussion, as well as from the examples in table 1.1, countries exhibit varying interest and motives for patronage and sponsorship. A descriptive analysis of the characteristics expressed within this book might offer an attempt at developing several prototypes that would serve as a set of logical and comparative polarities. Together they represent only a framework for a later detailed discussion and will, hopefully, present the basis for an integrated theory of private/corporate patronage.

NOTE

1. The term sponsorship is used within this book to incorporate all the traditional forms of patronage, and excludes commercial advertising of a company product and/or a profitable and commercial pop art or sports event. It includes the advertisement of support by companies of nonprofit performing and nonperforming visual arts, especially in countries where this is the only form of patronage.

PART II

North and South America

2

Corporate Patronage of the Arts in the United States: A Review of the Research

Rosanne Martorella

ABSTRACT

This chapter reviews existing research on the nature of corporate support of artists and arts institutions. After a brief history, a distinction is made between corporate foundations, giving programs, and art collections—all of which account for at least 10% of the income of arts organizations, and much more for the art market.

Several factors that have influenced corporate/business patronage are analyzed, including both external and internal conditions. The role of the economy is emphasized—as company profits increased over the last 25 years, so have contributions. However, given the recessionary period of the past three to five years, the reverse trend has occurred and fewer corporate dollars are going to support the arts.

Finally, the chapter summarizes the data collected on 24 of the leading contributors, revealing current trends, their estimated contributions, and the future of their support.

INTRODUCTION

Although the private patron remains the most important source of income for the visual and performing arts in America today, recent decades have seen the rise of government, foundation, and corporate patronage. As changes occur and new support systems arise, these new systems of patronage impact on artistic career opportunities, stylistic trends, the art organizations preferred, and the type of support.

Studies exist which reveal how corporate support of the arts indirectly effects the economy of a region (ACA 1976; CWI 1977; NEA 1993; Scanlon 1993;

Shefter 1993), encourages audience development (Blau 1986; Kirchberg 1993), and improves real estate values by cooperating with government in urban redevelopment (Zukin 1991). This chapter, however, presents an overview of the research on corporate patronage for the arts—specifically with regard to the actual dollar amounts, the different kinds of subsidies, and the motives for support. Despite critics who fear the mediocre nonaesthetic uses of art, American corporations are exemplary in their support, and now serve as a model for private companies and businesses abroad—in Western and East-Europe, as well as in South America and Asia.

While government funding of the arts is a form of aesthetic welfare in Europe, in the United States private funding is crucial to its survival. Private donations, including corporate, account for a quarter to half of nonprofit-arts income while the federal, state, and local government support amounts to 14%. The remaining income is received through ticket sales, rentals, dividends, and asset sales. The growth of corporate support has been steadily increasing since 1935, but has shown remarkable expansion since the 1960s. A brief historical overview will capture this development, highlighting significant economic, political, and social attitudes that facilitated the trend toward more corporate involvement.

THE DEVELOPMENT OF CORPORATE SPONSORSHIP

For over one hundred years, American law and public opinion were in agreement with the established English precedent that charity had no place on the corporate board of directors. Significant events after the turn of the century changed this position. World War I stimulated corporate giving, both by the profits of a war economy and the mechanism of War Chests which ultimately led to the United Way (a centralized and nationalized effort to encourage corporate and employee charitable contributions). At the same time, antibusiness feelings grew and antitrust laws were enacted. These developments ultimately led to the "public-relations" person, entrusted to offset ill feelings and critical responses to corporate policies.

The proliferation of private foundations in the 1950s, and the publicity derived by the efforts of Carnegie, Ford, and Rockefeller foundations, made corporations aware of the benefits to be derived from arts sponsorship and lead to the establishment of their own foundations and corporate-giving programs. Ford provided tens of millions of dollars to the performing arts, eliminated ravenous deficits, established countless dance and theater groups, and ensured a stable foundation for symphony orchestras across America well into the 1970s (DiMaggio 1987b).

A single event in the 1960s did much to firmly establish the arts as part of American life and legitimated their funding activity. In 1965, the National Endowment for the Arts (NEA) was established, justifying the position of the arts to receive federal funding—a government involvement which Americans had not witnessed since the Federal Theater Project under the New Deal's Works

Progress Administration. Although in the following years subsidies have declined, the NEA still motivates private foundations and corporate leaders to support the arts. Grant makers looked to NEA for legitimating some artists and arts organizations over others, and its matching grant programs encouraged a wider national distribution of arts funds, solidifying business/government partnerships. Concomitantly, major corporations opened offices in Washington. For emerging corporate elites in search of status, affiliation with artistic endeavors proved an effective vehicle for cultural achievement, visibility, and prestige.

In the mid-1970s when the federal government came in with unprecedented subsidies topping $100 million, art lobbyists hailed its commitment and dreamed of even more support for individual artists, allowing them freedom from the constraints of the market. Museum curators hoped for the opportunity to mount major exhibitions, while performing-arts administrators longed for innovation in repertory selections. To some extent, this was achieved, but a strong economic climate ensuring the entrance of private businesses did more to sustain artistic production. Greater business involvement came at a time when government allocations declined, along with a conservative thrust to support regional art and "egalitarian" art that would reflect the general public's interest rather than that of an urban elite.

Although it is not within the scope of this chapter to analyze the impact of government patronage, its support encouraged other forms of patronage and fostered a national consciousness and pride in American art forms and styles. The grant process insisted that art groups, as nonprofit organizations, develop more bureaucratic and efficient means of production, and it formalized artistic careers by the procedural rules it placed on them in their competition for revenues. Later corporate philanthropy came to recognize arts organizations that manifested more bureaucratized structures.

A KEY FACTOR IN ART SUPPORT: THE ECONOMY

Since the initiation of a corporate tax code in the United States in 1935, corporate contributions, in the form of cash or deductible noncash contributions, have risen steadily for the nonprofit arts, education, health and social services. Tax law changes in 1981 allowed a maximum of 10% of pretax net income to be contributed. But, as Michael Useem (1987) aptly indicates, the level of corporate giving is keyed to company income. As business income rises with the expansion of the American economy, so does the total amount of contributions. For example, Conference Board annual surveys and the Business Committee for the Arts surveys report the income of business firms before taxes.

As summarized in table 2.1, data include total corporate income, total corporate contributions, and estimated corporate contributions to the arts. In 1940 corporate income was $10 billion—while contributions to the arts were $38 million. By 1980 income reached nearly $242 billion—while total contributions rose to $3 billion, with the arts receiving nearly $300 million. By 1990 total corporate philanthropy reached nearly $7.9 billion with the arts absorbing an

Table 2.1
Corporate Income, Contributions, and Support to the Arts

Year	Total Contributions ($Billions)	Contributions as % of Pretax Net Income	Total Contributions to the Arts (%)	Estimated Amount to the Arts ($Millions)
1975	1.20	0.91	7.5	90
1980	2.36	0.99	10.9	257
1983	3.63	1.75	11.4	413
1985	4.40	1.96	11.1	488
1986	4.50	1.94	11.9	536
1990	7.90			600
1991				518

Source: Conference Board *Annual Survey of Corporate Contributions,* 1987, ed., p. 27; Useem, "Corporate Support for the Arts and Culture."

estimated $600 million. The Business Committee for the Arts 1992 survey, including all American businesses with annual revenues of over $1 million indicates that corporate contributions peaked in 1985 at $698 million, and declined to $518 million in 1991.[1]

According to data summarized by Useem, arts support increases with company profits; organizations essentially project a target of contributions based on a percentage of pretax corporate profits (Knauft). Table 2.1 lists the contributions for the years 1975, 1980, 1983, 1985, 1986, 1990, and 1991, revealing a consistent rise in the amount given to the arts—close to 2% at current levels and exceeding over $500 million annually.

In an interesting report, *Arts Funding: A Report on Foundation and Corporate Grantmaking Trends,* Nathan Weber and Loren Renz (1993) provide a significant amount of data on corporate foundations. Although they represent only a small amount of the total corporate contributions to philanthropy and the arts, corporate foundations do represent approximately 12% of foundation support to the nonprofit arts organizations. Table 2.2 attempts to highlight their importance by comparing total foundation support to the arts with that con-tributed specifically by corporate foundations. This data suggest that corporate foundations gave to the arts as follows: 1983, $18 million; 1986, $23 million; 1989, $33.5 million. While these figures appear low, the reader must bear in mind that corporate foundations represent 12 to 15% of foundation dollars, a fraction of the total corporate dollars contributed, and that only a quarter of all companies make any contribution.[2]

Undoubtedly as income increases so do contributions, and arts subsidies stand at approximately 12% of all corporate philanthropy—at around $500

Table 2.2
Arts Grants as a Percentage of All Grants from Foundations

Year	Foundation All Grants Dollars	Corporate Arts Grants Dollars	% of Grant Dollars
1983	$238 Million	$18 Million	13.2
1986	$322 Million	$23 Million	14
1989	$503 Million	$33.5 Million	15

Source: Weber and Renz, *Arts Funding.*

million at the present time—a total figure that is two and a half times that of subsidies from the National Endowment for the Arts and the state arts councils combined.

The Foundation Center report makes clear exactly where these monies come from within the corporation. Of 59 companies who responded with this information (including 44 company-sponsored foundations and 15 corporate-giving programs), more than nine out of ten arts dollars derive from contributions budgets rather than advertising budgets. Almost 94% (93.9%) of arts dollars in this sample came to them in the form of cash, with promotional services comprising 1.5%, and in-kind services less than 1% (Weber and Renz, 121).

Although privately owned manufacuring firms and the older financial institutions appear to have been the earliest corporate patrons, today all kinds of companies in divergent fields and industries collect and support the arts. However, since economic growth and larger revenues ensure support, it is not surprising to see some shift in industry types who support the arts at varying times, depending on company profits.[3] A study of corporate art collections[4] indicates that manufacturing and oil companies amassed their art collections in the late 1960s and 1970s, while the 1980s saw a proliferation of banking, real estate, and financial institutions supporting the arts.

Across the Board, a nonprofit research organization focusing on corporate income and contributions, reports that despite tax reform, takeovers, and pervasive budget tightening, corporate philanthropy is thriving. Almost 17% came from the top 20 corporate funders. Education continues to be the top beneficiary of corporate contributions, and the donation of equipment and personnel shows continued growth. Looking to the 1990s, the organization reports that giving will be cautious, linking philanthropy more closely to marketing strategy. Businesses' approach is twofold—to make a meaningful series of contributions that also make good business sense.

During the past few years financial, law, and communications/media firms show growth in their contributions to the arts while manufacturing and retail firms show a decline (Business Committee for the Arts, 1992).

MOTIVES FOR CORPORATE SUPPORT
AND THE IMPACT ON ACTUAL AMOUNTS

Several studies examine the motives given for supporting the arts, and they can all be viewed as factors which are either external or internal to the organization of giving. External factors include the single most significant factor—company profits—but also include other market factors such as firm type, product sector, and the role of other patrons, both private and public. Internal factors have more to do with the nature and style of the organization of giving—its leadership, its company size, and the professional roles described for art curators, consultants, and human resource personnel within the company itself. (See table 2.4 for a summary of this section.)

Two Canadians, Norman Turgeon and François Colbert (1992), attempted to delineate the considerations entertained by corporations in their decision-making process, listing 41 criteria. The grant-making process includes five categories: the effect of the arts event, the type of the arts event, the general effect situation, the institutional structure of the corporate sponsor, and the institutional structure of the sponsored arts institution.

The effect-related criteria are divided into, first, image objectives ("increase social involvement of the company," "increase public awareness of the company," "counter adverse publicity," "help raise employee morale," and "build goodwill among opinion-formers"); second, product objectives ("increase public awareness of product," change product image," and "identify a market segment"); third, sales objectives; and fourth, the chief executive's personal objectives.

Moreover, Turgeon and Colbert cluster event-related criteria ("company-product compatibility of event," "popularity of event," "geographical coverage of the audience," "necessity of funding," "artistic risk/chance"). The remaining criteria are market related ("pressure to participate" and "competitor's involvement in sponsorship"); sponsor-related ("management knowledge of the event/organization," "executive preferences," and "exclusive-versus-co-sponsor-decision"); and related to the sponsored organization ("professionalization and capacity of organization or event"). A content analysis of nine sponsored arts events measured the significance of these criteria. According to the analysis, effects of image dominate the corporate decision. Primarily, a sponsorship will be granted if it benefits corporate public relations with the neighboring community—if it improves the public perception of the company, if it aids staff relations, if it helps to identify the company's brand, and if it increases sales. Secondly, it will be granted if the sponsored event matches other promotional corporate activities, if the image of the event is compatible with the corporate image, and if a strong media coverage is furnished. The analysis appears comprehensive and includes all the influences on corporate sponsorship.

Because of the tendency to support neighboring arts institutions offering high visibility, and in their support of nearby artists and groups, corporations have facilitated the growth of regionalism of art styles and the decentralization of arts

events. However, many corporate foundations and giving programs are located in New York and favor the nationally recognized groups. Data specifically show that arts institutions in major cities receive a large portion of the corporate dollar. Undoubtedly, their willingness to associate with the more established groups encourages this trend.

The Foundation Center's report confirms the tendency of corporations to support larger well known institutions. For example, the Metropolitan Museum in New York, the Chicago Art Institute, Lincoln Center, etc., are given large allocations each year. This tendency was also confirmed by the case study conducted by the author on 24 leading corporate funders (1994). For example, well-known museum exhibitions were mentioned as receiving a disproportionate share of corporate philanthropy. Never mentioned for support was the allocation of funds for capital improvement—which does much to sustain the arts organization, but little to provide marketing strategies for corporate patrons.

Figure 2.1 summarizes the data collected by the Foundation Center on the percentage of arts grant dollars by corporations. It reveals that despite a decline since 1983, performing arts receive the most grants, seconded by museums, for the years 1983, 1986, and 1989. In addition, the income of museums seem to rely more heavily on corporate support, especially given the cost of mounting "blockbuster shows." Their boards certainly reflect corporate influence. In contrast, performing-arts organizations average 6–9% of their income from corporations with more coming from ticket sales and private patron donations. Both museums and performing-arts groups offer coporations the visibility and recognition of their company by such patronage. (See the chapter in this volume by Victoria Alexander, "Monet for Money: Museum, Exhibitions and the Role of Corporate Sponsorship.")

Table 2.3 outlines more specifically the types of support awarded by ten major corporate arts funders in 1989, revealing that "program support" received 51.8% of all the grants, while operating support garnered 16%. Undoubtedly, program support offers companies more visibility for their own company and products. Contributions for operating support are important to the internal stability of arts organizations, but do little to foster short-term visibility for a patron.

A thorough analysis of American companies was provided by Michael Useem using the *American Council for the Arts Guide to Corporate Giving* (1986); he lists 14 criteria that corporations consider in the granting process. In his survey of 458 corporations, Useem observes that most corporations award grants in the geographic locations of their headquarters. Other additional variables which encourage support include the role of the board of directors and the publicity value of arts events.

As a theoretical follow-up in 1989, Useem describes a taxonomy of ten factors which influence decisions, distinguishing between four market and six institutional considerations. "Market" considerations are the net income of the sponsoring company, sponsoring as advertising a product, improving a corporate image, and the company's dependence on the industrial sector. Most industrial sectors have a distinct tendency to give to one or only a few nonprofit causes.

Figure 2.1
Percentage of Arts Grants Dollars by Major Subject

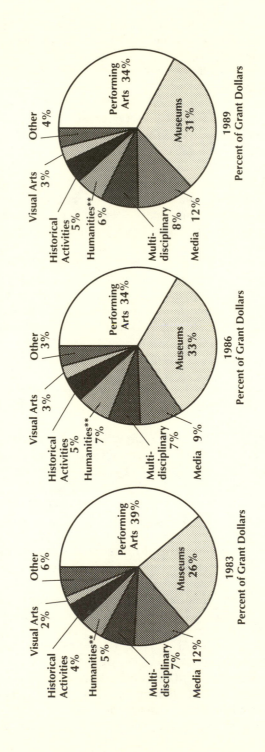

Source: The Foundation Center, 1992.

Table 2.3
Types of Support Awarded by Ten Major Corporate Arts Funders, 1989*

Type of Support	Amount	%	No.	%
OPERATING SUPPORT	$4,188	16.0	217	21.8
Annual Campaigns	49	0.2	4	0.4
Unrestricted	2,565	9.8	170	17.1
Income Development	1,546	5.9	41	4.1
Management Development	29	0.1	2	0.2
CAPITAL SUPPORT	2,312	8.8	46	4.6
Capital Campaigns	876	3.3	23	2.3
Building/Renovation	860	3.3	16	1.6
Equipment	130	0.5	1	0.1
Computer Systems	20	0.1	1	0.1
Endowments	381	1.5	3	0.3
Debt Reduction	25	0.1	1	0.1
Collections Acquisitions	21	0.1	1	0.1
PROGRAM SUPPORT	13,569	51.8	461	46.4
Program Development	1,879	7.2	122	12.3
Conferences	65	0.2	6	0.6
Professorships	10	0.0	1	0.1
Film/Video/Radio	5,806	22.1	25	2.5
Publications	58	0.2	5	0.5
Curriculum Development	23	0.1	2	0.2
Performances	3,957	15.1	261	26.3
Exhibitions	1,657	6.3	32	3.2
Collections Management/				
Preservation	75	0.3	4	0.4
Commissioning New Works	40	0.2	3	0.3
PROFESSIONAL DEVELOPMENT	567	2.2	31	3.1
Fellowships/Residencies	235	0.9	17	1.7
Internships	5	0.0	1	0.1
Scholarships	90	0.3	4	0.4
Awards/Services	236	0.9	9	0.9
RESEARCH	40	0.2	2	0.2
UNSPECIFIED	6,468	24.7	274	27.6

Source: The Foundation Center, 1992.
*Dollar figures in thousands. Grants may occasionally be for multiple types of support, i.e., a grant
 for new works and for an endowment, and would thus be counted twice.

Banks, retail, food, and tobacco companies give to health, human services, and the arts. Chemical and petroleum companies give to higher education and environmental protection. Generally these patterns reflect the corporate culture, but they also offset negative attitudes about the company or its product.

Useem's "institutional" factors include conditions within the sponsoring organization itself—its leadership, company size, management commitment, pressure from other organizations, competitive corporate environment, and the local attitude of business toward contributions.

Nonprofit organizations have always known the importance of their boards of trustees in attracting contributions and ensuring success by raising much-needed funds to offset expenses. The Conference Board surveys have long established that contribution levels are jointly set by a group of companies who share information with each other. Joseph Galaskiewicz (1985, 1991) reports how Minneapolis and St. Paul organizations attracted large numbers of corporate trustees, thereby ensuring company grants. His data also reveal that companies frequently share information about a nonprofit organization so that companies give similarly to neighboring nonprofit groups. Rosanne Martorella, in her study, *Corporate Art* (1990), reveals the key role played by a chief executive in selecting artwork, as well as the collaborative networks formed by the professional societies of corporate administrators.

This collaborative effort and communication among top-level managers and contribution officers of major corporations, reveal how a norm of cultural attitudes is developed and maintained within the business community. The business elite want to be identified with each other, and their visibility and worth is often measured in the amount and kind of financial assistance they provide to nonprofit organizations in their community. The pressure is on to match, keep up, or exceed giving levels established by the business elite.

Although few researchers have given attention to factors which inhibit corporate giving, these studies deserve mention since they add depth to our analysis and allude to the complexity of corporate giving in the United States. Cities across the nation vary in their corporate-art linkages. Obviously a strong corporate presence and a proliferation of well-organized and nationally known arts organizations ensure this partnership. On the other hand, in metropolitan cultures that have a presence and strong tradition of a self-conscious identity with old families of wealth—of upper-class noblesse oblige—there is less corporate support. Although the corporate expansion since the 1980s, relocations, and global corporate growth mitigate against old family influence, cities as Boston, Charleston, Houston, and Naples, Florida, continue to show significantly less support by corporations (DiMaggio 1982). One might also note their influence in arts organizations in the retirement enclaves for these families (Boca Raton, Naples and Sarasota, Florida; Phoenix, etc.)

Although contribution budgets are relatively small in comparison to the total budget of the corporation (usually less than 1%), the top levels of management are almost always responsible for their allocations, and contribution policies are clearly defined by a set of guidelines. For most companies, however, a rational

Table 2.4
Motives for Corporate Support

Type	Description	Outcome	Authors
External	The Economy	increased support art acquisitions	Useem Martorella
	Company Profits	contributions as a percentage of pretax corporate profits	Knauft
	Competitive Industry: firm/type product sector	needs publicity improved image	
	Marketing	advertisement	
	Government Funding	partnerships	Schuster
	Private Contributions	direct relationship	
	Sponsored Arts Institutions	well established	
	Inner-city Consortiums	urban redevelopment	Zukin Galaskiewicz
		metropolitan-linkages	Blau/Cwi
	Geographic Locales		Martorella
	Regionalism		Useem
	De-centralization	shadow government	Peterson
Internal	Nature and Style of Organization	routinization and professionalization of curatorial roles	Martorella DiMaggio
	Corporate Leadership and Company Size	increased support to company self-interest improved business climate recruit new managers	Useem Knauft
	Arts Organizations: well-known, popular with audience	less economic risk increased good image identify with quality	Martorella

decision-making process occurs in which the "bottom-line" approach is applied. Arts organizations receive sponsorship if they can prove that their art event will increase visibility and provide an enhanced public image to the company and its product.

Indirect evidence alludes to the intentions by corporations to support the arts as a form of "shadow government"—local corporations attempt to co-rule with the government through the invisible hand of an "internalized corporatism." Corporations are in constant need of government to provide regulations, land-use requirements, etc., that will suit their needs and provide for increased profits and productivity. It comes as no surprise, therefore, that corporations want to

firmly establish corporate images as "good and socially responsible citizens" that do well for the local community. Supporting the arts, and other nonprofit organizations, is a way in which corporations get entrenched in the community and receive the legislation and political favors they need.

While it is not within the scope of this chapter to argue the validity of the economic impact of arts' studies, mention must be made of them since they serve to legitimate government and corporate sponsorship to a sector of the economy that does need their support (Blau and Hall 1986; Cwi 1977; Kirchberg 1993; Martorella 1990; Scanlon 1993; Shefter 1993; Zukin 1991). It is significant to note that these studies do much to address the importance of government and corporate partnerships that have encouraged urban development and energized an economy of tourism which the arts both rely upon and contribute to.

In the literature on patronage and the arts, no mention is made of the declining source of income as a contingency of changed cultural attitudes in America. Social and economic conditions too complex for the present discussion have acted to lower the involvement of citizens in nonprofit organizations. Educational institutions, social agencies, community service groups, and arts organizations are witnessing a changed value orientation among their workers with fewer dollars and volunteers for these nonprofit organizations since the mid-1980s. The rise of the dual-income family and of the single-parent family in America leaves little volunteer time and money to donate. In addition, the culture of narcissism, the "me" generation, and the breaking of communal and national traditions result in less volunteerism and monetary commitment in general on the part of individuals.

A CASE STUDY: TWENTY-FOUR CORPORATE "STARS"[5]

The author identified 24 leading companies that exceeded annual averages of giving over a decade, and were confirmed as leaders by the Business Committee for the Arts and The Foundation Center in New York City. A survey was distributed in the spring of 1994, and more than half of those queried returned their questionnaires. Since all but two have art collections, questions were asked on the kinds of and motives behind corporate support, as well as the extent of art acquisitions at the present time. In addition to the information they offered, economic data was coded from the directory, *Corporate Foundation Profiles* (7th ed., 1992). While all of the corporate foundations in this survey had over $1 million in assets, the majority were located in New York City (8), three were in Minnesota, and the rest were in New Jersey, Chicago, Michigan, Missouri, Connecticut, Kansas City, Virginia, California, and Texas. Some of the more important findings include:

- companies that have active giving programs in support of the arts also maintain a corporate art collection;
- art collecting has been curtailed, with emphasis on maintaining the collection that exists and some deaccessing has occurred;

- corporate giving directly reflects the annual budget allocations, and is, thereby, a by-product of company profits;
- definite guidelines and corporate policies exist for both the corporate-giving and art-collecting programs;
- a full-time in-house professional maintains both the corporate-giving and art-collecting programs;
- seven report that art collecting has stayed the same over the past five years, while three report a significant change;
- all report budgeting constraints;
- all report a cutback in acquisitions, renovations, and/or construction;
- corporate giving favors support to museums, followed by performing-art organizations and those companies that produce more visible artistic events;
- respondents favor nationally known institutions, with less support given to local groups;
- all report either the economy or the CEO has changed corporate policies in support of the arts;
- most feel support is important and worry about young artists.

Table 2.5 reveals that these companies contribute above the average contribution to the arts of 10-12%; and, in fact, some are exemplary and outstanding in their suport. For example, from 1979–1983, the Bell System supported the American Orchestras on Tour, backing more than 580 concerts by 30 major American orchestras in 46 cities across America.

In general, it appeared that a corporate policy existed which included art support as an integral part of marketing strategy to acquire product visibility, an improved public image, goodwill in lcoal communities. Both their corporate giving to the arts and their art acquisitions made their commitment to arts patronage exemplary.

CONCLUSION AND FUTURE RESEARCH

This chapter has attempted to summarize the literature on corporate patronage of the arts, giving attention to both the external and internal factors that affect its development. A recessionary economy, a competitive marketplace for all industries, and a changed value orientation among corporate leaders has led to a decline in corporate patronage since the boom years of the 1980s. However, leading companies still support the arts in a way that makes "good business sense," supporting those arts organizations that are stable and well established, offer visibility for product, and have community accessibility.

Given this corporate priority, we will see few emerging art styles or the development of young artists in America who, throughout the past 25 years, have relied heavily on corporate patronage.

The case study attempted to specifically focus on the impact of the decline, and it appears research must go in this direction. In other words, it would prove analytically more productive to conduct small-scale case studies that focus on specific product sectors, company types, or individual organizations than overall

Table 2.5
The Leading Corporate Contributors to the Arts, 1989

Name*	Foundation Assets ($Millions)	Contributions to the Arts (%)	Estimated Contributions ($Millions)**
American Express	$ 1.0	13	5.4
Bell Atlantic	8.6	19	—
Chemical Bank	16.7	—	—
Dayton Hudson	19.0	43	7.3
Eastman Kodak Company	21.5	20	3.2
Exxon	32.7	—	—
Ford Motor Company	26.4	17	6.9
General Electric Co.	13.2	—	5.4
General Mills	37.0	19	—
Hallmark	28.0	32	—
IBM Corporation	—	—	13.5
J.P. Morgan	2.3	15	—
Manufacturers Hanover	16.7	10	—
Metropolitan Life	100.0	14	2.7
Phillip Morris	—	—	5.9
RJR Nabisco	11.5	10	—
Sara Lee Corporation	17.2	26	4.8
Southwestern Bell	42.0	19	35.0
Texaco	43.2	21	—

*This list has been identified by the Business Committee for the Arts, and The Foundation Center.
 Additional Sources: L. Renz, "Arts Funding by the Ten Leading Corporate Giving Programs."
 Arts Funding, The Foundation Center, New York, pp. 95-98.
**Includes support for artists and arts institutions of all kinds as well as historical research and
 preservation, public broadcasting, and libraries.

trends that have been the nature of research in the past. Important information is lacking because too many researchers have been unwilling to develop the case-study approach as a valid methodology in this area.

Because of this shortcoming, they have failed to address how stylistic trends may be affected, or to reveal more specifically how the arts have lost out over the past few years, or what younger artists and emerging art groups have been doing. From my observation, it appears that new and emerging art styles—or an "art scene"—seem to be shifting toward the universities—a trend analogous to the contemporary avant-garde composer who has relied on government grants and university appointments for a livelihood.

A secondary development, and one that needs serious attention by researchers, is the role of the "commercialization" of the "serious" artist who, in pursuit of work and a livelihood, develops his/her talents in the areas of the

decorative arts (i.e., fabric, furniture, interior design, fashion). While there has usually existed a distinction between the commercial/graphic arts and fine-arts movements, the distinctions seem to be narrowing. The reality of talented artists venturing into these commercial career opportunities is more commonplace.

NOTES

This chapter is the outgrowth of a paper that was presented at the World Congress of Sociology, Bielefeld, Germany, July 1994, and was made possible by a grant from the Assigned Research Time Committee at William Paterson College.

1. Higher range estimates (up to $1 billion) usually include support to the arts in the form of cash contributions, as well as monies allocated from business expenses, public relations, advertising, or marketing budgets. However, such allocations are minimally represented in the overall figures since most companies do not consider allocations from advertising, public relations, or marketing an arts contribution. Estimates vary according to reports and differ by the leading researchers in the arts (i.e., Business Committee for the Arts [BCA], Conference Board, American Council for the Arts [ACA], Corporate Giving Survey).

2. By law, foundations are required to spend 5% of their assets annually on grants and related expenditures.

3. An unprecedented construction boom occurred in the United States from 1975 to 1985, with private nonresidential construction estimated at $85.6 billion by 1985. Corporate profits were the highest during this period, and the greatest increase of corporate art collections occurred during this time as well. While approximately half of American corporations have collections with fewer than 300 works, an equal number have holdings of several thousand pieces.

4. I (1992) also revealed a relationship between economic growth and art acquisitions—almost half of the companies in my study reported over 15% growth during the period 1975 to 1985.

5. I wish to thank my student research assistants, Jennifer McAdam and Deepa Sudhwani, for their assistance in tabulating statistics and their attention to detail.

Corporate Involvement in the Arts and the Reproduction of Power in Canada

Gerald S. Kenyon

ABSTRACT

The linkage of status and power has long been a central theme in sociology, both in general and in the context of the arts. However, it is argued in this chapter that in terms of private-sector involvement, particularly at the level of trusteeship and patronage, linkages are as strong as ever. Moreover, major high-status national arts institutions do much to reinforce prevailing power structures.

To explore this phenomenon further, data were obtained from 23 leading arts institutions in Canada. The acquired information was treated with both network and content analyses. The characteristics of participating corporations and their places in national and international economies were examined and incorporated into the discussion.

While there are a number of analyses remaining, the results to date suggest that the high-status arts facilitate both class consolidation and elite integration, and that this occurs along both structural and cultural lines. Insofar as these processes are important in social reproduction, high culture appears to be playing a not insignificant part. Thus, despite the high status art world's image in the Western world of being free from external constraints and driven by creativity and novelty, and however its content may be counter to prevailing mores, it is argued that for the most part, the arts contribute less as a force for social change and more as a vehicle facilitating the reproduction of existing social formations.

Despite important national differences in private-sector participation in nonprofit high-status art worlds, in most developed countries, it is significant and growing. For example, in addition to individual giving and corporate sponsorship, governing boards of the largest and most prestigious nonprofit arts organizations and their various fund-raising and support committees are com-

prised of a substantial representation from the highest-ranking companies of the corporate world.

When taken together with the political economies prevailing at century's end, I suggest that such conditions provide a fertile ground for the production and reproduction of power and social control in the larger society. Furthermore, despite their often declared counter-hegemonic role, I argue that the arts are less a force for social change—that is, the *production* of society—and more an instrument for the *reproduction* of prevailing power structures. Moreover, it is suggested that the locus of this process is less at the level of the artist or artistic content and more at the level of arts organization—the arts per se speak only pages, art organizations speak volumes. Elsewhere I have expanded upon this theme, suggesting that contemporary high culture contributes to the reproduction of power through mechanisms which are both structural and cultural (see figure 3.1) (Kenyon 1994a). On the cultural side, upon analysis, elements of a market-economy discourse are significantly embedded in high-culture art worlds, despite their location in the third, or nonmarket, sector, and despite their often characterized role as society's conscience, where a critique of its dominant forces is regularly supplied (Kenyon 1994b). This chapter, however, addresses the extent to which the arts precipitate structural conditions that tie together the institutionalized elements of contemporary market economies, namely large-scale corporations. Thus, the question arises: To what extent do high-status arts organizations either create or reinforce networks among significant corporations?

Concomitant with much of the scholarship describing the nature of power have been attempts to explain its perpetuation. For example, while acknowledging the importance of socializing institutions, particularly the family and education, Pierre Bourdieu (1984) stressed the significance of differentially transmitted cultural content resulting in a strong link between taste, or "cultural capital," and status and prestige.

Figure 3.1
The Contribution of High Culture to the Reproduction of Power

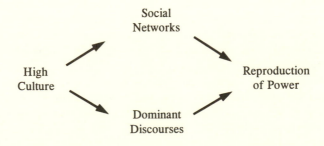

Power need not always be seen in a negative light. It can be argued that it is a necessary prerequisite to achieving common goals and welfare. To illustrate, if the case can be made that the arts provide an avenue for the full realization of human potentialities—the arts-for-art-sake argument—those in power can and do act accordingly, albeit while reflecting and subscribing to a discourse which has been socially constructed just like any other. The preservation of the arts, then, falls to those in positions of power, those who are able to take decisions independent of the "masses."[1]

Among the mechanisms facilitating consent is the social construction of identities. For elites, the continued involvement in high culture reinforces the reciprocal relationship between cultural capital and identity. The confidence such identities bring to the elites and the signs, symbols, and ununderstandable rituals and conventions of the arts serve to intimidate the nonelite. While one might expect resistance, it does not usually occur. For whether the distinction is respected, and the associated status revered, as I suspect it often is, only becomes significant in the absence of alternative identities. Given the power of mass media, numerous other identities are available and are often seized upon. By coming to know and by "following" institutionalized popular culture, whether it be sport, country music, or television "sitcoms," an internal solidarity is created involving colleagues with like interests. The result is passive consent, and the maintenance of "distinction." Thus, as Nicola Beisel (1993) points out, cultural objects acquire meaning which can only be understood by determining "the relationship between social structure, cultural schemas, and the construction of identities" (160).

THE ARTS AND SOCIAL REPRODUCTION

The basic question is What is the role of the arts in power reproduction processes? Much of the research on the link between the arts and class has focused upon consumers or audiences, and often has been related to content. Indeed, connections have been confirmed (DiMaggio 1987; Robertson 1983) and challenged (Gans 1974, 1992; Peterson and Simkus 1992). However important these findings may be, from the perspective of status attainment and the reproduction of power, I suggest that we need to go beyond a tradition begun by Thorstein Veblen (1899–1953) and consider the significance of institutional arrangements that have become firmly established among high status art forms. More particularly, the place of high culture in reinforcing the power of elites may be less through consumer activity (attendance at the symphony or visits to the gallery), and more through direct participation in the affairs of one or more high-cultural institutions (trusteeship and patronage). Thus, we need to determine the extent to which such participation involves today's dominant "seat of power," the private sector, and more particularly, how arts institutions, albeit unwittingly, facilitate a strengthening of relationships among major corporations and their representatives. One indicator of such a phenomenon would be the presence of social networks among corporate entities induced by arts organizations.

In addition to, and as an integral component of the production of the arts as such, the private sector contributes to the production of meanings, both in reference to the arts, and beyond. Private sector activities often afford significant opportunities to produce, disseminate, and reinforce discourses. For example, high culture, almost by definition, lends itself rather well as a site for the perpetuation of private enterprise and market discourse. Individual initiative, hard work, "tough" competition, high achievement, global standards, material rewards, and public esteem are all mutually embraced discourse elements. In addition, the world of private enterprise brings to the arts other themes, including demand-side economics, less government, and good corporate citizenship, as well as assumptions about individual autonomy, freedom, opportunity, creativity, and the artist as genius. At the same time, private-sector initiatives are taken, consciously and unconsciously, to secure widespread consent to the place in society enjoyed by high culture. While not reported here, an analysis of private-sector discourse as it prevails within the arts has been addressed elsewhere (Kenyon 1995).

DATA AND METHODS

To determine the nature of corporate networks precipitated by high-status arts organizations required the names of both persons (governing board members, major patrons, and donors) and relevant private-sector organizations that were associated with the arts (corporations and foundations). These were acquired directly from the appropriate arts organizations. After some reflection, a decision was taken, but not without some methodological choices about which organizations to include. Although it was tempting to pursue the problem crossnationally, the complexity of such an approach precluded its serious consideration. Thus, all data were acquired in Canada. Although Canadian society in general and its arts institutions in particular have some unique characteristics, given the international nature of the arts today and considerable common ground in the way the arts are created, produced, and distributed, the findings should have relevance beyond the Canadian context.

In selecting organizations, since the focus was on high-status art, I chose to concentrate on those performing- and visual-arts institutions which are generally held to be representative of the highest levels of achievement, or regarded as possessing "national" stature, or whose mandate is to cater to the "best" art or artists. These considerations, together with a desire to have a good representation of Canada's two major linguistic (and thereby cultural) groups, led to concentrating upon arts organizations in Ontario and Québec. Since the model incorporated support organizations, data were also acquired from both federal and provincial agencies having a direct role in assisting artists and arts organizations. Thus, granting bodies, such as The Canada Council, The Arts Council of Ontario, and the Conseil des arts et lettres du Québec were included, as were other relevant state agencies, including The Canadian Broadcasting Corporation/Radio Canada, and the Canadian Cultural Property Export Review Board.

Table 3.1
Organizations Used in the Analyses

Organization	Location
PERFORMING ARTS	
The Canadian Opera Company	Toronto
Les Grands Ballets Canadiens	Montréal
Orchestre Symphonique de Montréal	Montréal
The National Ballet of Canada	Toronto
L'Opéra de Montréal	Montréal
The Toronto Symphony Orchestra	Toronto
VISUAL ARTS	
Musée des beaux-arts	Montréal
Musée d'art contemporain	Montréal
McCord Museum of Canadian History	Montréal
Art Gallery of Ontario	Toronto
Royal Ontario Museum	Toronto
Canadian Centre for Architecture	Montréal
THEATER	
The Stratford Festival	Stratford, Ontario
The Shaw Festival	Niagara-on-the-Lake, Ontario
CULTURAL AGENCIES	
The Canada Council	Ottawa
The National Arts Centre	Ottawa
The National Gallery of Canada	Ottawa
The Canadian Broadcasting Corporation	Ottawa
Cultural Property Export Review Board	Ottawa
The Ontario Arts Council	Toronto
Conseil des Arts et des Lettres du Québec	Montréal
ADVOCACY ORGANIZATIONS	
The Council for Business and the Arts	Toronto
The Canadian Conference for the Arts	Ottawa

Finally, two advocacy organizations were included: The Canadian Conference of the Arts and the Council for Business and the Arts in Canada. The full list is given in table 3.1.

For the empirical work, several units of analysis were used, including trustees sitting on governing boards of arts organizations,[2] major individual patrons,[3] foundations, and significant corporate donors and sponsors. In addition, selected characteristics of persons and organizations were recorded, using both primary and secondary sources.[4] Data were placed in machine readable

form, which permitted using the capabilities of relational data base packages,[5] and network-analysis software.[6]

FINDINGS

Communication requires, at a minimum, both persons and context. When the two intersect, the result is a network of relations. The content of network communications will depend upon the characteristics of the communicators as well as those of the sites where communication occurs. Thus, to understand more fully the nature of networks linking high-culture and private sector enterprise requires knowing (1) something of the network elements, both those persons in the arts and the other spheres who, from time to time, interact in arts contexts, and those corporations with direct relationships with the arts, through sponsorship or as affiliates of persons; and (2) something of the network structures, i.e., those frames within which persons are situated, namely, arts organizations, corporations involved in the arts, and the arts-related state agencies.

NETWORK ELEMENTS

The characteristics of board members and patrons, and their corporate affiliations, are shown in tabular form. Tables 3.2 and 3.3 give an indication of the distribution of gender, ethnic origin, and two status markers of board members and major patrons.[7] In general, those in positions of power and influence in art organizations reflect the same characteristics as those typically in positions of control in the market economy. The exception is in some of the agency boards, where terms of reference may require greater diversity in board membership.

Regarding gender, the arts, stereotypically, have been traditionally viewed as the site of community voluntary involvement by upper-middle-class women. However, as shown in table 3.2, with respect to participation rates, women are underrepresented on the governing boards of Canada's major voluntary arts institutions, though in the context of federal and provincial cultural agencies, discrepancies tend to be smaller or disappear.[8] However, as shown in table 3.3, when it comes to patronage, the proportion of women donors falls to less that 25% in all categories.

With respect to ethnic origin, the findings indicate a not surprising regional factor, namely a relatively large proportion of Québec board members reflect French origins, particularly in Francophone organizations. However, of more significance is the sometimes major discrepancy between ethnic distributions among the boards of arts organizations and the population at large. Indeed, members of British origin are substantially overrepresented in both Ontario- and Québec-based organizations, while those with French backgrounds are underrepresented in Québec, as well as in Ontario. Those with Jewish origins are overrepresented in both jurisdictions. While not a part of this chapter, these findings suggest the need to pursue further the interaction of class and culture in arts contexts (Ogmundson and McLaughlin 1992).

Table 3.2
Characteristics of Art Organization Board Members (%)

Characteristic	Performing N=420	Visual N=308	Theater N=106	Agency N=145	Advocacy N=85	Total N=1064
GENDER (%)						
Male	73.1	63.8	73.6	55.2	65.9	67.4
Female	26.9	36.2	26.4	44.8	34.1	32.6
ETHNICITY*						
British Origin	46.4	53.6	68.9	44.1	56.5	51.2
French Origin	23.1	14.3	3.8	32.4	22.4	19.8
Jewish	6.4	6.8	7.5	7.6	5.9	6.8
Other	24.0	25.3	19.8	15.9	15.3	22.2
OTHER SIGNIFICANT						
VOLUNTARY ORGANIZATION	31.7	19.8	35.8	35.2	51.8	30.7
ORDER OF CANADA	6.0	8.8	8.5	9.0	10.6	7.8
PERCENT OF TOTAL	39.5	28.9	10.0	13.6	8.0	100.0

*General Population (1991 census); N=26,994,645

	British	French	Jewish	Other
Canada:	28.8%	22.8%	0.9%	55.5%
Ontario:	25.4%	5.3%	1.3%	68.0%
Quebec:	4.2%	74.6%	1.1%	20.1%

Table 3.3
Characteristics of Art Organization Patrons and Major Donors (%)

Characteristic	Performing N=994	Visual N=685	Theater N=309	Total N=1988
GENDER (%)				
Male	80.2	73.0	71.6	76.4
Female	19.8	27.0	28.4	23.6
ETHNICITY				
British Origin	51.3	48.9	70.2	53.4
French Origin	11.7	6.0	1.0	8.0
Jewish	6.5	9.1	4.5	7.1
Other	30.5	36.1	24.3	31.4
OTHER SIGNIFICANT VOLUNTARY ORGANIZATION	19.1	9.1	13.6	14.8
ORDER OF CANADA	5.4	3.9	5.5	4.9
PERCENT OF TOTAL	50.0	34.5	15.5	100.0

On the question of formal educational background, it was not possible to acquire anything like full information. What is available reveals above-average levels of attainment by board members and patrons. The prestige of their background educational institutions, while possibly of some importance at the pre-university level, is regarded as less significant in Canada than in, say, the United States, France, or the United Kingdom. For most of the sampled persons used in this study, at the time of graduation, there were many fewer post-secondary institutions than at present, with far less variability in standards, keen rivalries notwithstanding. Nevertheless, the information that was available through secondary sources shows a disproportionate number of board members and patrons with prestigious educational backgrounds, from Upper Canada College at the secondary level, to Oxford and Harvard universities at the postgraduate level. Though perhaps not surprisingly, persons in high-status art world networks seem to have been well positioned to acquire cultural capital,[9] which in turn, should be reflected in other attainments. This was explored, in part, by noting the occupations of board members and major patrons of each of the 23 organizations, and by examining their level of attainment within each. The results revealed that where information was available, the large majority of arts board members and patrons had chosen business careers, were affiliated with major corporations, and occupied senior positions,[10] in one, and often two or more, companies (see also, Kenyon 1992). Thus the substantial association between the status of arts roles and that of corporate roles prevails here, as has been shown to be the case in other jurisdictions. Furthermore, as a group, board

members and patrons with corporate affiliations could add to their credit a disproportionately high number of public honors, including the Order of Canada, and were substantially involved in other nonprofit organizations (again, see tables 3.2 and 3.3).

When it comes to corporate involvement in the arts, as shown in table 3.4, much of the business spectrum is represented. Of the 1,481 companies associated with the 23 arts organizations, the largest subgroup was banking and financial services, accounting for 19.1% of the total. An examination of the distribution of corporate type across art forms revealed no major differences. With regard to the status of those corporations linked to the arts, up to half of the country's "top" firms were present, with the performing arts (ballet, opera, and symphonic music) attracting the highest proportion.

NETWORK STRUCTURES

Much of social life is dependent upon a variety of information and influence networks. If the arts figure significantly in the processes of status attainment and power reproduction, as postulated here, then analyses should reveal structures which could facilitate communication, and, in turn, serve as sites for reinforcing dominant discourses and instrumental identities. For example, in the case of the private sector, networks should reveal class consolidation, showing ties among common class fractions, that is, among representatives of several industry groups. Moreover, it follows that the network elements should be comprised of a significant proportion of high-status corporations. Thus, after identifying several hundred corporations linked to arts organizations, only those regarded as enjoying high status and prestige in the business community were included. Specifically, the largest 140 corporations active in Canada were selected to represent the high-status business world.[11] Of the 140 corporations, 62 were involved in some way in the affairs of the 23 arts organizations studied here.

The general proposition was tested using a series of network analyses (Wellman and Berkowitz 1988; Scott 1991), employing GRADAP, a software package permitting the analysis of relatively large data sets (Stokman and Sprenger 1989). Upon examining the results, it can be concluded that there is a clear presence of arts-induced networks and subnetworks within the private sector.

While in the larger study, a variety of structural analyses were carried out to acquire a picture of art-induced status-attainment processes. Space permits reporting only two here. The first sought to discover the ties among corporations induced by art organizations when the corporate affiliations of the inner board members only were taken into consideration.[12] The second followed the same path, except corporations were identified as to the corporate affiliations of significant donors (individuals and foundations).

With regard to the formation of corporate interlocks through inner board members, a network analysis revealed a number of intercorporate networks within the original set of 140, including eight blocks and 12 cliques,[13] as shown in table 3.5. Upon examination of these, it is apparent that the larger ones are

Table 3.4

Characteristics of Corporations Significantly Associated with Art Organizations (%)

Characteristic	Performing N=643	Visual N=339	Theater N=433	Advocacy* N=66	Total N=1481
TYPE					
Oil and Gas	5.4	4.1	4.6	7.6	5.0
Other Resource	5.3	4.4	3.7	7.6	4.7
Manufacturing	19.3	17.4	15.9	13.6	17.6
Food, Beverage, and Agriculture	7.6	8.0	10.6	4.5	8.4
Banking and Financial Services	21.0	18.6	15.9	24.2	19.1
Media and Publishing	5.6	6.5	5.3	6.1	5.7
Retail Trade	3.1	4.4	3.7	4.5	3.6
Transportation	2.5	1.2	2.3	0.0	2.0
Communication	5.6	2.7	3.0	6.1	4.2
Investment/Development/Real Estate	8.9	12.1	6.5	6.1	8.8
Other or n/a	6.4	3.8	10.6	7.6	7.1
Missing	9.3	16.8	17.8	12.1	13.5
STATUS**					
By Profit	39.0/36.7/10.0	29.0/26.7/10.0	34.0/23.3/10.0	17.0/3.3/0.0	29.8/22.5/7.5
By Revenue	53.0/40.0/20.0	43.0/33.3/10.0	44.0/33.3/10.0	21.0/16.7/10.0	40.3/30.8/12.5
By Assets	50.0/46.7/20.0	37.0/43.3/10.0	46.0/40.0/10.0	20.0/13.3/10.0	38.3/35.8/12.5
TOTAL	43.4	22.9	29.2	4.5	100

*Council for Business and the Arts only.
**1993 Globe and Mail *Report on Business*, top 100 public/top 30 private/top 10 crown corporations (percent of those corporations affiliated with the arts which are ranked within each category).

Table 3.5
Art-Induced Networks and Subnetworks
among the Largest 140 Canadian Corporations

Networks	Components[1]		Blocks			Cliques[2]	
	N	Sizes	N	Sizes	Densities	N	Sizes
Among Corporate Affiliations of Inner Board Members of 23 Arts Organizations	3	45/2/2	8	2 to 31	.29 to 1.00	12	3 to 12
Among Corporate Affiliations of Individual Donors to 15 Arts Organizations[3,4]	1	35	4	2 to 30	.50 to 1.00	8	4 to 15

[1]Minimum multiplicity = 1
[2]Minimum size = 3
[3]Including foundations
[4]Note: Of the 23 arts organizations, only 15 solicit private-sector support

Table 3.6
Corporations Included in Two Largest Cliques Induced
by the Corporate Affiliations of Inner Board Members of 23 Arts Organizations

CLIQUE ONE		CLIQUE TWO	
Name	Rank within Type*	Name	Rank within Type
Burns Fry Ltd	25	American Barrick Resources	96
Can. Imperial Bank of Commerce	2	Bank of Montréal	3
Domtar Inc.	73	Canadian Tire Corporation	87
Hydro Québec	2	Canadian Trustco Mortgage	11
Ind'l All'ce Life Insurance Co.	15	Gulf Canada	60
Laurentian Bank of Canada	33	Molson Company	85
Laurential Group Corp.	22	RBC Dominion Securities	10
National Bank of Canada	10	Trilon Financial Corporation	9
Power Corporation	12	Trizek Corporation	36
Royal Bank of Canada	1		
Sears Canada	82		
Toronto Dominion Bank	5		

*Publically traded, private, or crown; by assets.

Table 3.7
Corporations Included in Three Largest Cliques Induced by the Corporate Affiliations of Individual Donors to 15 Arts Organizations

CLIQUE ONE		CLIQUE TWO		CLIQUE THREE	
Name	Rank within Type*	Name	Rank within Type	Name	Rank within Type
Air Canada	46	Bank of Montréal	3	Great West Lifeco Inc.	15
American Barrick Resources	96	Can. Imperial Bank of Commerce	2	Great West Life Assurance Co.	16
Bank of Nova Scotia	4	CN Rail	8	Imperial Oil Ltd.	23
Brascan Ltd.	45	Dofasco Inc.	63	Moore Corporation Canada	76
Canadian Pacific Ltd.	17	E-L Financial Corporation Ltd.	71	Power Corporation	12
Can. Imperial Bank of Commerce	2	George Weston Ltd.	53	Royal Bank of Canada	1
E-L Financial Corporation	71	Imperial Oil Ltd.	23	Seagram Company	25
General Motors Canada	14	Laurentian Group Corp.	22		
Imperial Oil Ltd.	23	MacLean Hunter Ltd.	97		
Loblaws Supermarkets	79	Molson Co.	85		
Moore Corporation Canada	76	Mutual Life Assurance	7		
Power Corporation	12	RBC Dominion Securities	10		
RBC Dominion Securities	10	Sun Life Insurance Co.	4		
Royal Bank of Canada	1	Trilon Financial Corp	9		
Trans-Canada Pipelines	34				

*Publically traded, private, or crown; by assets.

dominated by the largest financial institutions, but other business sectors are well represented, as shown in table 3.6.

When corporate affiliations of donors are considered, a number of networks also emerge. Probably of greatest significance is the appearance of several large cliques, that is, those networks where all of the members have ties with each other. Upon examining the three largest cliques (table 3.7), it can be seen that, again, financial institutions predominate, but other sectors appear here as well. Thus, the arts would seem to create ties both within and across corporate type and therefore enhance conditions precipitating class consolidation. In addition, where the networks among art institutions per se tended to be regionally oriented (Kenyon 1994a), those among corporations tended to be independent of the location of the arts organization. The significance of such networks is addressed more fully, as part of the larger study.

SUMMARY

The overall project was designed to test the proposition that high culture in contemporary society serves to reproduce the prevailing power structure. While only a small portion of the findings are reported here, the data suggest that high culture facilitates both class consolidation and elite integration, and that this process occurs along both structural and cultural lines. Insofar as these processes are important in social reproduction, high-status museums and performing-arts companies appear to be playing a not insignificant part. Thus, despite the art world's image in the Western society of being free from external constraints and driven by creativity and novelty, and however its content may be counter to prevailing mores, it is argued that, for the most part, the arts contribute less as a force of social change and more as a vehicle facilitating the reproduction of existing social formations.

NOTES

This chapter consists of a paper presented at the 8th International Congress on Cultural Economics, Witten, Germany, 1994. It is part of a research project for a doctoral thesis in art history at the University of London.

1. A major ingredient in this process, at least since Gramsci, has been some provision for obtaining consent from the powerless.

2. Given that most board-member terms are fixed, a three-year period (1989–1990, and/or 1990–1991, and/or 1991–1992) was used to broaden the base.

3. Given that the terms of trustees are usually limited, this category often includes former board members as well as persons active on major committees of the organization in question. Of course, some cultural agencies are excluded here since financial patronage is not a part of their mandate.

4. Over time, a substantial data base was created, consisting of approximately 5,000 cases; 3,000 persons; and 2,000 corporations and foundations.

5. Paradox for Windows, Version 4.5 (1992).

6. Gradap, Version 2 (1989).

7. Although family background is a key ingredient of models such as those based upon Bourdieu's theory, no direct assessment (e.g., SES) was undertaken, given that the project focuses upon the later stages of the status-attainment process.

8. Women who do serve could be appointed on the basis of either their own stature in the community, as part of the business or professional world, or on the basis of family or spousal status. A preliminary analysis suggests that the latter explanation continues to account for a sizable proportion of women board members. Thus, changes in female social and occupational participation generally are slow to be reflected in board membership of high culture institutions.

9. While it is beyond the scope of this paper to develop this line further, it was interesting to hear in several interviews the view that most corporate representatives on art boards are rather unknowledgeable about the arts form over which they preside.

10. President, CEO, president and CEO, vice-president, board chair, board vice-chair, and director.

11. Based upon total assets for 1992. Included were the 100 highest-ranking publicly traded corporations, the 30 highest-ranking private corporations (usually foreign or family owned), and the 10 largest crown (government-owned) corporations (*Report on Business Magazine,* 10, no. 1, [July 1993]).

12. The "inner board" was typically the executive committee, which would meet frequently and be responsible for formulating most policy and giving general supervision over its implementation. Given their substantial involvement in the affairs and events of arts organizations these persons can reasonably be expected to reinforce corporate interlocks, if they are tied significantly to corporations (in this case, to one or more of the largest 140).

13. "A block B of an undirected graph is a maximally connected subgraph having no point p such that B-p is disconnected. A clique C is a maximally complete subgraph G. Complete means that lines exist between each pair of points of the clique" (Stokman and Sprenger, 1989, 266).

4

Business Support to the
Arts and Culture in Argentina

Rodolfo S. Gonçebate
and Margo E. Hajduk

ABSTRACT

Research that focuses specifically on the relationship that links business support to the arts and other cultural activities is lacking in Argentina. Here, we follow two lines of inquiry. The first one refers to cultural organizations: the strategies and mechanisms implemented over the years to elicit business support, their organization and goals, and the major difficulties they encounter. The second inquiry seeks to understand the motivation that drives businesses to contribute to the arts, the type of projects they favor, and the source, size, composition, and distribution of economic sectors of business contributions.

The analysis is based on the information generated by a selected sample of cultural nonprofit associations. The results of this study may be considered an initial approximation to the relationship mentioned above, and a mapping of the area for Argentina. The issues raised here may benefit those organizations that promote high-culture activities, as well as future research on this field.

INTRODUCTION

Toward the end of the nineteenth century in Argentina, diverse cultural activities received support, generally provided by the upper classes. In most cases, the support was in the form of individual participation and financing, and can only be related to current business sponsorship in a residual manner. The persons who supported cultural activities were frequently owners or representatives of important businesses who were, however, acting on a personal basis.

The origins of the present-day business-arts relationship can be traced to the end of the 1950s and through most of the 1960s (Cancline). Examples include Kaiser Company in Cordoba, which sponsored the Bienales de Arte, and the

DiTella Institute, which through its various centers expanded its cultural activities during this period (King 9–33).

For more than a decade, the DiTella Institute was the only project in Latin America that maintained such a high level of financing for cultural activities. Year after year, the institute's costs increased until they exceeded one million U.S. dollars in 1967. Between 60 and 70% of its income came from external funds, which increased its financial uncertainty. All of the initiatives in Latin America suffered the same inability to maintain a constant level of investment.

The DiTella Institute stumbled along until 1969, when there was a collapse of the Siam DiTella industrial complex. The installation of a new military dictatorship hostile to cultural projects combined with the serious financial squeeze of the Siam business, and culminated in the closing of its art centers in May of 1970 and the intervention in the company in 1971 (King). The closing of the DiTella Institute created a vacuum in cultural activities that was not alleviated until the arrival of the new democratic era in Argentina—with the installation of the Alfonsin government of 1982.

To survey business support of the arts in the 1980s, we looked a few symbolic cases, each with its own peculiarities. From 1982 to 1990, Citibank sponsored the activities of the most important and well-known Argentine chamber orchestra, the Camerata Bariloche, organizing concerts in the most remote corner of the country. The project, its goals, and its implementation were designed in the United States by Citicorp. During these years, the bank, in the name of its foreign creditors, negotiated a swelling external debt for the Argentine government.

In the study of the nonprofit organizations of the 1980s, an amazing growth of business foundations is discernible. Many important businesses, including banks and industrial groups, created their own foundations. Through them, they developed cultural programs, and some were able to achieve a high level of recognition—as much in the cultural sector as with the public at large. The Banco Patriscios, the Banco Crédito Argentino, Konex, and Omega Seguros are some of the foundations that fall into this category.

The Antorchas Foundation started to develop its activities in 1985, and although it was financed through the legacy of a wealthy industrialist, it is not a typical business foundation. Today it is one of the most dignified and professional expressions of art and cultural support in Argentina. Through scholarships to artists and subsidies to institutions and cultural projects, it has made the creation and production of high quality art possible.

During this period, despite national and international companies that supported cultural activities, a long-term policy for financing the business-arts relationship did not exist, either within the state, or among the businesses in general. The cultural institutions' (CIs) initiatives were governed by traditional patterns of behavior and the expectations of the elite social circles, reinforcing, at the same time, the social prestige of those who participated in these events.

These characteristics still retain a residual validity that is apparent when analyzing the institutions that produce or diffuse "high culture." Their main tie

to CIs remains "personal," with their main objective being prestige. This tradition partially explains the lack of specialized departments, in the CIs as well as in the businesses, to coordinate, select, and realize the proposed projects.

As we have mentioned, the role of private contributors in the area of the arts has a long tradition in Argentina. The transformations in arts sponsorship that occurred over the past decades have not been accompanied by a parallel analysis of the conditions under which current art emerges. More specifically, the sources of economic support that have made cultural production possible have not been analyzed.

SOCIAL CHANGE AND ITS IMPACT ON THE ARTS

In the 1980s, the Argentine economy was characterized by serious problems that made its participation in the economic development and growth seen in more stable countries impossible. Its principal traits were an overdimensioned and inefficient central state; an economy that was closed and regulated by protectionist traits; an inefficiently run productive apparatus; strong corporate trade unions; a growing external debt; and unsustainable inflation.

On a political level, the country has gone through a transition, changing from a country typified by political instability and authoritarianism toward a democracy, which is opening the road to new alternatives, including those in the area of cultural activities. This process has occurred along with a growth in activities characterized by voluntary participation associations, such as the Asociasciones de amigos and other nonprofit groups that guard the cultural patrimony, and support the development of the arts (see Thompson 1992, 101–107).

On an economic level, a semiclosed economy has been transformed into a very different one, following, without major objections, the economic leaders of contemporary globalization, and characterized by openness, the search for expanding markets, the privatization of numerous state companies, and an increased role in the international economic system. On a social level, the population followed this process with growing demands and increasing expectations of more societal responsibility that would effect both the state and business.

It is in this context that we propose to describe some prominent characteristics of the businesses and the institutions that produce or diffuse high culture.

METHODOLOGY

We focused our research on the nonprofit cultural organizations that are the normal recipients of corporate donations. One objective was to understand the different aspects entailed in the relationship of the CIs with business.

Questions addressed included the nature and content of support as well as difficulties encountered. The aim was to investigate the motives of businesses, the projects they support, and the distribution of financing to various cultural activities. The information was obtained through interviews with CI authorities, who answered a series of 44 questions. Twenty-seven arts institutions located in

Buenos Aires were selected. There was a 77.8% response rate (21 responses) in the areas of music, the visual arts, film, literature, dance, and theater.[1]

THE BEGINNING AND THE EVOLUTION
OF BUSINESSES SPONSORSHIP

The business-arts relationship establishes a mechanism of supply and demand of sponsorship (or other types of support). We undertook to analyze, in this research, the aspects linking the demand side of the relationship. That is to say, the CIs' demands for support from the businesses. Without a doubt, this relationship responds to the particular needs and characteristics of both sectors, and the possibilities of growth are related to the responses and mechanisms that the groups use to facilitate the development of the exchange.

We analyzed the work being performed by the cultural organizations in relation to this demand for sponsorship, the procedures that are used, and the perceptions that they have of the supply.

More than 60% of the CIs date their founding to the beginning of the democratic transition process in 1982. It was in this decade and the first years of the 1990s that they established the majority of their business contacts. Nevertheless, it is interesting to note that some of the institutions interviewed mentioned business sponsorship dating as far back as 1912 and 1946, and two institutions mention the years 1963 and 1967. Only three of the CIs (14%) say that sponsorship is mostly based on personal relationships.

Most art administrators agree that times were better in the beginning, when businesses were more generous and relationships were informal. Nowadays, due to the economic restrictions and an increased demand for support, the CIs are required to work with an increased level of professionalism—permanently creating new ways to interest businesses, supplying them with constant and sufficient information, etc.

THE ORGANIZATIONS AND THE PROCEDURES
INVOLVED IN BUSINESS SPONSORSHIP

Recognizing that there is a new environment that demands that the CIs relate to the businesses differently, does not imply that they have implemented new techniques or hired professionals in this field. In fact, only 28% of the mentioned cases employed specialized personnel—a group with a specified goal, a public-relations boss, or someone hired on an ad hoc basis. In most of the cases, it was the director of the institution who established contact with the businesses (36%), or the board of directors (18%), or simply the person who had a contact (18%).

For 30% of the CIs, personal contacts with certain business executives was the way in, and in only 14% of the cases did they employ a designed brochure or a letter soliciting collaboration. After the initial interview, 62% of the CIs then presented the businesses with a written proposal. Contacts made through

embassies and social meetings were also mentioned as opportunities to establish relationships with businesses. The CIs attempt to establish contacts at the highest level of the corporate structure, normally the director or the president (66%), or deal with the departments that usually handle these themes (i.e., public-relations, advertising, institutional-relations, or marketing departments).

To identify possible contributors, the institutions utilize a general guideline, first following their intuition, and then a series of criteria that help determine those businesses in which they already have personal contacts. Next, they iden-tify those firms that most recently supported other events or institutions, and then those that traditionally provide support. The size of the company, along with the growth of the business, are also considered.

Consequently, with the registered economic changes, the new businesses, along with those that have been recently privatized, are in the sight of all institutions demanding support. The incorporation of capital and a foreign board of directors leads CIs to believe that the businesses will follow the American or European traditions in the field of business philanthropy.

The CIs tend to look for support from a certain group of businesses. The CIs showed in 71.5% of the cases that they are aware of the businesses that have already collaborated with other causes, and more specifically, 95% of the CIs take into account whether or not a business has already contributed to other cultural institutions.

In 57% of the cases studied, the CIs took into consideration that the request to the businesses should be done within a certain time frame—generally six to nine months before the necessity of counting on the support. Other CIs did not have annually systemized or programmed schedules, meaning that they request sponsorship for specific projects. The anticipation in these cases greatly depends on the span of the project and the type of relationship that a CI has with a busi-ness. The most common practice is to present the event two to six months prior to the need for funds.

In 85.6% of the cases the requests for collaboration are presented along with a preliminary budget, and 71.4% ask for a predetermined amount. The others are satisfied with what the company offers them.

It is interesting to note that while personal contacts are very important to establish relationships with the businesses, only 28.6% of the CIs have represen-tatives from the contributing businesses on their board of directors. The prac-tically nonexistent pro-active attitude of the businesses to involve themselves in causes outside of their work is shown in this research where only four (14%) of the CIs received spontaneous support from the businesses. It should be noted, however, that for one of these CIs, the gesture meant eight years of support.

Organizations appear to evaluate their support more in terms of the prestige and long-term trajectory of the arts company than the project itself. Public atten-dance at events, however, seems to be an important criteria for selection.

At the end of the project, 33% of the CIs polled do not send any sort of information to their sponsors regarding the development of the project that they have supported. Acknowledging this tendency, the CIs admit the need to correct

this failure in the future, so as not to cause counterproductive effects. The rest of the CIs relate the following information to the businesses: 62% send press clippings regarding the event; 47% inform the sponsors of public attendance; and 33% give information regarding the spending of the funds. They also send programs, entrance tickets, catalogs of the event to contributors, thank you letters, and one of the CIs organized a cocktail party at the end of the year to bring together the artist and the sponsors.

The lack of specialized personnel to serve as the nexus between those who design and execute the activities for the CIs and those people within the businesses who are in charge of evaluating the support often generates an unfavorable situation for the development of lasting relationships. A lack of continuity, scarce or inadequate information, carelessness in the following of the relationship once the contribution has been given, and a general level of improvisation are common.

FACTORS THAT MOTIVATE BUSINESSES

The cultural organizations consulted mentioned a series of factors that, according to them, moved the businesses to collaborate in cultural events. Without a doubt, the most relevant factor is the interest of a business to improve, change, or simply associate its image with cultural institutions that are valued in society. It is a very attractive manner to increase a company's prestige and secure publicity. IMAGE, PRESTIGE, PUBLICITY: these three things seem to be taken into account at the moment that a business is thinking about supporting the arts and culture.

REASONS FOR SUPPORT

Businesses wish to associate with those institutions whose image is already legitimate and prestigious within society, and those that consequently provide greater diffusion and visibility. The personal contacts of the executives with the directors of the organizations continue to be one of the reasons for their support, as are personal dedication and the work done by these institutions. The guarantee of quality that some CIs offer is also considered an influencing factor in decision making.

Further down on the list of priorities, the CIs mention a certain sensibility or identification with the works performed by the institutions that they are supporting, as well as the fiscal benefits that the businesses obtain by supporting nonprofit organizations.[2] With the exception of the United States and Canada, there are few industrialized countries that offer larger fiscal benefits. In general, the European countries place limitations in terms of the deductions and differentials for varied items according to the area of activity (see Schuster 1986).

Table 4.1 indicates that a company's image, its marketing strategy, and the personal desires of executives are the main reasons given for support.

Table 4.1
Reasons for Arts Support among Businesses in Argentina

Motivating Factors	% Majority
Improve its institutional image	66.5
Personal interest of some executives	43
A marketing strategy	48
Assumes the role that the state abandoned	38
Supports the demand of a determined public	28.5
Obtains fiscal benefits	28.5
Interest in cultural diffusion	24
Desire to promote the development of determined disciplines	14

The research indicates a certain skepticism by the CIs concerning the normal good intentions that guide the businesses, but also reveals that they are aware that they must appeal to the benefits that this co-participation brings to the businesses. Factors which inhibited growth in business sponsorship include the following:

- the scarcity of a business culture, which prevents the managerial class from seeing the different expressions or cultural organizations as natural partners to modify and improve their relationship and position in society—this is a mixture of ignorance of the impact that cultural activities have on society, as well as a lack on the part of management of an interest in the field;
- the "possible" economic and financial difficulties of the businesses, although this is seen to be a pretext or an excuse and not a real situation;
- the large number of sponsorship requests from other areas of philanthropy;
- a desire to sponsor causes/events that are more popular (sports);
- the lack of recognition for their support;
- the lack of professionalism in the cultural sector; and
- the lack of an official policy of incentives.

A recent study on business foundations in Argentina reveals that businesses accrue few fiscal benefits from their donations to CIs:

One of the reasons that could explain why, in Argentina, tax exemptions are not considered an important motivation for activities for the public's benefit on behalf of the businesses, has to do with [the fact that], until very recently, . . . tax to gains did not represent a relevant problem for the larger part of businesses, for the possibility of deducing losses of previous exercises, as well as accounting function that allows the indexation mechanisms in times of high inflation. The tax advantages derived from the industrial promotion system and the possibility of resorting to accelerated refunds of the investments have played an important role in tax evasion. It evidently deals with

mechanisms more efficient than the donations with the purpose of reducing tax payments, yet with decreasing validity in the current Argentine economic context. (Roitter 1994)

Deductions similar to those offered in the United States and some European countries could encourage businesses to amplify their collaboration with cultural organizations.

CULTURAL PROJECTS OF INTEREST TO BUSINESS

According to the CIs, businesses support those projects which are presented to them that deal with mega-events, with international or very well known artists—generally in the area of music or fine arts—and that have very extensive press coverage and publicity. Another aspect that is taken into account by the businesses is the quality of the projects; they favor those that are done by the most well known institutions and those that guarantee a return of their investment. They also mention that the activities that are most attractive are those that are short term, and those that offer the opportunity to associate their companies with other large businesses.

As a counterpart, few are interested in experimental or controversial projects, with artists who are not well known or have a smaller following. In general they find great difficulty in funding the activities that are in defense of patrimony, research, or those projects which are longer term.

Regarding educational projects or those focused on youth, some institutions mentioned that these can be very attractive, while others considered them very uninteresting. We assume that both of these situations refer more to the type of project and the selection of the appropriate business, than a general tendency of the business people.

Table 4.2 lists activities in which the CIs report involvement. The initiatives are grouped by their different disciplines, and the numbers correspond to the number of institutions that have received business support. It appears that musical events, including concerts, and museum exhibitions are supported above other forms of art.

RECOMMENDATIONS SUGGESTED BY CULTURAL INSTITUTIONS

Until now, the relationships of the cultural organizations with the businesses have been handled mostly on the basis of friendships, personal relationships, or commercial associations rather than professional networks. The increasing demand for business sponsorship, as much in the cultural sector as elsewhere, along with the need of the businesses to rationalize their expenses in terms of revenues produced, leads to an analysis of what modifications would guarantee better conditions for the development and growth of satisfying relationships.

Table 4.2
Types of Support by Businesses in Argentina

Description	Number
CULTURAL PATRIMONY	
Restoration, architectural patrimony conservation	4
artistic patrimony conservation	3
bibliographical patrimony conservation	1
Acquisition and donation of works (museums, libraries, archives)	3
LITERATURE	
Financing literary editions	2
Prize/contest sponsorship	1
Scholarship/subsidy sponsorship	1
Financing fairs activities	1
library equipment	1
MUSIC	
Financing individual concerts	8
concert series	5
Diffusion of music programs in the means of communication	5
Financing music education	3
Scholarship/subsidy sponsorship	3
Auspice of classical music festivals	3
contemporary music festivals	3
Financing (symphony, chamber) orchestras	3
national tours	2
international tours	2
Auspice of choral music festivals	1
jazz festivals	1
Financing first recordings	1
magistrates classes	1
Prize/contest sponsorship	1
FINE ARTS/MUSEUMS	
Financing individual expositions	6
large exhibitions	6
Equipment of exposition rooms and museums	6
Prize/contest sponsorship	2
Scholarship/subsidy sponsorship	2
Difusion of the programs in the media	2
Financing artists books	1
Publishing catalogs	1
Financing art education	1
Creating new space for expositions	1

Table 4.2 continued

Description	Number
FILM/VIDEO	
Financing film/video festivals	3
Prize/contest sponsorship	3
Program catalog publications	2
Financing cinematographic productions	1
Financing and equipment of cinematographic archives	1
Creating new spaces for the projection of films	1
THEATER	
Financing theater companies	2
Scholarship/subsidy sponsorship	2
Prize/contest sponsorship	1
Equipment of theater halls	1
DANCE	
Financing contemporary dance companies	2
national tours	1
international tours	1
pedagogical tours	1
Scholarship/Subsidy Sponsorship	1
Difusion of dance programs in the media	1
Financing artistic education	1

The organizations polled identified the following factors:

1. On the side of the businesses, causes or factors of change were observed on two levels:
 a. their effect on the business people as individuals
 —knowledge of the cultural needs of society
 —degree of contact with cultural institutions
 —need to include "culture" as a personal value
 b. their effect on business support of the arts
 —assumption of their social responsibility
 —perception of benefits for supporting the arts
 —report that support comes from an internal policy of the company, and not a personal issue of some executives
 —reliance on specialized personnel to make decisions
 —report that their foundations contribute more to the programs of nonprofit organizations than to their own programs
2. On the side of the cultural organizations, the following factors were considered:
 a. the need to professionalize the activities
 b. adoption of criteria of organization, planning, and efficiency

c. the need to elaborate and provide more information to the businesses
3. Aspects that generally involve the state and all of society were mentioned, such as:
 a. a better general economic situation
 b. policies that give incentives to these activities (including fiscal benefits)
 c. more and improved education
 d. the viewing of culture as nonelitist

SOURCES OF FINANCE

The cultural institutions were asked to identify and establish the percentages of their different financial sources of income to understand the importance of business sponsorship as a part of total income for each cultural institution. Table 4.3 details the sources of their income. It reveals that ticket sales account for less than 10% of income, while the remaining monies come from subsidies from government, donations, and business patronage (16%).

SUBSIDIES

In our survey, seven organizations received state subsidies—approximately 67% of their total income, with the highest recipient being the foreign cultural offices, for which the subsidies represent 100% of resources. These subsidies are also important for official orchestras, for the organization of a film festival, and for a theater organization, representing 63% of their income.

Under "other income"—an average of 53.4% of income—eight CIs included funds from fund-raising events (three CIs); the fees collected from functions, contracts, and other services rendered (four CIs); and the fees that the literary fair organizers charged their renters.

MEMBERSHIP FEES/SUBSCRIPTIONS

Ten institutions count on these resources, which represent 3 to 100% of total income, depending on the type of organization. Generally, music-related organizations were the most numerous recipients—with 25 to 50% of their resources coming from fees. Two artistic educational institutions reported this income as 80 to 100% of their total income. The ten institutions polled reported than an average 38% of their income was generated in this manner—representing 21.2% of the total income for all the organizations polled.

BUSINESS DONATIONS

Donations account for 16% of the average CI's income. Those organizations that are most dependent on these sources are the music organizations that organized concert series, for which business donations represent between 40 and 50% of total resources. Music events also count most heavily on the sales of tickets, which comprise an average of 16% of total income. The "individual

Table 4.3
Sources of Income among Cultural Institutions in Argentina

Income	%
Subsidies	26.2
Other Income	23.7
Social Quotas/Subscriptions	21.2
Business Donations	16.0
Ticket Sales	9.6
Individual Donations	2.6
Merchandising	0.5
Rent	0.2
	100.0

donations" (mostly to music and museums), the "merchandising" mentioned by one organization, and the eventual "rent" of capital total only 3.3% for the whole sector.

THE DISTRIBUTION OF THE BUSINESS SPONSORSHIP

Considering the difficulty in obtaining figures for business sponsorship, both on the part of the business as well as the cultural organization, it is impossible to perform an economic analysis regarding the major themes of sponsorship: the tendencies over time, the cultural disciplines that receive the most money, the economic sectors that are the major supporters, etc. We will therefore limit our study to the businesses that contribute in different ways to the sector, categorizing them by economic activity and their favorite recipients.

Based on the roster of sponsors that supported 18 cultural organizations in the years 1991–1993, the following conclusions can be drawn:

- During this period, the sign was positive in terms of the number and actions of companies that, year to year, gave their support. From 1991 to 1992, there was a 17% increase in number of businesses. This pace was notably reduced in 1993 to 0.07%, registering only a 4.2% increase in sponsorship activities.
- After grouping and organizing the businesses according to their relevant economic activities, it was observed that in the 17 sectors considered, there were practically no variations in their positions during the period—more similarities are apparent in the years 1991 and 1993, with 1992 showing changes in some sectors.
- The banking sector, without a doubt, was the most numerous. In the three-year period, it represented between 13.74 and 16.66% of total businesses, generating between 14.97 and 19.54% of the total sponsorship.
- One economic sector that registered a sustained support of the arts was means of communication, increasing from 2.76% in 1991 to 6.32% in 1993. To a lesser

degree, the telecommunications businesses improved their position, increasing from 2.76% of total actions in 1991 to 4.6% in 1993.

This would be an opportune moment to consider the changes that resulted from the privatization of several state companies (amongst them, telecommunications and the means of communication) and the forming of large businesses and multimedia groups. The majority implemented new forms of business communication, including sponsorship and patronage, with the objective of achieving a new image among consumers and the society on the whole.

Greatest interest and support can be seen among the banking, electronic/information, air transport, food/beverages, and oil/petrochemical industries for this three-year period. Several trends emerged from our data with regard to specific sectors:

- The automotive industry and the food and beverage companies supported more activities (3.5 sponsorships per company in 1992). However, on an individual basis, the most notable case was Deutsche Bank with six sponsorships in 1994 and four in 1992 and 1991 (always considering the information was provided by the CIs polled). Other companies that gave four sponsorships were Aerolines Argentinas, American Express, British Airways, Mercedes Benz, Moet Chandon, and Siemens. The number of companies that have contributed to three of the polled organizations is significantly greater.
- More donations in kind were given by the airline, beverage, and electronic/information companies.
- Music companies, followed by fine-arts museums, received the most actions of support from the businesses.
- Other arts events received less support (i.e., the foreign cultural representatives and literature).
- Dance, with two sponsors at its best moments, showed a great difficulty in interesting businesses.

SIZE OF THE DONATIONS

At the moment, it is not easy in Argentina to summarize business philanthropy. There are various factors that contribute to this, making it difficult to obtain information, including the lack of specific and separate information about individual business activities in the field; the fragile, or almost nonexistent, state audit of funds and actions of the nonprofit organizations; the deviation over a long period of funds coming from the black market to different destinations; the nonexistence of an intermediary institution to organize data bases and promote the investigation of the philanthropic activities.

If one takes into account that the present poll only looked at nonprofit institutions, and was especially careful to ask for aggregate information, not for the identification of the businesses and specific amounts of the contributions, the results obtained could be considered surprisingly poor. Only 12 of the 21 cultural organizations offer figures of their collections in 1993, ten did so for 1992,

and only eight CIs could give information on the events in 1991. The remaining nine organizations openly refused to give quantitative figures for their collections.

The scarce attention provided in certain formal areas of organization and administration of some of these CIs shows that they do not have the necessary organizational and logistical infrastructure to develop certain aspects of record keeping. Considering the limited information obtained, and not desiring to make inferences that could lead to erroneous interpretations, we limited our analysis to certain quantitative aspects of business contributions to the arts from other variables.

The CIs reported the size of the donations, establishing the maximum values that they had received as single donations, the smaller-amount contributions, as well as average donations. The data have been grouped and averaged in table 4.4, analyzing them by the cultural activity. The average value of the unitary donations is, for the polled groups, $5,200—with single donations ranging from $750 to $15,000. Thirty-eight percent of the CIs declared that the average contribution they received was higher than $2,500 but did not exceed $5,000. Thirty-one percent stated that the average was greater than $5,000 and was closer to the $10,000. The highest average values was reported by the foreign cultural offices (almost $10,000), followed by literature ($7,500) and music ($5,700).

Averaging the answers of 18 CIs in table 4.4, the most important unitary donation was $42,500—although values varied from $3,600 to $210,000. Of the two most important business contributions, one was in the area of literature ($210,000) and the other related to film ($90,000). Fifty percent of the institutions declared receiving unitary donations valued between $25,000 and $50,000.

Concerning the smallest unitary donations (designated "minor" donations in table 4.4), which range from $100 to $5,000, they were distributed as follows: in 47% of the cases, the cultural organizations received $500 or less; for 24%, the smallest donations did not exceed $1,000; and finally, 29% stated that this type of contribution was approximately $5,000. There were numerous cultural activities that benefited from these smaller contributions, which made possible the printing of programs and catalogs for events.

COMPOSITION OF THE BUSINESS DONATIONS

When analyzing what form of support the businesses contribute to cultural organizations (table 4.5), monetary support was most obvious, and only with difficulty did we obtain information regarding the monetary value of contributions in kind. Donations of computer equipment, or other types of electronic equipment, air tickets, insurance, catering, etc., are not regularly recorded by cultural organizations. The receipt of support from the businesses in the form of technical assistance or other services (i.e., hours of volunteer work) is not common practice by the majority of the cultural organizations in Argentina.

Table 4.4
Amount of Donations by Cultural Activity in Argentina

Cultural Activity	# of CIs	Donation General (13)	Averages Major (16)	Minor (17)
Foreign Cultural Offices	2	9.750	20.000	3.500
Literature	2	7.500	120.000	2.750
Music	4	5.670	38.500	550
Fine Arts/Museums	5	3.560	23.000	850
Film/Video	3	1.250	41.210	1.910
Theatre	1	750	n/a	n/a
Dance	1	—	30.000	500
Approximate General Average		5.200	42.500	1.500

The institutions polled informed us that money was the most common form of donations. Table 4.5 takes into account the form of support given to the arts organizations. Music organizations reported a total of between 80% and 100% of their business sponsorship came in the form of money. For the sample as a whole, this represents, for more than half of these organizations, between 40 and 50% of their total income—a figure that has made these organizations and their arts events very dependent on business patronage.

For the other cultural organizations, the contribution of money is less, and contributions in kind are an important component. This is the case for the foreign cultural representatives, who depend on the foreign-relations offices of their home country, and in general register very low indexes of business donations in the composition of their total income. The business contributions consist fundamentally of goods and services produced or carried out by local headquarters of foreign businesses interested in maintaining a close relationship with the state delegations.

It could be affirmed that CIs, more and more, resort to certain businesses in search of donations to cover specific necessities. The associations of friends of museums and official theaters, most of them created with the purpose of guarding the artistic and architectural integrity, frequently request equipment for the offices and materials to maintain their buildings.

The cultural organizations in the official sector, like the majority of public offices, as a consequence of budgetary cuts, have been decaying over time. So, the creating of associations of friends makes it possible, on the one hand, to generate new resources that guarantee the continuity of their management, and on the other hand, their independent administration. The state thus sees agile mechanisms of defense emerging from a third sector within its own institutions that over time give away some of its responsibilities.

Table 4.5
Arts Support by Type of Cultural Institution in Argentina

		Type of Donation	
	Money	In-kind	Services
Music	90.0	8.4	1.6
Museums	55.0	27.5	17.5
Literature	50.0	25.0	25.0
Foreign Culture Offices	23.0	77.0	0.0
Film/Video	58.0	42.0	0.0
Dance	20.0	50.0	30.0
Theater	n/a	n/a	n/a

Table 4.5 reveals that many CIs receive some form of equipment and office supplies. The in-kind donations that are most commonly received by cultural organizations are:

- catering and beverages, especially champaign
- airline tickets, international and domestic
- photographic materials
- computer systems, televisions, videos, photocopiers, fax machines, typewriters, and telephone systems
- illumination artifacts, paints, carpets, security systems, construction materials
- hotels
- advertising spaces in the media

In terms of technical assistance, or other business services, only six of the cultural organizations questioned mentioned receiving this type of support. This arrangement is not yet systematically offered by the businesses, nor has it been visualized by the nonprofit organizations as a valuable contribution that could help them incorporate modern technology in their management, marketing, and accounting departments. The assistance that some of the polled organizations received was from advertising agencies (4) and health plans (2). Technical assistance was also mentioned in the form of equipment and accounting advisory services.

SUMMARY AND CONCLUSIONS

The collaboration between the CIs and the businesses started early in Argentina. This relationship was basically driven by the upper classes, and was often due to individual initiatives. The 1880s, the 1920s, and the end of 1950s and most of the 1960s are specific turning points in the history of this relationship.

From the analyzed sample, we deduce that the ties between the CIs and businesses started in different ways, with personal contacts being most prevalent The selection of potential donors was done by taking into account previous collaboration, and the sponsorship given by the aforementioned businesses to similar activities. At the same time, there exist evidence of haphazard support and a lack of specialized personnel or intermediary organizations capable of channeling the supply and demands of the businesses with the CIs. The majority of these organizations recognize the need to modify their way of operating with business.

Cases in which there have been pro-active and long-term relationships established by the businesses with the activities of certain CIs are directly related to the quality of the proposals and the proper implementation of those projects, confirming the importance attributed to the organizational structure that supports the implementation of systematic actions in this field.

Businesses have not yet visualized the dimension of the returns—in terms of prestige and communications strategy—that they can obtain from their collaboration with the arts. Nevertheless, CIs recognize that the businesses are overwhelmed with sponsorship requests. Their funds tend to go first to social-issue projects such as health and education, along with recreation events that benefit their employees.

Their main source of income is generated by the CIs themselves (ticket sales, subscriptions, societal quotas, services, professional fees, and merchandising). Another major source, especially for those foreign arts organizations, is state subsidy, but these state subsidies benefited only seven organizations in the sample. Business donations constitute almost half of the income of the musical organizations, and for all the sectors represent approximately one-fifth of the income of the CIs included in the sample.

The data detect a tendency toward an increase in in-kind donations by participating businesses. The poll also indicates an increasing donating presence among the means of communications and the telecommunication companies associated with the recent privatization state businesses. Technical support through services provided by businesses still remains to be fully utilized.

In this survey, those that benefit the most from business sponsorship are the music organizations and fine arts/museums. Over the last three years, the distribution of business sponsorship has maintained stable, although its volume has apparently increased.

In the present panorama of an economy in transformation, one that is attempting to fight the practices related to tax evasion, it is probable that businesses, once consolidated, will show a greater interest in the tax benefits derived from donations to nonprofit institutions, and donations could increase. The government should encourage business participation by increasing the benefit percentage and implementing public policies directed to stimulating co-participation activities.

Finally, recognizing the limitations of this work, it is important that a national study be undertaken to analyze the cultural sector in detail, and the nonprofit organizations in general. Recent studies in many countries indicate a

tendency toward the extension and the expansion—as much in the areas it embraces, as in its economic and labor weight—of this designated third sector.

NOTES

We would like to thank Rosanne Martorella for helpful comments on several previous drafts.

1. Specifically, this sample included organizations of music (three orchestras, two organizers of concert series, one in music education); fine arts and museums (three associations, a federation of friends of museums, and one organizing a foundation fair); film (one foundation that preserves the cinematographic patrimony, one that is educational, and an organizer of a music festival); literature (a library and a fair organizer); dance and theater (domestic and foreign). Criteria for selection was as follows: recipients of business donations in 1993 (Hajduk 1994); the qualified opinions of persons in the cultural field; and publically recognized companies.

2. Benefit in the sum of taxable income, up to 5% of the total gain of the exercise (Law 24,073, dated 13 April 1992).

Business and Culture in Brazil

José Carlos Durand

ABSTRACT

This chapter will focus on the formation of the industrial and commercial patronage that stemmed from the immigration into Brazil of free workers from poor regions of Europe and Asia. It reveals how these immigrants, in gaining economic and political power, set the pace for arts patronage.

With regard to incentives to culture, several macroeconomic and marketing factors that account for the poor performance of the international corporations in Brazil will be analyzed as well. Although there is still a systematic lack of information about the profile of business enterprises and the magnitude of the resources involved, I intend to provide an analysis of the main incentive mechanisms for arts patronage.

INTRODUCTION

The analysis of the relationship between business and culture in any given country is a task which demands research and reflection in two quite distinct dimensions. One such dimension must be long term, so as to take into account the historical conditions under which the entrepreneurial class has been formed. It must describe the class repertoire of ethical and aesthetic values, lifestyle, and the relationships with other segments of the ruling class, and with the nation as a whole. Only thus is it possible to reveal the degree to which the nation's magnates and their clans are sensitive to meritorious acts in general, and to economic sponsorship of the arts in particular. In order to avoid unsatisfactory generalizations, research in this direction makes further demands: the entrepreneurial class must be broken down into its various segments of ethnic origin.

It must be analyzed from the point of view of what branches of business and what phases of the national economy were involved in the making of a fortune.[1]

The second dimension is more closely related to the present: it must describe the greater or lesser propensity, on the part of the national or multinational corporations installed in a country, to provide support for the arts. In such an analysis it is obligatory to comment on any government incentives that may favor corporate investment in culture. In more general terms, it is necessary to put forward hypotheses as to the branches of activity in which business is most sensitive to culture, and to the nature of the principal advantages or disadvantages—be they economic, political, or a matter of prestige—involved in corporate decisions to sponsor cultural activities or to abstain from initiatives of this sort.

The first approach is concerned with persons and families. The second approach is concerned with businesses as distinct from individuals, whose presences in the field of culture most commonly result from the decisions of professional directorships, or of heirs themselves concerned with culture.

As a case study, and with the brevity of this chapter in mind, attention is concentrated on a number of cultural initiatives undertaken in the Brazilian city of São Paulo in the period following World War II (1947–1951). It was at this time that there occurred a conjunction of favorable factors, capable of putting to the test the disposition and ability of certain entrepreneurs to involve themselves in the creation, the financing, and the upkeep of cultural institutions. The first thesis to be defended here is the following: that under the historical conditions in which it was formed, businessmen in Brazil have shown only a weak propensity toward patronage of the arts—at least when performance is measured with that of their counterparts in the United States and other developed countries.

Slavery had established itself everywhere in Brazilian society during the nineteenth century and there was no way for the ideology of equality, citizenship, and progress as the result of work to flourish as a civilizing pattern. This is a very different situation from that found by immigrants to the United States at the same time—there the descendants of the English maintained and fortified their position as a political, cultural, and economic elite. Thus, the new arrivals who enriched themselves in Brazil did not feel encouraged to fight for the improvement of the cultural level of the Brazilian population, as would be required for an effective orientation in terms of meritorious works and patronage.[2]

The second thesis to be upheld is that, in Brazil over the last decade, various prerequisites have been satisfied for an increasing business presence in the sponsorship of culture. Even so, structural factors such as recession and hyperinflation, together with a series of political and administrative difficulties that have rendered federal government activity in the arts either discontinuous or chaotic, have not yet ceased to prevent more intense participation by business in the arts.

INDUSTRIALIZATION OF SÃO PAULO

From its foundation in the middle of the sixteenth century until the end of the nineteenth century, when Brazil had for several decades been independent of Portugal, São Paulo was a province of no economic significance in the context of Brazil as a whole. The enormous increase in coffee production from the 1880s on was responsible for the intense urban growth of the first half of the twentieth century, and São Paulo became an important commercial and financial center.

Attracted by a policy favorable to the immigration of free workers for the coffee plantations (black slavery had been abolished in 1888), hundreds of thousands of individuals and families came to the State of São Paulo—from southern Europe, from the Middle East, and from Japan. After a few years as agricultural laborers, many of these immigrants turned to small-scale street trading, to craft work, and to urban services. Yet others, who had arrived in Brazil with technical qualifications, with degrees, or with capital, at once began a new life in a higher and more favorable position. Large numbers of foreigners successfully enriched themselves—in the retail trade, in imports and exports, in skilled craftsmanship, in industry, and in the professions. They formed in São Paulo a hybrid urban entrepreneurial class, hybrid in terms of ethnic background and nationality and largely made up of families who had only recently arrived in Brazil (Dean 1971). The old rural elite, Portuguese—Brazilian by origin—rapidly lost their economic punch in the little town which was by now turning into a metropolis.

The economic recession of the 1930s, followed by World War II, brought atrophy to the international coffee market; yet on the other hand, it restricted foreign competition in the area of manufactured goods, and even opened up a market for such goods in countries whose own industries had turned to wartime production. All this favored the industrialization of the State of São Paulo and its capital city of the same name. By 1940 São Paulo's economy had surpassed that of Rio de Janeiro, until then Brazil's largest city and the country's political capital. In the following decade, São Paulo also overtook Rio de Janeiro in size of population. At the time of the celebration of the fourth centenary of the foundation of São Paulo, in 1954, the slogan which best expressed the pride of the Paulistas was that they lived in "the world's fastest growing city."

The rapid industrialization of São Paulo during the first half of the twentieth century was accompanied by a no less rapid spread in the means of communication. Until the 1930s, government favor was decisive for a newspaper to flourish, political persecution could make one close down. By the 1960s, the media was in a very different situation; there were now daily newspapers and magazines with a nationwide circulation; radio was widespread in urban areas, and in 1950 Brazil, with a station in São Paulo, was the third country in the world to enter the television age. This diversification of the media was connected with a surge in market advertising in the country—a factor which freed the

communication enterprises from dependence on the coffers of the state and, it is worth pointing out, from the support of the parties in power.

PATRONS IN SÃO PAULO: THE SÃO PAULO MUSEUM OF ART (1947) AND THE INTERNATIONAL BIENNIAL FOR PLASTIC ARTS (1951)

It was in this context that the activities of Francisco de Assis Chateaubriand Bandeira de Mello gained significance. Chateaubriand came from the poor northeast of Brazil, where he graduated in law; while still a young man, he moved to Rio de Janeiro and went into journalism (Morais 1994). He set up his first newspaper in Rio at the beginning of the 1920s, with money lent by politicians. From there he became more powerful, always making use of pressure on the government, of threats of blackmail against politicians and businessmen, or of campaigns "of public utility" that served as a pretext to cover page after page of praise of bankers, ranchers, captains of industry, and big businessmen. In this way Chateaubriand obtained loans or donations, under advantageous conditions, to set up his newspaper and radio network in most of the Brazilian states—the Diários Associados (Associated Daily Press). He was also responsible for launching the first nationwide weekly magazine, *O Cruzeiro,* in 1928. Not for nothing was he called, in an article in the *New York Times*, the "William Randolph Hearst of Brazil" (Morais 460).

One of the "public utility campaigns" thought up and set off with immense energy by Chateaubriand was the opening, in São Paulo, of a museum of ancient and modern art—MASP, the São Paulo Museum of Art. Today, MASP holds Brazil's principal collection of art on an international scale. The idea came to its founder in 1946, following on the heels of a number of other campaigns. The two preceding ones had been for the foundation of flying clubs and for the protection of children. In these two movements, the businessmen of São Paulo had been pressed to donate planes and to finance the opening of aid posts for needy children; now he invited them to offer resources for the purchase of works by masters of world art from galleries in Europe and the United States. The advice of Pietro Maria Bardi, an Italian *marchand d'art* whom Chateaubriand had nominated as MASP's technical director, was his principal backing for decisions to buy—which were usually impulsive and guided by intuition. The moment was right: as soon as the war ended, the international art market was unstructured and, as a result of the difficult economic climate in Europe, the prices of masterpieces were particularly low. As a strategy for promotion, these purchases were loudly announced by Chateaubriand, who held a ceremony for each painting as it arrived in São Paulo. Sometimes there was more than one such ceremony; one at the port or airport at the moment of unloading, followed by another at a private mansion or at the museum itself. It was thus that Chateaubriand was able to pay, through high visibility in the press, a return for the "voluntary" contributions that he had received from a recalcitrant business community. To put it another way—he used money from the wealthy, whom he

terrorized with editorials which gave an exaggerated view of the dangers of nationalization, socialism and trade unionism in a worldwide context (Morais 483).

On the other hand, what with the recession and the war, Brazilian artists and intellectuals had long been unable to keep in touch with the vanguard movements which had electrified the Western world. Thus, to set up the International Biennial in São Paulo would be an epoch-making event for the updating of the elites and of local artists practicing in the visual arts. This is what happened, and from the first, in 1951, there followed a series of biennials right through the 1950s, all of them much visited and much commented upon. The founder of the biennial was Francisco Matarazzo Sobrinho, nicknamed "Ciccillo," an industrialist directly connected with São Paulo's richest and most important family of immigrant origin—the Matarazzos. As a figure in the art world, Ciccillo had already founded, in 1948, the MAM—the São Paulo Museum of Modern Art—among other initiatives which had included setting up a cinema company and a professional theater company (Almeida, *O franciscano*; Almeida, *De Anita*; Oliveira 1976).

PATRONS OF CULTURE

Thus the four personalities taken as a case study here will be Chateaubriand, Ciccillo, his uncle, Francisco Matarazzo (founder of the powerful IRFM—Francisco Matarazzo United Industries), and the son of the latter, Francisco Matarazzo, Jr., known as "Count Chiquinho" (literally, Count Little Frank), who succeeded to control of the IRFM at his father's death in 1937.

Francisco Matarazzo was of Italian extraction and arrived in Brazil in 1882; at first he went into the pork-fat business in the town of Sorocaba, in the interior of São Paulo State. In 1880, he moved to the state capital, and worked with the importation, processing, and packaging of foodstuffs in general. He extended his range of activities to include textiles and cleaning products, and through rapid verticalization came to cover almost every type of final consumer goods which could be produced in Brazil at that time. He was also an importer and exporter, and not infrequently took advantage of shortages of imported goods to corner the market and so make extraordinary profits. Thus enriched, he became the leading figure of the Italian community in Brazil, to which he served as banker, sending money from immigrants to their families in Italy and cooperating financially with Mussolini's government. In 1928, in company with other industrialists, he founded the São Paulo Center for Industry, today the largest industrial owners' entity in Brazil (Martins 1973). Born in 1854 to a decadent aristocratic family in the region of Castellabate, Francisco Matarazzo came to Brazil with his life's plan ready: this was to recover for the family the position which, in the distant past, it had once held.

What is of interest here is that Francisco Matarazzo was under constant pressure from Chateaubriand, in the course of his various campaigns, to come up with money. As the industrialist resisted the approaches of the journalist,

refusing to sign publicity contracts, he was held up to ridicule and charged with being miserly by the latter. Chateaubriand not infrequently ordered extensive articles to be written, denouncing "the precarious working conditions at IRFM." In 1946, Count Chiquinho, by now thoroughly fed up with being abused by Chateaubriand, accepted the suggestion that he might buy part of a rival newspaper as a means of facing the adversary on his own ground. But he found it very difficult to deal with journalists, accustomed as they were to independent thinking and the rejection of such authoritarian relationships. So, he gave up the idea and sold the newspaper.

In 1954, to commemorate the Fourth Centenary of the City of São Paulo, the Matarazzo family decided to found a "commercial university" in Brazil—the Conde Francisco Matarazzo Institute—inspired by the Università Commerciale Luigi Bocconi, in Milan. However, in the discussions regarding an agreement with an institution with the capacity to provide educational management for the project, the Matarazzo authoritarianism showed itself once again. After an uncomfortable experience with counterparts who insisted on being treated as equals, Count Chiquinho at last gave up the idea, and in the end sold the building to the government and the educational project came to a finish.

Certain circumstances came to define the failure of the Matarazzos to adapt themselves to new times: the extremes of authoritarianism, in particular with regard to attempts to control cultural initiatives—the newspaper and the institute—and the lack of interest in publicity to the point of not seeing that publicity had come to stay, a necessary result of growth of the media and the advance of American businesses in the Brazilian market. It is also worth noting that Count Chiquinho was an introvert, and disliked any form of intense social life. He was married to a cousin, and passed his leisure time very largely in the family mansion in São Paulo's Avenida Paulista, or on the farm, the Fazenda Amália, in the interior of the state. The farm was a large-scale agro-industrial enterprise. An album, produced in 1982 in commemoration of the centenary of the Matarazzos (Lima et al. 1982), shows one facet of Count Chiquinho's taste, the decoration of the house at the Fazenda. Eighteenth-century Venetian and Chinese furniture, a Rubens, a Brueghel, a landscape by Boilly (said to be its owner's favorite picture), some Guardis, and a Canaletto composed a markedly classical and Italian collection. There is nothing to suggest that this collection was at any time opened to the public.

If the principal Matarazzo line did not do well with regard to cultural philanthropy—a fact demonstrated by the episodes of the newspaper and the business school and by the count's refusal to join in Chateaubriand's fund-raising schemes—the same cannot be said of his nephew Ciccillo. Ciccillo's biography shows a young man, partly brought up and educated in Italy, who, at a particular moment, had to take control of a metal works left to him by the division of interests between his father and his uncle. The works produced packaging for the foodstuffs manufactured by the Matarazzo Group and had foreign technical advisers from American Can. Ciccillo prospered in relative independence from the principal line of the family. During a sea voyage to Europe in the postwar

years, he was persuaded by intellectuals from São Paulo of the value of modern art, and of the need to bring it closer to São Paulo—hence his decision to found the Museum of Modern Art and, shortly afterward, the São Paulo International Biennial for Plastic Arts.

Although Ciccillo at first came up himself with an important part of the money for his cultural initiatives, he tried as soon as possible to bring together partners from among his business friends, and to transfer maintenance costs to the state. A bachelor, he now entered upon a romance with a traditional São Paulo socialite, Yolanda Guedes Penteado; this facilitated his contacts with museums abroad and foreign embassies with respect to the setting-up of exhibitions. His nomination by São Paulo's city administration as president of the municipal commission for the coordination of the Fourth Centenary celebrations leaves no doubt as to how greatly this son of immigrants—even if plutocratic immigrants—felt himself honored. With regard to his tastes and aesthetic preferences, his biography produces a surprise: there is absolutely no sort of statement anywhere which might be taken as a parameter for his personal tastes or for the raison d'être of his initiatives. Ciccillo liked to say that he was "a man who understood nothing of art," that, in point of fact, he was no more than "an administrator of the arts." "When I'm fed up with the work here in the factory," he used to say, "I go and help the artists and intellectuals; I turn myself into the administrator they need." A recorded statement made soon before his death shows a man who, although he had spent almost his entire life in Brazil, spoke Italian mixed with expressions in French and Portuguese—Brazil's official language (Durand 133).

The role of Chateaubriand and Ciccillo in postwar São Paulo (reflected at the same time in Rio de Janeiro by the owners of the newspaper *Correio da Manhã*, who founded that city's Museum of Modern Art) is usually interpreted as being the occupation, by private citizens, of a space which government was not equipped to occupy itself (Miceli 76). At that time there were no effective public institutions with sufficient resources to promote the biennial or to acquire the collections at MASP. Thus, such large-scale initiatives were enacted by those indirectly interested, and their merit with regard to the cultural life of the city cannot be scorned.

However, initiatives of this sort cannot always be seen as typical examples of personal patronage, if by personal patronage we understand the spontaneous donation of large personal resources to culture. As we have seen, Chateaubriand's incursions into culture were always made with other people's money. And Ciccillo tried whenever possible to transfer the costs of his initiatives to the state. Proof of this lies in the fact that the state bore half the costs of the three first biennials, two-thirds of the fifth, and four-fifths of the one in 1961 (Durand 1989, 138).

My argument here is that a weak sense of identity with the adoptive country is assumed to be the key factor underlying an equally weak propensity to provide beneficial needs on the part of men of great fortune—spontaneous cultural patronage here included.[3] In the case of the Matarazzos, father and son, a

preference for Italian art and the habit of keeping their collections to themselves very well confirm this line of thought. The case of Ciccillo, the nephew, which apparently goes contrary to this thesis insofar as he stimulated and to some degree financed large-scale cultural initiatives, in fact confirms it, in that he tried to transfer the onus to the government, leaving his personal fortune untouched.

Analysis so far reveals profound transformation in the relationships between business and the media, business and the market, and business and the state itself. The spheres of action were relatively undifferentiated, a fact which allowed Chateaubriand and Ciccillo in some ways to act as if they represented government. On the other hand, public authority, be it federal, state, or municipal, was still not prepared in terms of budget or administration to do what Chateaubriand and Ciccillo had done. And the ups and downs of Count Chiquinho's own alliances with the press and the university world, together with his aversion to publicity and his closed lifestyle, are expressive of a business mentality which objective conditions were rendering obsolete (Martins 1973).

THE PRESENT ECONOMIC SITUATION

The industrial and financial growth of São Paulo, at first set off by the coffee boom, was not to finish soon. An enormous influx of foreign investments, above all in the course of the 1960s, brought development to São Paulo's industrial pole and introduced into Brazil the principal lines of industrialized durable consumer goods, including the automobile. The United States took up first place among foreign investors in Brazil. The teaching of economics, business, and public relations also developed, and specialized schools were founded; a market arose for executives, who were needed to fill posts in large Brazilian businesses and above all in the branches of foreign corporations. The electronic media was established with great success, bringing integration to the country through radio and TV networks which were largely sustained by private resources (advertising). Between 1950 and 1980, television became the country's principal means of communication, and by the end of this period, television alone absorbed more than half of all company expenditure on advertising (Ortiz 1988). The 1970s were a great success in economic terms. Growth of higher education was considerable, and the number of students in universities grew from 100,000 in 1960 to 1,500,000 in 1985. At the present time, about 3 million Brazilians hold a university degree.

It was only at the beginning of the 1980s, after more than five decades of rapid growth, that Brazil's economy showed signs of persistent recession. Profound recession brought paralysis to business, and the state, normally regarded as the standard-bearer of Brazil's economic development, lost this function due to its inability to mobilize resources through internal and external debt. This tendency, known to specialists as "the exhaustion of the developmentalist State" (Sallum 1988), still did not reduce the 1980s to a condition of stagnation. Much to the contrary, the Brazilian economy was known worldwide as being

hyperinflationary. Average devaluation of the currency was 100% per year between 1980 and 1982, rising to more than 1,000% per year from 1987 on. Drastic measures were taken to bring this under control; six plans for containment of inflation were tried from 1986 on, but with no success.

BUSINESS AND CULTURE IN BRAZIL TODAY: 1986-1994

With regard to the relationship between culture and the state, there was a great deal of change in Brazil following the postwar years. In 1964, an anti-communist military coup d'état interrupted the country's democratic regime, and in the 15 years which followed, Brazil lived through a situation in which intellectuals and artists were, by and large, opposed to military control of the state, and often had their work censored by the authorities. Putting aside this obscurantist factor, which was at its worst between 1969 and 1974, the period was otherwise prosperous from the point of view of governmental cultural administration. It was in the 1970s that Secretariats of Culture were first set up in the principal states of the federation, independent of the Secretariats of Education. At a federal level a number of important initiatives occurred, including the Program for the Reconstruction of the Historical Towns, the National Copyright Council, a company for the financing of films (Embrafilme), and the assembly of collections of documents in widely differing areas of culture (Miceli 68-70).

In July 1986 the first federal law permitting fiscal incentives to culture was passed—the Sarney Law, named after the president of that name. This authorized companies to channel 2%, and individuals 10%, of their income tax to cultural activities. Private cultural promoters (autonomous professionals, cultural marketing bureaus, foundations, etc.) were required to register with the Ministry of Culture as a prior condition for the proposal of projects to businesses and individuals interested in a fiscal rebate. Once registered, a cultural producer was able to offer his project to a company and receive the resources needed directly; the register and control of execution was necessary only when the sum of money involved exceeded the ceiling of approximately U.S.$10,000. According to the minister of culture at the time, Celso Furtado, this law favored

the shifting of initiative, from businesses to cultural entities and producers. While the law was in force, it attracted the approval of some 7,500 cultural entities and, according to an unofficial figure provided by a technical officer of the Ministry of Culture, mobilized something like 450,000,000 dollars. A quarter of this total was drawn from the fiscal incentive proper—that is, tax which was in fact not collected—while the rest came from capital introduced by sponsors from their own resources.[4]

Even today, no official quantitative analysis of the Lei Sarney—the Sarney Law—exists. And there is no organization of patrons to coordinate business investment in culture (such as the BCA in the United States, or Admical in France). In Brazil, so far there has been no agent outside the state which has been prepared to take upon itself the task of filling this lacuna in information.

Add to this the fact that galloping inflation has led to great difficulty in calculating profits and losses, and has stimulated speculative financial investment and reduced possibilities of middle- and long-term business planning. On the other hand, however, the transition in Brazil from a military regime to a civilian democracy from 1985 onward has been peppered with accusations of corruption in every area of federal administration, and there has been no lack of criticism with regard to abuse, on the part of business and of cultural entities, in use of the Sarney Law. According to the press at the time, the most frequent accusation was that, since previous approval of projects was unnecessary, it was easy to practice fiscal deviation by way of overestimated budgets—that is, it was possible for certain sponsors and those whom they sponsored to become accomplices in proposing a budget for a specific event far above the real market cost. In so doing, they divided between them what was in fact no more than illicit gain. Another criticism claimed that the Sarney Law was far too wide ranging in its definition of a cultural event or cultural goods which merited support. For example, big shows by Brazilian and international pop stars might benefit from sponsorship, even though they were among the most profitable and most easily marketed products of the culture industry. Despite all this, there are still many people involved with culture who invoke the Sarney Law as something of importance, and lament its extinction.

The election of Fernando Collor de Mello as president of the republic (1989) was twofold in its negative impact on culture. On the one hand, by way of radical neo-liberal rhetoric, Collor tried to bring about an abrupt reduction in federal bureaucracy, through mass dismissal of civil servants. Putting forward the claim that culture must survive in the context of market rules, he felt himself authorized to enforce a policy of running down, or quite simply of wiping out, federal organs of proven importance in the administration of culture. He was himself a political demagogue, brought up in a backward sector of the Brazilian elite)[5]; his policy had immediate effect on intellectuals and artists, most of whom had backed his rival in the presidential election. And on the other hand, the "financial healing" of the machinery of state, presented by Collor as a major guideline in his anti-inflationary economic policy, required the suppression of all fiscal incentives, and at last put an end to the Sarney Law.

It was only at the end of 1991 that Collor made some attempt to repair the damage done to culture. He nominated as minister of culture Ambassador Sérgio Rouanet, a well-known essayist, and charged him with the drawing up of a new law to cover fiscal incentives. Nevertheless, the rigorous evaluation of cultural projects introduced by the Rouanet Law together, with a percentage of fiscal rebate considered to be of little interest to business, have led to poor results. In 1994, only 11.6% of the $117.6 million available in fact were paid out to cultural producers.

The particular concern of the Rouanet Law was to do away with the possibility of fraud, made easy by the Sarney Law. Just as there is no consensus as to the efficacy, nor an exact knowledge of the results, of the two successive federal laws for incentives to culture, likewise there is so far no reliable balance of laws

with similar intentions at the state and municipal level, which began to multiply after 1990. This rapid expansion was a promising sign: they were, obviously, initiatives which arose in Brazil's richest states and most important cities— although initiatives of the sort are also recorded from smaller places and less developed regions. The states most involved were São Paulo, Rio de Janeiro, Ceará Pará e Espirito Santo, and the Federal District of Brasília. The cities were São Paulo, Rio de Janeiro, Belo Horizonte, Porto Alegre, Curitiba, Salvador, Vitória, Aracaju, Londrina, São Bernardo do Campo, Santo André, São Caetano do Sul, and Campo Grande. In most of these cases, the experiments have been recent. In some cases, even the instruments necessary for the operation of such laws (regulation, formation of committees, divulging of information, publication of tenders, etc.) are missing. Existence of only three books by Brazilian authors (and none in translation by foreign authors) under the general heading of cultural marketing, and all of these published recently (Almeida and Da-Rin, eds. 1992; Almeida 1994; and Muylaert 1993) is a clear sign that the subject is no more than incipient in a country where the publication of business literature is already a going matter.

Some incentive laws, however, do offer significant figures. In the municipality of São Paulo, the Marcos Mendonça Law has so far received applications for 620 projects, 118 of which have been approved and funded to a total of $11.9 million (Mendonça 13).

The federal laws have based incentives on income tax paid by companies and individuals; the state laws, however, have been based on tax on circulation of merchandise and on services; and municipal laws have been based on tax on urban property and on services, to name just some of the sources. This variety of resources will certainly be advantageous for the purpose of making funds regularly available when the system is fully operative. At the moment, even those laws such as the Marcos Mendonça Law, which are considered to be exemplary, only effectively channel to projects around 35 to 45% of the resources made available by taxpayers; this means that, in terms of improving the mechanisms, there is still a long way to go.

It should be remembered that Brazil is among those countries where income is most highly concentrated, and where resistance to an effective progressive tax system is strongest. Thus, there has so far not been a suitable climate for introduction of inheritance taxes on large fortunes, of the type of which, in other countries, allow valuable donations and enriches the public patrimony.

THE ROLE OF COMPANIES AND THE
IMPACT OF PUBLIC RELATIONS

It should now be asked: What is the role played by branches of international corporations, by large private and state companies, and by small- and middle-sized companies in this space as it takes shape? What do those at the head of big business think of cultural patronage as a means of keeping a corporation's image

in the public eye, together with its products, as compared with the alleviation of misery, sponsorship of sport, or even conventional advertising?

One reply to these questions can be put forward, bearing in mind the characteristic features of those companies which give most support to culture in developed countries. They are those same companies whose products do harm to the environment or to the human organism, and which need to reconcile themselves with public opinion, including the petrochemical, alcoholic drinks, and tobacco industries; those whose products are also culture, including newspapers and magazines, publishing companies, radio and TV companies; those which produce nothing material that can be "personalized" by way of design, of product engineering, or of conventional advertising, such as money—a "product" par excellence of banks and finance houses; those who direct themselves straight to the tastes of a nonpopular final consumer, and which need to demonstrate affinities with the world of aesthetics—clothing and decoration are good examples. They are those who work for the government and who see public cultural initiative as a way of expressing their thanks (i.e., the construction industry). And they are those whose customers are other firms—business to business—and whose purchasing public will fit in its entirety in a concert hall.[6]

Yet these features are neither necessary nor sufficient to inscribe a given corporation in the roll of cultural benefactors. There is a further very important factor: the cultivation and the cultural practices of a company's principal executives and—why not?—of their immediate family. This is why, with respect to the stimulation of expenditure by businessmen on culture, it is a useful and opportune duty to identify in Brazil's business community those who are particularly attracted to a specific sort of culture, or who have a special relationship with the cultural domain as a whole. A further factor to be taken into account is that expenditure on cultural events in the area of corporate or market strategy is in some part a business reply to the state of public opinion and to the social responsibilities expected of business as a whole, or of a business in particular.

Following this line of thought, it must be remembered that the psycho-social, political, and cultural environment in which business operates is changing. A new Federal Constitution, in force since 1988, has brought great change to social, political, and civil rights in Brazil. Furthermore, it has introduced chapters representing conquests which have been for a long time commonplace in advanced countries, and to which business must adapt: consumer rights, environmental protection, codes of advertising (including obligatory warnings of health risks in cigarette advertising), and other demands which show an improvement in level of consciousness on the part of the citizen-consumer; this in itself only stimulates investment to reinforce the corporate image. The very fact that a huge street movement involving students demanded (and helped to achieve) the impeachment of President Collor de Mello for corruption in 1992 is a further favorable sign: important segments of society now require responsible behavior on the part of the political and business elites. It is the lapse of time which separates these social conquests in Brazil from similar conquests in the developed countries of the Northern Hemisphere. This explains why

international corporations with a huge tradition of cultural patronage in other countries have never interested themselves, or have been too timid to involve themselves, in this area in Brazil.

An opinion poll carried out in São Paulo in 1994, the initiative of a cultural-marketing organization, tried to clarify the manner in which heads of business evaluate alternatives for expenditure on their corporate images and products. It is worth noting that, instead of consulting only large-scale sponsors, whose reasons are well known, a hearing was also given to businesses which had never been interested in turning to culture as a destination for resources aimed at institutional image or market effect.

Through in-depth interviews, the executives were invited to speak about the pros and cons of expenditure on (or investment in) culture, as compared with the expenditure on (or investment in) sport, alleviation of poverty, environmental issues, or conventional advertising. The conclusion, even if opportune, was mildly disappointing; cultural sponsorship was evaluated by a significant number of the businessmen interviewed as a risky and unrewarding option. First, quite a few had discouraging experiences to relate. There were cases where they had been approached by cultural producers with proposals which, in terms of budgetary competence, were less than professional; they had been offered events for one hundred thousand dollars, and had then been told that the event could in fact be put on for fifty thousand dollars, thus creating suspicions of amateurism or even of dishonesty. Second, many businessmen felt uneasy when the proposer, full of arrogance, pretended surprise upon finding that their artists and performers—even the obscure ones—were unknown to those of whom patronage was expected. Third, for many directors of businesses, culture brings to mind an area highly vulnerable to the quirks of genius or even madness, an area where the rules are very far from clear. Culture would not provide the businessman with that feeling of tranquility which he might gain from sport (for example), where everything follows a long-term calendar, where everything follows well-known rules and reaches a more clearly comprehensible public.[7] And finally, who is to guarantee that a cinema or theater director is not going to include some political manifesto in a product which will appear before the public under the seal of the company. At this point it no longer matters whether the political message is of the Right or the Left; the fact is that it is a nuisance—as much so as a gross manifestation of pornography might be.

The same opinion poll revealed that it is common for the advertising agency to come between the marketing personnel who decide on sponsorship and the cultural producer who puts the event on offer. What interest might a publicity agency have in culture? Why would an agency be interested in the client's opening up more options for merchandising, if this in fact means a reduction in the number of advertisements to be published in newspapers, etc. (bear in mind that the agency takes a guaranteed liquid percentage on the cost of every advertisement published)? It may be suggested, in this case, that an agency commission should be foreseen in the budget for a cultural event. Nor would it do any harm to be kind to the publicity people, who often feel insecure in cultural matters—

despite their spectacular attempts to demonstrate the contrary. Remuneration can be accounted for in advance, and the agency can be involved in the cultural initiative.

The principal underlying recommendations of the poll, directed to the cultural producer, would seem to be as follows: Do not make symbolic threats against the businessman and his agency on the basis of the prestige value of culture, and do not make economic threats through inconsistent budgets or the sacrifice of commissions. As the Brazilian market is less divided than that of the United States or the Western European countries, the weight of the various alternatives for merchandising in the whole context of business communication will also be less.

An impressionistic overview of the corporations which invest the largest sums in cultural patronage reveals a profile which confirms a number of the features mentioned above. They include petrochemical companies such as Shell; private financial institutions such as the Banco Real, the Banco Itaú, the Banco Nacional, Unibanco, Bamerindus; state banks such as the Banco do Brasil and the Caixa Econômica Federal; construction companies involved in public works such as Odebrecht; and finally, a cigarette company, Souza Cruz.

It should be put on record that when speaking of the large conglomerates, there is a tendency to create cultural institutions through which each corporation directs all that part of its resources intended for cultural sponsorship. This avoids fragmentation of support for others, and allows development of a distinctive line of action by way of behavior considered "endogamous," and generally directed toward a specific area of culture: the plastic arts and architecture for the Banco Itaú, cinema for the Banco Nacional, literary competitions for Nestlé, dance, music, and theater for Shell, and so on.

Today each of the largest sponsors spends something around $4 to $6 million dollars a year on culture. A recent report[8] with a focus on those who are directly involved with these large sums offers elements for sociological analysis. The Banco Nacional brought its efforts to converge on cinema at the moment when Ana Lúcia Magalhães Pinto, daughter of the founder and a psychoanalyst and cinema enthusiast, decided to close her office and join the directorship of the bank, "without a specific post," but concerned with corporate direction. Maria Christina Andrade Vieira, daughter of the founder of Bamerindus, dedicated herself to poetry before taking up directorship of the cultural association of the bank. Katy Almeida Braga, of the family which owns the Banco Icatu, a historian by qualification, had been a theater producer.

In addition to these women—it is well known that women have always been, in a bourgeois society, the link between artists, businessmen, and others in power (Fabre 1982; Benstock 1987; Chadwick 1990)—there are also the professional directors to be considered. Robert Broughton, president of Shell in Brazil from 1986 to 1992, has been praised for the skill and assurance with which he supported the dance group Corpo, authorizing in person a considerable amount of company money for this purpose. On his retirement, when he returned to London, he set up a cultural production company called Viva Brasil. Jens

Olesen, president of the McCann-Erikson publicity agency in Brazil, is also a constant figure in articles on business sponsorship. Born in Scandinavia, Olesen guides agency support toward events which spread the culture of his region of origin.

There is an enormous gulf between the restricted circle of large economic groups which make a habit of sponsoring culture, and the small, medium, and even large Brazilian businesses which have never ventured into this form of communication. The abyss is beginning to shrink, however; company names which are starting to appear as sponsors on the patronage lists, as a result of incentive legislation, are becoming increasingly numerous. They represent a wide variety of activities in industry, commerce, and services, and this variation tends to increase with the introduction of incentives based on a wider variety of taxes. Thus it is that private schools, bus companies, consultancy companies, engineering companies, garages and parking lots, garbage-collection companies, and other areas where the weight of the salary mass is very high by comparison with total income, or which occupy much high-value urban land are sectors to which tax reductions on urban property or services are attractive.

A sharper and more precise evaluation of the connection between business and culture in Brazil will still have to wait a few years more, until the tendencies now emerging have taken on a greater degree of clarity.

NOTES

1. The propensity toward altruism and public benefaction is often claimed to be based on religious values, with the suggestion that Protestantism is more favorable than Catholicism. Connections of this sort are not very clear, however, and it is in other parts of the repertoire of cultural values that one must look for differences in behavior with regard to good works and patronage.

2. Brazil, unlike the United States, did not have a civil war which represented the victory of a civilizing and libertarian ideal over the prejudices of slavery. So it was that Brazil, even though it entered upon the twentieth century as a federative republic, based on representative democracy and with a free labor economy, in fact continued to perpetuate inequalities.

3. The reactions of the owners of great mansions in Sao Paulo's Avenida Paulista, a most elegant address, during the 1980s, provide a number of eloquent examples of the weakness of tendencies toward patronage on the part of Brazil's men of fortune. These houses were to be preserved as public heritage—symbols of their epoch and architectural style—and in so doing would prohibit the use of the extremely valuable land for other purposes. Before their properties could be placed under a preservation order, they had them demolished, using bulldozers and dynamite, and usually in the middle of the night.

4. From a lecture by Edgar Acosta Diaz, special subjects coordinator of the Secretariat for Culture of the Presidency of the Republic, 17 June 1991, at the Economic Information in the Cultural Market Symposium.

5. Although he has a degree of no significance in economics, Collor is essentially a politician from the political oligarchy of Brazil's northeast, where he made his career as mayor of Maceió and governor of the State of Alagoas—to both of which he was nominated by the military. His military connections and his social origin place a great

distance between him and Brazil's artists and intellectuals, most of whom are from the south.

6. See Durand 1986; and Y. Sarkovas, D.S. Miranda, and A. Franceschini, Mendonça 1994.

7. The Brazilian sports-marketing scene has been estimated at $250 million per year, a significant sum—at least sufficiently so to bring about a first international meeting on the subject in 1994.

8. See "Os novos mecenas."

PART III

The European Community

Business Support for the Arts in Europe and CEREC

Ann Vanhaeverbeke

ABSTRACT

This article outlines the activities of CEREC, the European arts sponsorship association, formed in 1991 and funded by the European Commission and the private sector. It continues to analyze the trends of private arts sponsorship in Europe. In revealing the benefits sponsors receive, the chapter addresses their motives for such support, as well as the far-reaching implications of cultural policies on other areas of social policy, the environment, tourism, and the pan-European economy.

INTRODUCTION

Despite the difficult economic climate, interest in business support for the arts has continued to grow in all European countries. Although budgets may be cut as a result of the recession, statistics show that an increasing number of companies are turning to arts sponsorship, that once they have tried it they stay with it, and that long-term support programs are finding favor over expensive, one-night events.

Business sponsorship of the arts is regarded as an important supplement to state subsidy, local-authority funding, and revenue from the box office. In 1986, the Council of Ministers for Cultural Affairs declared that "the European cultural heritage and cultural activities in general benefit from a combination of public and private support . . . business sponsorship can enhance the cultural heritage and increase the production and dissemination of artistic activity . . . it should provide supplementary funding for cultural activities, not [be] a substitute."

In response to this and parallel calls from the European Parliament for the promotion of business support for the arts Europe-wide, the national sponsorship associations in existence at the time approached the European Commission in 1988 with a view to setting up a European secretariat. CEREC, the European arts sponsorship association, was created in March 1991 and is funded by the European Commission and the private sector. It comprises the ten national associations for business support for the arts currently operating in Europe and has access, through its members, to over 1,300 businesses, many more arts organizations, national press lists, government ministries, and local authorities.

CEREC focuses on four major areas: coordinating the activities of its national member associations; informing the business community on EC matters which have a bearing on sponsorship (such as, for example, the proposed directive on tobacco-advertising restrictions); counseling arts organizations on how to establish and maintain firm links with sponsors; and lastly, encouraging the business community to consider pan-European sponsorship of the arts as a challenging new business activity which coincides with the opening of the largest market in the world and the greatest business potential since the 1950s.

COMMON TRENDS

While there are, of course, national differences in attitudes toward the balance set up between the private sector, the public sector, and the arts, CEREC's job is to highlight the similarities. Across Europe, "good corporate citizenship" has become a recurrent message conveyed by all major companies to the outside world. Especially when a company is entering new markets, the success or failure of that initial investment depends on whether it can build mutual understanding and trust in the host country. It is essential for a corporation to interpret the word "customer" in its broadest sense, to embrace the whole society in which it operates. Corporate behavior must be satisfactory to the community, society, and country. The corporation must, in other words, be a good citizen. This new mood favors long-term and committed business support of the arts. It also means, however, that increasingly the arts are having to compete for business money with other fields (the environment, health, education, and scientific research).

Countries are in agreement that fiscal incentives, while affecting the amount they give to the arts, do not affect giving per se. No company in Europe gives to the arts solely to benefit from tax deduction. Indeed, at the time of print, Spain, Italy, and Denmark have yet to draft legislation on sponsorship, not to mention the Eastern and Central European countries that have not even the most rudimentary provision for private giving. In Italy, despite no obvious fiscal incentive, sponsorship of the arts in the form (mostly) of restoration of national heritage is regarded as a sign of good corporate management, and businesses thus spent an estimated £200 million on the national heritage in 1991 alone. Italian companies like Olivetti, Fiat, Gruppo Eni, and Ferruzzi, to name a few, also vie for corporate prestige and distinction through the arts.

Having said that, a fiscal framework provides parameters within which the private sector feels able to operate and be endorsed for it. For example, a French law passed in 1991, the Loi des Fondation d'Entreprise, makes it easy for French companies to set up their own foundations and has had a positive influence on the sponsorship climate. In the United Kingdom there is the Business Sponsorship Incentive Scheme (BSIS) run by Association for Business Sponsorship of the Arts (ABSA), matching new or increased sponsorship with government money. It is especially targeted at first-time sponsors, whether large or small, and has had a catalytic effect on arts sponsorship in that country. Since the scheme was introduced in 1984, national sponsorship figures have risen from £600,000 to close on £60 million.

A further incentive to companies is good media coverage. This is especially true in times of economic difficulty. Unfortunately, business leaders and journalists often think very differently on this subject; however, attitudes are changi,ng largely due to pressure and persuasion from the national sponsorship associations in the CEREC network. Crediting sponsors' names in the press is not a great deal to ask of newspapers, although they tend to argue that valuable space is taken up and that it is not their job to give free advertising to companies in an editorial context. In addition, with the recession forcing companies to review their arts-sponsorship programs very thoroughly, businesses are increasingly concerned with getting a clear return on their money. CEREC is currently conducting a survey on the media throughout Europe and the policies that each paper has (or does not have) vis-à-vis accrediting sponsors' names.

This has, in turn, led to a demand for effective evaluation of arts sponsorship, a challenge which is just being taken up by the national associations and market-research companies. While acknowledging that the arts provide an original and value-added means of communication, companies have to justify their spending. Companies have found it essential to begin a sponsorship program with a clear set of communication and business objectives—a checklist of targets. The success or failure of these goals can all the more readily be measured at the end of the arts program or sponsored event. To illustrate this I would quote the cK Chairman of a major computer company, Digital Equipment, who said: "We have never sponsored because we were doing well, but in order to do better. How much truer in a time of recession."

DECENTRALIZATION OF THE ARTS

As governments and the public sector in general are tending to spend less on the national cultural heritage, the arts are being funded by increasingly diverse sources: individuals, foundations, trusts, and sponsors. The vital relationship between government, the private sector, and the arts is one that is beneficial for all. The arts are thus less dependent on one source of income, and by increasing their sponsorship, partners are opening up their doors to new audiences who have often never consumed the performing or visual arts. The businesses, in supporting the arts, seek the endorsement of government; the government's role

is one of setting up better environments for sponsorship and guaranteeing its own commitment to the arts.

In response to these larger trend changes, arts sponsorship is becoming more beneficial to both business and the arts. Development managers within arts organizations are becoming more professional about seeking and maintaining sponsorship. There is also a growing involvement from local and regional public authorities, as opposed to the central government, and from small- and medium-sized enterprises (SMEs) as opposed to large corporations. The French association in the CEREC network, Admical, took this trend toward decentralized activity into account when choosing Arles, rather than Paris, as the setting for its 1992 conference on business sponsorship, and seminars run by the various associations are increasingly focusing on the potential for involvement by the smaller players. Simultaneously, arts sponsorship has become more international, with American and Japanese companies sponsoring pan-European arts. CEREC was created to cater to this multinational development.

CASE STUDIES

The recently launched Northern Telecom Arts Europe Program (NTEA) is the first European partnership initiative for the arts between CEREC and Northern Telecom. With NTAE, the Canadian telecommunications company demonstrates a commitment to encouraging cross-frontier communication in an exciting new open environment. The program is designed to promote collaboration and exchange between young European artists from all art forms and will ultimately embrace six European countries. CEREC advised Northern Telecom Europe when developing the program, and CEREC will be represented on the jury selecting the projects to benefit from it.

While the NTAE program is the first truly pan-European arts-sponsorship program (as opposed to a series of several national sponsored events), it is certainly not the first to look beyond national frontiers. Reasons for developing European rather than, or in addition to, national programs vary. When Guiness Brewing Worldwide sponsored the United Kingdom's Royal National Theater's European tour of *King Lear* and *Richard III,* which traveled to Cork, Madrid, Hamburg, Paris, Milan, and Brussels, the company was keen to present a strong pro-European profile while at the same time linking its name to the "best" of British culture. By sponsoring the nationwide 1991 Europalia Festival devoted to Portugal, the leading Belgian holding company, Societe Generale de Belgique, was concerned to give itself a European profile within its own market, Belgium. A positive return on sponsorship beyond the national level was not a priority.

The Foundation Electricité de France defines its sponsorship policy as encouraging artistic projects that link European countries and cultures. Since 1990, the company has promoted a number of exhibiti,ons including Le Corps en Morceaux to Paris and Frankfurt. This exhibit highlights the changes of techniques and styles in occidental sculpture from the Greeks to Rodin. Another exhibit, Memoires d'Egypte, which traveled to Strasbourg, Paris, and Berlin,

revealed the influence of Egyptian civilization on European art styles. An exhibition of archaeology was sponsored by this French company in Madrid. The company also has a three-year contract with the Villa Medici in Rome, consisting of financial support for the villa's restoration projects and exchange programs with the Espace Electra, a former power station converted into a cultural center by the Foundation EDE in 1990.

Visa's Olympic Art 92 gave five European artists a bursary and an expense-paid visit to the Barcelona Olympics, with studio and exhibition facilities provided to produce a series of Olympic-inspired works on track. This was followed by a touring exhibition. The artistic dimension to their much greater sporting sponsorship singled Visa out from the host of other official Olympic sponsors. Digital Equipment's sponsorship of the European Community Youth Orchestra (ECYO) has both political and marketing motives as the orchestra, funded by the EC, gives it privileged access to European institutions and national government leaders, as well as a prestige profile in the major cities of Europe and the world. Furthermore, the ECYO itself does not convey any one nationality, but rather a "European" one.

CEREC AND THE FUTURE

In the future, CEREC plans to build on its base of information for both the business sector and the arts. Two forthcoming publications include the "CEREC Survey on Pan-European Business Support for the Arts," a qualitative survey on corporate attitudes toward pan-European sponsorship; and the "CEREC/Arthur Andersen Guide to Business Support for the Arts in Europe—a Guide through the Fiscal Maze," a quick-reference guide to fiscal incentives for business support for the arts in 17 European countries. In addition, CEREC publishes a quarterly newsletter, "The CEREC Courier," which includes a profile on a business sponsoring the arts, a double-page of sponsorship opportunities (in terms of European cultural events) selected from the author's database, and news from the CEREC network. We have also drafted a guideline for good practice in arts sponsorship which will, in simple terms, outline the ideal relationship between the arts organization and its sponsor. The publication is aimed at smaller companies and local art groups.

Most European countries now have a national arts-sponsorship association to foster harmonious relationships between sponsors and sponsored, and to ensure that governments, while supporting private-sector participation, do not overlook their own financial responsibilities toward the arts in the mistaken belief that businesses can foot the whole cultural bill. In bringing such arts-sponsorship organizations together, CEREC can perform this function across Europe.

THE IMPLICATIONS OF MAASTRICHT

A recent cultural clause puts the arts on the European agenda for the first

time by providing the European institutions with a legal basis for proposing cultural policy and administering a larger budget. More importantly perhaps, the new cultural dimension gives the commissioner for culture communication and information the right to put forward opinions on the cultural implications of commission policies in other domains such as social policy, the environment, tourism, and so on. The commission views its priorities as encouraging cultural diversity, bringing the common heritage to the fore, promoting young artists, and improving knowledge and dissemination of the arts. In addition, it wishes to increase cooperation with nonmember countries, especially those in Central and Eastern Europe. Proposed agreements with Poland, Hungary, and former Czechoslovakia include a cultural clause. This interest in Central and Eastern Europe is reflected by the national associations for sponsorship, and, as part of its future training program, CEREC hopes to develop exchange opportunities for arts managers working outside the EC.

While the new work undertaken by the European commission is much welcomed, the geographical boundaries of the European Community do not ultimately determine cultural activities. National differences in levels of state and private intervention will continue to prevail. Maastricht or not, from a cultural viewpoint, Europe is already a reality with its identity defined by its diversity. Business sponsorship is also a reality that does not await political treaties. Markets and business opportunities are opening up, and are proving to be the key incentive for pan-European sponsorship, out-pacing the institutional changes.

The new feelings paraphrase Aristotle's dictum on the right attitude toward money: "any man can spend money, only a wise man can spend it wisely." The wise, in the case of pan-European sponsorship of the arts, must be found within the European institutions, the sponsorship associations, and must be the businessmen and women who make so many projects possible.

Corporate Collectors of Contemporary Art in Britain

Chin-tao Wu

ABSTRACT

In this chapter I would like first to review, albeit briefly, the major factors underlying changes in corporate support of the arts; next, I present a typology of these new patrons who have emerged since the 1980s; I then analyze why they venture into art collecting and what purposes an art collection serves in the business context; and finally, I examine what the outcome of corporate intervention in contemporary art may be.

POLITICAL, ECONOMIC AND SOCIAL CHANGE

The past decade has witnessed a burgeoning of corporate art collections in the United Kingdom. Not only has the number of corporate patrons increased over the decade, but the magnetism of corporate collecting has attracted a variety of participants across the whole spectrum of business, exerting a sea change in the kind of artworks being collected and the way they function in the business context. These changes, brought about by the political, economic, and social transformation under the Thatcher governments, are nowhere more prominent than in the phenomenon of those business patrons who set out to collect contemporary art in a conscious way heretofore unknown.

There is little doubt that Britain experienced profound political, economic, and social changes during the course of the 1980s. After Margaret Thatcher came to power in 1979, the Conservative party continued its successive terms of office under the dual banners of reducing public expenditure and expanding the private sector. Its radical program of economic and institutional reform, *inter alia*, has been modeled upon commercial enterprise, in which the overriding principle of the free market washes over any other concerns. A wide range of

activities previously conducted upon different principles, or protected by means of public funding from competitive market forces, has been "relocated" within the domain of the marketplace, with these goods or services becoming purchasable commodities. Starting as economic reconstruction, this political project has, however, increasingly filtered into other spheres of contemporary British society as the phrase "enterprise culture" becomes the buzz word of the day.

But to what extent is this transformation of British society into an enterprising collective related to the issue in question? For the limited scope of this chapter, I would like to draw attention to the illuminating case of legal services, since professional firms are among the most vigorous patrons to have emerged since the 1980s. The legal profession, traditionally regarded as the custodian of the law, is governed by traditional tenets of ethics and principles of justice. The United States Supreme Court, on the other side of the Atlantic thought "early lawyers in Great Britain viewed the law as a form of public service rather than as a way of earning a living and they looked down on 'trade' as unseemly" (Thomas 1982, 146). Tradition bound as it is, the profession, with its patrician airs and sense of professional noblesse oblige, has not been able to resist the insinuation of Thatcher's Revolution. In 1989 the Conservative Government (Lord Chancellor's Department) in its proposal for the future of the legal profession, championed the competitive spirit of the enterprise in no uncertain terms:

The government believes that free competition between the providers of legal services will, through the discipline of the market, ensure that the public is provided with the most effective network of legal services at the most economic price.

The commodification of legal service ensuing during the course of the decade has resulted in legal advice and skill being seen "in terms of its *marketability* as opposed to being a device in the negotiation of justice" (Stanley 1991, 206–215). In response to the increasing competition in the market, law firms have had to adopt the previously alien techniques of marketing and advertising, a practice which is the mainstay of consumerism in a capitalist economy, but whose access is denied to certain professions for the sake of the public interest involved. In explaining why his law firm commissioned art, Stephen Whybrow, senior partner at McKenna & Co., commented,

Like it or not the practice of law is moving from being a profession to a service business. In 1980 any form of promotion or advertising a solicitors' practice was not only prohibited but considered to be "fundamentally inconsistent with the interests of the public and with the honour of the profession. (Whybrow 1991, 18-19)

The Commissions, in which graduates from London art colleges were invited to participate in an art competition, were launched by the firm "to form a backdrop" for a reception to mark its return to the City of London and to ensure that its clients and contacts and others in the City were aware of its City presence

(Whybrow). The event, on no account the most glamorous of its kind, is not atypical of the way in which art collections, together with arts sponsorship, came to be appropriated by business as a marketing tool in the 1980s. The imperative of marketability in the Thatcherite enterprise is such that it draws almost every sector of business into this gravitational field of marketing, and professional firms, with their traditional culture, are the reluctant latecomers to enter the field of patronage.

Beyond a doubt, marketing the image of an art patron is not quite the same as conventional products promotion, which is a straightforward selling strategy. But if more subtly so, it is none the less still motivated by the self-interest of business. In a global market of sharp competition where both products and services are getting less and less distinguishable, for a company, the only meaningful differentiation from other competitors is an "enlightened" corporate image. And art, or arts in general, is ultimately promotable. John Hoole in *Capital Painting*, the catalog for an exhibition devoted to the City's art-buying companies, urged the noncorporate collectors:

To those other companies that are not represented here the gallery would like to append a note both of reprobation and encouragement. Some of your competitors have had the insight and flair to recognise the importance of art in the creation of their business image. As Max Bialystock said, "You've got to have style." (Hoole, 1984, 5)

Even if art collecting can elevate companies above the shabby cut and thrust of the business world, collecting contemporary art is no automatic choice. Not every company is willing to take a risk on contemporary art. The appeal of contemporary art, however, lies in the mythological cult of artistic personality and the strong association between avant-garde art and innovation within the paradigm of modernism that has provided the business world with a valuable tool to project the image of itself as a progressive and innovative corporate force. As Roy Chapman, managing partner of the Arthur Andersen London office comments, "We have the pictures to enhance and enliven the working environment. We are attempting to convey an image that is contemporary and progressive."

It is by no means untrodden territory for British companies to collect art. It has been the policy, albeit sporadic, of many banks to collect portraits of their distinguished chairmen or members of the boards, or commission silver or other precious materials to commemorate specific events for centuries. Even when they incidentally ventured into landscape paintings, their taste was very much confined to those of a much earlier date, or to views of the Thames or St. Paul's.[1] In the case of certain industries, such as construction, companies have for years commissioned artists to portray their business operations or design posters used in advertising. Collections of this type, either self-celebrating or business related in nature, if they could be taken seriously as a "collection" in their own right, dominated, with few exceptions, the interiors of boardrooms and executive floors of businesses before the 1980s.

THE NEW PATRONS

Standing apart from this time-honored tradition, the new breed of business patrons who have emerged since the beginning of the 1980s, especially in the latter half of the decade, however, has a very different outlook and scenario. Unlike earlier collectors, they collect contemporary artworks, works bearing no direct relationship to their day-to-day dealings. And by and large they have taken a more professional attitude toward collecting than the earlier collectors who used to purchase bits and pieces in an ad hoc fashion. Still hidden away from public gaze, the art in their hands was put to work to the best advantage in varied publications and sometimes even organized into catalogs to generate much needed publicity. Those earlier collectors, who do not wish to be left out of this trend, invariably have to assume a similar style of art buying. It is to the cohort of patrons of a more adventurous type that this chapter will now turn.

By the 1980s, corporate art buyers were predominately drawn from the financial sector, either banks or insurance brokers, with only a few distinguished exceptions. For example, BP and Arthur Andersen started buying art in the 1960s. A decade later, however, the landscape of corporate collecting presented an altogether different picture. Understandably the financial sector was still the main force in corporate collecting. Publications on the topic inevitably mention this group of buyers (Moncrieff 1991). In *The New Patrons*, for instance, a catalog to commemorate the exhibition on corporate collecting of the same title in 1992, half of the contributing lenders are from the financial sector (Bernstein).[2] More precisely, almost all of these companies are headquartered within the square mile of the City of London, the financial heartland of Great Britain with its enormous wealth and unique financial dominance.[3]

These financial high flyers have been joined by three different groups of new patrons. The most notable patronage comes from professional firms, such as legal and accounting firms. As mentioned earlier, the competitive edge of the free market unleashed in the 1980s altered the practice and the nature of these professions. Although one can argue that the degree of competitiveness in this particular sector is probably no more severe than that in others, the fact remains that lawyers and accountants, the producers of services, have direct and close contacts with their clients in a way that, say, the company producing household goods will never have to face.

The intimate contacts of this kind with clients have made these professionals particularly conscious of the image of their firms, especially the physical impression clients form when they first visit their offices. When asked the purpose of the collection, an office-services supervisor of a law firm explained,

I would say the purpose is for the public image of the firm. . . . They want to get away from the old fashioned image of the lawyers. Do you know what I mean? Sitting there in his office, with old prints on his wall, that's finished. Now it's the corporate, big business, big deal. . . . We have a lot of people coming in. . . . It's very important that they come in and they are always very impressed.

Moreover, most law and accountancy firms are owned by partners, as opposed to a corporation that is owned by faceless shareholders. As partners have to dig into their own pocket to pay for art purchases and as their personal fortune is thus more at stake in the appreciation or depreciation of artworks, their entry into this collector circle is all the more impressive and revealing. Two highly publicized collections are, for example, those owned by accountancy firms, Arthur Andersen and Cooper Lybrand Deloitte, both on the top five list of accountancy firms in Britain.[4] Although the Andersen collection was started in the late 1960s, it was only when the firm employed a curator in 1984 that an aggressive streak was brought into its collecting and gave its collection new heightened significance. As its curator, Glenn Sujo, boasts, "It is a museum standard collection and is not just there to beautify the building" (1990, 31).

The second group of art buyers is from the manufacturing sector. Unlike the service sector where companies have a direct contact with clients, the manufacturing industries face a multitude of "anonymous" consumers. In some cases they even have captive customers as products of some companies, such as Glaxo, are available only on prescription. Nevertheless the need to keep the company's name in the minds of the major markets cannot be over underestimated. Sir Allen Sheppard, the hard-nosed chairman of Grand Metropolitan, reportedly said that these days the consumer's eye passes straight through the first-level consumer brand to settle on the "meta-brand" of the company itself.

Although manufacturing companies as a whole are not as active as financial houses on the art market, the collections owned by the giants in the sector, such as ICI, BOC, and Unilever, are widely acclaimed and well located on the art circuit for cognoscenti. This is of course more a reflection of the financial strength of these companies than anything else. To celebrate its 12-year history of art collecting, for instance, Unilever published a catalog of its collection in 1992, *Unilever House London Contemporary Art Collection: The First Twelve Years*. In its introduction, Unilever was praised for "[keeping] abreast of the changing climate of the 1980s" in the development of British art in the decade (Beaumont 1992).

The third group of patrons consists of property developers. There are many reasons to make developers a special case. First of all, the majority of works invested in by developers for commercial and industrial developments are sculptures, an art form not favored by most business collectors. Despite the fact that the number of works owned by these patrons is much smaller than those in other kinds of company collections, their monetary value is immense. The dozen or so sculptures in the Broadgate Development, near Liverpool Street Station in London, for instance, are reported to have cost the developer, Stanhope Properties, one million pounds, far exceeding the initial budget any other company has spent on art purchases.

Secondly, the scale of these sculptures is, more often than not, physically overwhelming, especially in an urban center. Their sheer physical presence holds office commuters as captive spectators who have no choice but to see them. For instance, one cannot possibly pass Richard Serra's *Fulcrum* without

noticing its five huge rusty sheets of steel, each 60 feet high, straddling one of the exits of Liverpool Street Station. The visual impact these sculptures and their architectural setting have made on the fabric of urban landscape is immense.

Finally, unlike the art in other categories of corporate collections that is hidden away in offices, the art objects in the developers' ownership are on "public" display. This public access is nevertheless illusory since these objects are actually displayed on "corporatized" public spaces where around-the-clock surveillance operates through the hidden electronic systems in the complex and through the constant presence of security guards.

As part of a wider strategy of "quality" enhancement for a development, the conspicuous, but ostensibly disinterested, display of supposedly functionless objects is motivated by the social status and value which comes with the possession of "art." According to a recent study undertaken by the University of Westminster, art provision in a development does not add short-term value to the buildings in terms of an immediate increase in rental income, but it is perceived to be connected to the incremental marketability of a development, whose rewards are seen in terms of "ease of promotion, and a greater speed of letting or disposal" (Roberts, Marsh, and Salter 1993).

Beyond these groups of patrons, a phenomenon is worth noting before I turn to discuss why British companies are buying art. London, metropolitan city that it is, has a large number of resident foreign companies. These subsidiaries, or branches, very often possess an art collection if their parent companies abroad are very active in art collecting in their own countries. The way these collections operate is therefore not so much determined by the British context but is an extension of the parent company's policy, especially American multinational companies that first started the trend of art buying. As American multinationals globalize the world market, so do they export their concept of corporate art collections. While British companies hardly buy any works produced outside British soil, it is in this group of overseas businesses that the works being collected reflect the countries of origin of the parent companies—almost as if an art collection is a conspicuous display of national pride and identity.

THE ROLE OF SENIOR MANAGEMENT

Among the companies visited, the chief executive or chairman or in the case of professional firms, the senior partners, are the pivotal figures when it comes to the initiation of art collections. These people at the top echelon of the company are often reported as having great passion for art—in both the press and in the interviews I conducted with the staff in the company. They visit galleries, tour artists' studios, and buy at the main auction houses, all this on top of their already extremely demanding schedule (Goodison 1992; Adeane 1991).

It seems to be surprising, at least on the surface, that the senior manager should be personally involved in collecting to such an extent, especially when we compare the five-figure art budget with his duties of overseeing a business venture worth, in some cases, billions on the stock market.

The advocacy of these high-powered grey-suited men in companies' forays into art collecting, however, can be considered within the context of the historical transformation of capitalism and the way high-culture functions in society. The "alliance between class and culture," as Paul DiMaggio described it, continues (1982c, 35–50); only in the recent decades, especially the 1980s, has this alliance increasingly become one between business and culture, with corporations replacing the upper class as high culture's leading patrons (Useem 1984, 175). As family capitalism has declined in the twentieth century, so has the archetype of nineteenth-century magnate-collectors. The cadre of new company patrons in the 1980s referred to in this chapter are the byproduct of an incomplete transformation of family capitalism to institutional capitalism and their uneasy coexistence in the business community today. People such as David Rockefeller, the grand persona of the tycoons of a bygone era, who initiated a corporate art collection for Chase Manhattan Bank in the United States in the 1960s, therefore represent a transitional phase of this transformation.

None of the chairmen/chief executives I am referring to have family heritage in the way Rockefeller did. They are the professional managers emerging through the so called managerial revolution and their aspirations as art patrons for companies under their control are therefore achieved through their corporate position rather than family lineage. On the organizational level, the collection represents a driving force within the company, giving it a distinct entity of its own and allowing it to take an active part in the cultural sphere of contemporary society. Alex Bernstein, chairman of Granada Group, acknowledged this: "I believe that companies have some obligation to take over the role of private patronage."

Just as importantly, if more subtly, on an individual level, these chairmen/chief executives, being the guiding hand behind their company collections, have also been able to appropriate the social status and value which comes with being head of a company in possession of "art." The parallel relationship between a corporate art collection and the company and its chairman therefore illuminates that it takes more than the mere whim of the chairman to initiate a corporate collection. It also means, in some cases, as these highly mobile chief executives move from company to company, that they start collecting wherever they preside.[5]

Beyond the initiative from the top management, the most deciding factor inducing companies to venture into collecting is the relocation or renovation of their headquarters. The building spree of the 1980s property boom, especially in the late 1980s when there was an oversupply of offices, witnessed more companies moving into new purpose-built office developments. These high-profile buildings generally have large atriums and office spaces, lending themselves particularly well to art display. The moving of an office, an infrequent but significant decision for any company, is itself a befitting opportunity to refurbish the corporate image, as reflected in the choice of a prestigious building or its lack. This relocation always entails a huge budget to decorate the new offices, in which art is considered a component of the furbishment of space—thus, out

go the fusty architectural prints and legal cartoons; in go the large, bright paintings. Harry Anderson, the partner responsible for the art collection at the law firm of Herbert Smith when it moved to Broadgate, reportedly observed: "We were trying to produce an uplifting environment. It sounds a bit pompous, but that's what we were trying to do" (Morris 1994).

THE NATURE OF COLLECTIONS

Lucrative as the art market may seem to be, most companies take cautious steps toward their buying and do not venture into it without guidance from art consultants. With the growth of business buyers in the 1980s, there is an equal surge of consultants of varied caliber who cater to this specific market. This ranges from one-man/woman operation to companies like Art for Offices, whose large warehouse office in Wapping displays works by a stable of 600 artists.

Distinguished from these "up-market wallpaper salesmen or saleswomen," the Contemporary Art Society (CAS) plays a special role in mediating between business and artists, a peculiar British phenomenon. For a commission fee, the CAS advises companies on their art purchases in the same way as other consultancies. But unlike other consultancies, the CAS runs as a charity, with all the profits from advising companies going back into the organization to purchase contemporary art for museums and galleries in the country. This semipublic characteristic, as well as its close proximity to the Tate Gallery, gives CAS a political clout that none of the commercial consultancies have. The fact that it tends to recommend established British artists has given a similar flavor to the company collections they have so far advised on, and this is not without effect on the art market for young artists without established reputation.[6]

VALUE OF ART COLLECTIONS

Considering that financial houses with their keen eyes on speculation are the predominant buyers on the corporate art market, it seems surprising that very few companies actually admit that investment is an important factor in launching an art collection. It is true that contemporary art is much more risky than old masters and the British Rail Pension Fund's collection, the only collection in Britain set up purely for investment, was not willing to take the risk of buying contemporary works. But on the other side of the coin, when rates of inflation are running sky high, art does provide "reasonable prospects for long term capital appreciation, at least equal to inflation." In fact, senior managers often express their views on art investment euphemistically, as Bernstein writes: "They [works of art] were not intended as an investment—although they have turned out to be rather a good one," and "If you ask me personally whether or not I think in ten years it [the collection] will be worth more money than we paid for it, I think it will. But if you start thinking paintings as an investment, well, I don't."

Even if art should underperform on the market, the attraction of art as status conferring never ebbs away. Art has long been patronized by those with power and status in society. Its role in business environments therefore cannot be merely viewed from a utilitarian perspective, but also as a high-profile status symbol. As Paul DiMaggio says: "They [cultural goods] are consumed for what they say about their consumers to themselves and to others, as inputs into the production of social relations and identities" (1982, 133). When ICI, the world chemical giant, completed the renovation of its headquarters at Millbank in 1988 and its art collection, the company's glossy brochure proclaimed:

We might have chosen safe traditional paintings for this purpose but we decided instead to capture some of the diversity, challenge and vitality of contemporary British painting, so as to parallel ICI's approach to modern business life.

The dynamics of this image-making machine is certainly not limited to merely displaying artworks in company premises. Not only has the conventional method of producing a catalog been utilized to give an aura of permanence and scholarship to the collection, but increasingly the artworks have been reproduced to enliven the look of annual reports and other company brochures. Those dull monochromatic annual reports full of photographs of grey-suited male directors have been replaced by ones with splashes of bright colors and abstract shapes. And, in one case, a full page in a recruitment brochure is devoted to explaining ten works reproduced therein.

Most companies claim they buy art to support living British artists. It is true in a sense that most of them have a British-only policy, with Scotland-based companies only purchasing Scottish art or works representing Scottish subjects. The high-profile Robert Fleming collection, for example, is reportedly the largest collection of Scottish art in private hands. The *Telegraph Weekend Magazine* reported the beliefs of Bill Smith, a retired director acting as the keeper of the collection: "Our real idea is not just to build up a collection but in some way to foster Scottish art and to try to help some of the younger artists."

To go for younger artists is, nevertheless, not just a matter of social altruism, but a matter of pragmatism. The sky-high price for blue-chip artists is simply colossal, and only a few companies have the resources to play that price. When asked the reason why the company decided to collect contemporary British art, William Backhouse, chief operating officer at Baring Asset Management, recalls, "Old masters were out of our price bracket, very modern would not have appealed to my colleagues, so we narrowed the field to contemporary British" (*Telegraph Weekend Magazine,* 1991).

Then, what sort of contemporary art have this new breed of corporate patrons been collecting? At the time of writing, there has not been any systematic data collected on the topic, either from the perspective of corporate shares on the art market or from the content of the collections themselves. My own survey questionnaire tried to establish the preferred styles of the works amd seemed to be too demanding for men and women in the all-consuming business

world. With scarce information in hand, it is easier to say what people are not buying than what they are.

First, in terms of medium, sculptures and three-dimensional works are the least collectible among the corporate buyers, both because of the cost and of the space required to display them. When asked why his company does not purchase sculpture, a chief executive remarks, "We don't, no, partially because of financial reasons. . . . Secondly, these rooms don't lend themselves to sculpture." This is not an atypical response. A high percentage of collections are concentrated in the south east of the country. In particular in the City of London, where space is at an ultimate premium, few companies can afford American-style atriums and spacious corridors, except for outdoor sculptures owned by the property companies mentioned earlier and those who own outdoor ground or grand stairways. The issue is further complicated by the security concerns in the City. One director noted that sculptures were impractical, getting in people's way at times when thousands of people had to evacuate building.

Second, unlike corporate collections in America where sexual images are the prime taboo, British patrons seem to be able to endure nudes as long as there is not "explicit nudity" or they are not "overly sexual," to quote the terms used by interviewees when defining what is inappropriate for the corporate environment. Even when some nudes cause controversy, senior managers are able to justify their choice by referring to public art collections. One executive comments: "I believe that most good galleries in this world have paintings of nudes. . . . To say you are not going to have nudes is just as stupid as saying you are not going to have seascapes or landscapes or still lives."

And perhaps not surprisingly female nudes are treated differently from male ones, at least in the City where the whole ambience is aggressively masculine. The company just referred to did not purchase a drawing of male nudes by Elizabeth Frink because one of the executives "absolutely refused to have male nudes."

But nudity is certainly not the focus of controversy in British corporate collections. There is a higher degree of sentiment, and occasionally resentment, against abstract paintings than against those representing nudity. This is not to say businessmen do not buy abstract works at all; a few of them do. Indeed, in one instance, the reason to go for abstraction was to avoid stepping into any politically controversial subjects, as if abstract works were ideologically value free.

The fact remains, however, that British companies tend to buy figurative works. There is a profound feeling of unease toward, and sometimes even of being threatened by, abstraction among people who do not possess what Pierre Bourdieu calls "the code" to decipher splashes of colors and lines Bourdieu and Darbel (1991). One accountant in a bank referred to William Scott's works as "pots and pans" which, he said, as paintings, could not hang anywhere except in the staff restaurant. Another member of the staff in the same bank called a set of Barbara Hepworth's prints "fried eggs, lemon and the moon," which he did not consider as pictures at all. As mentioned earlier, corporate collections

are primarily shaped by senior managers. The collecting patterns I am describing inevitably result from their "tastes." Thus Edward Adeane, the director who is responsible for assembling the art collection at Hambros Bank observed: "By and large the Hambros collection is representational. I'm not particularly keen on abstract work myself. Also, I suspect that everybody tends to come along and say, 'Why did you buy that?'" (*Telegraph Weekend Magazine,* 1991).

The most often cited purpose of the collection is to enhance the working environment, for the benefits of the staff as well as the clients. A company brochure, "Windlesham," published by the BOC group, asserts this function for the art collection: "Windlesham houses an art collection to enhance the visual quality of the building for those who work in it. [Artworks] give staff, customers and visitors an opportunity to experience art in a business environment." Windlesham's brochure also states: "The primary motive was to create a more stimulating and enjoyable working environment for the staff and the many visitors to the building."

These statements of objectives, often made with public consumption in mind, say nothing however about how the staff really perceives the collection. Senior managers who initiated the collecting without doubt were enthusiastic to show me around, but people who are not on the top of hierarchy, more often than not, showed indifference. In some cases filing boxes actually obscured the view of the works. As a matter of fact, art in offices only reinforces the corporate hierarchy; the higher one is on the corporate ladder, the more expensive pieces one gets in the office, except for genuine public areas such as the reception lobby. Not every company will move a painting somewhere else if the employee happens to dislike it. One office manager observed, "If they don't like it, tough!" The chief executive in a financial firm stated, "It's [the painting] where it looks best. No. It stays there." From an employee's point of view, artworks in the office at best serve as "conversation pieces" for casual chats. Works by Georg Baselitz, for example, always invite comments from visitors, such as "Oh, your pictures hang upside down."

CONCLUSION

Given this growth in corporate buying, it is surprising that British businessmen are unwilling to talk about their influence on contemporary art—unlike American buyers who tend to be flamboyant in their collecting. Yet, when Sir Nicholas Goodison spoke out, he nonetheless voiced the underplayed power ego of other business patrons: "I believe that being bought by a corporate patron can make a difference to self-confidence and therefore to the development of a younger artist's career. That sounds a bit patronizing, which, in the true sense of the word, it is" (Goodison, 169). Is this corporate patronage ultimately beneficial to living artists? It seems that artists would not bite the hand that feeds them. Coming of age are thus not just corporate art but also corporate artists such as Bruce McLean, who created *Pestle and Mortar* for the Glaxo House atrium, the centerpiece of its art collection. McLean said of his work: "It is a

reflection of the company. Glaxo make things that make you feel better and healthier" (Glaxo 1992, 440) Does it? Or does it not?

The issue of stake in relation to corporate patronage is one of the uses of art by the powerful—there is nothing new in that. It is the meaning which art takes on in the social milieu of commercial space. And here lies a fundamental contradiction. Since the eighteenth century, it has been widely claimed in bourgeois culture that art is, of its very nature, above the sordid world of individual interests represented, quintessentially, by commerce. Indeed its very capacity to confer status on corporate patrons depends on this. Yet, as Bruce McLean's comment illustrates, corporate collecting is anything but disinterested. So the question is Can art bought by corporate capital and housed in commercial spaces be anything more than advertising and high-tone decoration?

NOTES

This chapter is from a paper presented at the 8th International Congress on Cultural Economics, Witten, Germany, 1994. It is part of a research project for a doctoral thesis in art history at the University of London.

1. For examples of bank collections before the 1980s, see Simon Houfe, "Art Treasures of the British Banks," *Bankers' Magazine,* December 1977, pp. 10–14.

2. In fact there are 24 lenders listed in the catalog, but I exclude the British Council and InterCity on the grounds that neither British Council nor the InterCity is in the private sector. Robert Mcpherson, the organizer of the exhibition, justified the inclusion on the basis that the commission by British Council of Patrick Caulfield's carpet is significant enough and the building is partly owned by British Gas. Interview with Robert Mcpherson, NACF, 5 February 1992. Another point to bear in mind is that although Save & Prosper Group and Hill Samuel Bank are subsidiaries of Robert Fleming and TSB respectively, their collections are operated separately. I therefore count them as different companies.

3. The only exception is *3i*, whose headquarters is opposite the Waterloo Station. The company has commissioned or acquired a work of art from an established artist each year since 1988. In addition to the ownership of the original piece, the work is used as a basis of the graphic design for its annual report and for reproducing silkscreens (of course with the artist's signature) as rare gifts to their senior managers and worthy clients (see Thorncroft).

4. Coopers & Lybrand is the top firm in terms of fee earning in the United Kingdom in 1993 and Arthur Andersen is the largest in the world.

5. This is the case with Cob Stenham, the former chief executive at Unilever who started the art collection there. When he moved on to become the chief executive of Banker's Trust, he initiated another collection there (see Thorncroft).

6. The CAS has advised on companies such as De Beers, ICI, Unilever, Pearl Assurance, and Stanhope Properties.

Art Sponsorship by the Austrian Business Sector

Brigitte Kössner

ABSTRACT

This chapter discusses private and public promotion of arts and culture in Austria. Questions addressed are why Austrian companies promote the arts, and how they connect their art projects to their corporate identity, as well as their support of the promotion of institutions and festivals. National case studies are discussed.

INTRODUCTION

Private support for art is gaining a larger influence in Austria, and it is essential for businesses to develop effective marketing and communication instruments. Numerous Austrian businesses have recognized this importance, as the worldwide art boom illustrates. The Pompidou Center in Paris, for example, registered 8 million visitors a year and is the most visited monument in the world. In Bayern between the years 1981 and 1988, the number of national museums increased from 420 to 800.

The trend is also clear in Austria as the sales for the Salzburg Festival performances and theater and museum attendance have risen. Along with this increase Austrian businesses plan to distribute 1.55 million schillings in the area of sponsorship within the next five years.

If one traces the development of sponsorship to the present day, one can see that the advancement of art and culture have a long tradition. The Roman Gaius Clinius Maecenas (70 B.C. to 8 A.D.), supported the most distinguished poets of his time. Across the centuries his name became an inspiration for supporting activities. Currently there exists a slight contrast between the sponsoring ideals

of previous times, and the goals of businesses pursuing economic and advertising goals.

The Austrian Business Committee for the Arts (ABCA) is an independent association of companies, which was prepared to respond early to the trend and secured itself a place as a trend setter. It has witnessed the continued growth of sponsoring activities in the past few years and has solicited numerous businesses for the art-sponsoring award, Maecenas, in 1989 and 1990. In 1993 its spending reached a high of 400 million schillings.

Founded in 1987 by Martin Schwarz, it is organized according to the regulations of the International Business Committees for the Arts. ABCA is a founding member of CEREC, the European Committee for Business, Arts, and Culture, and the official sponsoring organization of the European Union. ABCA establishes goals that promote meaningful cooperation between business and the arts, including art promotion by business enterprises, providing information about art promotion, and lobbying the government to secure fair rights and taxes for private art promotion.

ABCA gives information about art sponsorship and successful activities to the media and attempts to present art sponsorship to a broader public audience. With these goals in mind, it offers several services such as consultation to interested enterprises in the field of art promotion and sponsoring; offering care and control of the art project as needed by the sponsoring company; and handling mediation of national and international contracts between business and the arts.

THE EXTENT SPONSORSHIP

Sponsors contribute and donate money, materials, time, etc., because of their interest in art. Ideally, recognition is satisfied in part through the supporting art form, demonstrating the full value of investing in art sponsorship. In contrast to classical art sponsorship, which did not focus on the goals of both parties, current art sponsorship pursues the economic and communicative goals of the company as well as those of the sponsored organization. Art sponsorship is founded on the principles of performance, concentrating on one core economic and cultural area, chosen from a broad range of opportunities: print, tone, and picture medium (television and radio); art motif, musical instruments, and necessary accessories; cinema, theater, concerts, exhibitions, museums, and cultural events; statue protection, city restoration, maintenance of state murals; performance lessons; and general cultural performances.

The value of work in the art and cultural sector within the gross national product reached about 2.5% in 1990. In comparison, the building industry puts out 7% of the gross national product, and the leisure and tourist industry makes up 14.5%. Around 85,000 people, or around 2.5% of the jobs in Austria, deal with establishing, testing, and expanding "art and culture" in the broader sense. In comparison, the textile and clothing industry employs around 23,000 employees. The value of cultural works in private households and on the national

and international level totaled about 60.1 million schillings in 1990. This figure rose from 28.1 million schillings in 1980, with a yearly growth rate of 7.7%, which is outstanding when compared to the combined growth rate of the leisure and tourism industry (6.5% a year), or the nominal growth in the gross national product (6% a year). The increase in the private sector creates wonderful expansion opportunities for the art and culture economic sector in general. The cultural demand on the national and international level amounted to 11 million shillings in 1990, which had doubled since 1980. This money was mostly devoted to representable art (3.9 million schillings), education (2.5 million schillings), and museums with collections (1 million schillings). From 1988 to 1995 a total investment of 5 million schillings has been made available for renovation and maintenance projects. This money is taken from the already existing budget, from a city renewal fund called ASFINAG 1987.

Because of the current economic situation, companies have been rethinking their art sponsorship and reconsidering its effectiveness as a marketing and communication tool. Therefore, art-sponsorship activities have become better integrated into the corporate philosophy, and a direct connection between products and the sponsorship activities is being sought. At the same time, companies are looking for long-term sponsorship arrangements and lasting partnerships with the arts, rather than short-term activities. This long-term approach improves the overall quality of art sponsorship. While companies in general have continued their long-term sponsorship programs despite the recession, they tend to be more cautious about starting new projects. Companies are also trying harder to justify sponsorship to their employees, who are also being given more opportunities to become involved in these activities. Some companies are reluctant to announce their sponsorship; yet, they express a desire to support artistic programs by giving money, providing services for artists, and promoting their goals in the spheres of marketing and communication using the arts. Art sponsorship has become an essential part of public relations (PR) work and image maintenance and has become part of the political communication role in marketing.

A sponsorship strategy can be defined as the prearranged methods and goals that keep it in conformity with the marketing and communication goals of the business. Only then can the correct project be selected, and the specific target groups addressed. The careful planning of the sponsoring project is a prerequisite for a successful event. It must be well defined, and a responsible individual or consultant with knowledge of the project's development, and end goal, should be placed in charge. A complete timetable for the completion of the project must be drawn up, and a budget must be prepared.

In order to fully benefit from the sponsoring project, the sales promotion and the publicity work should be presented first within the company, especially within the range of classical advertising. Essential strategy includes connecting the art-sponsorship event with the product's other advertising; using the sponsored art arrangement as an ideal frame for company celebrations or the care of important customers; making the art a component of the company's advertising

brochures, packaging, etc.; letting the artist work with the company's technicians on new project designs; and acquiring an art collection for the company which serves as a focus point for social activities.

PRIVATE AND PUBLIC PROMOTION OF ARTS AND CULTURE

In Austria, in contrast to Germany, there are no cultural statistics regarding the complete economic contribution made by "art and culture." This lack of data is due to the difficulty of defining the Austrian conception of culture, and the existing criteria used for defining "art and culture" as an economic sector. In case of serious economic problems, companies want the freedom to act without outside pressure on their sponsorship activities.

Many companies are interested in social and environmental sponsoring as well as a combination of different sponsorships. In the future, artists will be asked to contribute complete sponsoring concepts and to examine more closely the firm's marketing and communication concepts. Sponsorship activities should be closely tied to advertising, public relations, and sales promotion. The international trend already points to a commercialization of art sponsorship which is expected to affect the traditional concept of art sponsorship.

REASONS FOR ARTS AND CULTURE PROMOTION
BY THE BUSINESS SECTOR

In contrast to traditional sponsoring, current business sponsorship directly promotes the company's economic and communication goals. Just as a marketing instrument becomes an important part of PR work and image building, arts events can be an easy way to increase public awareness. In traditional advertising the focus of communication is on a broad level of public awareness. Advertising in the media stands in the foreground as it is an efficient way to get the product to the people. Sponsorship can easily be incorporated into this means of advertising since it can utilize known personalities from various domains in a variety of advertising concepts.

The goal of furthering company sales is accomplished through advertising activities (demonstrations, sales, commercials, etc.). Through advertising one wants to entice the customer to purchase the product and this is where the unity between the sponsored program and sales plays such an important role. Sponsoring develops a connection between the customer and the product.

Public relations is meant to gain and maintain the trust and understanding of the customer. The sponsorship of sport, environmental, social, and art activities is easily linked with public relations, and demonstrates the company's awareness of its public responsibility. The conditions for sponsorship programs are connected to budget and time limitations as well as to the company's ultimate goals. The sponsorship program must also be able to reach the desired target group.

Along with the establishment of the Maecenas Art Sponsorship Award in 1989, a work survey of sponsorship activities was conducted. Sixty-seven

percent of the enterprises surveyed do without media evaluation of their sponsoring activities. Fifty percent of the firms typically sought out customer responses, while 45% completed their surveys through visitor analysis, 31% through questionnaires, and 19% did not analyze their sponsoring activities.

A large number of enterprises are making an effort to increase their sponsorship activities. Due to the belief that sponsoring is an effective marketing instrument, the quality of sponsorship has also increased. Individual firms see that the beneficial development of sponsorship is rapidly rising, in comparison to commercial activity, and wish to support such activities themselves.

Art sponsorship is on the rise and new sponsoring possibilities are being created every day. In light of European integration, sponsoring is becoming a service which can be exported, especially where the use of cultural images is needed. Cultural work calls for flexibility of the involved enterprise and increasing insight regarding the flooding of the commercial markets.

ART SPONSORSHIP IN AUSTRIA

For the celebration of the fifth anniversary of the Maecenas Award, the Austrian Business Committee for the Arts and "Orf" Broadcasting System prepared an exhibition, Five years of Maecenas, which gave a general overview of the active Austrian businesses who are involved in art and culture.

Until just recently the advancement of the arts was the sole responsibility of the state, but today more and more private businesses are providing financial support for the artistic and cultural events. Since 1989 the support from private companies has quadrupled from 100 million schillings in 1993 to a now estimated 400 million schillings. In 1990 51% of the top 500 enterprises in Austria were engaged in art sponsorship. In 1992, for the first time, art sponsorship surpassed sport, environmental, and social sponsorship. These sponsoring statistics and the following case studies thoroughly document the growing interest among Austrian businesses for the use of sponsorship as a marketing and communication instrument and point to the numerous possibilities for successful collaboration between business and the arts.

Softlab is a service business in the computer industry. Its achievements include successful integration of art in the selling process, both in interacting with customers and in deciding how the sponsorship activity will specifically affect the company's goals. Traditional communication has focused on small marketing groups. It was hoped that sponsoring would affect a larger market group. Sponsoring as an element of the communication strategy was tested and was found to be effective in reaching a larger market group. Art sponsorship established itself as useful within diverse areas of the firm (printing values, mailings, etc.). A work grant, which was a new concept, was set up to promote direct contact between workers, customers, and art groups and helped found the Softlab Cultural Partnership. Softlab's goal is to improve the use and integration of art in its own lab in Austria and, with the help of information from its

marketing group and the media, to move away from the technical image of the software industry.

Numerous Austrian enterprises are advancing young artists through making exhibition space available to sell work from contemporary art collections, writing off art prices, and dividing up art contracts to different artists. The Osterreich Saleninen AG promotes young artists through a promotional gallery. Schomer BauMax has a permanent exhibition of contemporary Austrian artists in its administration office and offers artists the possibility of exhibiting their work. The "Erste" Allgemeine Generali advances Austrian contemporary artists through its established collections of Austrian sculptures, which will be housed in its own museum. Romerquelle GmbH has held an art competition for young artists for over 11 years, and the Tiroler Sparkasse Bank AG in Innsbruck has offered a musical sponsorship award for eight years. The "Erste" Osterreich Spar-Casse-Bank is sponsoring the *Fron Mouse War,* a musical piece by Herbert Willi, a composer from Vorarlberg. The Kuner Osterreich Unilever GmbH has contracted students from the School of Applied Arts to design firm logos.

Since 1991 the GiroCredit Bank AG has sponsored the Austrian Gallery. Along with this GiroCredit also offers support through gratuitous services— bookkeeping and public service. For several years Leykam Murztaler has sponsored the Styrian Music Festival, and the Kapsch AG has annually sponsored the Vienna Concert House. For four years Kapsch AG has been the main sponsor of the Vienna Modern Festival. Siemens AG in Austria, through the promotion of the Hayden Concerts at Esterhazy Palace, is an example of the promotion of classical music in the regional area. The Creditanstalt Bankverein, along with its support of the Musical Youth of Austria, is attempting to bring quality music to the young population at an affordable price. The Lower Austrian Danube Festival is sponsored by a list of firms, including Siemens AG Austria, Niederosterreichische Landesund Hypothekenbank Ag, the NO-Landeshuptstadt Planungs GmbH, and the NO-Pressehaus Druck-und Verlags-GmbH.

A company's maintenance and recovery of local art and cultural promotion depends upon its growth level. The Bankhause Berger & Company made possible the restoration of the frescoes in an old rococo room in the firm's building. KallcoProjekt BautragerGmbH looked into the area of restoration of Schlobgasse 13 after an architectural opinion favored preserving the historical structure despite the changing of the function of the Biedermeier house from a living area to a work space. The Raiffeisen Zentralbank Osterreich AG preserved the Rudolf von Alt collection before its sale to a foreigner. Yves Rkocher endeavored to preserve and promote the musical and handicraft heritage of Austria through his sponsorship of the cultural organization Tauriska in the national park region of Hehe Tauern.

Enterprises make important contributions that often lead to the sponsorship of costly and useful technical procedures. These essential contributions supply cultural maintenance and promote new artistic forms of expression. Heukel Austria further developed an Austrian method for the recovery and maintenance of artistic treasures through its chemical knowledge.

Firms spent 4.3 million schillings for the graphic collection of the Albertina and the Austrian National Library. IGM Robotersysteme AG put its knowledge to the test with Artsat, a text-music message inside Austromir, which was sent into outer space. Awarovski created a new type of lighting system for museum display cases that protects the artwork through indirect rays while also providing the best possible illumination.

The past year has shown an increase in the diverse features of the projects put forth by the business world. Shifts in the areas of art, environment, and social sponsorship are occurring. The companies of Galerissimo Art and Design HandelsGmbH and Grundig Austria GmbH introduced an interesting combination of art and environmental sponsorship. The project Art Protects the Rainforest, utilized close to 300 artists and over a thousand paintings for the restoration of the tropical rainforest. Since 1988 AEG Hausgerate GmbH has given away the Environmental Art Award, which urges young artists to attack our industrial society's environmental problems through artistic means. ISI Metallwaren GmbH's project, Cliniclowns, pulls together art and social sponsoring. It involves artists and actors dressing up and visiting children at the Vienna University hospital.

The increase of participating companies in Maecenas, the art-sponsorship award reflects the rapid growth of art sponsorship by Austrian enterprises. Both the number of participating companies and the number of individual projects has tripled since the first Maecenas Award was presented in 1989. In 1989, 42 companies with 51 projects took part in the competition. In 1992, 137 companies with 169 individual projects took part. In 1993, 168 companies submitted 236 projects to be judged. Of the projects submitted for the Maecenas in 1992, 41% came from small- to medium-sized businesses, 40% from the top 500 businesses in Austria, with 14% from the bank sector and another 5% from the insurance sector. The year 1992 started the trend in which the Maecenas entries were not simply from the area of portrait art, but also from the areas of music, representative art, architecture, and literature.

Maecenas celebrated its fifth year in 1993. Maecenas 1993 was presented on October 28, 1993, during a gala night at the Technical Museum in Vienna by the Austrian Business Committee for the Arts (Initiativen Wirtschaft fur Kunst) and the ORF-Austrian Public Broadcasting Company. For the 1993 award, 168 companies entered a total of 236 projects. The winning companies received a valuable glass sculpture created by artist Claus Josef Riedel especially for Maecenas and sponsored by the glass factory Tiroler Glasutte GmbH. Awards were presented in three categories Best First Time Arts Sponsor went to both DHL International GmbH and Kapsch AG for cosponsoring the festival Zeitflub (A Question of Time). The Zeitflub Festival was initiated as an alternative event to the established Salzburg Festival. Recognition awards went to Matthias Essl-Holzbau for the sponsorship of the exhibition Ilya Kabakov—das Boot meines Lebens and IRIS-Leuchten-Bruder Veverka OHG for its project, Light and Design. Best Arts Sponsoring Project went to Wiener Stadtische Allgemeine Versicherungs AG for its overall sponsoring concept and especially for funding

the Austrian film festival Viennale 1993 and for its initiative Cultural Activities for the Young. Recognition awards went to D. Swarovski & Company for the sponsorship of the traveling exhibit Imperial Austria and Osterreichische Beamten-Versicherung for its initiative Childhood and the Arts—Let My Children Hear Music. Best Arts Sponsorship for Preserving the cultural Heritage of Austria went to Osterreichische National bank for sponsoring the initiative Preserving the Old, Shaping the Future—Austria Nostra. Recognition awards went to Josef Manner & Company AG for the restoration of Saint Stephans Cathedral in Vienna and to Salzburger Sparkass Bank AG for the restoration of the Marble Hall at the Mirabell Castle in Salzburg.

GENERAL TRENDS FOR ART SPONSORING

Strategic development, including plans for the sponsoring activity to be integrated with the company's marketing and public-relations concept and to allow the sponsorship program to promote the business's philosophy, should be strongly established. The inefficiency of traditional advertising and increasingly limited advertising methods allow us to investigate new alternatives. Desire to communicate with especially attractive target groups opens up new paths: direct advertising, telephone marketing, individual marketing, and even completely new forms of sponsorship. A reinforcement of the contact made with target groups is necessary. Relatedness to a local identity is suggested at a time of increasing religious zeal and patriotism.

In the new democracies of middle Europe, firms should maintain a low-profile image and wherever possible arrange communication with already receptive groups. To a great extent sponsoring activities are still novel there. The change from a working community to a leisure community is being carried out more and more in middle Europe, and it is expected these countries will experience an increase in organizations and free time. Thus a strong focus on culture will be necessary. Because of the significant changes occurring, the public will expect a project to incorporate a concept of complete social awareness and responsibility, not just an economic solution.

The Role of Foundations in Support of the Arts in Germany

Virginia Glasmacher and
Count Rupert Strachwitz

ABSTRACT

Data are presented on the growth and extent of foundation activity in Germany. Over 7,000 foundations support all nonprofit organizations, with 10% supporting arts and culture—amounting to approximately 100 million DM. Special attention is given to ten of the largest foundations two of which list arts and culture as their priority in funding. Finally, case studies are presented comparing two of the leading national banks, which have different perspectives on support of the arts in Germany.

INTRODUCTION

In contrast to the Anglo-Saxon tradition of private patronage, financing of the arts in Germany has been traditionally perceived to be almost exclusively the responsibility of the state. The roots of this public responsibility for the arts, though in fact never quite as dominant as popularly believed, can be traced back through German history over several hundred years. They have defined the self-perception of cultural agents, government institutions, and policy makers. Only very recently, due to stagnating or shrinking government budgets combined with discussions about privatization in the arts, can there be noted a shift in these traditional perceptions.

The position occupied by foundations in financing the arts must be understood within this context. However, while the financial contribution that foundations make to the arts is rather limited, relatively speaking, their role as independent and flexible agents proves a vital complement to both public (first-sector) and commercial business (second-sector) support to arts organizations and the careers of artists.

PUBLIC SPENDING FOR THE ARTS

Adding together funding of federal, state (*Laender*), and local (*Gemeinden*) governments, public spending for the arts currently figures at approximately 14 billion DM a year. Traditionally, the bulk of this figure, roughly 60%, is taken up by local public bodies (cities and municipalities), followed by the states at 38%, with federal spending for the arts figuring at a mere 2% (Toepler 32). In the years following reunification (1990–1994), the federal expenditure has increased by almost 11 percentage points to 13.2% of total public spending for the arts, as the federal government assumed financial responsibility for East German cultural institutions during this transition period.

As officially defined, public spending for the arts in Germany follows a three-pronged strategy—to secure the upkeep of the common cultural heritage; to aid creative artistic development in society; and to promote participation of citizens in cultural life (Toepler 26). In strong distinction to the U.S. model of selective cultural financing through the NEA/NEH structure, the emphasis in Germany is placed on the maintenance and upkeep of a cultural infrastructure.

Though following individual agendas within the cultural landscape, the different sources of public funding work within this common objective. Thus, for example, both state and local government agencies use the bulk of their funds to upkeep and develop publicly owned and operated institutions such as state theaters, museums, and opera houses. While private organizations and independent cultural initiatives are also eligible for funding from these sources, the emphasis is distinctly in favor of maintaining the status quo of the cultural landscape (Toepler 32–33). Venture capital for the arts is thus scarcely available from government—a significant gap left for nongovernmental funders to fill.

One area in which the realm of public and private sectors overlap in the German arts-funding landscape is that of the public arts foundations. The Kulturstiftung der Laender (Arts Foundation of the German States), for example, was established in 1988 as a way out of the constitutional dilemma prohibiting the establishment of a national arts foundation. Financed in equal proportions by the federal and the state governments, its purpose is the promotion of art and culture of national importance. The recipients of grants are exclusively public cultural institutions, not private and/or commercial organizations, but the foundation does seek to encourage private initiative in the funding of these public arts institutions. Projects are supported by fund-raising brochures, produced by the foundation for distribution by institutions to their potential private funders. This could develop as a potentially interesting structural complement to the traditional public-funding structures, but it has been argued that the foundation's impact to date has been too limited (Toepler 31). The foundation's main task has, in fact, been to fund or co-fund the purchase of works of art, books, manuscripts, etc., of national importance in order to prevent them from leaving the country or to retrieve them from abroad. In this field, the foundation has been reasonably successful.

In addition to the nationwide Kulturstiftung der Laender, most of the individual states set up their own arts foundations in the 1970s and 1980s. The usual motivation behind these so-called Laenderkulturstiftungen was to create arts-funding structures independent of political considerations that would complement the work of government. The scope and influence of these foundations vary significantly, depending on the size of endowment, the regional characteristics of the individual states, and the formulated purpose of the foundation. With an endowment of currently approximately 1 billion DM, the Bayerische Landes-stiftung (Bavarian State Foundation), is by far the wealthiest of the state foundations. It has funded 1,600 projects in the arts, research, and social welfare with roughly 250 million DM since its founding in 1972. In comparison, the Hamburgische Kulturstiftung (Hamburg Art Foundation), founded in 1988, uses the income from its 2.5 million DM endowment to encourage private initiative by offering cultural projects to private patrons and/or sponsors for funding (Toman 10–18).

THE GERMAN PRIVATE FOUNDATION SECTOR

By definition a German foundation is an endowment that serves a specific purpose. In most cases, it will take the legal form of a foundation under civil law thus constituting a distinct legal entity. There are, however, foundations under public law and organizations of a different legal nature that carry the word "Stiftung" (foundation) in their name, i.e., associations and limited companies. Also there exist a large number of endowments that do not constitute a legal person in themselves. They are termed nonautonomous foundations. Usually they have small amounts of liquid assets that serve a specific purpose. They are administered by a trustee. Finally, there are foundations under church law and a very large number of church foundations proper which only act as the legal owners of churches.

Foundations in Germany look back on a long-standing history. The oldest foundations still in existence date back to the tenth century. Despite this 1,000-year history, the importance of the foundation sector as a whole is a late twentieth-century phenomenon. Around 50% of foundations have been set up since 1945. While two existed in the year 900, 17 in 1200, 40 in 1500, and 174 in 1800, it was not until after 1950 that we witnessed an enormous increase in the number of foundations.

The last decade has witnessed a particular period of growth of the foundation sector with close to 30% of all foundations having been established between 1983 and 1994. There currently exist roughly 7,000 foundations in Germany with around 200 new ones being created each year. The total amount of assets which these foundations represent is estimated at 50 billion DM; but this figure must be treated with caution as the absence of public accountability of foundations makes it very difficult to calculate financial information on them with an acceptable degree of accuracy (Anheier and Romo 7). Like some of the other types of foundations, some cultural foundations were created in the Middle

Ages. But generally speaking, cultural foundations are a comparatively recent development.

Around 95% of all foundations are registered charities, the arts being one of the charitable purposes defined by fiscal law. Recognition of a foundation as a registered charity results in complete exemption from taxes on earnings and property as well as from the inheritance tax. A charitable foundation is only taxed for its profits on a commercial undertaking, which is perfectly legal within certain limits.

Table 9.1 lists the total number of foundations in each area of philanthropy and lists the percent of donations for each. A foundation may pursue its aims through its own projects or institutions (an operating foundation) or by giving grants to third parties to work toward the aims of the foundation (a grant-giving foundation). Approximately two-thirds of the German foundations are grant giving, and one-third are operating, as is revealed in table 9.2. This table gives an overview of the relationship between grant-giving and operational foundations in the different areas of foundation activity. As the table shows, foundations in the arts, research, and education are significantly more apt to be grant-giving foundations while in the area of health and politics the ratio of grant-giving to operational foundations is less defined.

FOUNDATIONS FOR THE ARTS

It has been shown that within the foundation community, foundations for the arts are a significant but not the largest subsector. The total figure of 1,066 foundations that actively support the arts at national, state, and local levels does imply, however, that the cultural landscape in Germany would be considerably poorer without the contribution of foundations. Not only does financial support for a wide range of cultural activities stem from the 837 grant-giving foundations, but 328 operating foundations actually assume full responsibility for ownership and/or management of cultural institutions and projects. About 40 German foundations operate museums. The largest and best known of these is the Stiftung Preußischer Kulturbesitz, a foundation under public law that was created by an act of parliament as the legal owner of the art treasures that had belonged to the State of Prussia—made extinct by Allied legislation in 1947. After many years of dispute over the question of who owns these art treasures, the form of a foundation was seen as the ideal solution since a foundation by definition does not have shareholders, proprietors, or members. Practically all the large public museums in Berlin, the former Prussian State Library and even the former Prussian State Archives are now owned and managed by this foundation.

This foundation is, of course, in every way exceptional. Generally a foundation will be in charge of one museum only. Others may give prizes to upcoming young painters or musicians, support archaeological excavations, help protect cultural heritage, give grants to local history projects, etc. Table 9.3

Table 9.1
Area of Support by Foundations*

	Number of Foundations	(%)
Arts/Culture	1,067	10.54
Economics/Consumer	75	0.74
Education	2,066	20.40
Environment/Nature	292	2.88
Family/Corporate	337	3.33
Health	643	6.34
International Affairs	210	2.07
Politics	64	0.64
Religion	330	3.25
Research	1,220	12.04
Social Welfare	3,241	31.98
Other	587	5.79
Total	10,132	100.00

*Foundations listed more than once are active in several areas.

Table 9.2
Type of Support by Foundations

Type of Support	Grant-Giving Foundations	Operational Foundations	Grant-Giving and Operational Foundations
Arts/Culture	648	174	154
Economics/Consumer	51	12	8
Education	1,439	355	205
Environment/Nature	213	32	37
Family/Corporate	264	32	26
Health	354	215	58
International Affairs	137	33	33
Politics	33	12	17
Religion	196	66	49
Research	897	132	143
Social Welfare	2,022	836	277
Other	414	77	70

Table 9.3
Specific Areas of Foundation Support and Their Frequency

Architecture	17
Art, General	320
Book/books/Literature	61
Culture, General	482
Design	5
Film	24
Fine Arts	69
Graphic Arts	21
Libraries	24
Monuments	113
Museums	63
Music, General	117
Opera	16
Orchestra	9
Poetry	9
Sculpture	11
Theater	21
Television	8

gives a few examples of specific areas of foundation support and their frequency as listed in their statutes.

It is interesting to note that of the ten largest German foundations (see table 9.4) only two, namely the Bayerische Landesstiftung and the Alfried-Krupp-von-Bohlen-und-Halbach-Stiftung, have significant programs emphasizing the arts. Of the remaining eight, four list the arts and culture among their aims but not as their top priority.

The Körber-Stiftung is an interesting example of arts patronage. The arts figure as one of several different aims of this foundation. The main emphases of the foundation's extensive programs are international understanding, research, and education. However, when the Deichtorhallen, a famous industrial site in Hamburg was to be converted into an exhibition venue for contemporary art and the project was in danger of collapsing through lack of public funds, the Köber-Stiftung stepped in and provided 25 million DM. The project was thus completed in 11 months, and a contemporary art exhibition space was constructed with the assistance of this foundation.

ART FOUNDATIONS ESTABLISHED BY CORPORATIONS

Although foundations are referred to as "corporate foundations," this is misleading. To avoid confusion, it must be pointed out that there are two main

Table 9.4
Ten Largest German Foundations, Their Assets, and Areas of Support

Rank	Name	Legal Seat	Year of Founding	Areas of Support*	Assets Mio. DM
1	Bertelsmann-Stiftung	Gutersloh	1977	AC,E, H,O,R	5.000
2	Robert-Bosch-Stiftung	Stuttgart	1921	AC,E,H, IU,R,SW	3.571
3	Volkswagen-Stiftung	Hannover	1961	R	3.100
4	Deutsche Bundesstiftung Umwelt	Osnabruck	1990	AC,E,EC, EN,H	2.690
5	Gemeinnutzige Hertie-Stiftung	Frankfurt/M.	1974	E,H,R	1.600
6	Bayerische Landesstiftung	Muchen	1972	AC,SW	1.300
7	Alfried-Krupp-von-Bohlen-und Halbach-Stiftung	Essen	1967	AC,E,H, R	660
8	Korber-Stiftung	Hamburg	1959	AC,E,EN, IU,R,SW	650
9	Carl-Zeiss-Stiftung	Heidenheim/B.	1989	E,R,SW	500
10	Hilfswerk fur behinderte Kinder	Bonn	1972	H	224

*Areas of Support
AC = Arts Culture	E = Education	O = Other
EC = Economics/Consumer	EN = Environment	R = Research
FC = Family/Corporate	H = Health	REL = Religion
IU = Intern'l Affairs	P = Politics	SW = Social Welfare

groups of foundations established by corporations. There are those established by the owner(s) of a (private) company. This is the case with the majority of the large corporate foundations. The term "corporate" is, strictly speaking, misleading as these foundations are in fact the realization of an individual's will—this individual who merely puts the fortune gained as an entrepreneur to a good cause.

The other type, which in fact deserves this term, denotes those foundations that are established by a corporate body as such to serve as part of the corporate communications strategy. This type of foundation is exemplified by a large number of art foundations established by local savings and loan institutions (Sparkassen). These foundations usually have a strong regional or local orientation and typically follow such purposes as the encouragement of local traditions and customs, the caretaking of local heritage, or the support of local artists. Other corporations, too, have established foundations of this type. Two very prominent examples are the Jürgen-Ponto-Stiftung (established in 1977 by Dresdner Bank in Frankfurt) and the Hypo-Kulturstiftung (established in 1983 by Bayerische Hypotheken-und Wechselbank in Munich). Although established by banks, their orientation is different, the founders being two of the largest German banks.

CASE STUDY: THE DRESDNER BANK ARTS FOUNDATIONS

Following the murder of Dresdner Bank executive board member, Jürgen Ponto, by terrorists in 1977, his widow, Ines Ponto, and Dresdner Bank jointly established the Jürgen-Ponto-Stiftung in his memory. The foundation is a poignant example of the particular role that foundations may hold in the support of the arts. The foundation is endowed with capital of roughly 3 million DM and aims to support young artistic talent, in particular young artists who, at the beginning of their career, have not yet received public recognition and financial support from other sources. The foundation seeks to actively identify talented artists in the areas of music, the fine arts, architecture, and literature. Rather than awarding artistic results—such as a young writer's first publication or a musician's first composition—the foundation's program areas are developed to nurture the process of artistic growth.

In the area of music, the foundation has run the program, Schools Perform Music since 1978. School orchestras, choirs, and bands are chosen from throughout Germany for two years to perform over a period of three to four days, called "Bundesbegegnung" (nationwide encounter), which ends in a final joint concert. The particular emphasis of the program is to bring together young musicians from the entire spectrum of educational institutions, ranging from low to high standard. One of the main goals is to foster a music audience from the entire social stratum.

In its brochure, the foundation makes it clear that this program was originally developed to offset the lack of emphasis on musical training and encouragement to young musicians in the public school system. Because of the foundation's success in this area, it has now refocused its support to other areas of the arts.

A further point to be mentioned in this context is Dresdner Bank's response to the historical changes of 1989. Shortly after the fall of the Berlin wall, the bank established a further art foundation, the Kulturstiftung Dresden. Equipped with an endowment of 12 million DM, the foundation is directed at supporting

artistic development in the city of Dresden. The emphasis is again on the identification and encouragement of young artists as well as sparking off new developments in the arts and in research.

With their emphasis on artistic development and exemplary support programs, these foundations reflect the role of foundations as instruments giving new impulses to the development of the arts, as contrasted to public funding, which aims at creating a structural basis for artistic endeavors in Germany.

CASE STUDY: HYPO-KULTURSTIFTUNG

Hypo-Kulturstiftung is an example of a different approach. Established in 1983 with an endowment of 5 million DM, the foundation successfully employs corporate communications concerns to balance inconsistencies in the arts world left by public funding.

The foundation runs two main programs—a cultural heritage award and an acquisition fund for museums. Both programs are distinct from public support in these areas. The cultural heritage award (50,000 DM a year) is awarded only to private owners of heritage sites. This emphasis is based on the assumption that public spending for heritage does not sufficiently encourage private initiative.

The second area of foundation activity is the operation of an exhibition space in the center of Munich. The exhibition hall runs an exhibition program, ranging from Egyptian art to contemporary painting and sculpture, and has received recognition by critics and curators alike as a highly professional exhibition venue. Though not necessarily known for experiments, the foundation, being financially independent, is not primarily concerned with high visitor statistics, and allows for a degree of risk taking (Fey 323–331). A telling example of the suspicion German art critics show toward corporate patronage of the arts is the fact that some critics still neglect to name the exhibition venue—the Kunsthalle der Hypo-Kulturstiftung—when reviewing the exhibitions. While there is no doubt as to the public-relations value the bank receives from the exhibition hall (proclaimed even by the board member responsible), it is nevertheless an exaggeration to perceive the space as solely set up for public-relations purposes.

It is, of course, interesting to note the totally different approach that two national banks, with a comparable turnover and offering practically identical services, assumed when establishing their foundations. The reasons are not only their very different traditions and the very different resources they have to make use of, but also that due to the failure of the general public to recognize a bank by its services, an arts foundation was perceived as a means of creating an individual image. In this context and in actual support for the arts, both cases have proved to be success stories.

ROLE OF ART FOUNDATIONS
AS COMPARED TO OTHER FORMS OF SUPPORT

There are several features that make foundations an indispensable element of the arts-funding scene. Foundations have a quality role to fulfill. Their unique position, arriving from their autonomy, longevity, and flexibility, makes them strong supporters regardless of their limited material possibilities.

Corporate sponsorship (as opposed to patronage) necessarily relates closely to the reward offered by the arts organization in terms of media coverage, other public-relations benefits, or even direct sales promotion. German fiscal law is extremely strict on this point. A foundation, consequently, bases its funding policy solely on the aims put forth in the foundation's statutes. Stemming from this independence, another important feature of any foundation is its flexibility (Loeffelholz 96–99). Public-funding programs are ruled by long-term policy considerations. Once a policy decision is taken, the bureaucratic apparatus renders alterations lengthy and difficult. Foundations are well adjusted to change programs quickly, should the necessity arise. They are suited to promote innovations and develop models that subsequently might live without external aid or be helped by public-funding venues.

Perhaps for more than any other purpose served by foundations this is indispensable for the arts. It is certainly true to say that compared to the tax payers' 14 billion DM subsidy, let alone compared to the approximately 75 billion DM of business turnover in the arts (book sales, theater tickets, etc.), the total grants of foundations (approximately 100 million DM) seem a negligible sum. The operating costs of the arts institutions entertained by the operating foundations do not relieve the government coffers of much of their burden either. Moreover, private support of the arts, through donations and voluntary work, seems at least as important and indeed it is.

But it should not be forgotten that the arts, more than any other field of human activity, have to rely on a sensitive premonition of changes in society as well as on the acceptance of values that can neither be measured by the bottom line nor laid down in laws and regulations. It would seem inconceivable that government bureaucrats and company managers alone could be able to provide a backing for these activities. Neither can the general public, who may legitimately change its mind at the spur of a moment, totally fill the gap.

So, in summing up, it may be stressed that the role of foundations is not to pick up where public institutions leave off in their arts-funding programs. A foundation is fundamentally part of the citizens' private sphere. By transferring assets to a foundation, a private or corporate owner does indeed disclaim ownership to them. But the new owner is still a private and autonomous nongovernmental institution. A foundation is a specific and vital element of a civic society, and it underscores the individual's contribution to public action.

Emerging Corporate Arts Support: Potsdam, Eastern Germany

Völker Kirchberg

ABSTRACT

Potsdam, as the capital of the new federal state of Bradenburg, which surrounds Berlin, is in the process of being restored. The arts, although not quite like in its illustrious past, are making a comeback through public funds granted by Western Germany. Since Potsdam is a significant factor in Greater Berlin's urban growth, most are optimistic of its revitalization. Analysis focuses on three aspects of art revival made possible by corporate funds: restoration of the Sanssouci Estate, restoration of other monuments, and performing-arts events.

INTRODUCTION: THE SIZE OF CORPORATE ARTS SUPPORT IN POTSDAM[1]

The unification of the two Germanies in 1990 presented sociologists with a unique opportunity to observe firsthand the the emergence of corporate culture in a former socialist country. Corporate culture should be described by the extent of social networks in the local business communities between the local arts and the local corporations, and by the degree of partnership between government and business. Due to the existing social networks and the political past, Eastern German entrepreneurs cannot copy the Western German corporate culture. For the same reasons, the investing Western German companies have to adjust their corporate culture to the new environment. Within this context, the size and scope of corporate arts support in the Eastern German communities may be an indicator of the smoothness of establishing a corporate culture that links together business, local government, and the pursuit of local amenities.

The unification had a considerable negative effect on the amount of revenues chaneled to arts institutions in Eastern Germany. There is no longer promise of

comprehensive government support as it existed before unification. Many of the cultural institutions did not survive the change, and the overall mood of the arts managers and producers is pessimistic. According to a representative survey of cultural institutions in 1991 (Stiftung Lesen and Deutscher Kulturrat 1992), 62% of Eastern German arts managers assess the future for their arts as poor when compared to the situation before unification. The state and municipal budgets in the East are not able to boost the attractiveness of cultural institutions to the degree needed to compete with the Western institutions and to sustain the pre-revolutionary level of audience sizes. In 1991, in terms of actual support, local and state governments in the five new states spent only $270 million ($1 = 1.50 DM) on culture and the arts, compared to $5.7 billion in Western Germany (Stiftung Lesen and Deutscher Kulturrat 1992). Arts support is a low-priority item within the public policy framework in Eastern German communities. Factors—like high unemployment (up to 40% of the labor force), rising crime rates, a lack of housing, and the help for asylum-seeking refugees—are considered more urgent.

Business in Western Germany has a tradition of giving to the arts (this corporate art support amounted to about $240 million annually in the early 1990[2] [Hummel, 1992]). Arts facilities in eastern Potsdam, an Eastern German community with a population of 140,000 southwest of Berlin, will be the example for analysis. Potsdam is the capital of the new federal state of Brandenburg, which surrounds Berlin and borders Poland to the east. This city has a long cultural tradition, instigated in the eighteenth century primarily by Frederick the Great, who built the summer retreat of the Prussian king, Sanssouci. Additionally, the city has hundreds of buildings of great historical and artistic value. Most of them need restoration due to more than 50 years of neglect. As the capital of a district of the German Democratic Republic (GDR), Potsdam served as the performing-arts center of the region west of Berlin. A theater for stage plays, a musical stage, a cabaret, a symphony, and, last but not least, the GDR-run movie industry in Babelsberg thrived. This culturally vivid past is now threatened.

This threat is mostly due to the decline of the Eastern German economy, a decline that is caused by a dramatic decrease of public funds. In January 1992 (the time of this survey), the unemployment rate in Potsdam reached 16%. This is very high when compared to Western German communities but low to average when compared to the Eastern German situation. Many Potsdam residents took advantage of the adjacent West Berlin economy that was, in 1992, still able to employ workers from the Berlin fringe communities in Eastern Germany.

Potsdam, the capital of the "Land" (state) of Brandenburg, has been traditionally a town of state employees. Almost 35% of all Potsdam employees work in the state or municipal administration. However, especially in the eastern suburbs of Potsdam which rely heavily on manufacturing, layoffs occurred in a big way. In these areas the unemployment rate rose to 40%. From 1991 to 1992, the number of unemployed people in the industries producing factory goods, e.g., machinery for other industries, increased 813%. The number of

unemployed people in the industries producing consumption goods, e.g., electric household appliances, increased even more—1042%.

It is certain that this sector of the economy will not recover in the coming years. All hope of Potsdam's economic recovery is based on the service sector. According to the Potsdam Economic Development Department, there is a realistic estimate that 12,000 new jobs will open up in this sector by the year 2000, especially in the banking, insurance, and movie industries. The restoration of the traditional German movie studios in Babelsberg (the former UFA and DEFA studios) by a French investor alone will (hopefully) generate more than 3,000 jobs.

To foster this economic change from a secondary- to an advanced-tertiary sector economy, the cultural attractiveness of the city is important. In this instance, Potsdam may be not dependent on Berlin (as it is in other areas of urban development), but Berlin may be dependent on Potsdam because Potsdam has a cultural heritage that Berlin lost in World War II and the era of East German socialism. The arts are a necessary ingredient of a livable city (Kirchberg 1993), and Potsdam's culture is an ingredient of Greater Berlin's vivid urbanism.

Today, other Central European cities like Prague, Krakow, Lodz, and Budapest cope with the same problem of an imminent loss of cultural heritage (due to neglect in the past and a lack of financial funds in the present). This cultural heritage, however, is one of the touchstones for a successful transition toward an advanced-tertiary-sector economy in those "heritage cities." The management of historic preservation and cultural attractiveness in these cities is fighting an onrush of a capitalistic modernism since 1989–1990 that solely has immediate profits in mind. Defending the arts and historic preservation in Central and Eastern European cities is not possible, however, by fighting the private investors; instead, the arts minded must persuade them to invest in and contribute to these urban amenities (Zaziak 1993).

In this study, corporate arts support is defined in a broader way than contracted corporate sponsorship. Contracted corporate arts sponsorship is "an agreement in terms of which a sponsor provides some aid to a beneficiary . . . and thereby derives the benefits contemplated in . . . its promotional strategy" (Abratt et al. 1987, qtd. in Turgeon and Colbert) and is engaged in mostly for advertising purposes. Here, the reported corporate art donations in Potsdam include those by corporate foundations and anonymous corporate giving in addition to contracted arts sponsorship.

The data for this report were gathered by qualitative empirical research; in-depth interviews were conducted with nine local arts managers, 11 corporate leaders, and seven directors of state and municipal agencies between February and June of 1992. Some economic experts were doubtful that there are corporations that already have generated enough profit to support the arts, and have the attitude that corporate responsibility extends beyond the corporation to the community. However, this was clearly the case. In the two years from 1990 to

1992, corporations, corporate foundations, and anonymous corporate executives contributed more than $4 million to the Potsdam cultural institutions.

To assess the impact of the Potsdam local corporate contributions on a national level and make it comparable with another city study, I have temporarily subtracted the anonymous and foundation contributions from the $4 million. I can thereby identify 16 corporations that have spent about $1.2 million for the local arts in Potsdam. This sum is comparable to the amount corporations spend in Western German cities: Hummel (1990) lists 36 corporations in the city of Bremen that contributed $1.3 million to the arts. Because Potsdam is a city with a long historical and cultural past, it is an obvious object for corporate arts support.

In the city of Potsdam, almost all the cultural institutions I interviewed receive major financial support from banks and savings institutions. The second supportive industry is the media (press and movie industry), followed by shipping and airline companies, next construction and car companies, and then electronic and food companies (see table 10.1).

In Potsdam, the arts are predominantly represented by monuments, not by the performing arts. Corporations, corporate-sponsored foundations, and corporate anonymous sponsors gave more than $2.9 million for the restoration of the Sanssouci castle and $800,000 for the restoration of monuments in the city. Companies gave only $330,000 to the local performing arts, and most of the amount ($270,000) was designated for only one event, a classic music festival on the Sanssouci Estate. These statistics indicate a predisposition of the local businesses for the representative, tourist monuments and landmarks, and a neglect of the cultural needs of the local population.

An illustration of this is the example of the major theater, which had played in a converted movie theater for the last 30 years. It had to move out of this humble place recently due to hazardous building conditions, and will continue to perform in another provisional building. It seems unlikely that money will be available to build a new theater within the next 20 years. The musical branch of this theater is threatening to close altogether, and the cabaret has had to put all efforts into a desperate search for private funding after being stripped of all public support in the course of one year.

MOTIVES OF CORPORATE ARTS SUPPORT

Nevertheless, the interviewed corporations seem to be receptive to the plight of the performing-arts institutions. At the same time, most businesses remain firmly committed to sponsoring solely historic preservation. To understand this predisposition, one has to know the underlying motives of these corporations in their support of the local arts. What is behind their funding decisions, even though they know the problems of the performing arts in Potsdam?

According to the American and German literature (Useem 1988; Hummel 1992; Fischer, Bauske, and Conzen 1987), one can distinguish four groups of corporate motives for arts support: social responsibility, image improvement,

Table 10.1
Arts Sponsorship by Industry Class (Potsdam)

		% Distribution by Business Sector				
Banks (%)	Press (%)	Trans (%)	Constr (%)	Auto (%)	Electric (%)	Foods (%)
66	55	44	44	44	38	38

corporate identity improvement, and personal interest of the chief executive officer (CEO). How do these motives rank in the business world of Potsdam?

Overall, the local corporations seek to maintain a low profile in arts sponsorship. In contrast to the American objective of corporate arts sponsorship that can be summarized with the phrase "do well and talk about it," the interviewed German companies favor a way of conveying their support to the public in a more discreet manner. They do not ask for big plaques at restored buildings, nor do they want to be rewarded by renaming a building after the sponsor or an ostentatious display at a performing-arts event (e.g., naming the event after the sponsor or displaying the name of the sponsor on stage). The interviewed corporations would conceive of this as rather pompous and damaging to their reputation as distinguished, but discreet, well-doers. For most, a very small notice on the last page of the program pamphlet is sufficient. However, the objective of disseminating the sponsor's name is still prominent; sponsors do wish to be recognized as responsible corporate citizens in the eyes of the public. In the minds of the corporate executives, a renovated historical landmark in the center of the city conveys this message better and longer than any sponsored one-evening or one-season performance.

As with most corporations in the East and West, Potsdam's corporations are rarely interested in pure nonprofit support. Corporations have donated only about one-eighth of the total local arts support anonymously, i.e., $470,000 out of about $4.0 million.

Almost all interviewed corporations trade on the motive of corporate responsibility for the local community. The Western German companies expanding into the "new territory" particular emphasize this responsibility:

The board of directors and I always strived for reunification. Now, at this moment, we can't lean back and just watch. Everybody has asked to contribute for resolving this serious situation. Our corporation, therefore, has also to rise to the challenge of putting new investments in this place, instead of enlarging our capacities in Hannover or Dortmund in western Germany. By investing here and supporting the local arts we are improving the quality of life for the people here, as we promised.

Not surprisingly, native Eastern German corporate executives are more personally touched by the recognized decline of cultural offerings in their home towns, and, therefore, take it upon themselves to improve their urban culture.

The "good deed" becomes valuable for the corporate business only if it is widely publicized. Publicizing this act of corporate citizenry improves the image of the company. Western German companies particularly are devoted to this goal since they are often regarded as outside intruders in the local community and have to prove their real attachment to the region. Nine out of 11 corporations name the motive of image improvement, and, joined with this motive, direct product advertising. A well-perceived company name triggers a good perception of its brands in the public (see figure 10.1).

Two more motives for donating to the arts are less important in Potsdam than elsewhere. Less than half of the surveyed companies emphasize the personal arts interest of the chairman (or his wife) as a factor for arts support. In general, with the increasing size of a corporation, the influence of the personal inclinations of the CEO vanishes. However, with emerging postindustrial companies, like the real estate and hotel company of an interviewed CEO, this may not be the case:

The main motive is the realization of my self-identity. I like to elevate myself to a more valuable level of living, therefore realizing my value orientation that is still idealistic. Becoming a friend of painters influenced my new understanding of the world and led also to new innovative approaches in my professional work. Since I support these innovative artists I see the world in a different angle. The best advice of my life I have received from them.

Tax-exemption is also not an incentive for corporate charity in Potsdam. This may be due to a lack of information. Of all interviewed, only the Western—none of the Eastern—German corporations in Potsdam are familiar with the complicated tax-exemption law (see Strachwitz 1991, for tax-exemptions under the German tax laws).

The desire to strengthen internal corporate staff relations by corporate arts support may exist in Germany, too, but it is less a reason to support the arts than in the United States. One-third of the companies listed the employees' identification with the company as a motive for corporate arts support. However, an important exception is the growing movie industry in a suburb of Potsdam, Babelsberg, the "Hollywood" of Germany. An executive of a movie company explains why:

Through arts sponsorship I can link the free lancers more closely to our movie company. They always have to be convinced that our company is not just a business venture but still a cultural institution. By supporting the arts we show to these people that we can't betray them and the arts, that we are still interested in the arts, and not only in commercial success.

Figure 10.1
Motives of Corporate Arts Sponsorship in Potsdam, West Germany, and the United States

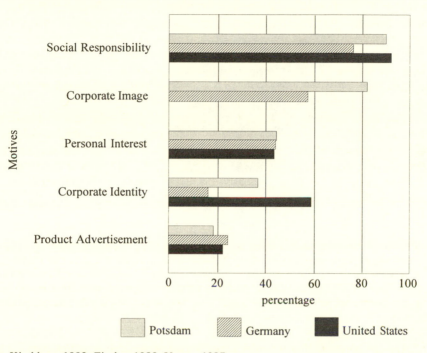

Kirchberg 1992, Fischer 1988, Useem 1987.

An often overlooked but important motive for corporate arts support is based on the corporate desire to be located in an attractive place. According to the interviewed corporations, art and culture are critical for a thriving community and for the local company, too. The image of the place is reflected in the image of the corporation. Indeed, nowadays culture is one of the more important location factors. More than half of the interviewed CEOs consider the state of the local arts scene as an influencing factor for the relocation of a company. The arts have three functions within an attractive urban life: an economic function (i.e., creating jobs), urban development, and a social function (i.e., therapeutic). The majority of the interviewed CEOs in Potsdam know of these functions and regard them as causes for their arts support, as one executive explains:

Seriously taking on a business in this community is strongly related to enhancing the image of the place you are located in. Attractive arts in this community can attract new investments. A boring place, at the opposite, would not lure the educated, highly qualified workers in this town, the workers this city needs in the future to thrive on

competitive industries. Plus, the chairmen of corporations who consider a move won't choose a culturally unattractive location, either.

A commmunity culture program can mitigate anemic behavior presently found in Eastern German cities. Revitalizing a depressed working force is an important corporate location factor, as an executive informs:

By our arts participation programs we reach more and other people than other social work programs can. These are not only the disadvantaged and disturbed young people in the suburbs but also "fortysomething" adults who are very depressed because many of them lost their jobs. This never happened to them before. Activating now their creative sensibility, giving them an artistic pastime, may help them to find their courage back to pursue new ways in living and job searching.

OBSTACLES AND PROBLEMS

The first and main obstacle is the desolate economic situation in Eastern Germany, with up to 40% unemployment in some cities. Eastern German companies have to cope especially with the loss of their markets in Eastern Europe. Nations like Poland, Ukraine, and Russia are not able to pay in hard currency for the goods produced now in this eastern part of Germany. Aggravating this, the original Eastern markets in the former GDR have been taken over by Western German companies. In addition, the manufacturing sector needs—in this period of reconstruction—every mark to buy or improve its machinery; companies are not able to spend money for public-relations tools like arts sponsorship, although they understand the motives for arts support. The local service-sector companies are a bit better off since they do not need to invest as much in new machinery as the factories. Investing in public relations is also critical for them since they are customer oriented, and their customers come mostly from their locality.

A second obstacle for corporate arts sponsorship is the lack of decision-making power among the local companies; formerly Western German companies, now located in Potsdam with a branch, not a headquarters, do not have the authority to decide whether or not to give to the arts. At the headquarters, somewhere in Western Germany, the Potsdam branch has to compete with all other branches for corporate sponsorship funds. Indeed, companies with headquarters in Potsdam or in West Berlin give more than companies only represented with branches in this region.

A third obstacle is the bureaucracy of state and local governments. Two-thirds of the interviewed cultural institutions complain about the inertia, incompetence, and indifference of the government administration that has decisive power over the cooperation between companies and municipal arts institutions. The following is a complaint by a director of a public museum in Potsdam:

I've heard of a potential sponsor for our museum and immediately tried to follow up this rumor, approaching the municipal office of culture. What happened was that nobody was willing to say anything about the potential sponsor: they neither denied nor confirmed it. Nobody was responsible, nobody understood that this information would save public money. Instead, everybody was afraid that this means more work for him or her personally. So, after a while I gave up trying to uncover this potential sponsor.

Apart from the problem of poor administration, a major threshold for the direct corporate support of arts institutions is the budget policy of municipal organizations, plus the principle of cameralism. "Cameralism" means that all revenues and expenses of municipal institutions have to be planned and endorsed by the municipal council during the annual budget debate. Therefore, no corporation can directly support a public institution. This principle can significantly hamper corporate arts support. If a company still wants to comply with the budget rules, the company has to be very patient to see the outcome of its support, until this revenue is granted as a budget item by the city assembly.

A fourth obstacle is based on the lack of commitment many Eastern Germans have to their own cultural heritage. Culture was inexpensive and, therefore, not valued as an important good. The arts were pampered in the old system, and Eastern Germans still expect the same in the new system. A Potsdam manager of a major arts festival complains:

I am an eastern German. And I have to say, even after the 1990 changes the same people are still administering our city. They haven't changed their ignorant, sometimes arrogant attitude toward the public. In addition, cultural supply was never a question of money for us, so people did not pay attention to the financial protection of the arts. Now they should be aware of it but the traditional negligence is still powerful.

To make things worse, German intellectuals—East and West, not only in the arts scene—often revolt against an ostensible dependency on business contributions. The fear of being abused by a "capitalist exploiter" prevails in German arts circles, and so does the notion of being too proud "to beg for money."

The different mentalities, often guided by prejudices against each other, present not necessarily an obstacle but a communication problem between arts and business. This is even more severe if, as in the case of Potsdam, the business world is mostly made up of Western Germans, and the local arts world of Eastern Germans. The gap is considerable: Western German corporate executives complain about immoderate demands and unrealistic expectations of the local arts institutions: "They believe that we, as the major German bank, can easily spend the desired DM100.000. As soon as we tell them that we are only able to give DM5.000, they are disappointed and resent our stinginess."

Eastern German arts managers, on the other side, complain about the sometimes perceptible superior, arrogant behavior of the Western German corporate representatives, and their inability to understand that the Eastern Germans did not grow up in a capitalistic elbow-pushing society:

You have to understand, we people in the ex-GDR are shyer than the people from the west. We grew up in a structure that fostered caution toward the official system on the one side, and that induced supportive behavior in the substructure of niches on the other side. We can't change our social behavior at once. This new legal and economic system is imposed on us without cognizance of our adjustment problems. We need time to learn the new rules and the new laws. In the eyes of some western Germans we seem to be slow, paralyzed, but we just need our time.

Connected to this insecurity is the fear of artists and arts managers of being abused for purely commercial purposes. This is not only due to negative anticipations but also to some already disappointing experiences. Some Western companies attempted to profit from the inexperience of Eastern cultural institutions. A big Western German bank restored a classic inner-city building by Schinkel ("Neue Wache") but only after being guaranteed the right to put its corporate logo and its "corporate color" over the walls of this building. And yet another French cosmetic company wanted to pay for the renovation of the main facade of Sanssouci, but only after being guaranteed that the corporate logo could be reflected on it laser at nights. (Fortunately, they did not succeed.)

Another problem for corporations can actually emerge from the composition of the business community itself. Some companies in the East are already aware of the damaging image of a noncontributor if everybody else in the local business elite or in the same industrial class contributes. This reference group pressure, corroborated by extensive empirical research done by Galaskiewicz et al. (1991) in Minnesota, may also be recognized as one of the main motives for corporate arts support. Without doubt, this is a major incentive for the German saving institutions: 97.2% of these companies support the arts. Under these circumstances, a savings institution would damage its reputation if it did not support the arts (Hummel and Waldkircher 1992).

STRATEGIES TO IMPROVE CORPORATE ARTS SUPPORT

Some of the innovative steps toward a more efficient sponsorship may sound pretty trivial to a professional American fund-raiser. However, Eastern Germany is a frontier land. Approaching the potential sponsor in the right manner is the first step most of the Potsdam arts organizations are struggling with. They do not spend enough time collecting in-depth information about as many companies as possible. Unlike the United States, Germany does not provide detailed books on corporate sponsorship. In the United States, fund-raisers can look through the annual or biannual *Taft Corporate Giving Directory* (Taft 1985, 1989, 1991) or the *ACA Guide to Corporate Art Giving* (Porter 1978, 1980, 1982, 1986). Partly because of this gap in information, only a short list of well-known big corporations are repeatedly asked for money by artists and arts institutions: Daimler-Benz, Lufthansa, BMW, and Siemens are leading this list. Each of these national companies get about 50 applications by arts institutions every day, which result in a corresponding high refusal rate. Siemens, e.g., searches actively for facili-

ties the company wants to support; it does not react to unsolicited applications. Eastern Germany is still a developing country to many firms. The problem is aggravated by insufficient applications. Overwhelmingly, arts institutions send preformulated bulk-mail letters to companies without adjusting each letter to unique corporate structures, or, even better, trying to get in touch with a corporate representative face to face. Only a very few interviewed arts institutions have a more sophisticated way of approaching sponsors, e.g., staging special performances for potential supporters, or including already committed corporate executives in the fund-raising process by letting them speak to their colleagues.

A second step to improve the link between business and the arts, then, is to overcome the cut-throat competition among the Eastern German arts institutions that are quite desperately trying to reach the scarce corporate funds. A lot of energy is wasted in this fight against each other instead of—at least on a local level—launching a coordinated effort. Unified fund-raising is stronger and displays a more serious and efficient image to all sponsors. In addition, the fund-raisers can learn from each other instead of hiding their strategies (Jeffri 1983).

A third step is the institutionalization of the fund-raising efforts. Only two of the interviewed cultural facilities already have a supporting "circle of friends." This fund-raising organization sets a stage for multiplicators, i.e., already supporting corporate executives who solicit their corporate companions for charitable arts contributions. In addition to the efficient stage for fund-raising efforts, the circle with its hierarchical structure of "single members," "contributors," and "favorable benefactors" provides social prestige, an integration in an elite network, and subsequent chances of further professional development for the members (Balfe and Cassilly 1991).

CONCLUSION

Corporate social responsibility is the dominant factor although it is strongly intertwined with the reason to improve the corporate image in an environment that is "conquered territory" for most of the Western German companies. The obstacles and problems of the business and arts relationship are certainly different from those in Western Germany, and also America. The economic situation in eastern Germany, and even more in the rest of Eastern Europe, is serious. Western German corporate executives discuss sponsorship issues with Eastern German artists and arts managers without recognizing the different experiences the former citizens of the GDR have with authorities. Prejudices occur on both sides. The municipal administration is almost paralyzed by indifference and negligence toward the local arts and toward the concept of corporate arts support.

The local arts institutions are eager to receive additional funds from the business world. However, the recent strategies to efficiently raise funds from corporations are not yet well developed. There is still some animosity toward a cooperation with business, partly grounded on their own experience with, or

hear-say stories about, companies who exploit this lack of knowledge for their commercial purposes. These problems may vanish in the future, but today, Eastern Germany is still a frontier land for corporate community relationships.

An efficient trilateral cooperation of the local arts, the local businesses and the public administration will succeed only if these three sectors surrender part of their narrow objectives. The public sector has to give up some of its public power, especially the principle of cameralism. Business has to broaden its objectives and not only be focused on immediate profits. And the arts should become more independent of public funds and be able to overcome still existing prejudices against the business world.

NOTES

1. My research on corporate arts contributions in Eastern Germany has been sponsored by the Berlin-based foundation Neue Kultur. Research is also based on results of a study of corporate arts sponsorship in the United States done by me in 1991, supported by a grant from the German Marshall Fund (#RG 8-90588-03).

2. The amount of $250 million, i.e., about 0.03% of the GNP, is a large sum compared to contributions of corporations in the United States, which gave $410 million to the arts in 1990, i.e., about 0.008% of the GNP (*Non Profit Times* 1991). In 1990 the public sector of the United States (federal, state, local agencies) spent $2.9 billion for the arts, compared to $5.7 billion in Germany.

11

Sponsorship and Patronage in Italy:
Some Regional Cases

Stefano Piperno

ABSTRACT

Historically speaking, the public-private relationship in Italy has been characterized by conflict and mutual diffidence. Legislation has tended to be restrictive, aiming to defend the cultural heritage from private speculation. The administering of relations between public and private financiers became one of the most important aspects of cultural policy in Italy in the 1980s. During these years, sponsorship increased rapidly in Italy, and the most significant form of collaboration took the form of sponsorship-patronage, consisting chiefly of the financing of exhibitions and restoration work.

This chapter presents a general outline of sponsorship and patronage in Italy, and the results of the first survey made in Italy by IRES of Turin, about sponsorship and patronage of companies located in the industrial region of Piedmont. It identifies the main targets of sponsorship involvement, the typical decision processes, the forecasts for the future, the assessment of this kind of activity, and the techniques employed. It occasionally compares to a similar survey on Lombardy. The analysis has implications for regional and national policy.

INTRODUCTION

In the past, the public-private relationship in Italy has exhibited conflict and mutual diffidence. Restrictive legislation has protected the cultural heritage from private speculation. As a result cultural policy has been essentially regulatory in nature, limiting the patrimonial rights of the owners of art treasures and imposing restrictions on their use—and in the case of moveable goods, circulation and exportation—or making certain types of maintenance and restoration work compulsory. As cultural policies increasingly stressed the need for aid for

valorization and fruition, the foundations were laid for supplementary interventions by private financiers along the lines described above, in the form of sponsorship and patronage. The interactions that have since developed between these sectors have undoubtedly rendered the networks and decision-making procedures within the cultural sector more complex: the logics adhered to by different financiers may reveal varying priorities in the choice between conservation and utilization, short-term and long-term financing, financing of ordinary and extraordinary management, and so on.

The administration of this network of relations between public and private financiers was an especially important component of cultural policy in Italy in the 1980s. Sponsorship increased with collaboration in the form of sponsorship-patronage leading the way and consisting chiefly of the financing of exhibitions and restoration work. We can suppose that the aim of business enterprises is invariably image enhancement, so as to provide a return on investment in terms of sale, prestige, etc.; however, but no in-depth analysis has been made of the decision-making processes that lead to specific choices as to which public bodies to sponsor. It is thus impossible to discover whether public bodies or corporations are the most forthcoming with proposals.

Although the economic and social relevance of private, corporate, and foundation support for the arts in Italy has increased since the early 1980s, research and data on the subject are few and far between. This chapter presents the initial results of two recent surveys made by IRES of Turin on corporate sponsorship and patronage in Piedmont, an established industrial region. It seeks to identify the main targets of involvement in sponsorship, and the typical decision-making processes thereof, as well as offering forecasts for the future and assessment of this kind of activity and the techniques employed in it.

The first section of the chapter briefly recalls the main economic aspects of the subject, looking at alternative forms of private financing of the cultural heritage—monuments, groups of sites, museums, including moveable cultural property—(see *Unesco* 1972, 1983) and the performing arts, and briefly outlines the role performed by the private sector in Italy in the last few years.

The second and core section of the chapter describes the results of the IRES survey, of the sponsorship activities the most important companies and foundations in Piedmont in 1991 and 1992. It occasionally compares the findings with the ones obtained in a similar survey carried out in Lombardy. The aim of this comparison is to enhance their significance by a sort of cross-sectional analysis.

The last section concludes with a few remarks on decision making in sponsorship and on the public-private relationship.

A PRELIMINARY FRAMEWORK

Alternative Forms of Private Financing of the Cultural Sector

There are three main alternative forms of private financing, or investment in the arts with a view to selling their services: prices, sponsorship, and

Figure 11.1
Alternative Ways of Private Financing of Cultural Heritage

Subjects	Private Financing*		
	Investment (market prices)	Sponsorship	Patronage
Individuals	1	2	3
For-profit Organizations (Business Corporations)	4	5	6
Nonprofit Institutions	7	8	9

*With or without public grants.

patronage. Likewise, there are three main categories of private financiers of the arts: individuals, business corporations and nonprofit institutions. Through all possible interactions of the two, nine cases that lend themselves to analysis are obtained (see figure 11.1).

Generally speaking, the first column of figure 11.1, investment, is associated with the so-called culture industry, and is economically possible whenever the part of the cultural heritage concerned presents a low degree of "publicness": an example of this might be that of a stately home restructured as a hotel (e.g., the Chateaux chain in France and similar initiatives in other European countries). In this case, we may assume that there are no market failures, nor any need for public intervention for redistributive purposes or considerations of merit.

Sponsorship and patronage are the other two ways of privately financing the conservation, renewal, and enhancement of the cultural heritage. They are apparently extraneous to the normal mechanisms of the market, and some argue that it is wrong to make a distinction between them. "We can never find unknown patrons" is one view offered in an international research study on patronage carried out by the Council of Europe (1987). I believe, on the contrary, that from an analytical point of view, it is useful to keep the two alternatives distinct. Sponsorship is directly related to the economic purposes of the private financier (barring individuals in this case), while patronage has a general public purpose. I do acknowledge, though, that it is extremely difficult to draw the line between the two. Indeed, an increasing amount of literature is being devoted to the economics of donations. It either attempts to provide an economic explanation for the performance of donors in terms of the interdependence of utility functions,

or interprets donations as investments. Such questions, however, go beyond the scope of this chapter.

For the sole purpose of this survey, the sponsorship of the arts includes any kind of funds provided by a body or company to a beneficiary involved in the production of the performing arts and/or the conservation or restoration of visual arts and monuments and artworks in general. This definition clearly fails to include "direct productions" by companies under their own management. For example, the famous FIAT-owned showcase of Palazzo Grassi in Venice falls outside it; even if it had been located in Piedmont, the initiative would have been excluded from the survey. The same applies to the impressive work in progress to turn the former Lingotto factory in Turin (again owned, though not completely, by FIAT) into a multipurpose cultural center.

Although the Palazzo Grassi and Lingotto projects are designed to have a deep-reaching, long-term impact on the arts, they do not qualify as sponsorship under the definition outlined above. Furthermore, private art collections managed by private companies or performances in the context of corporate meetings or conventions are not included in the survey.

May definition is based on the "relational" aspect of sponsorship—i.e., on the passage of resources between "social players" operating in diverse fields or in noncommunicating economic sectors. By way of an example, consider the case of a company which grants a sum of money to launch a cultural body or worker on a project devised by the former or agreed upon jointly. Another example might be the company that makes financial resources available for the restoration of a work of art or a monument by an independent operator. Of the fields that might be affected by grants, the following were taken into account: heritage museums, performing arts, literature, poetry, visual arts, publishing and community arts. Publishing in particular is considered only when moneys are granted to third parties, not when books are published directly by a company as a gift or promotion—a practice widely followed by financial institutions. Grants for educational purposes (such as donations to school libraries, company-sponsored professorships, etc.) were not considered. Contributions under the minimum ceiling level of 5 million lire were also excluded due to the difficulties involved in allocating such small sums to the proper donor and recipient. Finally, contributions in the form of technical or ancillary services such as printing, renting, and so on were overlooked insofar as their monetary value is extremely difficult to estimate.

The Role of the Private Sector in Italy

In Italy the private financiers who can play an effective supplementary role in the public financing of cultural activities are mainly business corporations and nonprofit organizations. Here, the private individuals who engage heavily in forms of patronage almost always operate in the context of nonprofit organizations, usually foundations. Historically speaking, the public-private relationship in Italy has been one of conflict and mutual diffidence. Legislation has tended

to be restrictive, seeking to defend the cultural heritage from private speculation. As a result, cultural policy has most often been regulatory, limiting the patrimonial rights of the owners of art treasures, imposing restrictions on their use, and in the case of moveable property, controlling circulation and exportation, or making certain types of maintenance and restoration work compulsory. The basic normative law (Law no. 1089/39) identified a sphere of conflict between public and private interests that had to be regulated by a set of official deeds (notifications, licenses, and rights of pre-emption, etc.). Its aim was mainly to protect and preserve the cultural heritage as a production resource. Later, the celebrated definition of "cultural deposit" was coined. Albeit a touch far-fetched, the affinity it draws between cultural heritage and fields of natural resources is most effective. The interactions which have since developed between these public and private sectors have undoubtedly made networks and decision-making procedures within the cultural sector more complex. The logics adhered to by different financiers may reveal varying priorities in the choice between conservation and utilization, short-term and long-term financing, financing of ordinary and extraordinary management, and so on. The administering of this network of relations between public and private financiers became one of the most important aspects of cultural policy in Italy in the 1980s. Thanks to these new forms of cooperation and "the marriage of industry and culture" (Industrial Association 1988), some observers compare the eighties to a sort of latter-day Renaissance. Although there are, alas, no precise data on the private financing of the cultural sector in Italy, the Council of Europe has estimated the figure for 1986 at 530 million ecus, the equivalent of about 660 billion lire, the highest for any country in Europe. More realistic assessments for the same year (Brosio 1989) put the figure at about 200 billion lire. Other estimates (Bodo 1989) are even lower: they calculate the figure at 130 billion lire in 1985 against 40 billion lire in the United Kingdom and 70 billion lire in France.

The 1980s were thus years in which sponsorship increased rapidly in Italy, and the most significant forms of collaboration took the form of sponsorship-patronage, consisting chiefly of the financing of exhibitions and restoration work. Such initiatives were further encouraged by special legislation envisaging tax benefits for donations and sponsorship. For example, Law no. 512 of 1982 and subsequent modifications thereof permit the subtraction from assessable income of the liberal allocation of cash sums for the purchase, maintenance, protection, and restoration of art treasures for public bodies and institutions, foundations, and legally recognized nonprofit associations. The few empiric studies available on the Italian situation (Ministry of Culture and the Environment 1989) have stressed the extent to which firms tend to manage sponsorship directly. The sole exception to the rule is that of banks, which are often compelled for statutory reasons to devolve a certain share of their yearly profits to charities or cultural institutions. Likewise, the aim of business enterprises is invariably image enhancement as a means of obtaining a return on investment in terms of sale, prestige, etc. As to the initiatives carried forward by pools of business corporations, no univocal tendencies are evident. Nor has any in-depth analysis

been made of the decision-making processes which lead to specific choices as to which public bodies to sponsor. It is thus impossible to understand whether public bodies or corporations are the most forthcoming with proposals. Authoritative observers (Ministry of Culture and the Environment) have nonetheless noted positive examples of public-private cooperation at a decentralized level, thanks to the initiatives of the Monuments and Fine Arts Offices and local bodies.

THE RESULTS OF THE SURVEYS

The first survey was carried out in Piedmont in 1992 to collect information only about single interventions by firms in the course of 1991. In 1993 another was made through a questionnaire structured to collect not only quantitative data about the extent of sponsorship in 1992, but also information about the economic status of the various firms, whether they have internal structures to deal specifically with sponsorships, their targets and objectives, intervention procedures, and relations with the public administration. An analogous questionnaire was also sent to a sample of firms in Lombardy by the Lombard Regional Authority.

Piedmont and Lombardy rank among the largest and most populous and developed regions in Italy. They boast the highest levels of GNP per capita (figure 11.2), along with Valle d'Aosta (a very small region), Trentino, and Emilia-Romagna. Both regions are among the 20 wealthiest European regions (figure 11.3).

However, while Lombardy has reached a stage of economic growth comparable with that of the most advanced European regions, Piedmont is still mired in a stage which, in terms of regional economics, could be defined as "dematurity," that is to say it is shifting its economic structure from traditional sectors toward new ones, such as telecommunications. This sort of transformation is usually followed by a significant development of the so-called cultural industries (press and publishing, cinema, recording), or industries with a high cultural added value and actual potential for employment (industrial creation, tourism, and leisure). Besides, along with these transformations, Piedmont is likely to witness a growing involvement of companies in sponsorship or patronage of activities related to the domain of learned culture, like written heritage, museums, monuments, visual arts, performing arts. The latter is the subject dealt with in our research, and, as we shall see, the results were quite significant.

The 1991 survey in Piedmont sampled companies using the following criteria:

- Firms that were the leading donors in Piedmont in 1989–1991;
- The most important private partners in cultural projects managed by local authorities in 1991;
- Private operators who have benefited from specific fiscal incentives in 1991 (Law no. 512/1982 and Law no. 555/1982);
- Members of the Consulta Torinese, a group of leading Piedmontese companies which has recently agreed to coordinate some sponsorship activities.

Figure 11.2
GNP Per Capita in Italian Regions, 1989
Index Numbers: Italy = 100

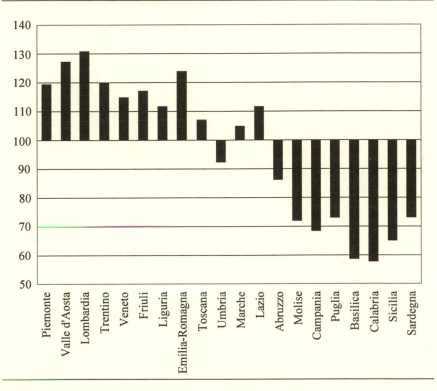

Source: *Istat.*

The above-mentioned criteria brought about the selection of 34 firms and 2 bodies (Turin Chamber of Commerce and the local Employers Association).

SIZE OF SPONSORED EVENTS

The survey singled out 250 events which generated about 32 billion Italian lire. To cover the grants given by companies not included in the sample, a further 10 billion lire should be added: the grand total would then be 42 billion. The adjustment is based on the following inclusions:

• Sponsorships under the 5-million-lire threshold, which, in the case of financial institutions such as banks, represent a constant flow of grants awarded by both head offices or local branches, used with a view to fostering relationships with the customers and the local authorities;

- Sponsorships by companies which did not submit data, but whose size is known because it was publicly advertised or because it can be assessed from the balance sheet of the beneficiaries;
- Sponsorships by firms not included in the survey.

All evaluation criteria adopted were revised with the help of officials in both the public and private sectors. It might also be useful to add that although we have no reliable time-series data to support our estimate, many sources have described 1991 as being one of the "poorer" years in arts sponsorship in Piedmont.

The most striking result of the survey is the discovery that arts sponsorship in Piedmont is concentrated on a limited number of events, each involving a sizeable amount of money. Nine sponsorships generated an outlay of 14,579 million lire, equivalent to 46% of the total 1991 expenditure. A further seven events costing between 500 million and one billion lire accounted for a spending of 4,785 million lire. If we add these two categories together, we have 16 events, each worth over 500 million lire, representing 61.4% of total expenditure and restricted to 12 projects, all but one in the field of art restoration and music.

Figure 11.3
Average Per Capita GNP 1989–90–91 in Purchasing Power Parity,
Piedmont and the Ten Richest European Regions
Index Numbers: European Community = 100

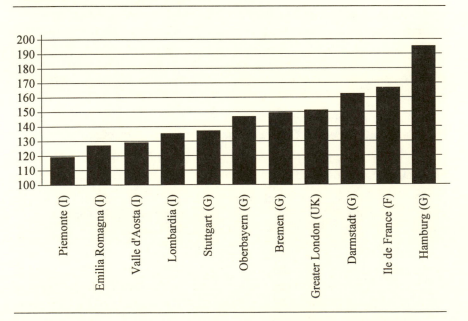

Source: EC, 1994; (I) = Italy, (G) = Germany, (UK) = United Kingdom, (F) = France.

It goes without saying that restoration work in Piedmont requires huge financial resources, owing to the sheer size of the buildings concerned and to their poor state of repair. Conversely, it is not always true that running cultural activities or staging musical or theatrical events require fewer resources: the voracious balance sheets of the Teatro Regio, Teatro Stabile, and RAI Orchestra in Turin provide proof of the fact. If large-scale sponsorship does not always stand for monuments or museum restoration, it is nonetheless true that many factors work in favor of art restoration when a sponsor has to make a choice (for reasons of priority, urgency, relative advantage, impact, prestige, etc.). Although there is wide acknowledgment of the sore financial situation and quality of the performing arts, they still do not seem to attract the support they deserve.

It would be misleading, though, to draw the conclusion that, for built-in reasons, sponsorship of restoration work usually involves large grants, whereas that in the field of performing arts requires limited resources. There are, in fact, many small projects in the former field that focus on a single painting, fresco, or altarpiece and depend on small donations.

Activities in the performing arts tend to concentrate on large-scale events that take up most of the outlay in the sector. forty classical music events absorbed 3,460 million lire, almost entirely to cover costs. In this instance, the flow of expenditure benefitted a few large-scale events: 58% went to one single production, 13.3% to three more, and the remaining 28.7% to 36 performances with an average cost of 30 million lire.

In a context such as this, the average cost of all events is not particularly significant. It is more useful to point out that only 16 events in the 500-million-lire-and-over bracket account for more than 60% of overall expenditure, and that 150 events are to be found in the 50-million-lire-and-under bracket. Moreover, the lower bracket borders with the vast, uncharted area of events costing five million lire and under. It thus transpires that a handful of projects gobble up the lion's share of expenditure, while all the rest are small-scale events.

DISTRIBUTION BY SECTOR OF ACTIVITY OF DONORS

The sector of credit and finance is the undisputed leader in the sponsorship field, shouldering 86.5% of outlays—although, in terms of number of companies, it accounts for only 32% of the sample. The picture is made clear in table 11.1, which shows the breakdown of spending by sector.

Figures are significant only for the following sectors: credit and finance, mechanical engineering, and textiles (all the other sectors put together fail to account for 3% of total contributions). This leadership role is further confirmed by the top three positions in the table of big spenders: these are held by banks, which hold down another three positions in the top 10. Outside the province of Turin, the situations show no sign of changing; in Turin local savings banks also play a major role.

Table 11.1
Sponsorship Businesses Sector of Activity, 1991

Sector of Activity	Millions It. Lire	(%)
Mechanical Engineering	2,697	8.5
Textile/Clothing	600	1.9
Food	276	0.9
Publishing	140	0.4
Building	47	0.1
Public Utilities	169	0.5
Credit/Finance	27,432	86.5
Insurance	194	0.6
Other	194	0.6
Total	31,700	100.0

The dominant position held by banks in Piedmont is mirrored in the Italian panorama: it thus marks the most significant difference visible between Italy and the rest of Europe. Two banks in particular have contributed on a regular basis—and with a hefty outlay of financial resources—to the upkeep of Turin's cultural heritage. The Cassa di Risparmio di Torino and the Istituto Bancario San Paolo di Torino are in fact the largest donors. Either directly or through their foundations, they supply 67.6% of total spending. In third place in the large-scale-events field is the Banca Popolare di Novara, which is followed by a throng of smaller savings banks.

Analysis of expenditure by sector reveals the limited contribution made by the metalworking sector. There are many reasons for this; the main one is that our survey excluded the Lingotto project, easily FIAT's largest in Turin. In 1991 Lingotto, a potential venue for sponsorship activities, hosted no major events. Moreover, Fiat's intervention there was of the direct management type, and hence outside the classic sponsorship pattern at the core of our survey.

Another interesting feature is the absence among sample companies of service firms—high-tech, consumer electronics companies, and public utilities. This further stresses the importance of the role played by banks.

SECTORS OF INTERVENTION

The breakdown of events by sectors of intervention reveals a strong concentration of investment around restoration work and aid to museums (table 11.2). Most museum projects also involve the restoration and refurbishing of the buildings housing collections and are, therefore, not significantly different from those expressly targeted for art restoration. It can thus be safely said that these two

Table 11.2
Sponsorship by Art Form

Art Form	Millions It. Lire	(%)
Arts Restoration	16,050	50.6
Museums	4,504	14.2
Classical Music	3,235	10.2
Meetings	1,803	5.7
Drama	1,215	3.8
Opera	1,150	3.6
Exhibitions	856	2.7
Publishing	778	2.4
Other Arts	518	1.6
Folklore	414	1.3
Literature	408	1.3
Archives/Libraries	402	1.3
Pop, Jazz	150	0.5
Ballet	135	0.4
Video	72	0.2
Paintings/Sculptures	10	0.0
Total	31,700	100.0

relatively homogeneous sectors together account for 65% of total expenditure. After art restoration and museums comes classical music receiving about 3.3 billion lire, 50% of which is absorbed by the Istituto Bancario San Paolo-sponsored RAI Orchestra. Conferences, opera, and theater are also located above the one-billion-lire threshold.

Art exhibitions, which are traditionally considered events capable of collecting a great deal of sponsorship, are only in sixth place. Even lower is the group made up of the visual arts, motion pictures, photography, television, painting, and sculpture. The activities of the Castello di Rivoli, a museum of contemporary art, are listed under the heading "Museums." It may be useful to point out that sectors such as motion pictures and photography are underestimated by our listing. This is largely due to the fact that our survey excluded events costing less than 5 million lire, and to other peculiar characteristics of sponsorship (as in the cases of the Turin International Festival of Young Cinema and Torino Fotografia).

In general, sponsors show a marked predilection for investment in the historical and cultural heritage. Donations for the restoration of works of art, museums, classical music, and opera account for 80% of total spending. It seems fair to conclude, therefore, that the current trend in sponsorship is toward conservation of artworks rather than the promotion of contemporary arts.

OPEN QUESTIONS

This preliminary survey did not seek to offer general conclusions. It is capable, however, of offering some provisional observations and of prompting a few international comparisons.

According to our estimate, total sponsorship in Piedmont may be valued at 42 billion lire. There is no comparable and reliable data for Italy, but similar assessments put the figure at 750–800 million FFr for France (Admical) and 360 million DM for West Germany (Institut fur Wirtschaftsforschung) in 1991. In the United Kingdom the 1991 figure was £35 million (ABSA).

Arts sponsorship in Piedmont is equivalent to almost two-thirds of the entire 1988 sponsorship budget in the United Kingdom. It should also be noted that the provision of resources by private donors to cultural activities in Piedmont would be far greater than the figure which can be evinced from our survey, if the following were included: direct production of cultural activities by companies; the acquisition of works of art for private collections; the growing use of cultural services and products in the public-relations activities of companies; and the supply of services and products at a token price to the arts world.

A peculiarity of the private funding of the arts in Piedmont and in Italy, as a whole, is the special emphasis given to restoration work. This is due in no small part to the magnitude of the Italian artistic heritage, but it must also be stressed that such interest by patrons is the result of independent-choice criteria.

Is the current trend moving too fast? Italy is undergoing a very difficult economic transition, and there can be no doubt that, in the years to come, resources will be increasingly in short supply. In fact, the squeeze is already being felt. More structural changes will be brought about by modifications to the legislation of bank activity in Italy: this will affect about 90% of donations in Piedmont.

Another question of interest is whether the sponsorships' current predilection for "conservation" activities might not be ascribed to a lack of communication between sponsors and producers of culture. There is no doubt that Italy, unlike many European countries, has no independent bodies specializing as intermediaries between the business world and arts world. The sheer size of the phenomenon in Italy begs for a better organized, more finely tuned strategy to channel available resources into the selection of projects.

THE 1992 SURVEY IN PIEDMONT AND LOMBARDY

In 1993 a questionnaire was mailed to 114 firms and organizations in Piedmont, of which only 50 responded. Of these, only 23 completed the questionnaire. A more satisfactory response was recorded in Lombardy where 45 questionnaires out of 150 were returned fully completed. We made use of the same criteria used for the choice of the sample in 1991. This result in itself is indicative of the significant differences which exist between the firms which operate in the two regions.

Figure 11.4
Arts Sponsorship 1991 Expenditure
(Billions of Italian Lire at the Current Exchange, December 1991)

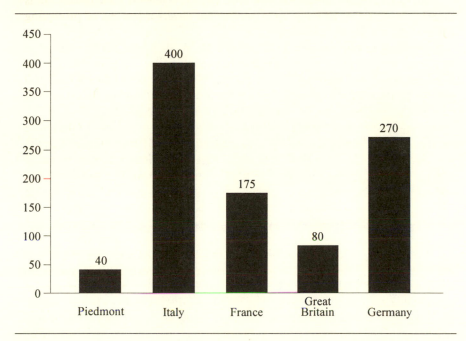

Source: Survey Fitzcarraldo; Estimate Fitzcarraldo; Admical; ABSA; Institut fur Wirtschafts-forschung.

In the case of Piedmont, it is necessary to stress the great difficulties encountered not only in collecting the data and information requested (as a matter of fact, the questionnaire used the previous year was much easier to complete), but also in obtaining a response from the subjects chosen. The principal motives for businesses' refusal to collaborate included situations of economic crisis; involvement in judicial inquiries; and changes in ownership and corporate management.

It is also likely that these situations led to a considerable drop in sponsorship activity.

As we have seen, analysis of the situation in Lombardy proved more satisfactory. The Lombard sample consisted chiefly of large firms. In 32 cases, they showed sales of over 500 billion lire, while only one showed sales of less than 25 billion lire. Here again, the preponderance of large firms was related to the fact that sponsorships are made mainly by firms which have the possibility of investing large amounts of money. Banks, too, confirmed their important role in the promotion of cultural activities.

On the other hand, we must not forget that despite the fact that the ceiling for single sponsorships was fixed at a somewhat low level (5 million lire), it was clearly the most sizeable sponsorships recorded in the preliminary survey. Likewise, the way the survey was structured (i.e., the mailing of questionnaires which required some time to complete) may explain why only companies with specialized personnel—probably the largest—participated.

In Lombardy too firms were reluctant to highlight single interventions and their locations. Only in 20 cases do we have an indication of the total value of sponsorships—38 billion lire in 1992—of which four were certainly located in Lombardy. Unlike Piedmont, Lombardy thus shows a relative fragmentation of interventions into different contexts and typologies.

In general, therefore, it is necessary to consider that the data presented refer to a low number of cases, especially in Piedmont. We believe, however, that the indications which they suggest are sufficiently representative of cultural sponsorship in the two regions.

CORPORATE-INTERVENTION PROCEDURES

The second section of the questionnaire concerns the procedures adopted by firms in their interventions in the cultural field. It analyzes the three fundamental phases of sponsorships: namely, planning, management, and control.

Dealing first with the genesis of sponsorship projects, 62% of respondents in Piedmont operate in the cultural field at the suggestion of external subjects (against 47% in Lombardy). This would appear to suggest that in Piedmont the propensity to develop projects autonomously is relatively low.

Initiatives developed inside companies are promoted mainly by the management—by the chairman, the managing director, the general manager, and so on. Only in a few cases do we note the involvement of peripheral departments. In general, in both regions, forms of interdepartmental interaction seem neither to stem from coherent reference models nor—even less so—from permanent internal working teams or "sponsorship committees" capable of ensuring an effective internal planning and communication process.

When it comes to proposing initiatives and projects, easily the most enterprising external subjects are cultural bodies and workers (associations, theaters, artists, museums, institutions). They are followed by municipal administrations and agencies specializing in sponsorship and cultural communication. Together with museums and monuments and fine arts departments, the same subjects emerge as the preferential partners or firms.

A number of difficulties transpire in the relationships between firms and external subjects. Respondents complain of a certain incongruity between the interventions proposed and strategies of corporate communication (70% of cases in Piedmont and 66% in Lombardy). In general, it is felt that the technical side of the projects is well specified, but there is a lack of information as to the benefits which the company may draw from financing them. At all events, the decision to finance a project is based predominantly on corporate public-relations

and marketing policies. The artistic quality and prestige of initiatives are, together with the reliability of partners, an indispensable reference point for firms. Indeed, in the credit sector, priority is attached to project quality, cost/benefit ratio, and communication and marketing policies, in that order. In general, though, few preliminary surveys and market studies are performed to verify the impact of the intervention *ex ante*.

The intervention management phase appears to be more highly structured in Piedmont. External structures are consulted only rarely (by just a quarter of respondents), whereas in Lombardy 46% of respondents declared that they made use of specialized where communication agencies, albeit "solely for certain purposes." A little over half the firms in Piedmont (against 71% in Lombardy) replied that they support interventions in the cultural field with specific investment in communication—especially in newspaper and periodical advertising and press office activities. Internal communication activities consist of the involvement of employees through invitations to and special conditions for the cultural events sponsored, or of information about the latter in the specialized press. In general, though, "corporate pride" would not appear to be one of the specific objectives pursued by firms in the cultural field. Here we see one of the main significant differences with respect to models of intervention in Britain and America, where internal communication plays an important role in cultural sponsorship.

One of the most important results of the survey regards control activity. This is generally not very widespread and, where it is implemented, only "banal" tools such as analysis of media coverage and audience or attendance data are used. Analogous surveys at a European level (such as the one performed by Arthur Andersen-CEREC in 1993) show that as many as 35% of firms performed market research to evaluate the effectiveness of their interventions.

CORPORATE EXPERIENCE IN CULTURAL SPONSORSHIP AND PATRONAGE

This part of the questionnaire was designed to evaluate the human and financial resources available and the philosophy underlying sponsorship and patronage activities.

The prevalent model is based on an internal structure. Some companies, banks in particular, rely instead on autonomous, albeit related, structures, such as cultural foundations. In such cases, a clear distinction emerges between the role of marketing and communication policies, for which internal structures are responsible, and that of cultural patronage policies, which are entrusted to foundations. In reality, the impression received was that such interventions tend to overlap considerably without a great deal of coordination.

Fifty percent of firms in Piedmont (62.2% in Lombardy) declare that they entrust the responsibility for planning sponsorships to a specific group. The latter is mainly located in the external-relations and/or communication-management area and, to a lesser degree, in the marketing-advertising area,

although company chairmen/general managers always have a big say in the final decision.

Both in Piedmont and in Lombardy, there are few firms which employ personnel specifically for these functions. When they do so, they do not always demand specific qualifications in the cultural field (in 50% of cases in Piedmont and 35% in Lombardy).

Just over half of firms and all banks in Piedmont and 70% of firms in Lombardy declare that they have specifically allocated resources to sponsorships and patronage. These figures are of some importance: the percentage of the communication budget earmarked for these activities increased from 9.10% in 1990 to 13.3% in 1993 in Piedmont, and from 16.8% to 18.8% over the same period in Lombardy. A breakdown of the budgets reveals that the highest share is used for contributions to external subjects (54% in Piedmont and 58% in Lombardy), followed by corporate-management expenses (38% in Piedmont and 25% in Lombardy), and, finally, by communication in support of interventions (8% in Piedmont and 16.7% in Lombardy). Sponsorship activities were considered a useful tool by the majority of respondents (66% in Piedmont and 71% in Lombardy). According to Piedmontese and Lombard firms, interventions in the cultural sphere, as opposed to other communications activities, gain in effectiveness if they are tailored to specific targets.

Interventions seek mainly to improve the town or area in Piedmont in which the firm is located (so-called corporate citizenship), and to enhance its image. Less importance is attached to specific objectives such as the attainment of market goals, attracting new customers, and promoting a product of service. Probably in other countries, sponsorships are better integrated into well-defined marketing policies.

In partial contradiction to the positive signals recorded thus far, there seems to be notable dissatisfaction over evaluating the effectiveness of sponsorships and/or cultural patronage as opposed to other forms of communication/promotion. Evaluation methodologies are effectively at the center of attention and research activities. The majority of firms verify results using unsophisticated tools such as attendance and media-coverage data. In general terms, it seems that firms rely on mere intuitions or sensations about the outcome of sponsorship rather than on proper evaluations.

RELATIONS WITH THE PUBLIC ADMINISTRATION
AND CULTURAL BODIES AND WORKERS

The third section of the questionnaire deals with the relationship between firms, the public administration, and cultural bodies and workers in search of support for their initiatives.

The answers reveal models of interaction which are, in certain respects, contradictory. Only in a negligible number of cases do firms complain that their initiatives are hindered by the public administration, whereas cases in which they declare an absence of contacts with or indifference on the part of public

structures are not infrequent. What does emerge clearly is that it is mainly local administrations (municipal and provincial authorities) who press for interventions. The main obstacles are identified as "the laboriousness of decision making" and "the difficulties involved in planning initiatives jointly." Both in Piedmont and Lombardy, significant difficulties emerge with regard to communication and comprehension of the reciprocal needs of the business world and the public administration, even though the public sector and local bodies in particular are regarded by firms as preferential firms in the cultural realm—first and foremost, in the devising and planning of sponsorships.

Vice versa, firms complain of the poverty of the requests of private cultural workers and bodies, which "tend to overestimate initiatives" and, in any case, fail to submit adequate documentation for the assessment of the benefits of corporate sponsorships.

THE FUTURE

The last part of the questionnaire seeks to assess the prospects of sponsorship/patronage in the two regions. Between 1991 and 1993, there was a drop in sponsorship activities in Piedmont and a certain immobility in Lombardy.

It is relatively easy to trace these trends to the downturn in the economic cycle experienced in Italy from the second half of 1992 (in 1993 the Gross Domestic Product decreased), hitting Piedmont (in the automotive and mechanical-engineering sectors) more than Lombardy.

There is, however, cautious optimism for the future (the survey was completed in winter 1993–1994). In fact 16 out of 21 firms in Piedmont and almost all banks forecast a development in cultural activities—more of sponsorship than of patronage—while 29 out of the 41 firms considered in Lombardy think the same way.

With regard to the activation of services to develop sponsorships, the demand which emerges the most is for the setting up of regional data banks of opportunities in both Piedmont and Lombardy, whereas interest in the setting up of associations of sponsor firms continues to be low. Here we have confirmation of the anomalousness of the Italian experience with respect to other countries, where firms tend to aggregate around poles of coordination such as associations of sponsors/patrons (like ABSA in Britain and Admical in France) for the promotion, regulation, documentation, and monitoring of initiatives.

CONCLUSIONS

Corporate sponsorship and patronage increased notably in Italy in the 1980s, as (and probably more than) in other European countries. This trend has been stressed in international comparative studies (Feist and Hutchinson 1990) that show how the European model of financing cultural activities—centered on the public sector—has shifted toward the American model, traditionally based on the private sector (Schuster 1985).

The development of private financing of cultural activities in Italy may, however, be traced to particular circumstances, such as the high level of corporate profits, the saturation of the advertising market, and the normative constraints of the banking system—which envisage the use of a large part of profits for cultural and social purposes—despite the inadequacy and difficult enforceability of back-up legislation.

Such conditions are not necessarily reproducible in the future. The economic crisis which has adversely affected the profitability of firms in the last few years and legislative modifications to the Italian banking system may hamper the development of sponsorship/patronage activities considerably.

To date, most interventions by firms have been aimed at the restoration and recovery of the artistic and architectural heritage (the data on Piedmont are particularly indicative in this respect). They have tended to take over the role of the public sector, which has seen its intervention shrink gradually on account of the mounting crisis in public finance. For firms, such interventions have represented the least risky choice available. They have often been undertaken for their "spectacularity"; that is, they have offered maximum exposure without the need for long-term strategies or innovative proposals in terms of management models.

On the other hand, cultural bodies and workers have also set out to collect the maximum short-term benefits from sponsoring firms, without constructing permanent models of interaction capable of fostering innovative forms of management and communication with users. These limits, less visible in periods of prosperity, have become only too conspicuous in the present period of economic crisis.

The surveys which we have presented refer to two regions in where the headquarters of some of Italy's most important manufacturing and service companies are based. They thus offer a clear picture of the most recent trends in the phenomenon of cultural sponsorships in Italy. Awareness of the importance of cultural sponsorships as a tool of corporate communication as opposed to other possible options (social or humanitarian commitment, scientific research, etc.) is growing more widespread. This view emerges clearly from the overall satisfaction expressed by the sample interviewed and from its explicit acknowledgment of the utility and effectiveness of investment in the cultural sector. A similar survey in the early 1980s would most certainly have prompted a different evaluation.

The result is an allocation of specific resources to sponsorships. The amount is a sizeable one, when compared with other European countries (albeit with all the caution any comparison of this type demands). Even recently it would appear to have been less adversely affected by the economic crisis and by processes of corporate transformation (takeovers) than might have been reasonably expected, especially in Piedmont, the region where the sectors worst hit (cars, textiles) are most concentrated.

The fundamental objectives of firms in undertaking cultural sponsorship-patronage activities seem to be that of justifying and confirming their social role. They seem more intent upon increasing their links within their local area and

community than supplementing their product-marketing policies. In this respect, such activities represent an extra resource for local development that local administrations would be advised to exploit even further.

Alongside these generally positive trends, problems do emerge with regard to the difficulty of evaluating sponsorship and patronage and, more important still, of communication with cultural bodies and workers and local administrations.

This last point seems extremely important and dense in implications for future policies. The improvement in public-private relations resides not so much in the identification of common objectives (albeit difficult to develop) as in the opening of common ground for the programming and promotion of cultural interventions on the basis of reciprocal recognition of autonomous strategies and objectives. A proposal which might ensue from this study is that of setting up regional agencies for the promotion and development of cultural sponsorship in partnership with the business world and the various economic subjects. Agencies of this kind might perform functions such as:

- monitoring trends in progress in the business world;
- collecting, processing, and distributingon data and information on artistic and cultural activities and projects at the regional level to secure additional private resources; and
- training public and private bodies and workers to improve their skills and qualifications in the field.

In this way it might be possible to create a "market" for cultural activities capable of developing the role of corporate citizenship and making the inflow on private financing more permanent.

Art Patronage Among Banks in Italy

Patrizia Zambianchi

ABSTRACT

This chapter outlines the extent and nature of art patronage among Italian banks. After a review of the nature of sponsorship, several bank collections are highlighted. Although many banks feature artists of their respective regions, most artworks date to the fifteenth century, and have been acquired to prevent private collectors from purchasing them. Many banks donate to the restoration of important works of art, and maintain palaces to exhibit their art, thereby contributing to the cultural heritage of Italy. This chapter also highlights the difference between "sponsorship" as advertisement, and "patronage" as art subsidy.

Within the Italian art market, banks have a prominent role and their presence is ever more widespread and diversified. This role is performed in different ways depending on the various institutes—not all possess collections but their presence in the artistic and cultural field is, in any case, even more considerable.

It is not a new fact that banks often come to fill the gap left by the public sector in the guise of modern princes, as promoters of art and culture. The state allotted only 0.19% of its budget to the artistic heritage in 1990, 437 billion lire was spent for sponsorship of cultural events. Whereas, in 1995 the expenditure should be around 507 billion lire (Benedetti). Available data do not always agree. According to a study by Hill and Knowlton in Italy in 1990, the private sector invested around 300 billion lire for the recovery and preservation of works of art (Rossi).

Moreover, from its inception, banks have held this role; in past centuries a bank was identified with its owner, today the image of the patron has changed to a corporate entity. One banker states that "it is no longer the banker himself who acts but the Bank with its joint teams that promotes the use of its profits in a wide cultural horizon."

In order to render the arts enjoyable to the public, banks have the necessary financial resources to carry out projects of protection, preservation, conservation, and make the most out of the national artistic heritage. For example, recently the restoration of Cimabue's *Maesta,* a valuable spire housed in the Uffizi in Florence, was completed. The cost, 350 million lire, was made available by the Banca Toscana, which is often involved in this kind of project (Lattes). Banks are present both as sponsors of exhibitions, restorations, and protection or preservation projects, viewing sponsorship as an investment in terms of image, and as neo-patrons, since they allocate shares of income already earned for cultural and artistic purposes.[1] Moreover, they are concerned with studies, research of documents, cataloging and publishing activities.[2]

In reality, the public does not perceive the difference between a presence as sponsor or as patron, since the message that is given is one of a concrete commitment of the bank in favor of "something," be it a show or a restoration, something which all can enjoy, and therefore, the results are, in any case, positive as far as image goes. It is, however, important to keep separate the two concepts, because they represent two realities—each distinct from the other. It is necessary to note that the participations are mostly of a preservationist nature, since it is crucial for banks to have general approval and they, therefore, prefer not to risk their initiatives on support of the "creative movement"—the impact of which is not predictable on public opinion. On the other hand,

the bank, with its joint teams . . . achieves three objectives: 1) A real contribution to the diffusion of knowledge and of culture through publications, sponsorship of initiatives, support and economic aid of shows, exhibitions, competitions, and so on; 2) A promotional presence, in the form of image of "editorial," generally this is very effective for the link that is created between an object of beauty and the logo of the sponsor; 3) and a favorable economic transaction, especially through the acquisition of works of art, and after Law 512 of August 2, 1982, a favorable tax benefit as well. (Bausi)

SPONSORSHIP

Sponsorship is included among normal marketing activities undertaken by companies, and represents a cost from which one expects an economic result. In this case, it is measured in terms of image, of the company's global communication; participation is often without social and cultural responsibilities that is, it is support of art for art's sake.

In the last few years this activity has been strongly revalued, allowing the development of active sponsorship, the direct promotion of cultural activities on the part of the bank, as opposed to passive sponsorship in which the sponsor limits itself to financing the art project. It has been estimated that in 1987, 800 billion lire was spent in Italy for sponsorship, almost half of which was for cultural sponsorship (including exhibitions, restorations and the like).

The Associazione delle Banche Italiane (Association of Italian Banks [ABI]) has estimated the expenditure for cultural sponsorship undertaken in the same

year by all Italian banks at 20 to 30 billion lire (Costantini). From an ABI survey on cultural sponsorship taken in 1986, among all the companies and credit institutions (around 350), with the exception of the almost 700 Casse Rurali ed Artigiane (regional banks), it emerged that of the about 230 billion lire spent for communication activity, 20%, equal to around 46 billion lire, was assigned to sponsorship.

The sector in which banks are most present is that of cultural sponsorship, in which around 90% of the companies are active. Cultural sponsorship is undertaken by all state-controlled banks (public institutions), and by Banche di Interesse Nazionale (BIN). The savings banks and Banche Popolari are in line with the national average while the Aziende di Credito Ordinario (credit institutions) record a sum somewhat below average (Crispi). These differences in levels of support may provide clues to the motives of the different types of banks.

All major companies are active in cultural sponsorship, while only 86.4% of minor ones are involved with art projects:

Within cultural sponsorship seven different fields have been determined: among these, the field in which banks are the most active is publishing (22.7% of activity), followed by projects in the musical field (21.1%). In third position are placed the displays tied to painting and sculpture (19.6%), then one participation on architectural projects and the participation in support of theater activity (13.2%). The remaining 7.3% is divided among "other" and film which represents only 3.1%. (Crispi)

Participation in the publishing field excludes all publishing activity relating to gift volumes, which is included in the general area of public relations. More than half of the credit institutions, 58.1%, publish their own gift volumes.

Separating the data relative to the seven categories of cultural activity, one can see how state-owned banks, public institutions, are most active within publishing and sculpture shows (22.3%), followed by publishing and architectural projects (18.5%). The BIN are active only in four fields—publishing, architecture, music, and painting and sculpture—in which their presence is divided equally. Projects in the field of music lead (28.1%) the sponsorship activity of the Aziende di Credito Ordinario (credit institution), followed closely by publishing (24.7%) and by painting and sculpture (21.3%); the savings banks and Banche Popolari are very close to the national average.

Major banks divide their commitment among projects in favor of architecture, painting and sculpture, and musical shows, each of which represent around 20% of total activity, whereas publishing activity (17.2%) finds itself 5 points beneath the national average. Among big banks, donations to painting and sculpture are in first place and represent 26% of the total. Publishing, architecture, and music are in second place with 21.8%. Small banks prefer to support music (22.5%), followed by publishing (20.3%). This last is, however, in first place (25.6%) among minor banks, with music following (20.3%) (Crispi).

Table 12.1
Art Sponsorship among Banks in Italy

Bank	Restorations	Year	Donations (Bil. Lire)
Istituto San Paolo di Torino	Museo Egizio di Torino	86–90	11
	Basilica di Superga Torino	89–91	6
	Abbazia S. Fruttuoso Genova	88	3,5
	Chiesa SS Martiri Torino	90–91	2
	Palazzo Chitterio Milano	92–93	7
Cariplo	Biblioteca Ambrosiana Milano	90	20
	Palazzo Te di Mantova	90	1,2
	Orto Botanico Brera Milano	91	1,5
	Villa Bozzolo a Varese	91	1,3
	Chiesa S. Andrea della Valle a Roma	90	1,1
Cassa di Risparmio di Torino	Palazzina di Caccia di Stupinigi (Torino)	88–91	7,5
Credito Bergamasco	Convento delle Servite a Bergamo	91	3,5
Banco Ambroveneto	14 paintings by Michelangelo exhibited in museums and churches	88–89	

Cf. *Il borsino delle sponsorizzazioni*, in A. Rossi.

Table 12.1 outlines the sponsorship of several banks, including the amount of expenditures in lire from 1986 to 1991.

NEO-PATRONAGE

The public credit institutes, the savings banks, the Banche Popolari, the regional banks, as well as some commercial credit banks, by statute must allocate a portion of their earnings to social and cultural purposes. The portion of income, estimated at over l66 billion lire, that the savings banks alone have set aside for projects of "public usefulness" have an important place in their planning (Crispi).

The role of patron implies a combined commitment, with responsibilities that have a cultural and environmental impact, as is confirmed by the remarks of a banker in Torino:

The concepts, of sponsorship and patronage, seem to me to be decidedly distinct, in that the basic attitude, the responsibility that one undertakes and the expectation of a return are different, not-withstanding the fact that the borders between one role and the other appear at times blurred. (Franco)

In the literal meaning of the term, the patron is one who helps and protects art and literature.[3] While keeping unchanged the aspect of generosity, this concept has evolved with time. Sums of money are no longer donated to artists so that they can produce their works without financial worries. Interest has moved from the creation to the preservation and safekeeping of the already existing artistic heritage, in order to safeguard it from negligence and from decay, or in order to make the most of it and allow it to be enjoyed by an ever-growing number of people.

To sponsor an initiative it is enough to cover the financial aspect with a commitment over a brief to medium amount of time; to be a patron means to take part in its accomplishment from the planning stages on, with a commitment that can last for a long period of time. Cultural commitment shows its effects in the image that the bank is able to give of itself, both inside and outside the company which improves its relationship with its community. Since services offered by banks are now somewhat homogeneous, the necessity of being identified in a unique way by clients can be accomplished by supporting cultural activities.

The involvement of the banking system is important because public institutions are inadequate and are not able to cope with a deficit situation, and the intervention of third parties—whether they be banks, industries, or others—is nothing less than notable, a sign of a social commitment that must be constant and carefully planned. As one banker states:

For some time there has been a ceaseless proliferation of artistic and cultural initiatives subsidized by the private sector (as especially for sports, but also there was an increase in funds for art and culture). Private patronage can, therefore, given [*sic*] a valid contribution most of all on the financial level; given that the lack of funds represents the crucial point of the difficulties cultural institutions face. (Franco)

Within these operations, in fact, the aspect of planning is often missing. This should be attended to by the public sector in that it is the administrator of the national artistic heritage, and therefore, in theory, able to commit to permanent observation of the heritage itself. Many enterprises remain, in fact, isolated, not included in the environmental context, without that coordination which could render them more organized and structured.[4]

It is necessary, therefore, to find a solution which would allow the private sector, be it banks or industry, to maintain its decision-making autonomy. At the same time the solution should orient the operations toward less sporadic initiatives in the attempt to make private interests compatible with those of the community, and to avoid random actions which risk appearing sterile rather than damaging.[5] In this way a double advantage would be attained: a greater guarantee of achieving a positive and defining image for the company that finances the operation, and the attainment of a more complete and appreciable result in the cultural concept.[6]

THE ART OF COLLECTING

Banks are present in the field of culture just as they are also collectors; their presence is significant because they are in a somewhat different position from that of the private patron or the state. Their efforts are destined to be admired by a very restricted number of people, and like artworks in private collections, they are not admired by the museum community. Banks buy paintings of moderate value to decorate their offices, and of great value for reasons of prestige (they are displayed in the offices of their highest officials) and of social and cultural interest. Often these acquisitions have the aim of safeguarding local artistic heritage.

The Casse di Risparmio and the Monti, closely following the traditions and realities in which they operate, have developed a greater sensibility toward collecting, allowing the salvaging and consolidation of artistic movements of the past. Some banks have created and manage private museums of noteworthy importance for the historical and artistic value of the works displayed there. The dominant direction followed in the collections is aimed at the preservation and salvage of important local works in order to avoid the acquisition of these works by private collectors and to make them available to the public.

The Banca Nazionale del Lavoro has been following for some years a policy of acquisition of important works of old art, including works of the fifteenth to nineteenth centuries by Lotto, Canaletto, Barocci, Spadarino, and Corot. The Banca Popolare di Milano has a collection of contemporary paintings and sculptures, including 12 Sironi and 12 Lilloni; others are by Marino Marini, Tosi, Picasso, and Pomodoro.

The Bank of Risparmio of the Province of Lombardy Cariplo has an interesting collection of nineteenth-century paintings, mostly by Lombard painters, including Induno, Bianca, Irolli, Fragiacomo, Milesi, and Morbelli. The Bank of Risparmio e Depositi di Prato has an appropriate gallery in the Palazzo degli Alberti in Prato dedicated to the paintings of the Tuscan school of the seventeenth century, which has been open to the public since 1983.[7] The Banca Toscana has put together a collection of modern art.

The Monte dei Paschi di Siena owns a picture gallery dedicated to the Sienese school in its headquarters at Palazzo Salimbeni in Siena. It has a collection of paintings, sculptures and applied arts of the Sienese school from the twelfth to the nineteenth centuries, at the Palazzo Chigi-Saracini.

Since 1982, the Cassa di Risparmio di Pisa has collected works of old art carried out in Pisa by Pisan artists or by painters who were in some way tied to the city. The Banco di Sicilia owns the restored Villa Zito, a mansion of the late eighteenth century in Palermo, which is open to the public and contains the offices of the Ignazio Mormino Foundation, with its stamp collection of 905 pieces, including a few unique examples which date back to the period of the Kingdom of the Two Sicilies. It also houses an archaeological museum that is made up of 4,750 pieces, a collection of maiolica, a coin collection, a collection

of antique prints, and a collection of around 800 paintings by Sicilian painters of the nineteenth century.

The Banco di Napoli is putting together a valuable collection of paintings of the seventeenth and eighteenth centuries by Neapolitan artists (Licata, Romeo, etc.). The Banco di S. Geminiano e S. Prospero has a collection of paintings, particularly from Emilia in the seventeenth and eighteenth centuries. The Banco Cattolica del Veneto, now called the Banco Ambrosiano Veneto, has a permanent collection in Vicenza, displayed in the Palazzo Leoni-Montanari open to the public, which numbers 14 paintings by Longhi and his school.

The Cassa di Risparmio of Genova e Imperia owns a collection of works by the great master of the Genovese school that go from the sixteenth to the nineteenth centuries, and of great foreign masters that worked in Liguria, especially in Genoa. The Credito Fondiario delle Venezie collects paintings from Veneto and Verona, especially ones from the fourteenth to the eighteenth centuries, and these are displayed in the restored Palazzo Pellegrini in Verona, which has been enriched by period furniture and decor.

These are only the most known examples of art collections not open to the public and very rarely publicized; the acquisition of works of art by banks and the total sum spent annually for such acquisitions are not made public. In the budget, costs undertaken are listed under the heading "furniture and decor" and therefore singling them out is impossible. It is, however, possible to summarize some common traits that characterize the picture galleries of banks.

Generally collections arise from search for a territorial identity. Collecting works by artists of the area in which the headquarters of the bank is located, or to which it is somehow tied, appears common. This is a way of deepening the relationship with the area in which the bank has its seat, accomplishes historical research that goes beyond the simple requirement of decorating, and acts to adorn or embellish offices. In the decorating of branch offices and agencies, works by artists of the nineteenth and twentieth centuries are almost always chosen, modern and contemporary works tied to the geographic area of which these works are representative. Works bought for such an end usually have a lesser market value when compared to those that make up the real core of the collection, even though they may be significant and of a good artistic level.

Thanks to the different needs to be satisfied, banks contribute in a considerable and continuing way to the art market. Their presence in this market does not contribute, as has been implied by many, to an unjustified rise in value.

The act of acquisition of a work of art is the final phase of a series of analyses and assessments, both qualitative and quantitative, of the work, its condition, and the value that can be ascribed to it. Also, the offer of acquisition, especially when made at an auction, is tied to a maximum sum set aside, beyond which the bank's delegate cannot go. The acquisitions themselves are made with the highest degree of discretion, in order to avoid speculations by dealers with few scruples. As far as the most valuable paintings go, a committee of art experts is always consulted. This committee can be permanent or established expressly, in order to assess the economic longevity of the acquisition.

NOTES

Translation from the Italian was done by Anna Squatritti, who resides in New York City.

1. In 1985 the Istituto San Paolo di Torino established the Foundation for Culture, Science and Art (Rampino).

2. From September 3–30, 1987, a show entitled Banks and Art oganized by ABI and ACRI was held in Milan at the Palazzo Bagatti Valsecchi (Frangi).

3. "Bounteous protector of scholars and artists; from the name of the Roman nobleman Gaius Cilnius Maecenas (ca. 69–8 B.C.), protector and friend of Horace and of other Latin poets" (Devoto).

4. This need for coordination of projects was corroborated many times during the conference Banks and Culture, by M. Bardotti, president of the Banca Toscana; U. Baldini, director of the Istituto Centrale del Restauro of Rome; and P. Alazraki, president of Zeli S.P.A. and of William S. Consultant.

5. For a discussion on the conflicts resulting from the different objectives of art restorers and patrons, see James Beck, "Masterpieces and Business," Marco Nardi Press. A.C. Quintavalle (1993).

6. Two proposals were made in 1988 by Confindustria in Rome: to establish a data bank linking art organizations and sponsors; and to establish a foundation that would coordinate projects to be located in Ferrara.

7. Including Caravaggio (1573–1610) *L'Incoronazione di Spine*, Bellini (1426 ca.–1515) *La Crocefessione*, and Lippi (1406 ca.–1469) *Madonna col Bambino à Mezzo-busto in Una Nicchia*.

Art Support as Corporate Responsibility in the Postindustrial City of Rotterdam, The Netherlands

Erik Hitters

ABSTRACT

In many areas of the welfare state, the limitations of government funding are being compensated for by corporate support. The arts in particular seem to offer opportunities to businesses to show their civic responsibility, their urban pride, as well as to obtain specific marketing objectives and advertising possibilities.

This chapter looks into the motives of businesses that contribute to the arts. It questions the idea of civic responsibility and its validity for modern-day business objectives. Especially in the postmodern city, businesses are not expected to be deeply rooted in the community, as their markets are changeable and their production is highly flexible.

The empirical basis of this chapter is a survey of businesses in the metropolitan area of Rotterdam; their contributions to the arts and the city, as well as their motives and objectives, are analyzed.

INTRODUCTION

The participation of companies engaging in the arts is mostly part of a larger program of sponsorship. Consequently for the professional sponsor, the representation or the aesthetic value of the sponsored art is seemingly less important than the effectiveness and efficiency of the sponsored sum. From a commercial objective, sponsoring art can be viewed as an appropriate business decision.

Arts institutions seek private support for the realization of projects or for their general operating expenses, and business is one possible source. In the Netherlands, however, there is hardly a tradition of arts institutions looking for private support, let alone begging for money from business. Art institutions consider that the greatest drawback to business support is the perceived dissimilarity

in objectives between donor and recipient that could pose a threat to the artistic autonomy of the institution. (If, for instance, a firm wants to sponsor an orchestra, it could try to influence the orchestra's choice of program, or even worse, the orchestra could of its own accord make adjustments to its programming to satisfy the sponsor.) All arts institutions agree that their main objective is an artistic objective, and that this may never be obstructed by the wishes of a sponsor, an audience, or a government subsidizer. It remains questionable, however, whether these observed threats from business are based on reality.

The state and local governments are the biggest subsidizers of the arts in the Netherlands. Government spending for the arts amounts to 1.1 billion guilders annually, accounting for 65% of all income for arts institutions. The earned income of art institutions adds up to 30%, and business support takes care of 5%; about 100 million guilders annually (Julien and Rozema 10). Yet government is in crisis and is being confronted with drastic cutbacks. Consequently, the subsidizing of the arts is under pressure as government is pulling back, and the institutions are being given greater authority over their own organization and income. The government puts pressure on the institutions to attract larger audiences, and look for other sources of money. The art organizations, in turn, are forced toward a market orientation: larger audiences, more fund raising, more efficiency, less bureaucracy, and leaner organizations. The business world serves as an example and has been designated as a new partner for the arts in the 1990s.

For local municipalities, which account for the more than half of government subsidization, this poses a dilemma. They are forced to cut back their expenses, and therefore they scrutinize their expenditures on the arts. At the same time, contemporary cities view the arts as an important factor in inner-city regeneration and development. As most large cities in the Western welfare states are confronted with increasing problems of urban decline, poverty, crime, and unemployment, and at the same time with budget cutbacks and economic recession, government officials and politicians are searching for new ways to approach these problems. One of the solutions is thought to be a renewed civic responsibility, aimed at citizens, but more particularly at the business community. Consequently, in many areas of the welfare state, the decline of government funding is compensated by corporate support.

So corporate support to the arts serves multiple objectives. The arts, in particular, seem to offer opportunities to businesses to show off their civic responsibility, their urban pride. At the same time business can pursue specific marketing objectives and advertising possibilities. For local governments this solves their dilemma as they can diminish their financial involvement in the arts, and at the same time increase the cultural attractiveness of the city as they engage in in a partnership with business.

In sum, it appears that business, art institutions, and local and state governments display a great dissimilarity of goals. Nevertheless, corporate support and sponsorship seems to be able to serve multiple objectives. The problem, however, is that the objectives of business remain hidden. Government policy is well

documented and policy objectives are part of a democratically controlled process of decision making. Arts institutions are public enterprises, with a publicly determined artistic objective. Furthermore, they are meticulously controlled by their largest subsidizer, the government. But the business world is usually secretive about its objectives as well as its organizations and finances. Businesses seem to reflect an image of commerce and economic prosperity, as their major raison d'être is making profit.

This chapter attempts to provide more clarity about the objectives and motivations, the volume and organization, of business support to art and other social causes in Rotterdam. It questions whether modern-day business in the Netherlands is showing signs of corporate responsibility in its policy toward art support. It looks into the motives of large companies that contribute to the arts. It explores the idea of civic responsibility and its validity in modern-day business objectives. Especially in the postindustrial global city, businesses are not expected to be deeply rooted in the community as their markets are changeable and their production is highly flexible and far reaching.

CASE STUDY: ROTTERDAM

The economic base of the city is formed by the port, which is claims to be the world's largest. Rotterdam occupies a very important position in the global urban system, specializing in transport and transport-related activities. However, a process of economic restructuring has led to a marked degree of deindustrialization in Rotterdam. Industry and transportation declined after 1980, and public and producer services are going up. The petrochemical industry is a very important sector in Rotterdam, being the biggest investor in the Rotterdam economy (Kloosterman 1993, ERBO 1993).

Rotterdam (with a population of about 600,000, and a metropolitan area, Rijnmond, of about one million) could be called the most non-Dutch city of the Netherlands. Its impressive skyline, composed of high-rise, mirror-glass buildings, bridges, and still-present cranes, is a result of the bombing of the inner-city in 1940, calling for a total rebuilding of the city center. Transport is very prominent in the Rijnmond area, and it can be characterized as a traditional, labor-intensive sector. The modern service sector is composed of communication, business, financial, and recreational services.

Rotterdam is a typical second city of the nation—the city of workers and the eternal rival of the capital, Amsterdam. The local government of Rotterdam is a very strong advocate of the arts and attempts to make Rotterdam as interesting culturally as the other large cities—The Hague, nearby, and Amsterdam. Compared to these cities, Rotterdam's cultural policy is very active, and is aimed at making the arts an integral part of the urban development since the city believes that the cultural climate can increase the attractiveness of the city for both future business and its citizens.

CORPORATE RESPONSIBILITY AND ART SUPPORT

The nineteenth and the beginning of the twentieth centuries was the heyday of the bourgeois city. The urban economy was booming as a result of the process of industrialization, and the urban community was the center of the society. In this period the cultural life was mainly a private matter, as the government played only a marginal role. Arts institutions were mainly self-supporting, and in small part financially supported by an urban elite. Until the beginning of the twentieth century, performing-arts institutions could support themselves through their income from ticket sales. Later, the financial pressure forced them to rely more and more on the support of the local elites, who were their main audience. It was this elite of wealthy and influential citizens and industrialists who successfully demanded support from the local governments (Hitters 1992).

From World War II onward, Dutch society was rebuilt as a welfare state. It was a period of continued economic growth and increasing prosperity. The extended support to the arts and its institutions could easily be fitted into the ideology of the welfare state. The interdependence between the art world and government grew tighter, and the private patronage diminished rapidly. The welfare state took care of a wide range of human needs—unemployment compensation, poverty aid, housing, social services, cultural facilities, etc. Business no longer felt inclined, or responsible, to provide for these matters.

The rise of the welfare state makes the Dutch institutional framework for corporate responsibility very different from that of the United States. A significant difference can be found in the financial base of a city's administration. In the Netherlands, a city is only responsible for an average of 12% of its own income from taxes. The state provides a fixed amount that is related to the number of inhabitants (28%), and a special subsidy is decided on by the state, and is related to the special needs of certain municipalities. This system is currently being changed to make cities more independent; but it makes clear that Dutch cities are not very dependent, in terms of tax income, on companies that are located within its boundaries. This can have a great impact on the relationship between businesses and the cities in which they are located. For example, tax deductibility of contributions plays no role in the Netherlands. In addition, the dependence on a national-income source results in the virtual absence of the concept of community in the Netherlands, and attempts to increase community awareness in the Netherlands are very seldom successful.

SURVEY RESULTS

A telephone survey was conducted in 1994 among the larger companies in the Rotterdam metropolitan area. In the Rotterdam Chamber of Commerce Directory, 384 companies were registered with more than 99 full-time employees, but only 271 could be used in the survey. One hundred fifty-four (57%) companies responded, forming the basis for this analysis. Six of the largest companies were interviewed personally, giving me the chance to visit the

company and to investigate more deeply the objectives and scope of corporate sponsoring.

Table 13.1 classifies business sector by types of business. Of the 271 companies surveyed, 59% have 100 to 199 employees (category 8), 29% have 200 to 499 employees (category 9), 12% have more than 500 employees (category 10–12).[1] Only 38% of the companies that support the arts have more than one person dealing with sponsorship and contributions who is not a member of a public-relations or marketing department. Sponsorship and contributions seem, however, to have an established place within the organization, as 87% of the companies state that all requests are managed by one person or department.

Forty-two percent of the respondents are sponsors in the cultural field, but 4% have ceased for reasons of economic recession or reorganization. Charity and sponsorship appear to be quite easily cancelled in times of economic setback, and according to one of the respondents, "It is hard to justify to the outside world to keep up the sponsorship of an orchestra while firing employees at the same time." Thirty-eight percent were contributors and sponsors of charitable and social causes, but not culture and arts.

Among the companies that answered positively to the question about whether they supported culture, an additional extensive survey was conducted, including questions about their backgrounds, motives, extent of their support, and the organization of contributions and sponsorship (n=60). Companies that contributed to other areas were asked similar questions in a shorter survey (n=114). All companies were asked to interpret nine statements about the role and responsibility of business toward society, the community, and the arts. In addition all respondents were asked to give certain company characteristics (n=154).

Table 13.1
Arts Support by Business Sector and the
Number of Employees in Rotterdam, The Netherlands

| Sector | Number of Employees (by category) | | | |
	8 (100-199)	9 (200-499)	10–12 (500+)	(%)
Manufacturing	41	14	9	23.6
Chemical, Oil	8	10	3	7.7
Construction	24	10	3	13.7
Wholesale	19	8	—	10.0
Retail/Hotel/Catering	10	4	3	6.3
Transportation	23	10	5	14.0
Producer Services	35	22	10	24.7
Column	160	78	33	271
Totals	59.0%	28.8%	12.2%	100.0%

In most cases, support is in the form of cash, and 54% of companies give less than ƒ25,000 (guilders), and 75% less than ƒ75,000. The average contribution is $3,000 annually. If we look at the characteristics of companies that contribute relatively more to culture, capital-intensive companies usually appear to contribute more than ƒ25,000 annually, and labor-intensive companies usually less that ƒ25,000 annually.

More than half of the companies claim that their budgets for sponsorship and contributions have remained stable over recent years. A quarter of the respondents have cut back their budgets. The expenditures for sponsoring and contributions do not seem to be an established part of a company's strategy. This can be noted by the fact that hardly any of the companies have a special budget set aside for contributions to the arts. For some companies there are different sources for sponsorship and contributions. For most companies these expenditures are part of the public-relations expenses (52%), the marketing budget (13%), or the advertising budget (10%). In the other cases, these expenditures are part of a special budget of the board of directors (17%) or come from the business expenses (12%). Only one company has a foundation. One could conclude that for most companies sponsoring the arts is a commercial activity.

Sponsoring and contributing to culture do not appear to be equally distributed among the various business sectors. Sponsors of culture are more often petrochemical companies, wholesale companies, or companies in modern services. Companies in industry, construction, retail/hotel/catering and transportation are less likely to sponsor the arts. In the latter sector, only 17% occasionally sponsor culture. In the petrochemical, wholesale, and modern-service sector between 55 and 60% of the companies contribute to culture. If the companies are regrouped as capital-intensive and labor-intensive companies, the labor-intensive companies appear to be sponsors of culture (46%) more often than the capital-intensive ones (39%). The difference is, however, relatively small, and a factor not likely to be of importance in a company's policy to sponsor culture. It appears that firm type contributes to sponsorship.

Sponsorship is equally distributed among consumer-oriented and business-oriented companies. This is remarkable, considering the emphasis of many sponsor-givers and sponsor-seekers upon the market aspects of sponsorship. Very often the factors of customer and geographic orientation are used by arts institutions to attract business contributions. Also remarkable is the fact that business-oriented companies that sponsor culture spend much less money on their contributions than companies that are consumer oriented. Of the business-oriented companies, 27% donate less than ƒ25,000 annually for culture. Among the consumer-oriented companies, 82% contribute more than ƒ25,000 annually.

Over 60% of the companies have a more-or-less permanent display of visual art. The companies range widely in collection size from a few pieces (28%) to a genuine collection (27%). Only 7% of the companies rent their art from an "art library." The same business sectors that sponsor the arts also display art more often, be it from their own collection or rented. Among companies in

petrochemicals, wholesale, and modern services, 80% display art. Art-collecting companies can be characterized as large, capital-intensive, and globally oriented.

COMPANY SIZE

Company size is an important factor for corporate giving to the arts. The larger the number of employees, the more likely a company is to sponsor culture. For example, of the companies with 100 to 200 employees, 40% sponsor the arts; in the companies with 200 to 500 employees, 43% sponsor art. Sponsorship increases to 59% of companies with more than 500 employees. This significance also holds for annual sales. The higher a company's sales, the more likely it is to sponsor the arts. It is clear, therefore, that a company's size, in terms of number of employees and annual income, is a determinant of sponsorship.

EDUCATIONAL LEVEL OF EMPLOYMENT

A decisive factor in corporate giving is the company's educational structure, an indication of the knowledge-intensity of a company. Companies that do not engage in sponsorship or contributions to culture have an average of 49% low-skilled, 34% medium-skilled, and 17% higher-educated employees. Companies that sponsor art have an average of 36% low-skilled, 40% medium-skilled, and 24% higher-educated employees. The educational stratification of a company's employees appears to have an influence on a company's choice to sponsor culture. The fact that those companies with relatively higher-educated employees are sponsors of the arts has been shown, and it appears that sponsoring is a means to reach out to a certain target group, to appeal to a certain lifestyle in which culture and the arts are a significant part.

DECISION MAKING AND MOTIVATIONS FOR SUPPORT

In most cases sponsoring or contributing decisions have to be approved by a senior executive, and 95% of companies stated that the president or chief executive officer (CEO) had a great deal of influence. Only 27% asserted influence by the board of directors, and only 13% by the board of commissioners. Stockholders had some influence in only 8% of the companies. This would underline a certain personal involvement in art support with top executives of a company which does not necessarily have to be shared by the company's general management.

The motivations or justifications that are mentioned by companies for their contributions and sponsorship policy in the cultural field have been grouped in table 13.2. Respondents could mention several motivations. More than 50% of the companies state their sponsorship is justified by marketing, commercial, or public-relations motives, expressing the value of sponsoring and contributing to the arts as an instrument of reaching potential customers. A third of the

Table 13.2
Reasons for Giving to Art and Social Causes

Motivations	Art Sponsorship N = 60	
	(N)	(%)
Personal Commitment	8	13
Corporate Responsibility	9	15
Enhance Brand Recognition	8	13
Enhance Relations	20	33
Marketing/Public Relations	33	55
Community Relations	15	25
Employee Benefits	5	8
Tax Deduction	—	—

companies mention the enhancement of business contacts, customer relations, or connection to a commission. With this specific motivation, companies aim their sponsorship directly at enhancing their relationships with their customers, or satisfying clients. Community relations, local involvement, and goodwill is mentioned by 25% of the companies. The same consideration can be recognized in the companies that state their motivations in terms of civic or corporate responsibility (15%), where society in general benefits from corporate sponsorship. Personal commitment and enthusiasm about arts is mentioned by 13% of the companies. Art support here is mainly a result of a personal interest of a top executive, CEO, or president of the company. Thirteen percent aim at enhancing the corporate or brand recognition. Employee benefits are expected by 8% of the companies. Along similar lines, sponsorship of art projects in educational organizations can be used to attract future employees, to recruit highly skilled employees. None of the companies claim to sponsor the arts for reasons of obtaining a tax deduction or financial investment.

PREFERENCES IN ART FORMS AND STYLE

Most companies are reasonably conservative in their preferences for art styles and art sectors they wish to sponsor. On the other hand, many companies have no specific preferences for certain forms of art. Dutch companies are no exception to the general trend in art sponsorship to support safe and established art forms, such as museums and music. Table 13.3 shows art contributors exhibit varied preferences. Useem (1989) quotes an American Council of the Arts study that showed that among art contributors in the United States, 91% supported museums, 87% supported orchestras, 84% supported theater, and 78% supported dance. Clearly the variance among Dutch art contributors is

Table 13.3
Percent of Art Companies Contributing to the Arts by Art Form and Art Style

	Company Support (%) (N=60)
Art Form	
Music	55
Theater	32
Dance	8
Museums	48
Visual Art	43
Festivals	42
Literature	3
Art Style	
Professional	57
Amateur	28
Cutting Edge	7
Established	52
Young Artists	28
Local Art	52
Large Audience	23
Specific Audience	28

somewhat larger. The same preference can be seen in their answers to the question about art style. Here, the 57% that prefer professional art and the 52% that prefer established art, underline the same trend. The 52% of the companies that support local art indicate that community relations play an important role in art sponsorship. Support for young artists was usually explained by referring to the company's image of being open to innovation and talent. It is notable that 42% of the companies support festivals. This can be explained by the high visibility of festival sponsorship, keeping in mind the mostly commercial motivation for business support to the arts.

In evaluating requests for support, companies place great value on the overall quality of the applicant. Since some companies have become more conscious of the impact of sponsorship, they review the size and type of audience more closely in their grant applications.

CONCLUSION

Art support and sponsorship by Rijnmond companies is very Dutch: careful and thrifty. Four out of ten companies give a model amount of f5,000 annually to culture and arts. Their favorite subjects of sponsorship are music and museums, examples of well-established, professional organizations.

Company size is the first important factor for corporate giving to the arts. The larger the company, in number of employees, the more likely it is to sponsor culture. The second factor is the business sector. Sponsors of culture are more often petrochemical companies, wholesale companies, or companies in modern services. Companies in industry, construction, retail/hotel/catering, and transportation are less likely to sponsor the arts. My regrouping of sectors into capital-intensive and labor-intensive businesses does not seem to have much relevance for art support. However, there is one regrouping that might explain more.

A decisive factor in corporate giving is the company's educational structure, an indication of the knowledge-intensity of a company. The educational stratification of a company's employees appears to have an influence on a company's choice to sponsor culture. The fact that those companies with relatively higher-educated employees are sponsors of the arts is an interesting detail. Apparently paternalistic aspects of educating the workers are no longer significant, as labor intensiveness is not significant. Sponsoring the arts is mainly a means to reach out to a certain target group, to appeal to a certain lifestyle in which culture and the arts play a significant part. A different regrouping of business sectors that would justify my findings would be by knowledge-intensity, or something one might call a post-fordist characteristic. Companies in wholesale, petrochemicals and modern services all have a greater number of higher-educated employees. This is not surprising for the latter two, but wholesale is generally assumed to be more of a traditional fordist sector (Kloosterman 1994). My findings show that this sector may have changed internally, to become a more knowledge-based sector. Wholesale has become strongly automated, dealing with large financial flows and trading of goods in a global market.

In conclusion, looking at the aspects of civic responsibility in art support, it is justified to claim that art support is for the most part, a public-relations-oriented activity, aiming at clear objectives to reach certain markets, and to enhance company relations, and is an instrument for reaching potential customers. A third of the companies mention the enhancement of business contacts, customer relations, connection to a commission, and an improvement of the corporate image.

NOTE

1. This classification is based on the Standard Business Code, which is part of the Chamber of Commerce registration and similar to that of the Chamber of Commerce yearly Rotterdam Business Survey (ERBO) justifying the typical Rotterdam economic structure (see ERBO 1993). A further classification is made in capital-intensive and labor-intensive companies. Labor-intensive companies are in manufacturing, construction, retail, hotel and catering and nonfinancial and consumer services. Capital-intensive companies are in petrochemical, wholesale, transportation, communication, financial, and producer services.

Modern Enterprise and the Arts: Sponsorship as a Meta-Mechanism of Culture in Greece

George Halaris
and George Plios

ABSTRACT

This chapter argues that given the decline of state subsidies to the arts in Greece and an increase in demand, corporations have come to fill the gap in lending major support to the arts. Amounting to over 3 billion drachmas annually, significant contributions are made by foreign tobacco, alcohol, and banking companies. A strong case is made that patronage is closely linked to the foreign companies' expansion into the Greek market with the arts being used to improve their corporate images and advertise their products. In addition, this chapter discusses the theoretical and aesthetic changes in artistic style and culture as a result of changes in patronage.

THE BEGINNINGS OF SPONSORSHIP[1] IN GREECE

The institutionalization of arts sponsorship in Greece and its consequent promotion has been greatly backed by the Association for the Support of Cultural Activities (OMEPO). OMEPO was founded in 1986 by "a group of intellectuals, businessmen and journalists" set "to encourage and enlist private initiative in the service of the cultural needs of the country" (OMEPO's Statute).

Members of OMEPO are the principal companies engaging in arts sponsorship. Membership is expanding and includes 61 companies in 1995 compared to 43 in December 1993. Besides, many other firms, small and large, occasionally engage in sponsorship.

It is impossible at the moment to draw up an exhaustive list detailing the total extent and size of sponsorship in Greece. Spectacular events relating to arts sponsorship (as well as to more commercially oriented "sponsoring activities") usually originate from large and powerful companies. These are often

multinational corporations operating in Greece. At the local-government level, there is a growing tendency toward support of local cultural events (e.g., festivals) with several firms engaging in support.

The phenomenon of arts sponsorship has taken on importance in Greece over the last four years. Three factors have played a major part in the emergence and development of arts sponsorship in Greece. First, there has been a shrinkage—or in the best case, stagnation—of the already very limited state allocation for culture. Subsidies for performing and visual arts, libraries, national heritage, etc. represent a mere 0.3% of the state budget (CEREC 1992). Second, economic demands for artistic and cultural production are increasing (Agrafiotis et al. 1985); and third, businesses are seeking new forms of communication strategies, aiming at both consumers and investors.

The tendency toward disengagement of the state from the production of commodities and services and the reduced significance of "collective consumption" leave a void in the formation process of consumer needs and habits. The enterprise is thus transformed from an economic unit into an integrated economic-cultural institution, with a subsequent transformation of communication strategy.

THE COMPOSITION OF SPONSORS AND OF SPONSORED CULTURAL ACTIVITIES

As a result of the crisis of the state, and of the mounting importance of the private sector in the economic life of the country, private industry has grown, albeit very selectively. Of great significance for the emergence and development of the phenomenon of arts sponsorship in Greece has been companies experiencing such rapid growth. As an example, 11 out of the 61 member companies of OMEPO are banking and insurance companies. The above assertion applies to them to a great extent. The presence of these companies is even more significant with regard to the amount of money invested in art sponsorship. They use art sponsorship in order to consolidate their positions as respectable, uncontested institutions. Further, 11 of OMEPO's member companies belong to the sectors producing "euphoric products" (tobacco, alcoholic drinks and beverages, confectionery, etc.). These companies seek to accompany the consumer, to "capture" him in his leisure, and to develop relations of "companionship" with him in the context of specific lifestyles.

The specific types, or product sectors, of OMEPO companies are listed in table 14.4 and include banking and insurance (11); tobacco, beverage, confectionery, and alcohol (11); food industry (8); daily use items (7); communication and media (6); tourism (4); telecommunications technology (2), etc. In general, light manufacturing and services, which have had economic growth, lead in arts support.

Foreign companies in Greece have played an important part in the development of sponsorship and represent 15 of the 60 member companies of OMEPO. It is remarkable that 1.6 billion out of the 3 billion drachmas of total arts

Table 14.1
OMEPO Companies and Firm Type

Firm Type	Number	(%)
Banks, Insurance	11	18.03
Tobacco, Beverages, Confectionery, and Alcohol	11	18.03
Food Industry	8	13.11
Daily Use Items	7	11.47
Communication and Media	6	9.83
Tourism	4	6.56
Car Trade	2	3.28
Construction	2	3.28
Metal Industries	2	3.28
Music Industry	2	3.28
Telecommunications Technology	2	3.28
Oil Companies	1	1.64
Foundations	1	1.64
Different	2	3.28

sponsorship for Greece in 1992 were allocated by Philip Morris Hellas for the exhibitions From El Greco to Cezanne and The Greek Miracle. The latter was mainly shown in the United States.

In general, tobacco companies are among the first and most important sponsors. This must be seen in the context of a continuous decrease in the consumption of cigarettes—24.5 billion in 1991 compared to 28.5 billion in 1986 (National Statistical Service 1991)—and an increasing qualitative shift toward foreign brands. The sale of imported cigarettes increased from 25.2% during the first seven months of 1993 to 30.5% for the corresponding period of 1994 (Vima 1994). This shift depicts the relative importance of the "Westernized," "individualized," rising middle classes among foreign-brand smokers, as is also shown by the National Statistics Service (NSS) data. Sponsored art activities, both by foreign companies and by Greek companies (trying in their turn to defend their image and part of the market), are to a great extent addressed to these social categories as well as to refurbishing tobacco companies' tarnished prestige.

Saturation in the advertising sector is also an important factor, causing firms to look to sponsorship activities as a means of indirect or even direct publicity. Indicative of the saturation in advertising is that during 1993, the total annual turnover of the sector amounted to 150 billion drs. (0.72% of GDP of 15,000 drs. or $60 per capita). Respectively, the total sponsorship expenditure of firms for 1993 is estimated at 3 billion drs. (or 2% of total expenditure for advertising). This indicates the great potential for further development of arts sponsorship.

In the context of the economic and cultural transformation of the business sector, advertising expenses are very high. This saturation, which is also organically related to message redundancy, pushes toward the integration and transcending of advertising within the frame of a total communication strategy along differentiated directions, and following international patterns.

Complementary to advertising, sponsorship as second-degree indirect advertising (cf., the more commercially oriented "sponsoring" as first-degree indirect advertising) falls within the scope of an active communications strategy. These two forms of publicity appear—from the company's view—as complementary, so that if a distinction is to be made, this should occur between firms which do have an active communications strategy and those which do not. We very often observe the same companies to be active in sports, TV, and radio sponsorship (which we call "sponsoring"). These two kinds of publicity constitute a dynamic form of promotion of the company's image and of its message toward different wide target groups, or toward the same target group, but through different "paths" of the psyche and different needs/values of the target group, as well as in the frame of the different uses of leisure time (Rigaud 1993).

It should be noted that the money spent for commercial sponsoring (TV, sports, etc.) is not included in the aforementioned total advertising figure (150 billion drs.) and is several times more than the amount spent for arts-sponsorship purposes. On the other hand, sponsorship expenses are distributed to various artistic/cultural forms, as listed in table 14.2: music 64%, theater 17%, visual arts 11%, national heritage 7%, and literature 1%.

The companies that seek to enhance their public image as respectable institutions engage the sponsorship of cultural activities, mainly activities of academic art (in addition to the more important direct promotion of their products). This category of enterprises (banks, large tobacco companies, etc., or the various foundations of large corporations—especially in the face of the recent "stigma" characterizing tobacco companies) thus sponsor big concerts or important exhibitions, etc., where recognition is certain, especially if the events are addressed to large target groups (the middle classes). Other enterprises that seek even broader target groups (e.g., insurance companies or some banks with a regional anchoring) orientate their sponsorship activities toward popular mass events of wide resonance—such as those which refer to national heritage, to cultural roots and identity, etc. On the other hand, the more general orientation to music relates to the leading position of music in the artistic cultural life of Greeks, the prestige accompanying the recently founded Athens Concert Hall, and to the proliferation of concerts brought about by the increasing number of private radio stations.

ARTS, SPONSORSHIP AND CULTURAL CHANGE

The aforementioned, information as well as the interviews with representatives of business and other institutions, and the analysis of various arts-sponsorship activities have led us to make several conclusions. The present form

Table 14.2
Sponsorship by Cultural Form

Cultural Form	(%)
Music	64
Theater	17
Visual Arts	11
National Heritage	7
Literature	1

of arts sponsorship in Greece is a combination of patronage and advertising. A newspaper interviewer noted: "Sponsorship offers an excellent vehicle, a field of competition, which is at the same time a real social service. In this sense sponsorship is a form of marketing, while on the other hand it has its roots in public relations" (Georgiadi 1993). And it is indicative that during the latest period, size and mention of a sponsor's name on publicity material for sponsored art activities are more apparent than before.

Besides, insufficient development of symbol commodity in Greece (and of the needs to which it is addressed), as well as its confinement within traditional patterns, makes that sponsorship tend toward advertising. When sponsoring the arts it favors "classical," "reliable" artistic works, rather than innovative artistic creations.

Particular sponsorship activities are directed toward one or the other of the above-mentioned combinations. The end result, as well as the specific sponsored art form, will depend on the kind of commodity or service produced by the sponsor; the current communication strategy of the company; the kind of artistic activity which is sponsored; and the ownership status of the enterprise (personal, incorporated, or publicly held through stocks).

The educational level, preferences, interests, etc., of the owner, the director, or other persons in charge seem important as well. "Decisions with regard to particular sponsorship activities often depend on affects and friendship relations," according to I. Watt, director general of Philip Morris Hellas (Watt 1994). It is also indicative that directors or presidents of important donating companies are personally mentioned in the "List of Benefactors and Donators" of the Athens Concert Hall; most of these companies are at the same time sponsors of its various artistic cultural activities.

Certain attributes can be discerned in the broader cultural paradigm that is supported through sponsorship. The paradigm is more individualistic (referring to the way of life: work, communication, leisure, etc.) when compared to that of the past. This is expressed both in the changed relationship of the public to the works of art and in the cognitive, thematic, symbolic, and value elements of the works supported by sponsorship. This orientation characterizes both sponsors

and the recipient institutions. It is not accidental that the artistic activities which have attracted massive support by sponsors and also large numbers of people revolve around the classical, individualistic, or bourgeois ideal of the past. It is characteristic that the most important (with regard both to money spent and to visitors—600,000 individuals) sponsored art event of 1992 was the exhibition From El Greco to Cezanne. Also, four out of the six cycles of the Athens Concert Hall for 1992–1993 were Helen; Wagner; The Eighteenth Century from Bach to Mozart; and Mozart, Beethoven, Brahms, Chopin, Schubert, Rossini, Verdi, Donizetti, etc. Furthermore, an important part of sponsored activities revolved around themes on classical Greece (Annual Calendar 1992–1993).

Yet, the specific aesthetic features of this individualistic paradigm depend on the artistic cultural transformation of pre-existing collective/societal/communitarian patterns and ways of life in Greece and abroad. In this context, it is understandable that a fifth cycle of the Athens Concert Hall in 1992–1993 was dedicated to modern interpretation of Greek folk music.

Another aspect of the cultural paradigm shows that rather than relating to entirely new artistic creations, artistic patterns rise through activation, redefinition, or reinterpretation of pre-existing works of art from the Greek and the world "repertoire." They refer to the aforementioned individualistic bourgeois ideal (in a new reading of an "aristocratic" type) as well as to the redefinition of national identity in European tones and nuances. In this sense, artistic production supported by sponsorship is, to a great degree, oriented to the past, without being romantic. It is rather the romanticism of the nonromantic, and when referring to modern art, it is a romantic (museumlike) demodernization of the modern. This also explains the particularly important part of music in the whole of sponsored artistic activities.

Both the content of the work of art and the public's relation to it carry another form of "sociality" that is different from the communitarian/affective as well as from the societal/rational one of the past. This new sociality refers to coalitions of individuals related to one another through common, but also antagonistic, interests. This form of sociality, strengthened by sponsorship, is not only establishing itself in the artistic life of Greek society, it is also spreading to other spheres of social life as well. This phenomenon is reflected not only in the cultural pattern corresponding to the work of art but also in the way in which the meaning is produced. The latter is related with "post mass" (deconstructed/differentiated mass) forms of communication between the public and the work of art.

Thus, it is understandable that sponsorship goes together with an "ethical investment" of artistic communication and of social life more generally. "The importance of sponsorship . . . is not just material. It is rather an ethical act," declares the president of Ergo Bank, which was awarded the Grand Prix Lysicrates for art-sponsorship activities (Bibas 1994). Ethical investment takes place in the context of what G. Lipovetsky has named "post-moralist society." According to Lipovetsky, "ethics has become a strategic axis of communication of the enterprise, a public relations constraint and an instrument for the

management of the corporate image. The flourishing of sponsorship is another manifestation of the dynamic rise of 'ethical strategies'" (Lipovetsky 1992). In this frame, sponsorship supports those artistic events which aim at rationalization of the aestheticized behavior toward the world, the works of art, and the conditions of living. This also leads to the suppression of boundaries between "mass" and "high" culture, art and the nonartistic spheres, art and economy, commodity and image, reality and imagination. People are confronted with "dream-images which speak to desires, and aestheticize and de-realize reality" (Featherstone 1982).

Therefore, sponsorship works as a catalyst for a post-ethical lining up, not only of the arts, but also through the arts, of any other form of communication and action. The development of a widely acceptable corporate image, which constitutes its main end, does not refer to the consumer attributes of the commodity but to the sociocultural values of the enterprise. The corresponding communication strategies are rather founded on the enterprise's social function as an integrated microcosm. "Big corporations aim at playing a broader economic, social and cultural role," declares the Philip Morris Hellas advisor (Koutoupis 1993).

In this sense, the enterprise emerges not only as a producer of commodities but also as an instigator of a more accomplished version of the "acceptable" way of life. It appears as a maker of culture, and its products as the means for the attainment of this end (cf., lifestyle). It articulates the symbolic-consumer properties of the separate commodities in a broader cultural pattern—attitudes, behavior, etc.—which must first become lodged in the consciousness of the citizen-consumer. This indicates that what mainly changes in the case of sponsorship are the codes of consumer behavior, which grow stronger.

Sponsorship is addressed to the consciousness of a public deeply in need of socio-symbolic differentiation, previously shaped by mass consumerism. As a consequence, the development of sponsorship activities, as well as their publicizing, presupposes and sustains mass forms of artistic and commodity communication. "Publicity in the media constitutes the best method for measuring the impact of an act of sponsorship . . . in some cases, sponsors evaluate the publicity in broad lines . . . whereas more often, one counts the centimeters of newspapers, columns and the minutes of radio or TV commentary" (Villni and Urbanet 1993).

An orientation toward socio-symbolic differentiation is also the reason for the parallel, more or less intensive, recourse of the enterprise to the practice of more commercial "sponsoring" activities (sports, TV). Sponsorship thus appears as a lever of "post mass artistic and commodity communication." In this way, if sponsorship needs the artistic-communication institutions of the liberal bourgeois past on the one hand, it does presuppose mass communication forms on the other hand. As a result, new, intermediate, more complex institutions of artistic communication are emerging.

In the artistic field, sponsorship strengthens a double and simultaneously controversial process: enhancing the particularity of the sponsored art form;

obscuring boundaries among the various art forms, leading to the formation of a new form of artistic syncretism, or synthesis between art and other forms of culture. For example, in 1992–1993, eight performances in the Athens Concert Hall were a combination of "classical" films and live classical music (Annual Calendar 1992–1993). Again, three out of six cycles during the same period were a combination of concerts or drama, opera, lectures, reading, and symposiums. The same or similar combinations are observed with regard to artistic events bearing on national identity, ancient Greece (e.g., Dimitria), or other contemporary themes.

In turn, this helps to explain some other phenomena which are clearly observed in artistic activities supported by sponsors:

- the recourse to the use of new technologies for the interpretation of "classical" works of art;
- the aesthetic deconstruction as well as the information "loading" and interconnection of works of art, along with a tendency toward a maximum aesthetic investment of the information material;
- and as a consequence of the above, the development of cultural management and of an elaborate information network, which become as important as cultural production itself.

This complex process stands in structural analogy to the form and function of TV flow. Sponsorship thus leads to the "televisualization" without television of an ensemble of pretelevision art forms (music, theater, literature, etc.). We call this phenomenon "extra-television televisualization" of art and culture.

CONCLUSIONS

We can consider that sponsorship strengthens the transition from a strictly aesthetic norm to a complex social function of the work of art (Mukarofsky). This also leads to the formation/elevation in the center of the artistic life of texts and facts lacking a strictly aesthetic function, which, in turn, contribute to the organic merging of life and art. The latter is an essential characteristic of the postmodern (Featherstone 1991). These processes tend to abolish the autonomy of art, attracting the catalytic interference of nonartistic subjects and mechanisms. Indeed, under these conditions, the significance of the art is not located in the work of art itself nor its morphological perfection, but rather in its social function as well as its extensive introduction into social life. Inversely, art witnesses the impetuous invasion of a great and multiform cluster of social relations establishing themselves as a decisive, regulatory factor in the artistic life; the wide socialization of new patterns of aesthetic forms and the broad aesthetic elaboration of new patterns of social relations; and finally, the formation of a new artistic syncretism (Plios 1993).

In the same sense, A. Cauquelin has spoken of the transition from modern art (regime of consumption) to contemporary art (regime of communication). In

the latter, sponsorship is becoming more and more an active ingredient. Communication technologies are a crucial factor, establishing networks as multipolar systems of interconnection, allowing that the "sign takes precedence over the thing. . . . The role of the artist diminishes. . . . Publicity produces meaning. . . . The designation 'this is art' comes from the 'mise an vue' not from the work of art itself" (Cauquelin 1993). In this context, the various professionals organizing/participating in the production/circulation of the works of art, who also "make the information" relative to the artistic production and pass it on to the media, acquire a leading role, "to the point of becoming the real producers."

A characteristic example is that of the exhibition From El Greco to Cezanne. "All media were mobilized, as well as the Ministry of Culture and well-known Greek TV/movie stars to promote the exhibition," declares the director of the National Gallery, stressing at the same time the importance of sponsorship (Lambraki-Plaka 1994). The capital role of the gallery's director herself as the leading professional has been stressed in various occasions.

Sponsorship and sponsors tend to constitute an element of growing significance in the artistic communication system, contributing to a more organic interweaving of culture and economy and, in this light, to a relative simplification/ decrease of the complexity of the aesthetic content. The realm of art merges with society itself and its communication function, in the context of the new, upgraded role of the enterprise—community as a main social "subject"—which takes on the active shaping of its market, "completely transforming the economic and social landscape" (Ramantsoa 1992).

We could conclude that sponsorship becomes a vehicle of promotion, both in the sphere of art and by means of art, of the integrated production—consumption process—which has been called "prosumption." In this process a main role is fulfilled by the new technologies. And this is a more general condition leading to the writing of new "myths."

NOTE

1. By the term "sponsorship" we mean specifically the "arts sponsorship," or "corporate support of the arts." Thus we distinguish "sponsorship" from "sponsoring," which has more commercial functions and is used in sports, TV, or other mass events.

PART IV

Asia and the Pacific

15

Art Audiences and Art Funding: Contemporary Relationships between Art and Business in Australia

Annette Van den Bosch

ABSTRACT

The differences that have emerged in patterns of corporate collecting and sponsorship, and the increased need for private-sector investment in state art galleries in Australia, are the subjects of this chapter. The pattern of relationships between art and business in Australia is different from that of the United States and Europe, and provides a comparative study that may prove useful.

Investment in Australian art began in the 1960s and even today the major corporate collections are distinctive "sixties" collections of contemporary Australian artists. The shifting relationship between private- and public-sector patronage is an important aspect of arts policy and the development of audiences; and a major private collector and arts patron has the capacity to dominate regional arts institutions and establish the reputations of local artists through his capacity to confer both aesthetic and financial value. Two collections are presented which serve as a model for corporate collections: that of the Reserve Bank and that of the chemical company, I.C.I.

INTRODUCTION

Australian corporate collectors buy the art of their own country. This is the major trend in corporate collections worldwide. Any differences can be seen as an effect of a specific social and institutional history. Investment in Australian art began in the 1960s and even today the major corporate collections are "sixties" collections, representing the blue-chip contemporary art market that was formed at that time and its influence on taste. Collections such as those of the Reserve Bank and I.C.I. (a chemical company) provided the model for corporate collections.

The Reserve Bank of Australia (which performs the same functions as the United States Federal Reserve Bank) established the bank's collection in the 1950s and 1960s under its chairman, Dr. H.C. Coombs (Klepac 1992). Dr. Coombs concentrated on the works of emerging Australian artists, found through his own friendships with Australian artists and immigrant gallery directors such as Rudy Komon, who introduced new dealing practices to Australia. The value of the collection increased enormously during the "boom years" until 1975 when economic and political factors restricted acquisitions. During those years, banks that built new skyscraper corporate headquarters in Sydney and Melbourne, such as the National Australia Bank, A.N.Z. Bank, and Westpac, for example, also established corporate collections.

The other significant model for Australian corporate collectors was the I.C.I. collection, also begun in the 1950s, by the chairman, Ken Begg. The I.C.I. collection includes important colonial, modern, and contemporary paintings. The catalog of the collection was recently published under the title, *A Story of Australian Painting* (Eagle and Jones 1994). The collection was begun to complement the first of the glass-tower blocks to be built in Melbourne. Since its opening 35 years ago, the collection has outgrown its headquarters. Works from the collection, which is one of the most significant historical collections in private hands, have been lent to state galleries for exhibitions. The publication of the catalog, which is designed for school and bookshop sales, represents a new commitment to make use of the collection for educational and public purposes. I.C.I. also assembled a contemporary art collection in the 1980s which traveled to regional public galleries throughout Australia. This collection is not regarded as a permanent collection, and obviously does not have the same investment value as the historical collection. It will be dispersed by being gifted to state and university galleries.

Investment is the major purpose of collectors such as the Reserve Bank, I.C.I., B.H.P., and J.G.L. Investments. J.G.L. has the most significant collection of 1940s, 1950s, and 1960s art in private hands. The collections represent an investment in blue-chip Australian painting. Corporate collectors claim to be cultural actors in Australian society, and the collections are used to represent the corporations' role as leading Australian companies. When the J.G.L. Collection was shown at the National Gallery of Victoria in 1984, the exhibition was entitled The Great Decades of Australian Art: Selected Masterpieces from the J.G.L. collection. The foreward by the director, Patrick McCaughey stated: "[The collection] covers the years 1940-1965—those 'canonical years' when modern Australian art came of age, won broad recognition and established an aesthetic and cultural authority which subsequent generations have not displaced" (McCaughey 1984).

The claims made for the collection are not undeserved. The collection was assembled by Julian Stirling, one of the dealers who established the investment market for Australian art. Stirling continued his involvement with the collection in the 1980s when several works by the 1940s social-realist painter Josl Bergner were added. Paintings by Bergner represented the influence of social history in

the 1970s. The collection does not include the work of women artists, and this exclusion serves to emphasize the investment function of the collection. The major critics of the period, such as Robert Hughes, ignored women artists (Hughes 1966). Though subsequent exhibitions and publications have redressed the balance, and the prices for women artists' works have increased substantially at auction, they have not been added to the collection.

The J.G.L. Investments' collection does not include the work of Aboriginal Australian artists either. In contrast, Dr. Coombs, who had been active in the arts and in the Federal Government Policy in Aboriginal Affairs, included Aboriginal art by David Malangi and other Aboriginal artists working in the 1950s and 1960s in the Reserve Bank Collection. The chairman of I.C.I. during the 1980s, Milton Bridgland, who was responsible for developing the historical character of the collection, added Aboriginal paintings which had come to prominence in Australia and abroad in the 1970s and 1980s. Prominent West Australian corporate collectors, Janet and Robert Holmes a Court, developed a major collection of regional, Aboriginal, and Australian paintings. Their collecting and sponsorship gave them a great deal of influence in West Australia but had much less influence in the eastern states. The galleries and market for Aboriginal art had established high prices for bark and canvas painting in Central Australia, the Northern Territory, and New York, and this was the type of work bought for most corporate collections. The vast number of corporate collections in Australia are not collections of the caliber of the I.C.I. Collection. They are collections of art from the 1970s and later which were bought to furnish the interiors of new premises. The collectors often employ an art consultant, who is not a dealer but who buys from dealers' galleries, or frequently directly from artists themselves. The consultant will choose a theme or media which suits the client and even commission work from artists who the consultant works with on a regular basis. These artists are generally mid-career artists, with reputations established in the dealers' galleries, who can produce artwork with an established style. The practice of commissioning from a restricted group of artists undermines the function of criticicsm and the market. The budgets for such collections, rather than a collection policy, determine the type of work purchased, and often the corporations make no further acquisitions after the initial collection has been purchased.

The degree to which the collection is understood or appreciated by corporate employees or clients will often depend on the corporate executives' interest and knowledge of art. The consultant may be encouraged to give talks to employees about the works and even produce a catalog. The consultant may produce museum-type wall plaques to inform employees and clients; register the collection or teach an employee registration procedures; arrange for valuations and insurance; and ensure conservation requirements are implemented. One of the criteria for selecting collections should be the audience who will view it. Corporate collections have a role in educating a different audience than that of the public galleries. Unlike in the United States, the dominant attitude of Australian corporate collectors of this type is to regard the collection as private.

Sometimes the work is not even hung in public reception areas, and employees may be unaware that their corporation has an art collection.

The major collectors and sponsors of artwork completed after 1970 are the Transfield Corporation and the National Australia Bank. The National Bank Collection began in and 1975 was shaped by the influential art dealer Georges Mora. The collection is a survey collection of 100 Australian paintings from the 1970s and includes some tapestries (based on paintings) which were commissioned from the newly established Victorian Tapestry Workshop (Lindsay 1982). The collection was completed and exhibited at the National Gallery of Victoria in 1982. Since the collection was to be displayed in the bank's headquarters in Australian capital cities and their offices abroad, there were restricted acquistions after that date. Two series of genre paintings were collected: Peter Tristler birds and Jean Langley's flowers. In 1989 a specific budget was allocated for a commissioned series of paintings of Australian rivers from well-known artists. The bank also owns artwork from previous decades, mostly portraits of chairmen, which are hung in boardrooms. However, the London offices of the bank have a collection of Dobell and Drysdale paintings from the 1960s when, under the patronage of Sir Kenneth Clarke, these painters established their reputations as Australia's leading artists. The National Bank Collection is fairly typical of the conservative character of bank collections. It is also typical of corporate collections of contemporary art, though most collections would not be as large nor have had access to a dealer as influential as Georges Mora.

The corporate sponsorship of the National Australia Bank has largely been associated with their corporate collection. The collection has been exhibited frequently at the Armidale Regional Gallery in northern New South Wales. Armidale Gallery was built to house the Hinton Collection, an important collection of Australian modernist paintings which the bank collection complements. This association led the bank to support a regional conservation task force in New South Wales, called Conservation on the Move. Georges Mora, the bank's consultant, was also a consultant to the Museum of Modern Art at Heide, which houses another important modernist collection. The bank contributed to the restoration fund and to a Georges Mora Memorial Fund established after his death. The bank donated a Drysdale painting, *Broken Mountain*, to the National Gallery of Australia from its London collection and a number of other donations at the time of the Australian Bicentennial in 1988. National Australia Bank sponsorship also typifies the far more restricted policies of banks since the recession began in Australia in 1989. Most have not been prepared to justify collection and sponsorship policies to shareholders. A new breed of managers has been appointed who have replaced artworks in branches with corporate logos and product advertising. The generation of corporate executives, who initiated corporate collections and sponsorship and reinforced these activities through their own relationships has been displaced by the executives who have been hired to cut costs and increase profits. The "boom and bust" of the 1980s has had significant effects. A critic of this period remarked: "I hated the sloppiness of the art boom; it provided every form of bad behavior humans are capable of"

(Hughes 1994). The art collectors of the 1980s were speculative investors, often associated with corporations involved with financial and property speculation or corporate takeovers.

In Australia, some of the major corporate collectors were hotel and resort developers. An international standard for resort accommodation was widely adopted for new hotels and refurbishment projects that required a new level of sophistication in interior fittings and in the field of art display. Art Incorporate, art consultants whose business developed in the 1980s, specialized in collections for major hotel groups and resort developers such as Qantas, whose sponsorship of Australian art abroad had begun in the 1950s in Australia House in London.

The more infamous 1980s collectors included Alan Bond and Christopher Skase. The financing of the purchase of Van Gogh's *Blue Irises* by Sotheby's auction house was widely criticized for underwriting a record sale price. When the Dalhold Collection (Bond's family company) was sold through Christie's in Australia, (*Blue Irises* was reclaimed by Sotheby's), the collection could not match the "boom" prices paid for it. Many 1980s collectors were profoundly ignorant about art and suffered huge losses when the bottom fell out of the market in 1990. Jean Sherman of Sherman Galleries in Sydney has developed new strategies to counter the loss of confidence by corporate collectors. Sherman Galleries has formed an investment group of collectors, called Mecenat, to spread the financial risk among a group of corporate executives. The gallery is also developing a market for Australian contemporary art among Japanese corporations with business interests in Australia.

Art sponsorship has risen during the 1980s and will continue to grow. Transfield Corporation is the most prominent sponsor of contemporary art, as it sponsors the Biennial of Sydney, Australia's most influential exhibition of international and Australian contemporary art. Transfield's role as a sponsor has been far more significant than its role as a collector. Transfield is a leading provider of engineering, shipbuilding, construction, and maintenance services to the defense, maritime, power, process, and building industries. The corporation is a leading player in the Asia-Pacific region and this, together with the Italian ancestry of chairman Franco-Begiorno-Nettis, means that it aims for an international profile for its art sponsorship. The national publicity which the Biennial attracts, plus the audience, has kept Transfield's support for the Biennale over a 20-year period. It has been estimated that the maximum audience for any Australian contemporary art event is probably about 60,000 people out of a population of 17 million. Although the number is small, the audience for the Biennale, includes the leading national and state galleries' players in government and business, the young, and upwardly mobile. This is the audience targeted by corporate sponsors. The current relationship between art and business in Australia is characterized by corporate sponsorship for major exhibitions and galleries whose prestige ensures that they attract the right audience.

The National Gallery of Victoria (N.G.V.) has the longest association of any state gallery with private foundations. The Felton Bequest, which dates from early this century, enabled the gallery to become a major player in the postwar

art market, establishing market records through the purchase of works such as Romney's *Portrait Group of the Leigh Family* at the peak of the 1958–1959 boom season in London. In 1978 the gallery established the Art Foundation of Victoria. The chairman of the foundation for the first ten years was Hugh Morgan, the chairman of Western Mining—one of Australia's wealthiest and most successful companies. The foundation has become essential because inflation in the prices in the art market since 1958 has meant that only one major artwork per year could be funded from the Felton Bequest. In the last 15 years nearly all gallery acquisitions have been funded through the money raised by members of the Art Foundation—including individuals and corporations.

In 1988 the N.G.V. Business Council was established as an incorporated association to raise the sponsorship required for exhibitions, to attract financial support from the business community through donations and functions held in the gallery's exhibitions rooms, and to act as advisor to the gallery on business matters. Corporations who support the foundation or the Business Council can book receptions and dinners in the exhibition rooms where their guests can enjoy major traveling exhibitions. In the last 12 months, exhibitions of Van Gogh and Renoir attracted 6,500 and 4,000 people respectively to off-hour functions. The success of these "education and entertainment" functions in providing financial support to the gallery also indicates the problem.[1] There is a major crisis in curatorial research and the development of collections in Australia. While traveling blockbuster exhibitions attract audiences and, hence, sponsorship, this and other public institutions have come to rely on such exhibitions at the expense of developing quality exhibitions from local collections or supporting curatorial research for international exhibitions developed in Australian galleries. The erosion of government funding for state galleries in the 1980s is continuing and a public institution such as the National Gallery of Victoria may become totally funded from foundations in this decade.

The conflict of interest that results from competition for sponsorship funds does not allow major galleries to plan and fund exhibitions as part of a national program. Conflict between galleries has had an impact on the credibility of Australian institutions as borrowers from major overseas museums. An article in a major daily newspaper, *Sydney Morning Herald,* entitled "Art Wars" (1994), referred to the competition for audiences between the National Gallery of Australia (N.G.A.) in Canberra, and the Art Gallery of New South Wales (A.G.N.S.W.) in Sydney. Canberra is relatively sparsely populated and Sydney is the most populous city in the country. Intense competition led to the A.G.N.S.W. planning an exhibition of Indian art that was to be held one year before a planned exhibition at the N.G.A. When the two major institutions approached the Indian Government this year to borrow the same pieces, the request of the director of the N.G.A., Betty Churcher, was refused. This practice of staging mirror exhibitions led to the canceling of an exhibition, Gauguin in the South Pacific, which the N.G.A. had planned for 1995, the centenary of Gauguin's visit to Australia, because the A.G.N.S.W. offered an exhibition, Gauguin and the Pont Aven School. The latter exhibition was

borrowed from one major private collection, and organized fairly quickly. The relationships between audiences, sponsorship, and funding has produced forms of competition that undermine the previously cooperative relationships established through Art Exhibitions Australia, a corporation set up by the federal government in 1980 to foster the touring of major exhibitions in Australia.

The Myer Foundation, a family foundation established in 1959, has initiated sponsorship policies which signal future directions. Business and government in Australia are developing programs to expand the audience for Australian art in Asia. The Myer Foundation, with the Mazda Foundation, established the Asialink Centre at Melbourne University. The policies of Asialink are to promote Australian culture in conjunction with the Federal Department of Foreign Affairs and the Australia Council, and to support projects which develop Australians' knowledge and relationships in Asia. Their Art to Asia Program supported three exhibitions of contemporary Australian art and artists-in-residence in Thailand, Malaysia, India, Indonesia, the Philippines, and China during 1993–1994. In a speech at a Business and the Arts Dinner in 1991, Garillo Gantner, vice-president of the Myer Foundation, spoke of and made the link between creativity and prosperity that underlies the foundation's policies:

Artists change preceptions, and perceptions change the climate in which all of us, not least business and government, operate. If the perception of Australia were that of a country with a creative, vibrant, diverse and confident culture, that perception would help to sell our exports. Culture sells. Its that simple and its that difficult.

NOTE

1. The current annual budget for the National Gallery of Victoria is A$11 million, A$6 million is provided by the state government, A$2 million through door admissions, and the shortfall of A$3 million largely through the Art Foundation and the Business Council.

Japan's Corporate Support of the Arts: Synopsis of the 1992 Survey

Association for Corporate Support of the Arts (Kigyo Mecenat Kyogikai)

ECONOMIC STAGNATION AND ARTS SUPPORT

We again conducted a survey of business support of the arts—for the year 1992. Unlike the results of the survey conducted in 1990 and 1991, the 1992 survey concluded that the whole year was seriously affected by the collapse of the intensive-growth period of prosperity, which began in the late 1980s (the so-called bubble economy). Quite a few corporations suffered decreases in both net and gross profits which forced them to drastically restructure and cut their expenses. Immediate and obvious cuts included the curtailment of advertisement, entertainment, and transportation expenses. The most symbolic decrease, however, was in company-sponsored concerts and other artistic events. It was commonly thought that negative growth in the Japanese economy throughout the past few years would lead to a significant decrease in corporate support for the arts.

CORPORATIONS WHO SUPPORT THE ARTS: AN INCREASE IN RATIO VERSUS A DECREASE IN THE OVERALL NUMBER

A total of 403 companies responded to the 1992 survey, 52 companies (11.4%) less than participated in the previous survey. However, the companies who did not reply this year were mainly those who do not support the arts—153 companies—signifying a decrease of 46 companies (23.1%) from the total of 199 companies in the 1991 survey. The overall number of companies supporting the arts was 250, a decrease of only six, or 2%. In the 1992 survey 62% of companies supported the arts, compared to 42.7% for the 1990 survey, and 56.3% for the 1991 survey. Moreover, 17 of the companies who do not currently support the arts indicate that they are planning to instigate support in the near future. When these companies are considered as potential supporters of the arts,

the percentage becomes even higher. With these figures, one may conclude that corporate support of the arts is steadily growing in Japan.

MANAGERIAL AND FINANCIAL RESOURCES

Corporate support of the arts is usually sustained by a combination of managerial resources, such as personnel, goods, and money. Most corporations place importance on actual financial support. The survey showed that financial support is overwhelmingly popular and that more than 70% of the respondents support the arts financially. A total of ¥23,612,197,000 (Japanese Yen) (U.S.$214,663,100) was spent by 186 companies for arts support. The approximate amount per company is ¥126,950,000 (U.S.$1,154,090). When compared with the figure for the previous year, the total amount of financial support shows a decrease of 6.8%. This decrease is probably due to the sluggish economy, but the decrease is relatively minor when compared to the general scope of Japan's depressed economy.

In-kind support of the arts or support through personnel services is impossible to measure but has definitely increased, enough, at least, to augment the decrease in financial support. In any case, corporate support of the arts in Japan is alive and well and is being sustained by contributions of money, manpower, and other resources.

As in the previous year, music received the greatest amount of business support in 1992, outpacing the amount received by the visual arts and theater. Out of 1,774 supported art programs, more than half of the programs were music (35.9%) and visual arts (15.8%).

Means of business support to the arts vary, but the greater part of support was financial support (70.0%), and then labor assistance (32.6%), providing physical facilities (19.2%), and in-kind support (12.7%). Businesses indicated that more than 50% of the money for arts support comes from their advertising budgets and contribution funds.

The total amount spent for corporate support of the arts during the year 1992 was ¥23.61 billion (U.S.$21.4 million), and the average amount per company was ¥126.95 million (U.S.$1.15 million). As compared with last year's survey, the total amount has decreased by ¥1.76 billion (U.S.$1.6 million). The amount donated for arts support per company is shown in table 16.1.

GRADUAL GROWTH IN ARTS SUPPORT

A look at the comparative figures from the previous year vis-à-vis corporate art support verifies the above conclusion. The 1992 survey included a set of new questions intended to determine how various companies were maintaining arts-support programs despite the economic downturn. The new questions inquired if there was an increase or decrease from the previous year in such things as the number of programs supported and the total amount spent, the number of requests for support, the number of staff members in charge of arts-support

Table 16.1
Art Support per Company in Japan

Amount	(%)	No. of Companies
Under ¥10 million	31.7	59 companies
¥10 million–¥50 million	29.6	55 companies
¥50 million–¥100 million	10.2	19 companies
¥100 million–¥500 million	22.0	41 companies
¥500 million–¥1 billion	3.8	7 companies
¥1 billion up	2.7	5 companies

programs, and employee interest in the support programs. All together, 80% of the companies responded that there was either an increase or no change from the previous year. More than 40% of the respondents indicated an increase in the number of requests for support and employees interest in the support program. The considerable increase of requests for support is mainly attributable to the weak economy's effect on artists and the fact that awareness of corporate support of the arts is growing, resulting in more applicants among artists and art organizations. The increase in employee interest and awareness indicates a growing understanding of the importance of arts support within the business world.

Corporate support of the arts is steadily growing, as can be ascertained from the fact that more than 80% of the respondent companies supported the arts at the same level or on a larger scale than the previous year. The number of companies who indicated a decrease in support was relatively few: 10% indicated a decrease in the number of programs supported, 15.2% in money spent, 6.8% in number of support requests, 2% in number of staff members involved in arts-support programs, and 2% in employee interest in arts support programs.

Reasons for corporate support of the arts vary, but the major reasons are corporate citizenship awareness, image improvement, and establishment of corporate culture. This result has not changed since the 1990 survey.

CONCLUSION

Corporate support of the arts in Japan stands firm despite the adverse effects of the economy. The survey also showed that some companies instigated support for the arts without sufficient preparation and understanding, and that an exaggerated image of corporate support of the arts has been created by media sensationalism. The recent economic downturn has weeded away all but the companies who are truly serious about arts support.

A comparative decrease in arts spending is not so serious when seen in the light of the one-percent philosophy, as in the case of the Federation of Economic Organizations (Keidanren) which turns 1% of its profits over to philanthropic

causes. If profits drop then arts support will also drop, but the basis for continued corporate support of the arts in Japan has been firmly entrenched and is expected to continue growing.

PROBLEMS TO BE CONSIDERED

Although corporate support of the arts has been established in Japan, the survey indicated that several matters must be taken into consideration, including the problems of art education; diversification of support programs; non financial support; arts budgets; evaluation and policy; communication with artists; and taxation problems.

Arts Education

Corporate support of the arts tends to overwhelmingly concentrate on music, fine arts, and theater. As a result, corporations support concerts, art exhibitions, or theater and tend to ignore other areas of art or the art process, for example the routine support of artists, support of management organizations, and scholarships or fellowships. Of course, sponsoring a big event like a famous concert or exhibition is great publicity and makes a deep impression on both the public and company employees. Although such support is necessary, support to individual artists and art organizations is also vital. In the long run, support for the so-called artistic infrastructure—both individual and institutional—will make for excellent end results in the form of concerts, exhibitions, and theater.

Diversification of Support Programs

As in the past, this survey indicates that the most popular kind of support is for music. Moreover, the popularity of music as an object of corporate support is not peculiar to Japan. Such support needs to be re-thought, however, if the reason is just because supporting music is a safe bet or because everyone else is doing it. A diversification would naturally follow if corporations decided which kind of art to support according to their corporate or managerial philosophy.

Nonfinancial Support

This year's survey reveals, as in previous years, that financial support of the arts is the most common kind of support, followed by labor assistance, lending of physical facilities, assistance in-kind, and other miscellaneous forms of support. However, financial support decreased by about 10% this time, whereas manpower assistance and other types of support increased. This trend provides suggestions for future corporate support of the arts. For example, it can be made clear to the corporate world that monetary funding is not the only form of arts support, especially in times of short money supply.

Employee interest in the arts tends to be strengthened if they have the chance to help the artists, provide physical facilities, or make available the company's goods or services. The utilization of managerial resources in corporate support of the arts is effective for both the corporation and the artist.

Arts Budget

The number of companies which maintain a budget for arts support was 43.6%, a slight improvement over the 40.3% of last year's survey. Yet this is a rather small percentage considering the fact that a majority of these companies have either a special arts section or a section which oversees the arts support. On the other hand, companies who do not maintain an arts budget often donate money whenever asked. For corporate arts-support programs to maintain a continuity and vitality, however, more companies should maintain an arts budget rather than rely on passive attitudes of support.

Evaluation and Policy

Out of a total of 250 companies, 232 companies reported that they have a basic policy or philosophy concerning their own corporate support of the arts. This means that almost all the companies engage in arts sponsorship with a certain idea in mind. This figure is larger than last year, and it indicates that corporate support of the arts is steadily growing.

The survey also inquired into the problem of evaluation of arts-support programs. Based on the ideals and policy of the company, how was evaluation carried out? About half of the companies replied that the results were judged from both inside and outside of the company. Other companies replied that evaluation was based on artistic value or by a numerical criterion. Regrettably, more than one-third of the respondents replied that they had no criteria for evaluation of their arts-support programs. Without a stable criteria for such evaluation, there is a danger that a company's arts-support programs may result in superficial activities. We strongly recommend that more companies establish some sort of criteria that will act as a guideline for their future support of the arts.

Communication with Artists

Opinions and impressions of the artists were received from 45 companies, and they included quite a few complaints and criticisms. Friction between artists and businessmen seems to stem from the artists' lack of awareness of the regulations and customs in the business world. In this case, it is probably the business world which needs to become more flexible and try to improve the situation. Often times, the business world's lack of awareness of the artistic situation results in unfair criticism of the artist. In any case, it is vital that the business and artistic communities work together toward a mutual understanding, and one

of the important duties of our organization is to act as a mediator within this process.

Taxation Problems

One of the requests made most frequently to our association from the corporate world was that we press the government for an early revision of the taxation system in favor of corporate support of the arts. This request was made by a majority of companies in both the 1990 and 1991 surveys. In the 1992 survey, 90% of the respondents expressed the desire that we either press for an immediate revision (201 companies) or a revision at some time in the future (28 companies). A further breakdown of the replies showed that a majority of the companies either desired that the government raise the tax-exemption limit for arts-support programs or create more tax-exempt organizations. More than 30% of the companies also noted that political contributions should be dealt with separately from general contributions. Revision of the Japanese taxation system is the primary prerequisite for the sound development of corporate support of the arts. Without such a revision it will be impossible to expect continued expansion in this area.

NOTE

This White Paper published by the Association for Corporate Support of the Arts in Japan is reproduced in its entirety with the exception of statistical tables. Some of the data from these tables is inserted in table 16.1.

Art and Cultural Policy in Japan

Kenichi Kawasaki

ABSTRACT

This chapter summarizes the extent of cultural activity in contemporary Japan, highlighting three coexisting components: government-sponsored organizations, privately run organizations, and the more commercial segment of the popular-culture industry. Although government support is small, the activity by private enterprises, especially IEMOTO, is extensive and widespread among the Japanese population. Privately run newspaper, broadcasting, and department-store companies are shown to sponsor extensive activities and courses which educate, provide recreation, and impact on family-style issues. Data are presented on the extent of support by privately sponsored cultural centers, and on the value of the fine-art import market in Japan.

INTRODUCTION

Cultural activity in contemporary Japan centers around three components. The first sector is a central government with a gigantic bureaucracy. As part of a consistent social hierarchy, the central government controls a number of local governments and through social educational activities of local governments, manages commuter organizations or residential associations. The second sector is a complex network of cultural industries which have independent administrations, and is commercial in nature (e.g., mass media, department stores, distribution industries, etc.). Their enterprises contain not only traditional arts (such as Japanese flower arrangements, tea ceremonies, etc.), which have been established as the IEMOTO institution (Japanese traditional art associations), but also include more common tastes and hobbies, most of which originated in Western Europe. The third sector is significantly different from the above two

components. That is to say, it is (advanced) popular culture, originating in the United States or England and stemming from the student movements of the 1960s.

Contemporary Japanese culture began toward the end of the 1950s when the economy started to revive after World War II; it crystallized toward the end of the 1970s, and became prosperous by the end of the 1980s. A number of sub-cultures within contemporary Japan neither overlap nor oppose each other. Curiously, they have coexisted. It is thought that this is a result of compartmentalization—a way of cultural management in which heterogeneous elements coexist by dividing into both some genres of culture and some activities. It seems that this tendency contradicts internationalization policy, and the policy that the Japanese government advances. But I would like to point out that Japanese cultural policy is difficult to change.

COMPARTMENTALIZATION AS A CULTURAL POLICY

In Japan, the central government has played a primary role in producing culture. The Agency for Cultural Affairs, independent of the Ministry of Science, Education and Culture since 1968, is at the center of cultural administration. An expert, Ikuko Arimatsu, described artistic activities:

the role of the Japanese government has been to both arrange cultural conditions where Japanese people can widely enjoy their artistic culture and also develop a totally harmonized artistic culture through its support of individual or activities of artistic/cultural groups. (Arimatsu 1993a)

It was not intended for the state to directly intervene in the cultural activities of Japanese citizens since World War II. In reality, the Japanese government has had a leading effect on culture and plays an important role. As a result, it has been able to maintain Japanese traditional cultures, and coexists somewhere between traditional cultures and nontraditional cultures.

There is a discrepancy between government and citizen roles. Cultural agencies within the government aim to support activities or "keep their harmony." But from a citizen's point of view, there actually appears to be more forced control of what should be cultural activity. Why do activities seem to be induced? With little direct subsidy and monetary support, the Japanese government has not spent its budget on artistic/cultural activities and has not mobilized its political power in the direction of arts support. The government has been controlling Japanese culture through a network of local governments or well-managed social groups, consisting of experts or celebrities. For example, in the budget of the Agency for Cultural Affairs in 1992, one notices that the cultural budget was low when compared to its overall budget. The total amount of the annual budget in 1992 was ¥49.6 billion (yen) (about a half-billion dollars).

The allocations of the cultural budget are also controversial. Three-fourths of its total was reserved for the maintenance of traditional assets and traditional

arts. Only a quarter of it was spent on supporting other artistic activities. More specifically, the maintenance of traditional arts (e.g., Kabuki, Nou, etc.) held 13% of the total cultural budget while only 5% of it was assigned to other artistic activities (e.g., opera, ballet, classic music, etc.).

Local governments account for about half of the artistic/cultural activities in Japan. Funds are applied to both support the tastes or hobbies of the population as well as to build museums and music halls. The number of museums and music halls constructed have declined since the 1980s.

Despite its control over such a small portion of cultural activities, social implications result from its political and economic nonsupport. (This pattern is not limited to contemporary society, but is common throughout Japanese history.) Primarily, a symbolic function of the compartmentalization policy is that the Japanese state voluntarily legitimates Western and American culture, and, at the same time, protects traditional Japanese culture. Consequently, the government gives cultural legitimation to opposite cultural traditions. When the two opposite cultural powers contradict each other, the government can force the Japanese arts and culture into becoming the "official" cultural position. Secondly, the state has the function to grant legitimacy. However, local governments, enterprises, and citizens pay some money and do support artists and artistic activities. In keeping social order, the minimum budget bears maximum efficiency.

PRIVATE CULTURE:
IEMOTO, THE CULTURE CENTER, KYOUSHITSU

In contemporary Japan, the private cultural sector consists of IEMOTO (Japanese traditional art associations), the Culture Center (cultural education centers, commercialized-tastes circles), and Kyoushitsu (other tastes circle). They are managed independently and have national administrations. These private cultures are related to the history of Japanese culture.

The main institution, IEMOTO, includes traditional arts or crafts (such as Japanese writing, poetry, flower arrangements, tea ceremonies, etc.). These activities have been widespread among citizens since the late 1950s. Particularly, Japanese women are fond of learning such arts or crafts, and tend to regard them as an aspect of being well educated. Nowadays, many IEMOTOs have similarities to the Culture Center and Kyoushitsu and are in some ways commercial.

The Culture Center was organized in the late 1970s by private enterprises. It was designed to cater to learning aspirations of urban people in a collective setting. According to research conducted by the minister of science, education and culture, the administrative agents belong to the following troups: newspapers, broadcasting groups, and department stores (including large supermarkets). The focus of these Culture Centers is: cultural enhancement/education; physical training and recreating; and, home life styles.

Table 17.1 summarizes the efforts of newspaper, broadcasting, and department-store companies in 1989. The largest number of courses were offered by newspaper companies (18,800) reaching almost 400,000 participants. Department stores, as part of their marketing strategies, offered 9,000 courses and had almost 150,000 participants. Other cultural activities included physical training and home-life-style courses. All in all, almost 750,000 individuals participated.

Lastly, Kyoushitsu offers art education at various places (leased halls/private houses, etc.). The central part of Kyoushitsu consists of playing music, painting pictures, and performing arts. But the boundary with other arts is not clear cut. Classical music and ballet are almost totally dependent on this kind of Kyoushitsu. Because the markets for them are small, and they cannot expect support by government administration or private enterprises, these Kyoushitsu economically support ballet and classical music.

JAPANESE POPULAR CULTURE AS A THIRD COMPONENT OF CULTURE

In Japan, popular culture has developed in various fields. The majority of Japanese enjoy the arts by "style switching," showing loyalty to one style or form over an extended period. Similar to other mass societies with ambiguous distinctions of social class, this form of cultural experience has emerged in Japan and is different than the form of cultural activity described in the previous section.

In particular, when we analyze contemporary popular culture, it is most important to analyze the enormous music industry, as well as the commercial art market with its distinction between fine art and popular art. In the case of music, the market for popular music is far larger than the one for classical music. For example, the Japanese music industry was second only to the American one. And the sale of music tapes and CDs in Japan reached ¥500 billion ($5 billion) a year in 1992. With the expanding East Asian and Southeast Asian markets, added to the Japanese market, these mixed markets are as large as that of the United States. In Asian countries—including Japan—popular music has cultural hegemony and forms of classical music are supported by the middle class. Along with internationalization or globalization of popular music, popular music acquires more cultural hegemony. In addition, the market for popular music has developed and widened into related media—including the development of CDs, copying products, and Karaoke. These new markets have become one of the most important fields within the culture industry. This is applicable to other markets of mass media as well.

FINE-ART CULTURE IN CONTEMPORARY JAPAN: THE JAPANESE ART MARKET

The Japanese art market is characterized by its self-sufficiency, and by its duality. The traditional market of NIHONNGA (Japanese traditional paintings)

Table 17.1
Cultural Education Centers, 1989 (Values in 1000s)

Field of Study	Newspaper Company Courses	# of People	Broadcasting Courses	# of People	Department Store Courses	# of People
Cultural Enhancement	12.5	268.6	5.2	87.8	9.0	149.7
Physical Education and Recreation	2.7	62.7	1.0	16.4	3.0	60.6
Home Education and Home Life	1.4	27.2	0.4	6.1	0.7	15.3
Others	2.1	35.7	0.4	7.2	0.7	11.0
Total	18.8	394.2	7.1	117.5	13.3	236.6

Source: Ministry of Education, Shakai Kyouiku Chousa (Research on Social and School Life), 1990.

is extensive and has no desire to expand. Because the painters, art dealers, and clients are tightly connected to each other, the painters have organized a number of peer groups based on similar drawing and economic interests. As a result, a social hierarchy has been established by artists, and is reflected in the art market as well.

The most important characteristic about the export-import art market is the tendency for an import surplus to exist in the Japanese art market. For example, in 1992, the amount of imported goods was 11 times that of exported art goods in trade statistics. In 1993, the former reached 17 times the quantity of all art exports. France and the United States headed the list, importing two-thirds of all fine-art works, both in 1992 and in 1993 (see table 17.2).

Further, when we focus on painting, collage, prints, and sculpture, the ratio of imports from France was above average. According to Shinichi Segi, a well-known art critic for over 25 years, the average ratio of imports from France was 60% (Segi 1991, 1993).

Since the 1980s, French imports have come to equal the strong and consistent support of traditional Japanese art. Over the last 30 years, a "duality" of the art market has emerged with the coexistence of French Impressionist works alongside traditional Japanese paintings.

Since the economic recession of 1991, the import market has become smaller and returned to its 1970s size. Currently, since the traditional market has been insular, it has not grown. In addition, there is a surplus of French Impressionist works.

Table 17.2
Import-Export of Fine Arts and Collections,
Amounts and Values of East and Southeast Asia

Exports unit: amount: number (thousands) value: million $					Imports unit: amount: number (thousands) value: million $			
A.(92)	A.(93)	V.(92)	V.(93)	Destination	A.(92)	A.(93)	V.(92)	V.(93)
16.0	9.2	30.9	49.0	Total	1086.9	1062.8	513.3	536.5
8.1	0.2	0.3	0.6	China	208.1	197.4	30.5	52.9
0.4	0.2	0.2	3.1	S. Korea	541.6	476.0	16.6	12.6
0.4	2.3	0.5	1.6	Taiwan	48.1	37.5	5.7	1.3
0.3	0.1	0.3	0.3	Hong Kong	30.8	10.2	0.6	0.6
—	—	—	—	Philippines	—	—	—	—
—	—	—	—	Malaysia	—	—	—	—
0.2	0.8	0.9	0.5	Singapore	—	—	—	—
—	—	—	—	Thailand	9.2	58.2	0.1	0.3
—	—	—	—	Indonesia	—	—	—	—
2.0	2.1	9.1	17.0	U.S.	83.9	97.0	114.7	115.1
0.2	0.5	0.1	0.4	Canada	0.7	1.3	1.4	1.1
0.5	0.3	1.9	1.1	U.K.	36.1	51.0	33.4	30.2
0.5	0.3	5.0	8.0	France	58.9	68.4	171.6	133.5
0.5	0.5	0.7	11.3	Germany	17.6	3.2	14.1	14.7
0.1	0.2	0.1	1.4	Italy	27.2	27.2	27.9	12.0
—	—	—	—	Spain	5.2	2.2	25.1	7.8
—	—	—	—	Brazil	—	—	—	—
—	—	—	—	Argentina	—	—	—	—
—	—	—	—	Russia	0.9	5.5	3.0	3.1
0.1	0.1	0.7	1.3	Australia	1.6	1.0	0.9	0.7

Source: Ministry of France, *Annual Statistics of International Trades,* 1994.

There is some minor interest in contemporary art. The Penrose Institute, established in Tokyo three years ago, decided to withdraw from the Tokyo art market. But despite the economic recession, some factors have supported contemporary art. For example, the Tokyo metropolitan government opened a museum for contemporary art in the waterfront area of Tokyo in March 1995; and the Nippon International Contemporary Art Fair (NICAF) is still maintained in Yokohama, and curators of a younger generation have begun to take an active part in its artistic activities (Lufty).

CORPORATE PATRONS

Corporate support of the arts has recently thrived. Before the 1980s enterprises had no legal or tax incentive leaving only very rich individuals to support artistic activities. Most of their support was seen in construction and management of their own museums. However, Japanese enterprises began to think that they needed to make a contribution to Japanese society, and some of them recognized the necessity of artistic support.

The Association for Corporate Support of the Arts was established in 1990. A White Paper of the association in 1994 analyzed that, despite economic recession, the tendency has not weakened. About 300 enterprises in Japan had begun to support art by the end of the 1980s, and most of them (244 companies in 1992) continue to do so according to this research. The largest subsidies are to music (35.9%), painting (15.8%), and drama (5.9%). Since only 70% of expenses are covered, other support is necessary (ACSA, 1992, 1993).

CONCLUSION

Although there are a number of agencies and vehicles for cultural activity in Japan, problems result from the divergence of popular culture, and its economic significance, from the official cultural policy of the Japanese government. While the latter legitimates predominantly Westernized culture (i.e., in the form of Italian and French painting, etc.), there is a proliferation of traditional Japanese cultural activity among the Japanese. This situation has created an economic problem—the Japanese art market is self-sufficient, yet has a dual character, and is witnessing an increasing and alarming high import of art. These problems were only briefly discussed and require further analysis.

Japanese Corporate Collectors: A Social and Industrial Elite

Rosanne Martorella

ABSTRACT

After a brief review of some of the more newsworthy art purchases from Sotheby's and Christie's, an analysis of the role of the arts in contemporary Japanese society is presented. The economic and political factors which contributed to both the increase and sudden decrease in the lucrative commercial art market is also discussed. Spending on the arts has returned to the 1986 level. The chapter ends with a review of several corporate gallery holdings, and their publicity value in Japan today.

INTRODUCTION

On November 9, 1989, Willem de Kooning's *Interchange* (1955) was auctioned for an outstanding figure of $20.7 million at Sotheby's of New York to Shigeki Kameyama, a Japanese art dealer of the Mountain Tortoise Company; five days later, this same dealer bought Picasso's *Mirror* (1932) for $26.4 million. The Tokyo-based Yasuda Fire & Marine Insurance Company stunned the world by its purchase of Van Gogh's *Sunflowers* (1889) for $39.9 million from Christie's London in March of 1987. Each sale represented the largest price paid for a contemporary and Impressionist work of art. The 12 days of bidding on Impressionist and modern art occurring in November of 1989 was a brief period, but Christie's and Sotheby's reaped close to $1 billion in sales— 14 works were auctioned for more than $10 million each, and 137 works went for more than $1 million each. Artists such as Manet, de Kooning, Van Gogh, Jasper Johns, Monet, Mondrian, and Renoir were most precious to American, European, and Japanese dealers, with the Japanese keeping the prices for Impressionist works at a record high (*New York Times* 17 November 1989, 33).

In recent years, other paintings sold for incredible prices that no one could have predicted, such as Picasso's *Au Lapin Agile* (1905) for $40.7 million, and his *Acrobate et Jeune Harlequin* for $38.5 million, Jasper Johns' *False Start* for $17.1 million, Pontormo's *Duke Cosimo I de'Medici* for $35.2 million, Renoir's *La Promenade* for $17.7 million, Warhol's *Shot Red Marilyn* for $4.1 million, Gauguin's *Mata Mua* for $25.2 million, Picasso's *Yo, Picasso* for $47.9 million, Monet's *Le Parlement, Coucher de Soleil* for $14.3 million, Pollock's *No. 8, 1950* for $11.5 million, and Derain's *Bateaux dans le Port, Collioure* for $19.6 million (*ARTnews* May 1987),

Collectors represent the wealthiest and most powerful individuals, institutions, and corporations worldwide. Audiences at auction sales include many Americans, but an increasing number of Swiss, Australian, and Japanese buyers as well. Japan's collectors prefer to purchase from the approximately 300 dealers in Tokyo, but the wealthiest and corporate magnates buy from Christie's or Sotheby's London and New York auctions.

In focusing on the buying patterns of Japanese collectors, analysis must include a history of the role of arts in contemporary Japanese society, and the political and economic background for the emergence of a commercial market for art. These factors will be seen to affect style preferences, prices, motives, and the social function of art in Japan.

THE ARTS IN CONTEMPORARY JAPANESE SOCIETY

Japan has relied most heavily on private and commercial support of the arts with serious music, dance, theater, and the visual arts enjoying audiences nationwide. Japanese interest has included both traditional performing arts from their own culture, and, more importantly, modern styles introduced from Europe during the last century.

Almost 90% of the population considers itself middle class, and this has meant both participation and appreciation in all forms of art. Since 1945 postwar development has had its effect on the growth of the arts. The visual and performing arts have gained occupational status and concert, theater, and dance attendance has risen. Total attendance at art museums in 1974 was just under 10 million, and another 30 million visited general, scientific, and historical museums. Modern office and Western-style buildings demanded to be decorated with "Western" paintings and watercolors. "Cultural life in the form of attendance or participation in an art activity has grown more diversified and more widely diffused throughout the country during the past thirty years than in any time in Japan's history" (Havens 5).

Three-fourths of the 1,500 galleries in Tokyo rent their spaces to emerging artists. Major shows and exhibits have increased and seem to favor the works of the late nineteenth-century French school of Impressionism. Traditional genre, such as the bunraku puppet theater, has enjoyed public sponsorship and has almost 100 performers who perform nationwide. Traditional styles in painting have had a recent revival, with the works of both contemporary musicians

and artists enjoying less popularity. In fact, Japanese artists feel ignored when audiences favor Western styles. On the other hand, there have been a growing number of Japanese dancers, actors, and instrumentalists, who perform the more popular and better-attended performances of Western artworks. Instrumentalists, especially string players, perform with major orchestras around the world.

Undoubtedly, the Japanese have a high regard for the works of French painters, especially those of the Impressionists. Their initial exposure of Western art was to the works of these artists, and it seems to have set an impenetrable taste level. Consequently, the wealthiest in the society, especially doctors, dentists, real estate developers, and corporate executives vie for acquisitions on a soaring and expensive world market.

ECONOMIC AND POLITICAL FACTORS
IN THE DEVELOPMENT OF A COMMERCIAL MARKET

In about 1955, the economy of Japan reached its prewar level of output, and continued to grow unabatedly at an average rate of 11% a year until the world oil crisis in 1973. Since that time, it has outperformed other main industrial powers. Despite its growth, accumulated wealth, and worldwide power, the Japanese government has few public art museums, and has allocated a mere $200 million for all arts expenditure. Although attendance at museums grew in the 1970s, the majority of people who visited art exhibits since the 1950s attended special shows at department stores. It is, therefore, significant that the current expression of arts consciousness among the Japanese, and the frenzy of buying, occurs within a milieu of strong preferences for the works of Impressionists, or of their Japanese disciples. The Japanese found themselves with lots of money to spend, but wanted to ensure the durability of their commodities so their purchases had to have the legitimacy associated with established art associations, well-known names, recognizable labels of quality, and so forth— commodities that were part of the world of consumers and were "conspicuous" by the status they guaranteed to the buyer and user.

About the time Japan became a modern world power, its artists traveled to France to study, and the upper class emulated the tastes of Europeans—French culture in general became, for the Japanese, the exemplar of modern culture. Therefore, it is not surprising that present acquisitions favor Impressionist works. From 1962 to 1971 nearly 900,000 works of art were imported into Japan. In 1980 alone, it was estimated that $750 million was spent on Japanese works, and another $250 million for imports. The first year Christie's paid attention to Japanese collectors was in 1969. More Japanese had entered the market by the mid-1970s, but it was not until the late 1980s that they became significant buyers on the world art market. S. Seigi reports on the value of imported arts from 1986 to 1992: 1986, ¥70 billion; 1990, ¥614 billion; 1991, ¥141 billion; 1992, ¥70 billion. The drastic decrease occurred as a direct result of the "bubble economy," as Japanese spending on art imports returned to its 1986 level.

Of the 30 dealers who sell works of art, only a small number, however, import expensive European art, or buy at auction for a very selective clientele. While the Tokyo market for domestic art shriveled since 1973 (at the time of the oil embargo), sales abroad climbed for the sought-after and most popular masters. The Mainichi estimated in 1978 that there were at least 300 Utrillos, Dufys, and Picassos in Japanese collections, along with 200 Renoirs, 100 Monets, and thirty each by Cezanne and Van Gogh. Very few are considered first-rate (Haven 120).

With the increased availability of money among a predominantly middle-class society who vied for social prestige, the purchase of art for display in homes or offices implied refinement, taste, and status. Japanese businessmen, bankers, trading-company and department-store magnates, feeling the competitiveness from the global economy, sought to gain an edge by the increased publicity and public-relations value that the display of a Van Gogh or a Renoir would definitely ensure. More recently, they have begun to see contemporary works in the offices of their clients, and their desire to compete internationally has led them to emulate the collecting patterns of their clients who share "cultural capital." One dealer unknowingly alludes to this, and says: "The paintings are symbols of prestige. . . . When Japanese businessmen visit an American company, they see the American president's office, and they say that they have the money, and that they should buy the work of a famous artist, too. They want to be international" (*New York Times* 86)

The high price for a painting reflects a higher level of taste and worth to enormously wealthy yet artistically naive corporate tycoons. They are determined to compete for the highest quality works available. Dealers benefit from such inflated prices and guarantee their prices by a buy-back policy. Add to this the competitive nature of status-seeking Japanese and corporations vying for a larger and larger share of the world market for their products, and a well-known work by a master is well worth the incredible price paid, given the publicity and status it is sure to confer. A well-known New York dealer, Richard Feigen, who is actively selling to Japanese collectors addresses the importance of the overall economic situation and its impact on artistic style preferences: "People are afraid of stocks and bonds and precious metals . . . the art of some brand-name impressionists has been turned into a quasi-financial instrument, and there is a widening gap between prices for that art and any other kind of art."

A commercial market has grown rapidly within the last 20 years despite a lack of historical precedence, government subsidies, or support of their own artistic traditions and artists. Japan's politico-economic position worldwide, the existence of a number of respected Tokyo-based dealers with an elite clientele, and, of course, the status awarded to artistic concepts and lifestyles developed outside of their own culture act to sustain the vitality of this market.

THE MEANING OF PATRONAGE

It is only recently that Japanese artists could enjoy patronage from government, private corporations, or wealthy individuals. They have come to rely on a set of private groups/leaders that sponsor them, exhibit their works, and provide clients for acquisition. It is a system quite different from that of Western Europe or North America. It is within this milieu of a highly segmentalized market for the arts that private corporations, and wealthy individuals, have come to play an important role as benefactors.

Throughout its history, and given the philosophy of Confucianism (which spoke of benefiting the common good), Japan has not had a tradition of philanthropy. In its feudal era, sponsorship aided home-town artists rather than a national art form:

Shinto was the nurse of the arts in old Japan, but the esoteric priest Kukai (774–835) was their tutor and Buddhism their benefactor for nearly a millennium. Neither religion imparted much of a charitable tradition, whether for the arts or for social welfare. During the Tokugawa period (1603–1868) Kyoto aristocrats and regional fief lords, the latter scattered in castle towns, patronized art because it reinforced their status, adorned their ceremonies, and lent refinement and cultivation to the new warrior elite. . . . Government became the benefactor of the arts after the Meiji restoration in 1868. . . . The state promoted an architectural style from the West. . . . But only when cultural life became fully democratic, after World War II, did most Japanese stop thinking of art as singing, dancing, acting, or painting and start regarding the work as something in itself. (Havens 30)

During the early twentieth century, there were a few industrial magnates who supported the arts, impelled by the pleasure of such support. Generally, patronage was scattered and individualistic. As the aristocracy declined, a manufacturing and commercial middle class dominated the country, and corporate wealth grew, becoming the latest and most important patrons of the arts today. Their support, however, had to be seen as part of business activities. Since it has been shown there was no tradition of philanthropy, corporations came to accept the notion that they had no responsibility to support public programs which benefited the common good, or an art form which had merit in and of itself. Traditional forms of artistic networks, the importance of the methodology of an art form, and the segmentalized structure of the market account for the justifications by corporate executives to purchase Western art, primarily for exhibition in their corporate headquarters.

EXAMPLES OF ART COLLECTIONS AND CORPORATE GALLERIES

Currently, there are almost 300 collectors actively looking for works of art for their galleries/museums. Most are top-level executives whose wealth grew from their real-estate investments, and fortunes accumulated from takeovers. The Japanese Art Institute estimates that several million Japanese visit special

shows of foreign and classical Japanese art, and that art from abroad accounts for at least two-thirds of these special shows and three-fourths of their audiences. The leading newspapers and department stores have been most prone to exhibit and have been the main collectors of historically important Impressionist works. Similar to the growing popularity of museum blockbuster shows in the United States, businessmen are sure that their sales are directly affected by the number of visitors to their galleries—designed for small and outstanding collections.

Isetan's Renoir show, for example, attracted more than 10,000 visitors per day in 1979. Consequently, the department stores Isetan, Mitsukoshi, and Seibu maintain art "museums" on their top floors, and Seibu maintains a curatorial staff to oversee its small, but important, collection. The Yasuda Fire and Marine Insurance Company purchased Van Gogh's *Sunflowers* to commemorate its centenary, and publicized its acquisition: "It is fitting that the sunflowers will be going to Japan as one version was destroyed during the bombing of Nagasaki, and also because the first sunflower painting was made in 1888, the same year Yasuda was founded."

Seijiro Matsuoka, a Japanese real-estate entrepreneur frequents galleries in London and New York to purchase works which he exhibits in his privately run museum, Matsuoka Museum of Art, which houses his well-selected collection of Chinese ceramics, classical Japanese artworks, Picassos, Renoirs, Egyptian antiquities, and Indian sculpture. He is quoted in the *New York Times* as expressing his love of outbidding a competitor, and with pride cherishes an Egyptian piece, of which he said, "It's the mate to one at the Walters Art Gallery in Baltimore" (1986).

The Dainippon Ink and Chemicals Company, which produces synthetic resins, ink, and other chemicals, established the Kawamura Memorial Museum of Art in 1990. It contains a wide range of works, including Japanese paintings by Korin Ogata and Tohaku; Western paintings by Rembrandt, Renoir, and Chagall; works of abstract art, Dadaism, and surrealism by Kandinsky, Malevich, and Man Ray; and postwar American art works by Pollock, Rothko, and Stella. The president, Shigekuni Kawamura, states the art collection has a "multiplier effect" that stimulates creativity and research. But with over 1,000 visitors each Saturday, and over 300,000 visitors annually, the museum has contributed to the public awareness and image of the company. In a report, Kawamura claims that "customers come from overseas, they evaluate us highly as a cultivated, international company which is not concerned solely with its business. This is not an outcome we planned, but is a very satisfying one."

The Seibu Department Stores, headed by Tsutsumi Seiji, which has long provided space for art to attract more people to its stores, opened the Seibu Museum of Art on the 12th floor of the Ikebukuro branch in 1975. Since then, it has managed museums in several larger exhibition spaces and galleries which highlight contemporary art, but, more popular are the major shows of twentieth-century masters like Miro, Munch, Ernst, Moore, and others.

The Fukutake Publishing Company has had an international reputation in philanthropy, and since 1990 has been determined to support the arts as part of its corporate image building. Fukutake opened the Yasuo Kuniyoshi Museum, which contains over 200 works by Yasuo Kuniyoshi—an internationally known artist. The company made the concept of "Benesse (living well) its ultimate ideal . . . aiming at the development of the company and the improvement of people's lives through its work, has naturally led to the wish to return something to society and the community."

The most popular corporate museums that influence the Japanese art scene do so by running museums "to publicly exhibit their art collections, implement original art programs utilizing their technologies, and develop art as part of their business" (ACSA). The most important companies include: Dainippon Ink and Chemicals, Canon, Shiseido, Sezon Group, Wacoal, Fukutake Publishing, Heineken, and Kajima Corporation.

The Directory of Corporate Support of Art in Japan lists 44 corporate-sponsored museums which predominantly contain the works of well-known European artists (especially of the Impressionist era), and of nationally recognized Japanese artists. Of these 44 museums, the focus of style preferences is revealed as follows: European (18); Japanese (18); and postwar American contemporary art (13). Another 44 galleries were listed which focus on exhibitions of young emerging artists predominantly from Japan. These museums are affiliated, especially, with companies in which high technology (i.e., multimedia) or avant-garde design (i.e., advertising) lends its support, relating product development to the employment of artists. These galleries function to stimulate employees to think creatively. But, more importantly, it has been shown that art support contributes to increased status and image accrued from the publicity of these exhibitions.

PART V

Some Implications of Sponsorship

Monet for Money?
Museum Exhibitions and the
Role of Corporate Sponsorship

Victoria D. Alexander

ABSTRACT

In this chapter, I examine how funding, especially corporate funding, shapes art-museum exhibitions. It is important to examine museum exhibitions supported by corporate grants, along with government, foundation, and individually sponsored exhibitions, to learn about the effects these funders might have on exhibitions. Focus is upon the exhibitions mounted by large American art museums between 1960 and 1986, as museum funding changed drastically during this period.

INTRODUCTION

Until the mid-1960s, museums were primarily funded by individual philanthropists and local city governments. Since then, corporations, governments, and foundations increasingly support museums (DiMaggio 1986a). Looking at exhibitions and museums in my sample, corporations reveal a steady and consistent growth in sponsorship from 1970 to 1986. The average number of exhibitions per museum funded by corporations is steady at about 0.15 per year from 1960 to 1968, but increases rapidly thereafter to 4.67 per year in 1986.[1]

Since museum exhibitions are increasingly funded by corporations, they may be influenced by corporate preferences. Museums are organizations that, among other things, mount exhibitions. These exhibitions cost money, and can be funded internally through the museum's operating budget or through an internal entity such as a ladies' council. Or exhibitions can be funded by an external entity such as an individual, a foundation, a government agency, or a corporation. When museums make decisions about exhibitions, they are motivated by

tangible resource flows, such as external funding, but they are also concerned with the museum's legitimacy.

Funders come to museums with certain tastes and concerns. When their tastes and concerns clash with those already institutionalized in museums, external funding creates problems for museum decision makers. Museum managers deal with such conflicts by trying to fund exhibitions that appeal to funders and that are also consistent with their visions of museum integrity. Thus, it is important to note at the outset that external funders do not dictate museum exhibition contents. Rather, exhibitions are the result of a collaboration among persons holding various ideas of "proper" exhibition formats and subjects.

It is important to note as well that the impact of funding on exhibitions is more probabalistic than causal (see Lieberson 1985). Funders do not force museums to mount specific types of exhibitions. Rather, museums have an idea of the types of exhibitions they would like to mount, what we could call an "exhibitions portfolio." Similarly, funders have a "funding portfolio" of the types of shows they might like to sponsor. When funders sponsor exhibitions, the result is an increase in the number of exhibitions where the exhibitions portfolio and the funding portfolio coincide.

GOALS OF MUSEUM FUNDERS AND CURATORS

A key assumption of this research is that funders have objectives that shape their giving, and that different objectives favor different artworks. Here, I give a brief overview of corporate funding in America to characterize corporate goals, contrasting these to the goals of other funders and to goals of museum curators.[2] I concentrate on differences among goals that lead funders to sponsor "popular exhibitions," those attracting broad audiences; "accessible exhibitions," those made up of artworks that are easy to appreciate without art-historical training; and "scholarly exhibitions," those based on art-historical research and knowledge. I focus on these three categories because attracting audiences (through accessible and popular exhibitions) and attending to art-history research (by mounting scholarly exhibitions) stand in contrast in museums. The scholarly model of museums, however, was institutionalized in the 1920s and has held sway as the "traditional" museum until recently (Meyer 1979).

Corporate funding has a long history in the arts (Allen 1983; Martorella 1990, chap. 2). Yet, it was not until the 1960s that corporations began to fund the arts in substantial amounts (Porter 1981; Gingrich 1969). At this time, corporate leaders began to believe that cultural philanthropy was a form of highbrow advertising that could improve their corporate images (Galaskiewicz 1985; Useem 1988a). Large, national corporations have the biggest influence on the arts arena, as they have proportionally larger philanthropy budgets than smaller firms.[3] But in large and small firms alike, the chief executive officer's personal preferences strongly affect the destination of corporate philanthropy dollars.

"Corporate self-interest" is the prime determinant of whether a corporation will fund a given arts project (Useem 1987; Useem and Kutner 1986). If the

philanthropy does not in some ways benefit the firm, it will not donate the money. Along these lines, corporations are likely to fund museums whose programs attract large middle-class audiences, and tend to fund exhibitions which have good public-relations and publicity value; corporations are less interested in art per se (Porter 1981). In addition, corporations are conservative and, in their own collections, tend to focus on more easily understood styles of contemporary art (Martorella 1990). Thus, corporate funders are likely to sponsor exhibitions that are accessible and popular—exhibition types that would help them reach their goals. They would be less likely to sponsor scholarly exhibitions.

The popularity and audience appeal of exhibitions are important considerations for corporate funders. Yet, corporations do not want to fund mindless pablum, as some critics have implied. Rather, the art itself must maintain its legitimacy for the association of art with the corporate name to achieve what Balfe (1987) calls the "halo effect" of illuminating the corporation.

The goals of corporations do not match those of other funders or museum curators. Government agencies attend to their own political, popular, and professional goals. They must appease politicians who vote on their budgets, and pay attention to public perceptions of their operations. These goals lead government agencies to fund popular and accessible exhibitions. On the other hand, government funding is doled out by peer review panels made up of art historians who enjoy the scholarly aspect of exhibitions. Funding by foundations (other than corporate foundations) is harder to classify, as foundations are quite varied, but a study by DiMaggio (1986b) suggests that, in the aggregate, foundations are conservative and are not interested in funding popular or accessible exhibitions, though they may be interested in scholarly art, given their close association with individual elites. Individual philanthropists and museum curators, while they may disagree on specifics, tend to focus on art history and the scholarship involved in an exhibition. True to the traditional vision institutionalized in museums early in this century, curators and individual philanthropists believe that museums are places for quiet study and appreciation, not places to entertain milling crowds.[4] As such, individuals are particularly interested in funding scholarly exhibitions rather than popular or accessible exhibitions. Similarly, curators wish to mount scholarly exhibitions, which give them prestige among their museum and university colleagues, and are not interested in the popularity of a show or its accessibility to non-art historians. Clearly, the new "institutional" funders—corporations, government agencies, and foundations—have objectives that do not match those of curators and traditional philanthropists. Institutional funding, then, is likely to offer the biggest challenge to curators seeking to fulfill their exhibition goals.

DATA AND METHODS

To learn about the effects of funding patterns on exhibitions, I studied exhibitions mounted by large museums from 1960 to 1986, more than 4,000 exhibits from 15 museums. Table 19.1 lists the museums in the data set.

Table 19.1
Museums and Time-Points in Sample (Even Years Only)

Art Institute of Chicago, 1960–86	Metropolitan Museum of Art, 1960–86	Saint Louis Art Museum, 1960–78, 84–86
Brooklyn Museum, 1960–72, 80–84	Museum of Fine Arts, Boston, 1966–84	Toledo Museum of Art, 1960, 64, 68–86
Cincinnati Art Museum, 1960–82	Museum of Modern Art, 1960–86	Wadsworth Atheneum, 1960–86
Cleveland Museum, 1960–80, 84–86	National Gallery, 1966–84	Whitney Museum, 1960–74, 78–82
Detroit Institute of Art, 1960–86	Philadelphia Museum of Art, 1960–84	Yale Art Gallery, 1960, 66–78, 82–86

To create the data set, I first developed a "large museum universe" which included the top 36 museums ranked by the annual expenses for museum-related items in 1978. The 1978 National Center for Education Statistics (NCES) Museum Universe Study provided operating expense data.[5] Then I consulted annual reports of museums in the Thomas J. Watson Library at the Metropolitan Museum of Art in New York City, and the Reyerson and Burnham libraries at the Art Institute of Chicago. Rather than choose a sample of museums, I attempted to gather data on every museum in the universe. Six museums fell out of the sample when information on them was not available in either of these central archives. I coded all exhibitions from the annual reports available in the archives: 6,337 exhibitions from 30 museums; however, I limited the quantitative data set to museums for which I found annual reports for at least ten of the 14 time points.

I collected data for even-numbered years from 1960 to 1986, creating 14 time-points for each museum. The data set starts in 1960, about five years before significant corporate funding of the arts, to provide a baseline, and ends in 1986, before the recent controversy over government funding of "obscene" art (Dubin 1992). I chose to code exhibitions from large museums. Large museums, unlike smaller museums, shape artistic canons, thus they form a conceptually distinct category of museums. I also focused on temporary, special exhibitions; I did not code museums' permanent exhibitions. I coded each exhibition mounted by sample museums by type of funder (corporate, government, foundation, or individual),[6] exhibition format (traveling, blockbuster, or theme), and content (artistic style).

There are three main dependent variables: popular, accessible, and scholarly exhibits. Popular exhibitions are indicated by blockbuster shows and traveling

exhibitions designed to attract broad audiences.[7] Popularity indicates that a large number of people came to view the exhibition. Accessible exhibits are those that require no art-historical training to appreciate and enjoy; this variable is indicated by the "theme show." Such exhibitions are organized around a theme, rather than around a traditional art-historical category. These are shows such as The Window in Art, which included only paintings and drawings incorporating windows. Various art styles can also be accessible to untrained audiences. Decorative art, crafts, ancient artifacts, and Impressionist paintings are examples of accessible styles. Accessible styles are usually figurative, so that untrained audiences can see the story of the work; they are often beautiful in a classic and traditional sense, and/or they display a craftsmanship or artistic skill that is clearly the product of a great artist. Scholarly exhibits are indicated by canonical art shows. In other words, art which is drawn from the traditional canon, the best art as defined by art historians. I used styles that are part of "the" history of art (e.g., Janson 1986), which is now called the history of Western art. This category, canonical art, is comprised of three style categories; classical art, European art (medieval through nineteenth century), and modern art. Using logistic regression techniques, I linked funders to these three types of exhibitions to determine the impact of corporate funding. I also analyzed funding of 14 styles of art for a more detailed understanding of funding effects.

RESULTS

Funding sources affect the kinds of exhibitions that appear in museums; specifically, many funders increase "popular" shows that reach large audiences. Table 19.2 presents a series of logistic regressions, the first of which shows results of logistic regressions with traveling and blockbuster exhibitions as the dependent variables. Independent variables are dummy variables for the type of funder, thus the regressions test for associations between type of funder and each dependent variable. The four types of funders are not mutually exclusive (i.e., exhibitions can be sponsored by more than one funder). Exhibitions that were not funded by any of the four external funders are omitted. In other words, the comparison group for the b coefficients is composed of exhibitions funded internally.

Table 19.2 demonstrates that corporate and government entities disproportionately sponsor traveling exhibitions. Table 19.2 also shows that corporations, foundations, and government agencies disproportionately fund blockbuster exhibitions. The results suggest that both government and corporate funding is associated with popular exhibitions. Foundations, which were expected to fund fewer popular exhibitions, actually funded more of one type of popular exhibition, blockbusters, but did not fund a disproportional share of traveling exhibits.

Table 19.2 also demonstrates that corporations sponsor more accessible art, as indicated by their sponsorship of theme shows. Corporations often sponsor theme exhibitions thematically. Examples include *Horse and Man,* a Metropolitan Museum exhibit underwriten by Polo/Ralph Lauren, which displayed hunting

Table 19.2
Effects of Type of Funding on Popular, Scholarly, and Accessible Exhibitions
(Logistic Regressions)

Funder[a]	Corporation	Government	Foundation	Individual	(constant)
Popular[b]					
Traveling	1.000***	1.174***	0.255	0.015	-0.470
Exhibition	(.151)	(.139)	(.198)	(.157)	(.242)
Blockbuster	1.785***	1.203***	0.923*	-0.302	1.302
Exhibition	(.334)	(.343)	(.377)	(.493)	(.516)
Accessible[b]					
Theme	0.577***	-0.223	0.036	-0.383***	1.371
Show	(.104)	(.121)	(.142)	(.121)	(.185)
Scholarly[b]					
Canonical	-0.330*	0.775***	0.171	0.244*	0.216
Styles	(.159)	(.132)	(.177)	(.120)	(.221)

* $p < .05$
** $p < .01$
*** $p < .001$
N = 4026 exhibitions
Notes: [a]The variables individual, corporation, government, and foundation are 0,1 variables and are not mutually exclusive. The omitted category in this case is exhibitions not funded by any of the four categories of funder.
[b]All variables are 0,1 variables where 1 indicates the presence of the trait.

prints and apparel. Undercover Agents: Antique Undergarments from the Costume Collection of the Fine Arts Museums of San Francisco, was supported by Victoria's Secret, the lingerie firm. Fisher-Price Toys sponsored the U.S. tour of Jouets Américains, an exhibition of American toys organized by the Musée des Artes Décoratifs in Paris. And Folger's sponsored several traveling exhibitions of its silver coffee pot collection.

Individuals are negatively related to accessible exhibitions, as the summary of the goals suggests. Foundations have no relationship to accessible exhibitions. Government agencies do not sponsor more accessible exhibitions, contrary to what we expected based on their goals. On the contrary, the government is negatively related to theme shows at a level that approaches significance ($p < .066$).

To test the relationship between types of funder and scholarly art, I looked at funding of exhibitions of the traditional canon of high art. Table 19.2 demonstrates that, as expected, corporations fund disproportionately fewer of the canonical styles. Individuals and governments fund more canonical styles, while foundations are not particularly associated with scholarly art.

Table 19.3
Effects of Type of Funding on the Style of Exhibitions (Logistic Regressions)

Funder[a]/Style[b]	Corporation	Government	Foundation	Individual	(constant)
Modern	-0.457*	0.935***	-0.241	0.274*	1.317
	(.206)	(.150)	(.236)	(.145)	(.283)
European,	0.120	0.181	0.558*	-0.013	1.528
Mid-19th Century	(.218)	(.191)	(.221)	(.176)	(.296)
Classical	0.348	0.450	0.066	0.865*	2.902
	(.528)	(0.489)	(.655)	(.376)	(.705)
Postmodern/	-0.003	1.783***	-0.953*	0.102	2.483
Contemporary	(.295)	(.204)	(.452)	(.274)	(.495)
American	0.384	-0.323	0.092	0.546**	2.099
Old Masters	(.255)	(.286)	(.325)	(.192)	(.393)
American Ethnic[c]	0.104	0.225	—	-0.203	4.200
	(.553)	(.500)		(.523)	(.746)
Asian	-0.254	-0.784*	0.840**	0.764***	2.309
	(.323)	(.350)	(.282)	(.186)	(.432)
Photography	0.046	0.366	-0.176	-1.420***	3.723
	(.259)	(.224)	(.334)	(.387)	(.513)
Craft/Costume	0.226	-0.769*	-0.467	0.495**	2.984
	(.251)	(.313)	(.378)	(.176)	(.466)
Commercial	0.656*	-0.682	-0.033	-0.522	4.001
	(.329)	(.449)	(.485)	(.394)	(.662)
Mixed Styles	0.275	-0.587*	0.046	0.537***	1.970
	(.217)	(.252)	(.274)	(.157)	(.346)
Local Artists	-0.713	-0.420	0.084	-1.033**	4.911
	(.433)	(.358)	(.404)	(.389)	(.671)
Child/Community[d]	-1.294*	-2.280***	-1.516*	—	7.432
	(.511)	(.714)	(.717)		(1.084)
Other Styles	0.382*	-0.892***	0.269	-0.561**	2.469
	(.182)	(.227)	(.223)	(.184)	(.321)

* $p < .05$
** $p < .01$
*** $p < .001$
N = 4026 exhibitions
Notes: [a]The variables individual, corporation, government, and foundation are 0,1 variables and are not mutually exclusive. The omitted category in this case is exhibitions not funded by any of the four categories of funder.
[b]All variables are 0,1 variables where 1 indicates the presence of the trait.
[c]During the period sampled, no foundations sponsored an exhibition of ethnic art.
[d]During the period sampled, no individuals sponsored an exhibition of children's or community-oriented art.

Table 19.3 explores the association of funding and artistic styles in more detail, with implications for funding effects on both accessible and scholarly exhibits. In this table, style of exhibition is divided into 14 dummy variables, each of which serves as a dependent variable. The table demonstrates that corporations fund fewer modern exhibitions, and perhaps not surprisingly, sponsor more commercial art shows. Commercial art includes such items as advertisements, posters, product development, and commercial design. Thus, commercial art may include artworks that are actually corporate products.

Corporations are not interested in children or in community outreach (none of the funders are). Interestingly, corporations fund disproportionally more of the category "other styles." Since this residual category is what is left over after coding for the traditional canon, for postmodern and contemporary art, and for non-Western art (all of which are styles that are established in contemporary or traditional art-history literature), it encompasses those "styles" which are not in any sense part of art history. This is further evidence of corporations' disinterest in traditional art-historical classifications.

Governments sponsor a disproportionate share of postmodern and contemporary art, thus sponsoring scholarly shows of living artists. Interestingly, government also sponsors a larger share of modern art. Two characteristics distinguish both modern and postmodern styles: they predominantly contain American artists, and they tend to require some art-historical training to appreciate. Government sponsors are negatively associated with several other styles: Asian art, craft and costume, mixed styles, child and community-oriented art, and "other styles."

Individuals sponsor more of the modern and classical exhibitions and those of American old masters, Asian art, craft and costume, and mixed styles. (The last, mixed styles, largely reflects sponsorship of patron collections containing mixed styles of art.) Individuals sponsor less photography, local artists, and "other styles," and no child/community shows. The only style that foundations have a positive association with is medieval through nineteenth-century European art. Foundations, like other funders, sponsored few child/community exhibitions. They also sponsored no ethnic art, and a lesser share of the postmodern exhibitions.

DISCUSSION

It is clear that funders prefer to sponsor certain types of exhibitions, those that help funders meet the goals behind their philanthropy. In the aggregate, corporations fund more popular and accessible, but less scholarly, exhibitions, compared to exhibitions that museums underwrite with internal funds. Government agencies sponsor popular exhibitions, but also scholarly ones. Foundations also encourage popular exhibitions in the form of blockbuster exhibitions. Individuals tend to fund scholarly art, and are disinclined to sponsor accessible exhibitions. Thus, some funding pulls museums away from traditional concerns, while other funding reinforces these concerns. Curators, however, resist chang-

ing their own preferences for scholarly exhibitions to satisfy corporate and government funders' desires for popularity and accessibility. Funders have goals that shape their giving. But the goals of the funders conflict with one another, and more importantly, with normative visions of museum integrity held by curators. It is important to recognize that museums must continue to garner legitimacy both from funders and from other actors, internal and external to the organization, especially curators, critics, and scholars who are oriented to the art-historical merit of a museum's operation.

As I have shown elsewhere (Alexander forthcoming), museum curators operating within an institutional context actively manage external pressures so as to keep museums functioning as closely as possible to curators' normative requirements. Funder pressure for accessibility is mainly handled by changes in exhibition formats, as curators mount more traveling and blockbuster exhibitions that, nevertheless, retain their art-historical merit. While the number of blockbuster, traveling, and theme exhibitions increases relative to the total number of exhibitions, there is little change over time in the proportion of either the various artistic styles or canonical art that is exhibited in a scholarly context.

Funding, especially corporate and government sponsorship, has consequently encouraged museums to mount shows accessible to broad audiences. This new emphasis on blockbusters, theme exhibitions, and popular subject matter does not make most curators happy (McGuigan 1985). They often assert that corporations and government have "distorted" the types of shows that museums put on. A general theme among curators (but not among museum directors) is a belief that corporations, especially, constrain and flaw exhibitions. The evidence from this research, however, suggests that this is not true. Though the new, institutional funders prefer more broadly based exhibits, museums clearly have some discretion in balancing large, crowd-drawing exhibitions with much smaller ones that lack external support. Museums attempt to balance mass-appeal shows and smaller, more academic shows. Indeed, I believe that the new funders have given curators more freedom than they have had in the past. If museums are primarily funded by wealthy, elite donors, then curators are limited by the ability and desire of those patrons to fund their ideas. Additional funders create more options. Each type of funding has its own limits, but now there are several types of limits from which to choose. Nonetheless, questions of discretion and constraint are analytically complex; clearly, even if curators are free to choose within a set of possibilities, that universe of possibilities is determined by funding.

Curators often believe that corporations have contributed to the "Disneylandization" of museums, and that museums are sullying the prestige of their art treasures by accepting tainted corporate money. There is some basis for this claim in the sense that, through their patronage, corporations have encouraged popular and accessible shows that appeal to bigger and less well trained audiences. Nevertheless, the pejorative tone of the curators' critique reflects their disdain for new definitions of museum functioning which focus more on audiences and less on art. These changes are not wholly the product of corporate

sponsorship. (Corporations could only wish to be so influential!) Nor are curators powerless in the face of such changes. But to a large extent, curators have lost their supremacy in museums, and they now must share the control over determining what a museum is, how it should operate, and who should be its public with other coalitions of museum personnel. This is understandably uncomfortable for curators. The administrative side of the museum, which is growing as a result of funding and other changes in the past several decades, views increased funding with glee. Directors often assert that increased institutional funding has made museums more active and viable than they have been in the past. Interestingly, government agencies take less heat from curators than do corporations, even though government funding is strongly associated with popular exhibitions. I believe that curators are willing to forgive government agencies their sponsorship of popular exhibitions because government agencies are also strongly associated with the types of scholarly exhibitions that curators most value.

In sum, it is easy to see the general orientations of funders translated into exhibition outcomes. However, this funding effect is tempered by institutional pressures which lead museum people to maintain the legitimacy of museums by retaining art-historical standards in the face of pressures for increased accessibility of exhibitions, and by the ability of museum managers to balance the demands of funders.

Art is a social product, and what is seen in museums is an important component of what art becomes institutionalized in the canon (Crane 1987; Danto 1987; Williams 1981). To the extent that museums legitimate and signal current definitions of the artistic canon, museum exhibitions influence artistic boundaries. Along these lines, the research suggests that art is shaped by mundane organizational processes. The research suggests, as well, that though corporations have broadened the format of art exhibitions, the actions of professional museum curators ensure that the basis for inclusion of artworks in exhibitions remains art-historical merit, rather than mere popularity.

NOTES

I would like to thank Rosanne Martorella and Völker Kirchberg for comments, and the Program on Non-Profit Organizations at Yale University, the American Association of University Women, and the Program on Nonprofit Governance at Indiana University for financial support.

1. Interestingly, corporate funding declined somewhat in 1973–1974, coinciding with the 1974 stock-market crash and the oil embargo.

2. The characterization of funder and curator goals here is greatly oversimplified. See Alexander (forthcoming; 1990) for a fuller discussion.

3. Corporations often set up foundations to manage their philanthropic activity. For the purposes of this study, corporate-foundation funding is synonymous with direct corporate contributions. There are some differences between corporate giving and corporate-foundation giving, however. Useem points out that the philanthropy budget of corporations that set up foundations is buffered from fluxes in corporate income and is thus more

stable (Useem 1987). In addition, governmental reporting procedures are more complex for corporate foundations than for corporations.

4. On the separation of high and popular arts and the "sacralization" of culture, see DiMaggio (1982a, b) and Levine (1988).

5. I based the sample on 1978 expenditures of 36 museums in the universe through a rather complex procedure which involved excluding museums inappropriate to the sample (e.g., those that did not mount special exhibitions) and adding large museums which were missing from the NCES survey. The museums on this list, more or less, are museums with annual expenditures of $1 million or more in 1978. See Alexander (1990) for details.

6. I was able to identify major funders. Exhibitions can be funded by more than one type of external funder.

7. Traveling exhibitions appear in more than one city, and blockbuster exhibitions are mass-appeal shows indicated for the coding by three factors (1) the use of advance ticketing, especially by Ticketron, (2) high attendance figures, or (3) mentions in the annual report of long lines of people waiting to get into the exhibit. Note: some people consider blockbusters to have, by definition, corporate funding. This is not the case with my coding scheme.

The Rise and Fall of the Impresario

Patricia Adkins Chiti

ABSTRACT

After a description of the role and function of the impresario throughout the history of opera, the activities of several well known impresarios are reviewed. The significant contributions of Manuel Garcia, Domenico Barbaia, Giovanni Paterni, and others, especially their ability to increase the income of leading opera houses, are presented. The paper concludes by showing the importance of the new impresarios and musical education for the future of the live performing arts.

INTRODUCTION

The modern **impresario**[1] should have no knowledge of anything pertaining to the theater and should know nothing of music, poetry, painting, etc.

He should contract, through friends of friends, **scenic artists, musicians, dancers, dressmakers, stage extras**, etc. and try to cut down on the costs of these **people** so that he can pay more to **i musici** (castrato soloists) and above all **the female artistes, the bear, the tiger, the lightening flashes, the thunder bolts, the earthquake effects**, etc.

When he receives complaints from the artists about their **roles**, he should send **express instructions** to the poet and the composer so that they **ruin** the drama but satisfy the artists.

He should contract **inexpensive musicians** and **reputationless girls** and should ensure that they are **flighty** rather than **virtuous** and that they have plenty of **protectors**. He should **rent boxes, stalls, balconies, ticket offices**, etc., as quickly as he can once he has taken over a theater so that he can pay his **rent** punctually and have sufficient money for **wine, wood, coal, and flour** for the entire season.

The aforegoing is taken from a most instructive and amusing book *Teatro*

alla Moda (*The Fashionable Theater*), written by the composer and satirical author Benedetto Marcello (Venice 1686—Brescia 1739) and was first published in about 1720. *The Fashionable Theater* gives "advice" to almost every category of theatrical and musical artist or worker: poets, composers, *musici* (castrato soloists), *cantatrici* or *virtuose* (female soloists), impresarios, orchestral musicians, scenery designers and painters, dancers, comediennes, dressmakers, pages, stage extras, prompters, music copiers, lawyers, protectors (patrons were of two kinds—those who helped the theater and those who were on intimate terms with the virtuose), program sellers, ticket vendors, virtuosas' mothers, etc. A section is dedicated to the setting up of raffles, lotteries, and gambling circles, and also to a series of "supporting workers" such as singing teachers, carpenters, and blacksmiths.

It should be remembered that from the origins of melodramma until the eighteenth century, great importance was given to spectacular stage settings. Venice, in particular, was famous for opera productions which revolved around scene changes perhaps even more than around plots and music. Giacomo Torelli introduced the use of a lever for quick changes, and the public was quite used to seeing heavens, oceans, thick forests, and deserts making way for regal palaces and dim, dark caverns. Many impresarios hired elephants, camels, horses drawing carts or carriages, and even dancing bears with the same ease with which they hired musici and virtuosas. Stage engineers were much in demand for the production of lightening flashes, thunder claps, rainstorms and even earthquakes.

The term "impresario" encompasses many different roles today: agent, mediator, promoter, talent scout, administrator, general opera director, marketing manager, publicity expert, financial consultant. This term was originally applied to a profession halfway between that of a theatrical administrator and director and that of a promoter of opera and musical events.

From the seventeenth century onward private owners of theaters (buildings that would later be built and run by municipalities or states) rented out their property, sometimes for only a single season, to an impresario who was responsible for the hiring and payment of librettists, composers, singers, musicians, dancers, stagehands, scenery painters, costume and wig makers, and all theater personnel, from those used for shoveling wood into basement ovens to women selling tickets, flowers, and lemonade. The impresario covered his costs and earned his livelihood by the sale of tickets. Since subsidies (or financial help from local or national administrations and/or private patrons) were virtually unheard of, further income could come from differing sources and above all from the renting of boxes, balconies, and stalls inside the theater and the installation of, and profits from, a gambling room inside the house—such as that at the San Carlo Opera House in Naples or the construction of a casino like that in Monte Carlo. The impresario was financially responsible for his seasons and could become extremely wealthy or even end up in a debtor's prison like Perrin, the first director and impresario of the Paris Opèra. He could also, of course, "break even" if he paid his artists lower fees than was normal or if he

programmed popular works that the public was prepared to see over and over again. If the impresario were particularly illuminated he could also discover new composers and commission new works, guide and refine public taste, and even introduce new artists, and create careers, schools, and even artistic genres.

The term "impresario," used in Italy from the end of the sixteenth century until the middle of this century, was applied to a person who might well own a theater, a private company, or be the artistic director of a number of family enterprises made up of singers and instrumentalists.

SOME EXAMPLES FROM THE HISTORY OF OPERA

In this context mention should be made of the tenor Manuel Garcia, famous in operatic history as the first Count Almaviva in Rossini's *Barber of Seville*, father of two great prima donnas, Maria Malibran and Pauline Viardot Garcia, and of the most important singing teacher of *belcanto,* Manuel Garcia, Jr. The elder Garcia was a composer, organizer, teacher, and impresario and took the entire family (as well as cousins and distant relations) and many friends on tour, first to London for performances and then in 1825 to New York where he presented the first full-length season of Italian operas. From New York the company traveled down through America to Mexico City where, for two successive seasons, Garcia ran the Municipal Theater.

In today's musical world the impresario is usually a large company employing a number of professional organizers with effective publicity and promotion departments. This impresario occasionally "creates" a musical or theatrical production and is thereby known as a "promoter"; but generally speaking the work of the modern impresario is synonymous with that of a major artists' agency or a recording company. It is no secret that many of the artistic decisions being taken by opera houses, festivals, and symphony orchestras are "helped along" by jet-traveling entrepreneurs with monthly salaries from organizations considerably larger than that of the Garcias of yesterday's world. On the other hand, the promoter of Broadway musicals, West End shows or rock tours has much more in common with the Italian impresario than may appear at first glance.

Italian Opera was created as an amusing pastime for the upper echelons of society but by the time the seventeenth century was underway, many smaller Italian cities (and many which were far from small—Venice, for example) had begun to build municipal theaters. Here, the presence of an impresario (sometimes the owner of the theater but more often than not a free-lance entrepreneur) was essential, which confirms that music production was first, and foremost, a commercial undertaking. The seventeenth century also marks the creation and hiring of singing "stars" whose presence in a "piazza" (the name given to a town or theater where a company or production was based) was essential for box-office well being. The public soon tired of hearing the same operas night after night and this led, inevitably, to the demand for new, contemporary works. Music history remains indebted to impresarios like Domenico Barbaia, Giovanni

Paterni, Vincenzo Jacovacci, Bartolomeo Merelli, Alessandro Lanari, and many others who not only set up commercially solid enterprises but who also commissioned and produced new works from Rossini, Bellini, Donizetti, Verdi and the hundreds of composers who represent all that is meant when we talk about Italian Opera.

The "opera industry" flourished until the arrival of the gramophone, the radio, and the film industries, all of which can do without live performers and stagehands. The artistic and economic growth of this industry was due to the impresarios who invested time and money in new ideas, creations, and even in new buildings. By the middle of the last century the Italian middle classes were comprised of lawyers, doctors, government and bank employees, wealthy landowners and farmers, teachers, and tradespeople. This was the class that earned money and was prepared to spend it on entertainment. It had very little contact with the aristocratic world and even less with the lower classes and was itself subdivided into two "underclasses" that kept the same distance between themselves (and the same distrust) as that between the upper middle classes and the aristocrats. One segment of the middle class grew steadily wealthier due to financial speculation, and it was this class that invested in musical activities and built new theaters.

The Roman Teatro Alibert, also known as the Teatro delle Dame, had been built as a financial investment by Count Antonio Alibert and after an initial period, when it had obtained the patronage of the Sovereign Order of Malta, it was gradually rented out to a series of impresarios. Among the first were the Balmas Brothers, who used it for gambling and cock fighting, and Madame Tourniaire, who used it for circus shows and pantomime performances; it then "fell into" the hands of a certain Giovanni Paterni, a wealthy wine and spirits merchant. Born in 1799 (he died in Florence in 1837), he had a reputation for stinginess. He tried to spend as little as he could on new productions. In 1820 he ran the seasons at Teatro Valle in Rome. This theater was originally built in wood in 1730, and was the theater in which the first productions of many Rossini operas (*Demetrio e Polibio, Cenerentola, Torvaldo e Dorliska*) as well as many first Roman performances of operas by Mozart and Verdi were to take place. Paterni was criticized in the papers for the "indecent costumes" that his choristers wore. Eleven years later his company sent an official appeal to the city governor of Rome complaining that it could not live on the wages paid by Paterni. In 1833, however, the impresario convinced Donizetti to compose *Torquato Tasso* in only three months for a fee of six hundred scudos.

The composer Hector Berlioz, who stayed in Rome during the 1830s, remarked that the theaters produced operas with "scratch" orchestras made up of people who did other jobs during the daytime: "There is usually only one violoncello. This is a man who works as a goldsmith during the day and he is far better off than his colleague in the pit who works as a straw-seat maker." Another composer, Felix Mendelssohn, considered the Rome opera-house orchestras "little better than screaming cats necessitating a radical reform." When Alessandro Lanari (1790–1862), known as the "King" or "Napoleon" of "All

Impresarios," took over the Apollo Theater in Rome in 1834 the *Rivista Teatrale di Roma* wrote that "the orchestral musicians talk all the time, they applaud the singers on stage, and when they are taken to task by the public they get up and leave their places and walk around the theater." However, notwithstanding the unorderly behavior of the orchestral players, this theater produced the first performances of *Il Trovatore, Un ballo in Maschera,* and *Duca d'Alba* and was also the scene of many of the Roman premieres of other operas by Verdi.

The present day Teatro dell'Opera di Roma was the brain child of a hotel proprietor, Domenico Costanzi, who was born in Macerata in 1819. In 1851 he opened a small hotel in one of the principal thoroughfares of Rome, in the via del Babuino, and within a couple of years had made enough money to build two large hotels in the same area, the Albergo di Roma and the Albergo di Russia. He followed these with a hotel that still stands today, the Hotel Quirinale.

Costanzi quickly realized that foreign tourists coming to visit the Vatican City wanted to hear Italian opera but that the other Roman theaters presenting these were in unpleasant and dangerous parts of the city. Furthermore, as the result of his research, he discovered that the impresarios running those theaters preferred to rent out boxes and balconies to families from the lower middle classes.

Costanzi decided to build a large theater on land next to his Hotel Quirinale and determined that this should cater to upper-middle class residents and foreign tourists. He completed his building within 18 months and made a contract with an impresario-administrator, Vincenzo Jacovacci, who was to be responsible for the day-to-day running of the theater, the mechanics, and the stagehands, and who was also to form a company for the inauguration of the building, and for eight performances of Donizetti's *Lucia di Lammermoor.* The initial contract also stipulated that from the 20th of December until the 12th of February the program should consist of symphonic instrumental and vocal music. From the 12th of February until the end of the carnival season Jacovacci had to organize at least 12 balls, and on the 2nd of March Costanzi would take back his theater and organize his own programs. The Teatro Costanzi opened on the 27th of November 1880 with Rossini's *Semiramide*; subsequently the direction of the theater passed into the hands of the Milanese publisher Sonzogno who had already tried to take over the running of the Teatro La Scala, then very much in the hands of the publisher Tito Ricordi. Edoardo Sonzogno (1836–1920) commissioned new works from young Italian composers and produced the first performances of Mascagni's *Cavalleria Rusticana* and then *L'amico Fritz, Lodoletta, Il Piccolo Marat* as well as operas by Puccini (*Tosca*) and Zandonai (*Giulietta e Romeo*). In 1911 Teatro Costanzi was directed by the soprano Emma Carelli, and in 1928 it was given a new name Teatro Reale dell-Opera.

Musical life in Milan today centers around the Teatro La Scala, a couple of symphony orchestras and a number of long-established concert societies. Operatic activity, even within this great city, was always secondary to that of cities like Rome, Venice, Naples, and even Parma. The Teatro Carcano opened in 1803 with Federici's *Zaire* and also housed productions of ballet, prose, and

variety. Donizetti's *Anna Bolena* was first produced in this house, as was Bellini's *Sonnambula* in 1831. In 1833 Carcano also put on the first Italian concert entirely devoted to the music of Richard Wagner. In the 1890s Sonzogno bought the Teatro Cannobiana (originally built in 1779), redesigned the interior, modernized the seating arrangements, changed its name to Teatro Lirico, and began his Milanese series (in 1894).

First he produced Samara's *La Martire,* followed in 1897 by Cilea's *Arlesiana,* which saw the debut of tenor Enrico Caruso in the title role. It was in this theater that Cilea's *Adriana Lecouvreur* and *Fedora* were first performed, as were Giordano's *Marcella,* Leoncavallo's *Zazà* and works by many foreign composers such as Massenet, Berlioz, Charpentier.

While Sonzogno and Ricordi were both publishers with vested interests in their program choices, an earlier impresario such as the aforementioned Allessandro Lanari was not. He left much personal correspondence from which it can be seen that he was as concerned with the well-being of his artists as he was with that of his composers and librettists. In the course of his lifetime he not only commissioned *I Capuleti e i Montecchi, Norma, Beatrice di Tenda, L'Elisir d'Amore, La Parisina, Pia dei Tolomei, Maria di Rudenz, Attila,* and *Macbeth* but also many other operas that have not remained in the general repertoire by Pacini, Mercadante, and Ricci.

The impresario Bartolomeo Merelli (Bergamo 1794–Milano 1879) is often considered the most Milanese of all impresarios, and in fact he began his career in the city to which he travelled as a young man to study law and where he found himself working for a theatrical agency. In 1818 he followed an opera company to Vienna, impressed the Viennese with his business acumen and was nominated director of the Imperial theaters. He opened his own artists' agency and then set about organizing seasons in London, Berlin, and St. Petersburg. On his return to Milan in 1826 he continued his agency work but also ran seasons in Como and Cremona and from 1836 until 1863 (with few interruptions) he took over the direction of all the performances at the La Scala Theater while continuing to run those in Turin and in Vienna. On very good terms with Rossini, Bellini, and Donizetti, he was responsible for the contract which took Rossini to Paris for *Guglielmo Tell,* as well as that which introduced an all-Italian company into the Thèatre des Italiens in Paris. He commissioned Donizetti's *Lucia di Lammermoor,* Mercadante's *Giuramento,* Pacini's *Saffo,* and all of Verdi's early operas: *Oberto, Nabucco, I Lombardi Giovanna d'Arco.* One of the most famous impresarios of all times, he also wrote a book of memoirs entitled *The Memories of an Eighty Year Old Musical Dilettante.*

But above all Merelli has left behind a long series of anecdotes which describe very clearly the relationship between an impresario and the people working for him. It is said that he had to audition the future prima donna Maria Malibran and that she decided to sign one of her own compositions, a pastorale (she was also an accomplished composer).

"Do you like it, Merelli?" she asked.
"Very much," replied the impresario, "but I prefer you."

He put her under contract for a fee of 3,000 Austrian lire per performance and regained his investment by astute publicity of the diva. On one occasion he even held an auction of some items of personal clothing that Maria had left in her lodgings: a pair of old slippers and a dressing gown. Merelli always said that "singers were useful for more than just singing."

The most fascinating impresario in Italian history is, without a doubt, the Milanese Domenico Barbaia (Posillipo–1778 Naples 1841). It is said that Barbaia, or Barbaja, was for Rossini what Merelli was to be for Verdi—a businessman-friend who, while looking after his own economic interests, also managed to commission and produce some great music. (He was also the lover of Isabella Colbran, who then left him and the King of Naples to marry Gioacchino Rossini.)

Barbaia began his life as a waiter in a Milanese cafe where he is credited with the invention of the "barbaiata"—coffee or chocolate served with whipped cream. He earned enough to be able to win the tender put out by the La Scala Theater for the gambling rooms in the entrance hall of the building. He was later nominated director of the Neapolitan gambling halls and, above all, of those within the San Carlo Theatre. When this theater was completely destroyed by a fire in February 1816, Barbaia had it rebuilt in less than a year and took over the direction of the house. Between 1821 and 1828 he also gained the direction of two theaters in Vienna where he introduced operas by Rossini, Bellini, and Mercadante. In 1826 he won a contract as impresario for Milan's La Scala Theater where he programmed works by Bellini, Donizetti, and, of course, Rossini.

It is said that Barbaia had only one thought in his head: to make as much money as possible. He was well known for his avarice and for his hard treatment of singers, composers, and dancers. He had, however, a sixth sense for "quality" and commissioned a long series of new works from Rossini: *Elisabetta regina-d'Inghilterra, Mosè, Il Turco in Italia, Otello.* Barbaia's sixth sense also made him import new operas for the San Carlo Theater and later for La Scala: Spontinik's *La Vestale,* Mozart's *La Clemenza di Tito,* Gluck's *Ifigenia in Aulide.* He helped to enlarge the repertoire currently in vogue, and he also insisted upon the orchestration of all "recitatives" in the operas he produced thereby hastening the arrival of a *durch componiert* (total music work) as can be seen in Rossini's *Elisabetta* or in Mayr's *Medea a Corinto.* Every European country (and the United States) has a number of impresarios who have worked their way into music history. Certainly one of the most famous non-Italian impresarios and entrepreneurs of the last century would have liked to become a singer had the salaries available been large enough. Perhaps it is just as well that he did not succeed.

Maurice Strakosch (1825–1887) was born in a Moravian village where he made his debut as a child pianist. He traveled to Germany, studied composition

with Sechter in Vienna, and finally obtained a contract as a singer with the
Zagreb opera house. Economic problems led to the breaking up of the company
and Strakosch traveled to Italy where in 1843, in the Teatro Italiano in Vicenza,
he met the Patti Family, a large traveling company of singers and musicians led
by the father, singer and impresario Salvatore Patti. Strakosch set out to organ-
ize a tour for the Pattis in the United States in 1848 and, after the success of
this, he married one of the Patti daughters, Amalia, and started to give singing
lessons to another daughter, Adelina. He organized her debut in 1850 in New
York, and her theatrical debut as *Lucia di Lammermoor* took place at the New
York Academy of Music in 1859. Strakosch "invented" the "Queen of Bel-
canto," Adelina Patti, and took her to London where, from 1861 onward, she
sang for 25 consecutive seasons. He organized the private life and career of the
"greatest soprano in the world" and made her one of the most highly paid
singers in operatic history. But Strakosch did more than just "invent" Patti. He
also brought European artists to America and American artists to Europe. His
brother Ferdinando Strakosch directed theaters in Rome, Florence, Trieste, and
Barcellona, and his brother Max followed Maurice's activity at the Teatro
Apollo in Rome and at the New York Academy of Music. He was succeeded by
his son Roberto and also wrote a guide book for would-be impresarios with the
title *Memories of an Impresario* (Paris 1887).

COMMENTARY

In the course of this century, all the major theaters, orchestras, and festivals
have been placed, by their administrative committees, into the hands of salaried
directors; and even if many of these (Gatti-Casazza, Rudolph Bing, Francesco
Siciliani) have been real "talent scouts," they have come to rely more and more
on agents who earn their livings as representatives of artists and musicians but
who are not in a position to "create" new works or new genres. Some agents
work more as artistic secretaries and are purely mediators without real knowl-
edge of voices, instruments, or even repertoire.

Financing for musical activity is found in part within state culture budgets
(as in Italy) and in part from private sponsorship for "events," individual
productions, or special festivals and concert series. It is said that ticket sales
alone are insufficient to cover the running costs of theaters and concert halls. It
is also said, time and time again, that there is a dichotomy between what the
public will pay to hear and what composers would like to write. Many musicians
and critics complain that the general public has little or no interest in contem-
porary works. And yet, if one reads newspaper reports, or even private corres-
pondence, written from the late sixteenth century onward, one is faced with the
same problems of how to fill a theater, and how to present new works. Promo-
tion and ticket sales are not new problems.

It is highly probable that it was easier to have a full opera house when there
was nothing else going on—no cinema, television, records, home video. The life
and work of the impresarios would suggest, however, that theaters always had

to be filled and tickets sold. The public has to be convinced to leave home, travel across cities (in past centuries these had unlit streets, bad pavements, thieves and pickpockets en route), and then buy tickets and stay put until a performance ends. Barbaia and his colleagues covered many expenses with collateral activities: gambling halls, refreshment rooms, the sale of mementos ranging from "sonnets" about the singers to smelling salts and printed music. Famous singers were not employed for every performance nor were box office "lollipops" always planned.

How did the impresarios do what they did? They cut costs by reducing salaries and by putting soloists and musicians under long-term contracts. They used their own costumes and scenery for as long as they could. Modern opera magazines often give the impression that the "stars" of the show are the new scenic effects or the "designer label" costumes. When an impresario had a set of Royal Turkish gowns he used them for every plot set beyond the Mediterranean Sea.

Far be it for me to suggest that theaters and festivals should set up slot machines in their Green Rooms or restaurants, but the special rooms for the sale of mementos, books, and records (as witnessed at the Metropolitan Opera House in New York) have certainly proved successful.

The primary problem today is that of music education. Until the beginning of this century, the seat-paying middle classes all knew how to listen to music because they went to the opera from the time they were children. They bought pianos (of all dimensions), and they also bought printed music which they played for their own amusement. To play and sing music presumes that you can read it. Singing and playing music is a wonderful way of preparing for a performance given by professional musicians. Whatever record companies may believe, pushing a CD into a Wakman is not the same thing.

This article began with Benedetto Marcello's instructions to a modern impresario and must end with some thoughts on new guidelines that might be useful for present-day entrepreneurs who would like to maintain old traditions and create new ones.

Marcello talked about the preparation of librettos, of new opera scores, of stage effects, of publicity and promotion (I wonder how many singers today would pass unobserved if they traveled with parrots or owls?), of filling theaters, of coping with tantrums. Marcello, however, was writing about the theater in an age when the public considered an evening at the opera "great fun" and when the same public went to church to hear a sung Mass, and to coffee shops for the latest news about the opera "stars" of the day, to catch up on what was "in" or "out."

Impresarios knew that the public would buy tickets for "stars" but also for new stage effects and new works and performers. If they got the combination right, they could sell all the seats in the house. But they could also create new masterpieces and send the public home singing.

Times have changed and perhaps the next century will bring with it a new breed of impresario-entrepreneurs who may just have to start their subscription

campaigns in a different way. They are probably going to have to push to have live music taught and practiced in all schools. When children are again singing songs (of all kinds) and are playing musical instruments, then we shall again have a new public for what will obviously be a new kind of musical adventure.

NOTE

1. The words in **heavy type** are written as in Marcello's original: his text is literally peppered with **heavy type**.

Positive Rationales for Corporate Arts Support

Roland Kushner

ABSTRACT

Corporate arts support is sometimes normatively criticized because it does not overtly increase firm profits. This chapter presents a positive analysis of corporate patronage of the arts, using five rationales. Three are criteria used to maximize the interests the of share-owner: economic rationality, individual managers (the rationality of individual incentives), and other constituents (stakeholder management rationality). A rational process is carried out technically with external (interorganizational rationality) and internal (procedural rationality) systems. It is argued that these rationales are practiced in all corporate patronage actions. Implications are drawn for contribution managers, arts managers, and for future research.

INTRODUCTION

To business critics and theorists advocating share-owner wealth maximization as an optimum, arts support and many other types of philanthropy are perverse, smacking of managerial discretion run amok. How, it is rhetorically asked, can such behavior be justified when contributions are demonstrably less important than return on investment to share owners (Epstein 1993)? Friedman (1972) challenges managers who make social and philanthropic spending decisions. According to these views, corporate support of arts, other nonprofit activities, and social spending in general have no place in the objective function of the firm. There is no normative justification for donations that is as important as profitability is as a motivator for business decision making. In general, observers and shareholders expect corporate actions to be directed primarily toward this objective and doubt that philanthropy (in any area) leads to ultimate profitable results.

Empirically, corporate support of the arts is extensive, and, while not growing as fast as in the 1980s, it is still a widespread phenomenon. The Conference Board's report on 1992 describes corporate giving in 371 large companies.[1] Arts support by these firms made up 11.8% of their total 1992 donations, and the median corporation in the sample gave 9.6% of its contributions to the arts, totaling $243.6 million (Buenventura 1994). *Giving USA 1994* concurs in the 11.8% estimate, implying that total corporate giving to the arts in 1992 was $698.9 million (American Association of Fund Raising 1994). Arts support from 1988 to 1992 was between 11.2 and 11.9% of total donations.

Despite criticisms, then, American business maintains substantial and ongoing support of the arts. This indicates a discrepancy between reported and imputed motives on the one hand, and apparent actions on the other. This calls for exploration, and perhaps explanation, of why corporate support of arts has such vitality. This chapter addresses these questions from a positive perspective, suggesting explanatory theories for the behavior. In Stultz's (1980) delicious phrase, corporate philanthropy is "motivationally complex"; this chapter untangles some of the complexity without relying on a theory of altruism or justice or a moral assertion that business has a duty to contribute to the arts. Plainly, firms support the arts; with this given, the issue of interest here is not whether they *should*, but why they *do*.

The thesis advanced here is that firms have multiple means to explain, justify, and rationalize their arts expenditures that do not require a moral underpinning, but can be explained in positive terms as a matter of business policy. This chapter presents these arguments descriptively rather than normatively: theories and anecdotal evidence are presented, and the conflicts between certain theories are explored. There is no a priori assertion of the superiority of a particular explanation; what is proposed is that these all operate simultaneously when corporations make arts donations or refuse to donate. They are theoretically designated as entering in donation decisions in either substantive ways, relating to the interests whose preferences are to be met, or in procedural ways (Simon 1982).

The chapter presents five rationales for corporate support of the arts. Together they provide a framework of justification that can be used to explain this confusing type of business spending. As the rationales are stated, they are developed and demonstrated with data acquired while researching and observing nonprofit arts organizations and a corporate patronage market in an eastern state from 1984 to 1994. Implications are drawn for research and practice.

RATIONALES FOR PATRONAGE OF THE ARTS

The first three rationales are substantive in character. They identify the interests that are served and thereby articulate the criteria used in decision making; the others are procedurally rational, indicating the means by which those interests are served. The three rationales which identify the interests being

served are economic rationality, in which all activities of the firm are planned explicitly to contribute to profit maximization; the rationality of individual incentives, which explains support of the arts as a characteristic of specific individuals in a corporate structure; and stake-holder management rationality, which considers how firms attend to demands imposed simultaneously by constituents and shareholders. Two rationales speak to procedural issues: as participants in networks of organizations, firms practice interorganizational rationality to interact with certain kinds of external organizations; and, firms practice technical rationality with internal decision structures and administrative processes to efficiently manage patronage.

ECONOMIC RATIONALITY

Financial economics theorists (e.g., Fama and Jensen 1976; Jensen and Meckling 1986) look at corporations and corporate management as agents for shareholders. In a share-owner wealth-maximization regime, managers' act in the interest of shareholders. This interest is measured by the present value of profits, discounted back to the present time at rate(s) reflecting risks associated with different upcoming events. That is, where W_0 is share-owner wealth, R_t and C_t are revenue and cost for time periods $t = 0, 1, 2, ..., T$; and $i_{p,t}$ is the interest rate i at which events of different risk classes ($p = 1, 2, ..., j$) and occurring at different times are discounted back to the present.

Economic rationality treats arts support as a specialized form of promotion which should return risk-adjusted net revenues comparable with those of any other promotion. The worth of any project is in its impact on the bottom line so analysis focuses on profitability. Arguably, arts support is a high-risk technique to generate revenue when compared with other marketing devices. Cause-effect relationships may be less clear because of novelty or unfamiliarity. In the language of equation (1), arts support falls into a higher risk class p_1 than, say, an ad campaign, p_2. Economically rational patronage should be based on a methodologically sound projection that arts support will lead to desired financial results.

Typically, the term "sponsorship" indicates support which is promotional rather than philanthropic in nature, and where some specific marketing benefits are anticipated (Bergin 1990). Chew (1992) measured the impact of AT&T's support of news programming on public television and found that viewers who were aware of the funding rated AT&T higher in multiple areas relating to customer services than those who were unaware. Mescon and Tilson (1987) provide multiple examples of how firms integrate sponsorship of visual and performing-arts organizations into their overall marketing plans. A case example from the festival industry shows how a firm pursued specific marketing objectives with sponsorship.

In the mid-1980s, a bank in a mid-sized city sought to increase its visibility in a neighboring county. Expanded presence, it was believed, would lead to

increased retail activity and commercial lending. Concurrently, an entrepreneurial civic group was organizing a major new arts festival in that county's largest city. The bank perceived that supporting the festival was a means of reaching this market, and committed extensive resources to it, including the services of the bank's advertising and design firm. At the time, and for that market, the financial and organizational commitment was innovative and large scale.

The festival was a success and the sponsorship gave the bank new entrées into commercial and retail marketplaces into the late 1980s. In the 1990s, it appeared that additional festivals had diminishing incremental impact on revenues, and the bank reduced its support. A bank executive reviewing the episode some years later agreed that it had been a "good investment." Moreover, the festival's donations from other businesses skyrocketed, as other regional and national firms clearly found comparable opportunities to implement marketing strategy.

What defines this episode as being economically rational is exchange, rather than altruism, as the justification for support. In making their decision, the firm sought specific benefits in return. In addition, the impetus for support came from the marketing department, pursuing an objective articulated in a strategic plan. That plan incorporated operational follow-up in retail and commercial lending activities. Whether successful or not, a decision can be justified that anticipates improved revenues, decreased expenses, or both, and can be defended as a sound business decision in a share-owner wealth maximization regime.

THE RATIONALITY OF INDIVIDUAL INCENTIVES

For many arts organizations, fund-raising techniques include the use of personal premiums, invitations to social events, and other incentives to attract donations from businesses as well as from individuals. In the festival described above, corporate sponsors hosted a reception in a restricted part of the festival with close access to featured performances. The well-watered VIPs at such an event may well be achieving corporate purposes but are clearly enjoying personal rather than corporate benefits. In this setting, forces in addition to share-owner interests are driving firm behavior.

Another view of patronage, then, explains corporate support of the arts as a function of the interests of individual executives. If economic rationality is the first order of business, this motive can be viewed as a means for managers to exploit shareholders. Friedman (1972), for instance, challenged corporate social spending in general as immoral because managers who make such allocations are, in effect, expropriating share-owner proceeds. According to Friedman, managers should earn maximum returns for shareholders, who then make their own social or artistic spending decisions. Managers should not make these decisions for them.

Still, arts support often stems more from the desires of individual managers than from "business purposes" for several reasons. Shareholders may object to patronage founded on a personal-consumption incentive, such as when a recipient organization produces art that matches the executive's personal preference. This can be portrayed as noncash compensation. When the executive is a trustee or other volunteer with the arts organization, firm support correlates with the executive's personal time (or perhaps that of the executive's spouse). In yet another situation, incentives offered by the nonprofit event or organization benefit the executive rather than the firm. When the executive receives free tickets to the reputation-laden charity ball, when sponsorship gifts go to the individual rather than the corporation, and in other circumstances where the individual benefits, personal exchange can be the rationale. Where the chief executive officer is the final decision maker (as in art acquisition, e.g., Martorella 1990), individual incentives and executive power will affect firm decisions.

Economic rationality champions the share owner's wealth as the firm's optimum goal, with individual utility at most a subgoal that should not figure into a firm's decision making. But this pre-supposes that ownership and control are separated, a common characteristic in a publicly owned firm. In smaller or family-owned businesses, both rights likely rest in the same individual. It is interesting, then, to note that there are more family-owned firms and many more smaller firms in the United States than there are large, publicly traded firms. Table 21.1 compares proprietorships, partnerships, and corporations in 1989.

Table 21.1 shows asymmetry between the distribution of business as a phenomenon and the distribution of business receipts and earnings. Clearly, large companies generate the most receipts and profits. Equally clearly, most companies are small. If $25 million in assets is a dividing line between private and public ownership, ownership and control are separate in cases accounting for 64% of receipts and 89% of profits. So, for arts organizations, the greatest potential lies with larger companies where normative prohibitions against individual incentive rationales may govern. But, small business is more common. Corporations with sales over $10 million make up only 0.4% of all businesses. Generally, in smaller businesses, managerial decision making parallels shareowner choice. Philanthropy as noncash compensation does not conflict with firm optima if manager and owner are the same. In a small firm, patronage that is not an economically rational use of firm resources can nonetheless be a fully legitimate individual expenditure.

Another arts festival has worked, over a period of years, to raise money from small business owners. This has required considerable resource allocation to development (small donations take as much effort as large ones), but has generated interest among a wider business community. In so doing, they are creating loyalty among businesses whose potential to donate may increase. An Indiana University study suggested that small businesses are more generous, with firms of 100 or fewer employers giving 3% of net income to charity compared with 2.5% for larger firms.[2]

Table 21.1
Distribution of Business Activity by Business Type and Asset Size, 1989

	Business Type			
	Proprietor-ship	Partner-ship	Corporation < $10 Million Sales	Corporation ≥ $10 Million Sales
Business tax returns	72.8%	8.4%	18.4%	0.4%
Business receipts	5.9%	4.0%	18.8%	71.3%
	Asset Size			
	Assets < $25 Million		Assets ≥ $25 Million	
Business receipts	35.3%		63.7%	
Net Business Income	10.8%		89.2%	

STAKE-HOLDER MANAGEMENT RATIONALITY

In a stake-holder management approach, the corporation is viewed as "an organizational entity through which numerous and diverse participants achieve multiple, and not always congruent, purposes" (Donaldson and Preston 1995). In the share-owner wealth maximization view, investor interests are paramount and corporate moves are only legitimate to the extent that they contribute to this optimum. In the stake-holder management view, a firm is a nexus of diverse interests from whom resources are obtained and who receive the outcomes of firm activity. Stake-holder management challenges the primacy of share-owner wealth maximization with a perspective that recognizes co-equal interests and contributions of multiple constituents. Employees, customers, communities, suppliers, and governments are recognized broadly as having legitimate interests in the outcomes of corporate decisions.

The case that philanthropy is an appropriate way to interact with broader communities has been made in the courts and in academia. In *A.P. Smith Manufacturing Company v. Barlow*, a New Jersey court recognized that gifts contributing to "the betterment of social and economic conditions [allow] corporations to discharge their obligations to society while reaping the benefits which essentially accrue to them through public recognition of their existence" (cited in Stultz 1980). Shaw and Post (746) argue that "corporate stockholders in their role as stockholders and in their role as members of the social community, share with all others the obligation to act, or to follow a rule governing a class of acts, that will maximize the public welfare."

A firm serving multiple interests can legitimize arts-support policies as a means to fulfill the needs or wants of one or more constituent groups. Arts support may fall into the "wants" category more clearly than the "needs" category and so, like contributions motivated by the desires of individual executives, patronage is easily criticized. The same rhetorical critic cited in the introduction can question the use of corporate resources to support an arts agency as a means to placate employees. Nonetheless, when firms support the arts in order to distribute returns to resource owners other than investors, then stake-holder management may be the rationale.

Employees appear to strongly influence corporate donation decisions. In matching-gift programs, workers choose the recipients of corporate generosity. Similarly, employees' willingness to volunteer with organizations provide directional signals as to appropriate recipients of company financial support. Voluntary employee commitment most clearly differentiates stake-holder management as a rationale for patronage from individual incentive. An individual manager can undoubtedly channel firm financial resources to an arts organization. Upper-level managers may also be sensitive to "quality of life" and "corporate citizenship" issues. But employees at lower hierarchical levels, volunteering their own time, also signal the overall charitable character of a firm.

Community factors play a role in patronage when "corporate citizenship" is the justification. Firms concentrate donation dollars where their facilities are located regardless of where their sales originate. Rider (1994) found statistically significant differences when comparing local sales with contributions and national/international sales with contributions. A greater proportion of donations was made locally than the proportion of sales dollars generated locally. This supports the notion that donations are made first to local communities regardless of where sales originate.

While human-service donations may be justified as a means of solving problems in a community, arts support can be more readily associated with community-advancement intentions. A festival manager, recently retired from a long career as an executive in industry, said:

[It] helps to answer some questions when a spouse is brought it, we're interviewing a new metallurgical engineer, or a new sales executive, and they're coming in from Ohio or wherever, and they're looking at school systems, but they're looking at the cultural base. You know, what is here for the kids, I mean, "We were active in Toledo in the Symphony" or "We used to attend this." You know, "What are all these things [here]?"

Firm support of the arts cannot feasibly be tied to specific recruiting decisions; the implication is that sustaining the cultural level of the community is a continuing policy.

To this point, the interests of shareholders, individual managers, and other stake holders have been considered and explained. Serving these interests provides deterministic criteria for use in donation decisions. Rationality, however, connotes that the criteria inherent in preferences are used to implement patron-

age policy. The next sections describe first external and then internal factors that come into play as these criteria are applied.

INTERORGANIZATIONAL RATIONALITY

Patronage is a boundary-spanning function in which businesses interact with other organizations. Factors relating donors to nonprofit recipients and to other firms play a role in arts support. In the political economy between business and nonprofit sectors, firms purchase donations and nonprofits sell them. Firms purchase donations to satisfy economic, individual, or stake-holder objectives, and nonprofits sell donations to achieve similar objectives, and others related to a specific program mission. These can be studied as organizational purchasing, similar to the way that goods or services are purchased for any other corporate purpose. Campbell (1985) classifies buyer and seller strategies as competitive, cooperative, or command. A situation in which there are few cultural organizations in a community (command-marketing strategy) and many prospective business donors (competitive-purchasing strategy) is described as a seller's market. In this situation, a focal organization might be the only one providing cultural services of a desired type. In a buyer's market, many nonprofits seek donations (competitive-marketing strategy), and a smaller number of firms are willing to make donations (command-purchasing strategy). Small cultural organizations typically face buyer's markets, while major cultural institutions find it easier to interact with firms with a wider marketing scope and a larger cultural contributions budget.

Donations are influenced by the types of nonprofits with which a firm wants to associate, planned uses for patronage funds, and particular behaviors of a nonprofit. Small firms may, for instance, prefer to support small nonprofits over a community's large cultural institutions. Another interorganizational factor is how donations are used. A firm may only support capital expenses, excluding program or operations. This policy can restrict the pool of applicant organizations to those with capital needs and/or plans. Firms may also pursue or avoid certain kinds of interdependencies with nonprofit arts organizations. On the one hand, being viewed as a steadfast patron to a small number of recipients can reduce boundary-spanning costs and the number of decisions to be made, thereby focusing patronage to best advantage. On the other hand, donations made automatically can make the recipient dependent, a corporate-welfare recipient. For this reason, some firms specify that they will only fund a portion of a project's expenses, or that they will only provide "seed money," or initial capital. A bank's support of a festival in its early years was explicitly designated as seed capital. The bank objected when the mature festival requested continued donations at the same high level.

Recipients, as well as donors, choose the organizations with which they interact. Larger nonprofits find it easier to maintain relationships with business, manage the boundary-spanning, and sustain cooperative relationships with business. Blau and Rabrenovic (1991) found that contact with businesses was

positively associated with a number of indexes of organizational size (full-time staff, income, individual client base, board size). Kushner (1994) proposed that the source of donated funds was a significant area of strategic choice for non-profits. He suggested that for an arts organization serving general community interests with mainstream artistic programming, corporate support would be more important to overall financing needs than for an organization that was pro-grammatically focused on a narrowly defined artistic interest.

Business-arts relationships can help both types of organizations fulfill long-term objectives of strategic importance. The donations referenced here have had the potential, and in some cases the character, of so-called strategic alliances (e.g., Roos and Asborn 1992; Parkhe 1993), in which firms execute extensive, multifunctional contracts with other organizations. The festival referenced in the section on economic rationality maintains multifunction, multilevel, long-term relationships over the years with firms who work actively to contribute to its success. This is consistent with Aiken and Hage's (1968) findings that organiza-tions with joint programs are typically more innovative. Patronage of the arts helps business and cultural organizations develop coordinated communities through mutual adaptation and dependence (*cf.*, Hallén, Johanson, and Seyed-Mohamed 1991).

Interbusiness factors can also affect donation policies. Business funds given to arts organizations position a firm in a network of organizations that includes at least the recipient and possibly other businesses, including competitors. Nonprofits requesting corporate support are often asked to specify the names and sometimes the contribution levels of other businesses, informing a prospective donor of the company they will keep. This enables a business to evaluate the stature a prospective recipient has in the business community, and to consider the competitive impact of collaboration. A decision to donate or not to donate indicates, in part, the types of organizations, business or nonprofit, with whom a firm wants to be associated. The list of donors in the back of the theater program is scanned not only for names, but also for ranking and relative place-ment.

Reputation and reciprocity with other businesses can influence patronage. Reputation as an element in managing stakeholders is self-evident; however, reputation in a business community can also influence arts support. For firms whose principal markets are other organizations, support of arts organizations can enhance reputation and/or position in competitive markets. An interesting question arising here is whether failure to donate impairs reputation. If donor firms have greater status among their peers, does it follow that firms that do not donate have a lower status? Arguably, they do not—reputational benefits are asymmetric. Reputation and its positive consequences accrue to those who give, but damage to those who do not is limited.

Reciprocity between businesses also affects donation decisions. Galaskiewicz and Burt (1991) describe "interorganization contagion" in which views of peers in a social network of corporate contribution officers are considered as firms make donation decisions. Many donation decisions are made by chief executives,

who are commonly members of professional networks of chief executives. On an informal rotating basis, chairmanship of annual campaigns such as the United Way, united arts appeals, or prominent capital campaigns pass between members of this community. Stature in the professional network appears to carry with it the obligation to reciprocate with a firm donation in response to a personal appeal from a peer executive. An orchestra executive director described the corporate-funding environment in a particular community:

> "But really making the appeal on a marketing basis doesn't get it. It's still a *quid pro quo*. The Chairmen of company X and Y . . ."
>
> Q: "They exchange contributions."
>
> A: The unstated message in it is, "When you were the Chairman of the United Way, we got behind you. I'm chairing the campaign for the [orchestra], now it's your turn to . . ."
>
> Q: "And I'll get you next year, right."

TECHNICAL RATIONALITY

Finally, patronage policies generate systems that can be technically rational (Thompson 1967). Klepper and Mackler (1986) describe an effective screening process as "essential for orderly management, and . . . vital for freeing up executive time." They suggest written contributions guidelines to distribute to organizations requesting support, and internal specification of how decisions are to be made, and by whom. Thus, patronage activities generate internal structures and mechanisms to implement decision rules emerging from interest-based rationales. An informed personnel structure involves the staff of departments who respond to economic, individual, and/or stake-holder factors as decision criteria. Thus, when patronage is founded on economic rationality and viewed as an extension of marketing activities, marketing staff are involved in the decision. When a manager's individual interests are to be optimized, a technically rational patronage process puts some or all decisions into that manager's hand. The executive position gives the macroperspective; to the extent that patronage is regarded as delivering strategic, organizationwide benefits, approval of patronage proposals is properly associated with a chief executive. When patronage is seen as extending employee interests, human-resource departments contribute to decisions. Community- and corporate-relations departments may also play a role in patronage. Arts support carries connotations both of charity and marketing, and patronage decisions are often jointly made by marketing and community-relations staff. Given certain departmental representation, the hierarchical level of decision making is affected by the size of a donation, the saliency of arts patronage in overall corporate policy, executive interest, and internal issues of power.

As a purchasing process, philanthropy can be evaluated using techniques used to analyze organizational buying behavior. Möller (1993) suggests that the intensity of search and the degree of commitment are two dimensions which

classify organizational buying. Arguably, the level of commitment should be matched to the intensity of search and selection. A technically rational approach to patronage, then, matches a low policy commitment to patronage to a routinized response to patronage decisions. Correspondingly, if patronage is an important policy domain to which an organization is highly committed, an extended problem-solving approach is more likely.

Firms may experience inertial pressure to support the same cultural agencies as in previous years because it is easier and therefore less costly to maintain a donation pattern than to initiate a new one. To reduce the problem-solving effort, firms may try to purchase as a "straight rebuy," rather than conduct a "new task" purchase by donating to new organizations in each funding cycle (Doyle, Woodside, and Michell 1979). More familiar cultural organizations make it easier to treat donations as standard purchases. Lehman and O'Shaugnessy (1982) suggest that different combinations of standardization, complexity, and dollar commitment can make different criteria (economic, performance, cooperative, or adaptive) more salient in any given purchasing decision. Performance criteria increase in importance when decisions involve novel or complex factors. A cultural organization proposing a new and complex program with a detailed interorganizational contract to a prospective recipient should focus attention on its capabilities and skills to deliver on its commitments in order to facilitate a positive donation decision.

Taken together, these factors suggest that established cultural institutions with histories of successful performance and conformity to donor requirements will find it easier to obtain patronage support than shaky or unknown organizations. In addition to reducing donor concerns about the success of the donation, it is simply less expensive to make the decision.

IMPLICATIONS

This chapter has identified five areas of managerial interest which play independent yet related roles in the ways that business organizations donate to the arts. These areas are described as "rationales" because they identify either preferences (economic rationality) or application (technical rationality). In any given decision, more than one decision, rule, or procedure can dominate. This leads to a number of interesting possibilities for research and suggestions for practice.

A broad conceptual framework in which to study corporate philanthropy has been proposed. While each of the rationales is based on prior studies and theory regarding corporate decision making, this combination of purpose and method has not been considered as it applies to corporate patronage of the arts. An empirical test of this would examine if the rationales are robust and contribute independent knowledge to our understanding of patronage. This could be done with a causal modeling study or some other multivariate technique. While this chapter has focused on corporate support of the arts in particular, the same

issues of substance and procedure apply to multiple areas of corporate philanthropy.

If they are validated empirically, knowing these rationales can help managers on both sides of the donation/fund-raising market by identifying the areas of principal management interest. Business decision makers need to designate the policy issues and the criteria which enter decisions and design procedures which maximize attainment of those criteria. Similarly, they need to inform nonprofit organizations about their criteria and procedures. Nonprofit managers should be aware of the decision environment that confronts prospective donors and the importance of particular criteria. Fund-raising should be a persistent process in which arts organizations judiciously tailor their offerings and solicitations to individual corporate programs.

Finally, the positive intent of this chapter is restated. Clearly there is normative dispute over the appropriateness of criteria other than profit making for corporate decision making. This chapter has not attempted to resolve those disputes, pointing instead toward a multilevel explanation of how and why corporations give money to the arts.

NOTES

Thanks to Don Chambers, Jeff Gordon, Hal Hochman, Jim Lennertz, Victor Rosenburg, and Linda Rider for their comments, suggestions, and interesting theoretical perspectives. An earlier version of this chapter was presented to the Eastern Academy of Management, Ithaca, New York, 5 May 1995.

1. Of these, 240 were members of the Fortune 500 or the Fortune Service 500 in 1992.

2. Cited in the *Chronicle of Philanthropy,* 14 October 1994, p. 15. It is not known if this difference is statistically significant.

Bibliography

ACSA. *Japan's Corporate Support of the Arts*. ACSA, Diamondsha, 1993.
——. *Japan's Corporate Support of the Arts*. ACSA, 1992.
——. *Corporate Support of the Arts in Japan*. ACSA, 1991.
Adeane, Edward. *Telegraph Weekend Magazine,* 19 January 1991.
Agency for Cultural Affairs. *Cultural Policy in Japan: Current Situation and Future Issues*. 1988.
Agrafiotis, D., G. Papagounos, and X. Xiradakis. "Cultural Policy in Greece." Athens, 1985, pp. 13-19.
Aiken, Michael, and Jerald Hage. "Organizational Interdependence and Intra-Organizational Structure." *American Sociological Review* 33, no. 6 (December 1968): 912-30.
Alexander, Victoria D. "From Philanthropy to Funding: The Effects of Public and Corporate Support on Art Museums." Ph.D. diss., Stanford University, 1990.
——. "From Philanthropy to Funding: The Effects of Corporate and Public Support on American Art Museums." *Poetics: Journal of Empirical Research on Literature, the Media and Arts*. Forthcoming.
Allen, James Sloan. *The Romance of Commerce and Culture: Capitalism, Modernism, and the Chicago-Aspen Crusade for Cultural Reform*. Chicago: University of Chicago Press, 1983.
Almeida, C.J.M. de. A arte é capital. *Visão aplicada do marketing cultural*. Rio de Janeiro: Rocco, 1994.
Almeida, C.J.M. de, and S. Da-Rin, eds. *Marketing cultural ao vivo—depoimentos*. Rio de Janeiro: Francisco Alves, 1992.
Almeida, F.A. de. *O franciscano Ciccillo*. São Paulo: Pioneira, 1976.
Almeida, P.M. de. *De Anita ao Museu*. São Paulo: Perspectiva, 1976.
American Association of Fund Raising Council. *Giving USA*. New York, 1994.
American Council for the Arts (ACA). Corporate Giving to the Arts. New York: ACA Books, 1988.

Anderson, Arthur. *Graduate Opportunities*. London, 1992.

Anheier, H., and F.P. Romo. "Foundations in Germany and the United States: a Comparative Analysis of Size, Scope and Variations." In *Foundations—an International Research Symposium Organized by VOLUNTAS, The International Journal of Voluntary and Non-Profit Organisations & Laboratoire D'Economie Sociale*. Edited by Anheier and Knapp. Vol. 1. Sorbonne: Université de Paris; Manchester 1993.

Annibaldi, C. "La Musica e Il Mondo: Mecenati e Committenze Musicali in Italia Tra Il Fourteenth Century." *Edizione Il Mulino, Rome* (1992).

Arimatsu, I. "On Cultural Support of the Arts by Japanese Government." In *Japan's Corporate Support of the Arts*. ACSA, 1993a.

———. "On Cultural Support of the Arts by Local Governments in Japan." In *Japan's Corporate Support of the Arts*. ACSA, 1993b.

"Art's Big Top—The Japanese are Buying Western Fine Art." *The Economist Journal 39*, no. 7579 (3 December 1988): 86.

"Art Collectors Have Tough Time Making Tax Deductions Stick." *Wall Street Journal,* 4 May 1989, p. C1.

"Art Wars." *Sydney Morning Herald,* 14 May 1994, sec. 5.

Balfe, Judith Huggins. "Artworks as Symbols in International Politics." *International Journal of Politics, Culture and Society* 1 (1987): 195-217.

Balfe, Judith H., and Thomas A. Cassilly. "Friends of . . . : Individual Patronage through Arts Institutions." Ed. des Femmes, 1987. Paper presented at the conference on Social Theory, Politics and the Arts, Jacksonville, Florida, 1991.

Barthes, Roland. *The Semiotic Challenge*. New York: Hill and Wang, 1988.

Baumann, T. "The Eighteenth Century: Comic Opera." In *Oxford Illustrated History of Opera*. Oxford, Oxford University Press, 1994.

Bausi, L. "Atti del Convegno Banca e Cultura." *Mondo Economico* 18 January 1992.

Beaumont, Mary Rose. "An Introduction to the Collection." *Unilever House London Contemporary Art Collection: The First Twelve Years*. Catalog. London: Unilever plc.

Beck, James. "Masterpieces and Business." Marco Nardi Press. cf., A.C. Quintavalle. "Distruzione o Restaurazione?." Corriere della Sera, 16 December, 1993, p. 35.

Beisel, Nicola. "Morals versus Art: Censorship, the Politics of Interpretation, and the Victorian Nude." *American Sociological Review* 58 no. 2 (1993): 145-62, 1993.

Benedetti, G. "Sponsorizzazioni nell'arte-Privato meglio dello Stato." *Corriere della Sera,* 6 May 1992, p. 17.

Bennett, O. *British Cultural Policies 1970-1990*. Boekmanchier, England, 1991.

Benstock, S. *Femmes de la rive gauche. Paris, 1900-1940*. Paris, 1987.

Benway, Susan Duffy. "Full of Bull? When Wall Street Prospers, 'Art' Thrives." *Barron's* 66, no. 25, 23 June 1986, pp. 8-9.

Bergin, Ron. *Sponsorship and the Arts: A Practical Guide to Corporate Sponsorship of the Performing and Visual Arts*. Evanston, IL: Entertainment Resource Group, 1990.

Bernstein, Alex. "Granada Television Ltd." in *The New Patrons: Twentieth-Century Art from Corporate Collections*. London: NACF, 1992, p. 48.

Bianchini, F. *Urban Cultural Policies*. National Arts and Media Strategy Discussion Documents 40. London: Arts Council of Great Britain, 1991.

Bibas, A. In *Tehnes and Horigi*. no. 5, 20 November 1994.

Blau, Judith R., and Peter Hall. "The Supply of Performing Arts in Metropolitan Places." *Urban Affairs Quarterly* 22 (1986): 42-65.

Blau, Judith R., and Gordana Rabrenovic. "Interorganizational Relations of Nonprofit Organizations: An Exploratory Study." *Sociological Forum* 6, no. 2 (1991): 327-43.

Bodo, C. "Alcuni aspetti del rapporto pubblico-privato nel finanziamento della cultura in Italia e all'estero." *Informazioni IRESM* nos. 1-2 (Gennaio-Febbraio, 1989).

Bourdieu, Pierre. *Distinction: A Social Critique of the Judgement of Taste.* Cambridge: Harvard University Press, 1984.

———. Historical Genesis of Pure Aesthetics." *Journal of Aesthetics and Art Criticism* 10: (1987) 201-10.

Bourdieu, Pierre, and Alain Darbel. *The Love of Art: European Art Museums and Their Public.* Trans. Caroline Beattie and Nick Merriman. Cambridge: Polity Press, 1991.

Brosio G. "Pubblico e privato nel finanziamento dell'arte e cultura in Italia." *Economia Pubblica* nos. 9-10 (Settembre-Ottobre 1989).

Buenventura, Maria R.M. *Corporate Contributions, 1992.* New York: The Conference Board, 1994.

Business Committee for the Arts. "Survey of Arts Organizations' Business Support." New York: Business Committee for the Arts, 1993a.

———. "Why Business Should Support the Arts: Facts, Figures, and Philosophy." New York: Business Committee for the Arts, 1993b.

———. "Foreign-Based Business Giving to American Arts Organizations." New York: Business Committee for the Arts, 1992a.

———. "National Survey of Business Support to the Arts." New York: Business Committee for the Arts, 1992b.

Campbell, N.C.G. "An Interaction Approach to Organizational Buying Behavior." *Journal of Business Research* 13 (1985): 13, 35-48.

Cancline, Nestor Garcia, ed. *Culturas Hibridas,* Buenos Aires, Argentina: Sudamericana, 1992.

Carelli, A. *Emma Carelli.* Rome: P. Maglione Editore, 1932.

Carter, T. "The Seventeenth Century. In *Oxford Illustrated History of Opera.* Oxford: Oxford University Press, 1994.

Castile, Rand. "The Great Corporate Art Collections of Japan." *Corporate Design & Realty* 4, no. 8 (October 1985): 58-60.

Caulkin, Simon. "Value for Money." *The Observer,* 24 April 1994.

Cauquelin, A. *L'Art Contemporain.* Paris: PUF, 1993, p. 43.

Celletti, R. "Impresario." In *Encyclopedia dello Spettacolo.* Rome: Edizione S.I.A.E., 1957.

CEREC. *Association Update* (December 1992/January 1993): 1.

Chadwick, W. *Women, Art and Society.* London: Thames and Hudson, 1990.

Chapman, Roy. "Taking Stock: Art for Art's Sake." In *Accountancy Age.* 3d ed. December 1987.

Chew, Fiona. "The Advertising Value of Making Possible a Public Television Program." *Journal of Business Research* (November-December 1992): 47-52.

Chiti, P. Adkins. *Almanacco delle Virtuose, Primedonne, Compositrici e Musiciste d'Italia dall'A.D. 177 ai Giorninostri.* Istituto Geografico DeAgostini, Novara, 1991.

"Collector Who Went West." *New York Times,* 3 January 1986, p. C21.

Conference Board. *Annual Survey of Corporate Gift Giving.* New York: The Conference Board, 1993.

Conseil de l'Europe. "Mecenat en Europe." Paris: La Documentation Francaise, 1987.

Constantini, A. "I Francesi ci fanno sapere che l'Italia e il paese che spende di piu." *Il Giornale dell'Arte* 56, (May 1988): 71.

Coopers & Lybrand. Annual Report. London, 1993.

Cox, Meg. "Art Prices Continue Their Trip to the Stars, Belying Predictions about a Market Fall." *Wall Street Journal* 19 May 1988.

————. "Japanese Firm Named as the Art Lover with Big Yen for Van Gogh Sunflowers." *Wall Street Journal* 9 April 1987.

Crane, Diana. *The Production of Culture.* New York: Sage Publications, 1992.

————. "Art and Money: Social and Institutional Networks in Art Collecting." Paper prepared from presentation at the Eastern Sociological Society Meetings, Boston, 1 May 1987a.

————. *The Transformation of the Avant-Garde: The New York Art World, 1940-1985.* Chicago: University of Chicago Press, 1987b.

Crispi, G. Palamenghi. "Un'indagine ABI sulla Sponsorizzazione Culturale." ABI, Rome, 1987.

Cummings, M.C., Jr., and R.S. Katz, eds. *The Patron State.* New York: Oxford University Press, 1987.

"Current Trends in Cigarette Smoking." *Vima* 25 September 1994.

Cwi, David. *Economic Impact of the Arts and Cultural Institutions: A Model for Assessment and A Case Study in Baltimore.* Research Division Report no. 6. Washington, D.C.: National Endowment for the Arts, 1977.

Danto, Arthur C. *The State of the Art.,* New York: Prentice Hall, 1987.

Danziger, Charles. "Who Rules the Japanese Art World?" *Tokyo Business Today* (June 1989): 34-36.

Daudt d'Oliveira, A. "Viabilizar a produção cultural." *Jornal do Brasil*, Rio de Janeiro, 4 July 1994.

Dean, W.A. *Industrialização de São Paulo.* São Paulo: DIFEL, 1971.

de Angelis, A. *Il Teatro Alibert o Delle Dame.,* Edited by A. Chicca. Tivoli, 1951.

————. *La Musica a Roma Nel Secolo XIX.* Edited by Dott. G. Bardi. Rome, 1935.

de Angelis, M. *Le Carte dell'Impresario: Melodramma e Costume Teatrale Nell'Ottocento.* Edited by Sansoni, Florence, 1982.

de Dominici, G.I. *Teatri di Roma Nell'età di Pio VI, a Cura Della Società di Storia Patria.* Rome, 1985.

Dentsu Institute for Human Studies. *A Research for Information and Media Society.* DIHS, 1994.

Devoto, G., and G.C. Oli. "Nuovo Vocabolario illustrato della lingua Italiana." *Selezione dal Readers Digest,* Milan, 1988.

DiMaggio, Paul J. "The Nonprofit Organizations in the Production and Distribution of Culture." In *The Nonprofit Sector, A Research Handbook.* Edited by Walter W. Powell New Haven: Yale University Press, 1987a.

————. "Classification in Art." *American Sociological Review* 52 (1987b): 440-455.

————. "Introduction." In *Nonprofit Enterprise in the Arts: Studies in Mission and Constraint.* Edited by Paul DiMaggio. New York: Oxford University Press, 1986, 3-13.

————. "Support for the Arts from Independent Foundations." In *Nonprofit Enterprise in the Arts: Studies in Mission and Constraint.* Edited by Paul DiMaggio. New York: Oxford University Press, 1986, 113-39.

------. "Cultural Entrepreneurship in Nineteenth-Century Boston: The Creation of an Organizational Base for High Culture in America." *Media, Culture and Society* 4 (1982): 33-50.

------. "Cultural Entrepreneurship in Nineteenth-Century Boston, Part II: The Classification and Framing of American Art." *Media, Culture and Society* 4 (1982): 303-22.

Dizionario della Musica e die Musicisti (UTET). *Unione Tipografico*. Turin: Editrice Torinese, 1988.

Donaldson, Thomas, and Lee E. Preston. "The Stakeholder Theory of the Corporation: Concepts, Evidence, Implications." *Academy of Management Review* (January 1995): 65-91.

Doyle, Peter, Arch G. Woodside, and Paul Michell. "Organizations Buying in New Task and Rebuy Situations." *Industrial Marketing Management* 8 (1979): 7-11.

Dubin, Stephen C. *Arresting Images: Impolitic Art and Uncivil Actions*. New York: Routledge, 1992.

Durand, J.C. *Arte, privilégio e distinção*. São Paulo: Perspectiva/EDUSP, 1989.

------. "Mercado de arte e mecenato: Brasil, Europa, Estados Unidos." *Revista Brasileira de Ciências Sociais* 1, no. 2 (1986): 56-67.

Eagle, M., and J. Jones. *A Story of Australian Painting*. Macmillan: Australia, 1994.

Epstein, Marc J. "The Fall of Corporate Charitable Contributions." *Public Relations Quarterly* (Summer 1993): 37-39.

ERBO. *Enquete regionale bedrijfsontwikkeling*. Rotterdam: Kamer van Koophandel, 1991, 1992, 1993.

Etzioni-Halevy, Eva. *The Elite Connection: Problems and Potential of Western Democracy*. Cambridge: Polity Press, 1993.

Fabre, Gladys C. "La contribution des femmes à une avant-garde." Paris: Des Femmes en Mouvement Hebdo, Volume 94, 1982.

Fama, Eugene, and Michael Jensen. "Agency Problems and Residual Claims." *Journal of Law and Economics* 26 (June 1983): 341-45.

Featherstone, M. *Consumer Culture and Postmodernism*. Sage, 1991, p. 7.

------. "Postmodernism and Aesthetization." In *Modernity and Identity*. Blackwell, 1982, p. 270.

Feist, A., R. Hutchinson, and I. Christie, eds. *Funding the Arts in Seven Western Countries*. Cultural Trends 1990, issue 5. London: Policy Studies Institute, 1990.

Fey, H. "Kulturförderung der Bayerischen Hypotheken—und Wechsel-Bank AG München." In *Kulturförderung: mehr als Sponsoring*. Edited by Strachwitz and Toepler. Wiesbaden, 1993.

Figges, Sir John. "The Art Market: Western Art and the Japanese." *Apollo* 126 (August 1987): 114-15.

Finn, Edwin A., Jr., and Hiroko Katayama. "Follow the Money." *Forbes*, 138, no. 14 (29 December 1986): 25-40.

Fischer, Heinz H., Franz Bauske, and Brigitte Conzen. *Die Wirtschaft als Kulturforderer*. Koin: Kulturkreis im Bundesverband der Deutschen Industrie BDI, 1987.

Foucault, Michel. "Truth and Power." In *The Foucault Reader*. Edited by Paul Rabinow. New York: Pantheon Books, 1984, pp. 51-75.

Franco, Z. "Atti del Convegno Banca e Cultura." *Mondo Economico* 18 January 1992.

Frangi, F. "Cosi le Banche Hanno Scoperto il Sottile Fascino dell'Arte." *Mondo Economico* 36 (14 September 1987).

Friedman, Milton. "The Social Responsibility of Business is to Increase Its Profits." In *Issues in Business and Society*. Edited by George A. Steiner. Kingsport, TN: Kingsport Press, 1972.

Galaskiewicz, Joseph. "A Longitudinal Analysis of Corporate Contributions in Minneapolis-St. Paul." Washington, D.C.: Independent Sector, *Spring Research Forum,* 1991.

———. *Social Organization of an Urban Grants Economy: A Study of Corporate Contributions to Nonprofit Organizations*. New York: Academic, 1985.

Galaskiewicz, Joseph, and Ronald S. Burt. "Interorganization Contagion in Corporate Philanthropy." *Administrative Science Quarterly* 36, no. 1 (1991): 88-105.

Gans, Herbert. "Preface." In *Cultivating Differences: Symbolic Boundaries and the Making of Inequality*. Edited by Michèle Lamont and Marcel Fournier. Chicago: University of Chicago Press, 1992.

———. *Popular Culture and High Culture: An Analysis and Evaluation of Taste*. New York: Basic Books, 1974.

Ganter, Garillo. Business and the Arts Dinner sponsored by Australian Capital Equity and Western Australian Department of the Arts, Perth, 27 November 1991.

Garbesi, M. "La Cultura ha la sua Borsa e mille miliardi da spendere." *La Repubblica* (15 May 1988): 20.

Georgiadi, M. Interview in *Kathimerini*, 1993.

Gingrich, Arnold. *Business and the Arts: An Answer to Tomorrow*. New York: Paul S. Eriksson, Inc., 1969.

Glasmacher, V. "Cultural Patronage in Germany." In *Conference Report of Participation in Culture*, a conference organized by INTERPHIL, Bath, 10-12 July 1994.

Glaxo. "Pharmaceutical Giant Sponsors Art." *Arts Review* (September 1992).

Glueck, Grace. "The Fine Art of Collecting Collectors." *New York Times,* 3 May 1987, sec. 2:1.

Gonçebate, Rodolfo. "Foundations in Periods of Political and Economic Uncertainity: Lessons from Latin America." *VOLUNTAS* 6, no. 2 (1995). Forthcoming.

Goodison, Sir Nicholas. "Art Is Life." *Arts Review* (May 1992): 168.

"Growth Rate of Giving Slows as the Recession Takes Its Toll." In *NonProfit Times* 5. no. 3 (1991): 1, 6, 15.

Hajduk, Margo. *Financiacion Privada en las Artes y la Cultura: el Rol de las Empresas como Nuevos Mecenas*. Buenos Aires: Authors Edition, 1994.

Halaris, G. "Techno-economic Change and Cultural Prospects: Which Sociological Paradigm?" International Sociological Congress, Paris, 1993.

Hallén, Lars, Jan Johanson, and Nazeem Seyed-Mohamed. "Interfirm Adaptation in Business Relationships." *Journal of Marketing* 55 (April 1991): 29-37.

The Handbook of Non-Profit Organizations. New Haven: Yale University Press, 1987, pp. 340-59.

Havens, Thomas R.H. *Artist and Patron in Postwar Japan: Dance, Theater, and the Visual Arts, 1955-1980*. Princeton, N.J.: Princeton University Press, 1982.

Hitters, E. "Culture and Capital in the 1990s. Private Support for the Arts and Urban Change in the Netherlands." In *Built Environment* Vol. 18, no 2. Oxford: Alexandrine Press, 1992.

————. "Particulier initiatief en lokale cultuur." Edited by J. Burgers. *De Uitstad. Over stedelijk vermaak.* Van Arkel Utrecht, 1992.

Hoole, John. "Foreword." In *Capital Painting: Pictures from Corporate Collections in the City of London.* London: Barbican Art Gallery, 1984.

Houfe. Lord Chancellor's Department. *The Work and Organization of the Legal Profession.* London: HMSO, 1989, Cm. 570.

Hughes, Ray, "The Art of the Dealer." *Good Weekend, The Age* (5 March 1994).

————. *The Art of Australia.* Ringwood, Australia: Penguin, 1966.

Hummel, M. "Neuere Entwicklungen bei der Finanzierung von Kunst und Kultur durch Unternehmen." In *ifo Schnelldienst* (1992): 8-24.

————. *Standortbewertung und Kulturfinanzierung durch Unternehmen in Bremen.* Munchen: ifo-Institut fur Wirtschaftsforschung, 1990.

Hummel, Marlies, and Cornelia Waldkircher. *Wirtschaftliche Entwicklungstrends von Kunst und Kultur.* Berlin: Duncker and Humblot, 1992.

ICI Group. *Contemporary Art at Millbank.* London: ICI, 1991.

Incagliati, M. *Il Teatro Costanzi: 1808-1907, Tipografia Editrice* "Roma," Rome: n.p., 1907.

Industrial Association. "Il matrimonio industria-cultura. Obiettivi e percorsi nell'iniziativa culturale dell'impresa." Rome: Sipi, 1988.

The Inner Circle: Large Corporations and the Rise of Business and Political Activity in the U.S. and the U.K. New York: Oxford University Press, 1985.

Janson, Anthony F. *History of Art.* 3d ed. New York: Harry N. Abrams, Inc., 1986.

Jarro. *Memorie d'un Impresario Fiorentino.* Florence: Leoscher & Seeher, 1892.

Jeffri, Joan. *Art Money—Raising It, Saving It, and Earning It.* New York: Neal-Schumann, 1983.

Jensen, Michael C., and William H. Meckling. "Theory of the Firm: Managerial Behavior, Agency Costs and Ownership Structure." *Journal of Financial Economics* 3 (1976): 78-133.

Jones, Francine, ed. *Corporate Foundation Profiles.* 7th ed. New York: The Foundation Center, 1992.

Julien, R.L.C.I., and L.T. Rozema. *Gemeentelijk kunstbeleid vergeleken. Onderzoek naar omvang on aard van het kunstbeleid in 27 Nederlandse gemeenten, waaronder 16 knooppuntgemeenten.* Research Note RN 1991-01, Groning: Faculteit Bedrijfskunde, 1991.

Kawasaki, K. *Production of Culture in Tokyo and Japan.* Bulletin of Komazawa University, vol. 43, 1995.

————. *Information Society and Contemporary Japanese Culture.* Tokyo: University Press, 1994.

Kenyon, Gerald S. "Market Economy Discourse in Non-Profit High Status Art Worlds." *The Journal of Arts Management, Law and Society* 25, no. 2 (1995).

————. "Corporate Involvement in the Arts and the Reproduction of Power." Paper presented at the XIIIth World Congress of Sociology, Bielefeld, Germany, 18-23 July 1994a.

————. "Market Economy Discourse in Non-Profit High Status Art Worlds." Paper presented at the 20th Conference on Social Theory, Politics and the Arts. Louisiana State University, 20-22 October 1994b.

————. "Art World Interlocks and the Production of Taste." *Boekmancahier* 4 (1992):70-79.

King, John. *El Di Tella y el Desarrollo Cultural Argentino en la Decada del Sesenta* Buenos Aires: Ediciones de Arte Gaglianone, 1985.

Kirchberg, Volker. "The Effect of Socio-Economic Conditions of Metropolitan Areas on Local Corporate Arts Suport." Paper for the 8th International Conference on Cultural Economics, University of Witten/Herdecke, 24-27 August 1994.

——. "The Arts as Ingredients of a Livable City—and Corporate Contributions as a Way to Finance Them." In *Managing Historic Cities*. Edited by Zbigniew Zuziak. Krakow: International Cultural Centre/City Prof., 1993, 87-93.

——. "Motives for Corporate Arts Support—A Comparison of the United States and Germany." Unpublished paper, 1992.

Klepac, L. *The Reserve Bank of Australia Collection*. Australia: Macmillan, 1992.

Klepper, Anne, and Selma Mackler. *Screening Requests for Corporate Contributions*. New York: Conference Board, 1986.

Kloosterman, R.C. *Double Dutch: An Inquiry into Trends of a Polarization in Amsterdam and Rotterdam after 1980 Lille*. Unpublished paper, 1994.

Knauft, E. Burt. "Profiles of Effective Corporate Giving Programs." Research Paper. Washington, D.C.: Independent Sector, 1989.

Kornhauser, William. "'Power Elite' or 'Veto Groups.'" In *Social Realities: Dynamic Perspectives*. Edited by George Ritzer. Boston: Allyn and Bacon, 1974, pp. 391-405.

Koutoupis, T. Interview in *Vima*, 24 March 1993.

Kushner, Roland J. "Strategy, Structure, and Organizational Effectiveness: A Study of Nonprofit Arts Organizations." Ph.D. Diss. Lehigh University, 1994.

Lacata, G. "Nascono le pinacoteche in banca." *Corriere della Sera*. (11 July 1986).

Lambraki-Plaka, M. Interview in *Diafimisi* 581 (1994).

Lattes, W. "Cimabue Restaurato torna agli Uffizi." *Corriere della Sera*. (21 December 1993):17.

Lears, T.J. Jackson. "The Concept of Cultural Hegemony: Problems and Possibilities." *American Historical Review* 90 (1985): 567-93.

Lengermann, Patricia M., and Jill Niebrugge-Brantley. "Feminist Sociological Theory: The Near-Future Prospects." In *Frontiers of Social Theory: The New Synthesis*. Edited by George Ritzer. New York: Columbia University Press, 1990, pp. 316-44.

Lesen, Stiftung and Deutscher Kulturrat, ed. *Strukturwandel oder Substanzverlust? Die kulturelle Infrastruktur in den fünf neuen Bundeslandern*. Mainz: Stiftung Lesen, 1992.

Levine, Lawrence W. *Highbrow/Lowbrow: The Emergence of Cultural Hierarchy in America*. Cambridge: Harvard University Press, 1988.

Lieberson, Stanley. *Making It Count: The Improvement of Social Research and Theory*. Berkeley: University of California Press, 1985.

Lima, J. da C., et al. *Matarazzo 100 anos*. São Paulo: privately published, 1982.

Lindsay, R. *The Seventies: Australian Paintings and Tapestries from the Collection of the National Australia Bank*. Melbourne, 1982.

Lipovetsky, G. "Le Crepuscule du Devoir." Paris, 1992, pp. 269-71.

Loeffelholz, B. "Stiftungen als 3. Säule der Kulturförderung." In *Europäischer Kulturföderalismus—Positionen und Aufgaben der Kulturstiftungen*. Wiesbaden 1991.

Lufty, C. "Japanese Art: Young Crowd." *ARTnews* 93, no. 9 (1994).

Lyotard, Jean-François. *The Postmodern Condition: A Report on Knowledge*. Minneapolis: University of Minnesota Press, 1984.

Maecenata Management GmbH. *Maecenata Stiftungsführer: 1111 Förderstiftungen.* Munich, 1994.

———. *Dokumentationszentrum Deutscher Stiftungen.*

Mahar, Maggie. "What Price Art? In an Overheated Auction Market, It's Whatever You'll Pay." *Barron's* 67, no. 26 (29 June 1987): 6-7, 29-82.

Maione P.G., and F. Seller. "Gioco d'Azzardo e Teatro a Napoli dell'età Napoleonica alla Restaurazione Borbonica." *Musica/Realtà,* no. 43, Anno XV, Naples, April 1994.

Marcello, B. *Teatro all Moda.* Milan: Edizione Ricordi, 1956.

Marconi, G. "Musei e Opere: La Scoperta del Futuro." *Milano* (12-17 September 1988).

Martins, J. de S. Conde Matarazzo, o empresário e a empresa. 2d ed. São Paulo: Hucitec, 1973.

Martorella, Rosanne, ed. *Corporate Art.* New Brunswick, NJ: Rutgers University Press, 1990a.

———. "CEOs, Art Consultants, and Dealers as Gatekeepers." In *Corporate Art.* Edited by Rosanne Martorella. New Brunswick, NJ: Rutgers University Press, 1990b.

Masoero, A. "Oltre San Fruttuoso." *Mondo Economico.* no. 49, (14 December 1987).

McCaughey, Patrick. *The Great Decades of Australian Art: Selected Masterpieces from the J.G.L. Collection.* Melbourne: National Gallery of Victoria, 1984.

McGill, Douglas C. "Helping the Rich Buy Art." *New York Times,* 22 April 1987, p. 22.

———. "Japanese Investors Spur Higher Prices in U.S. Art Market." *New York Times* 10 December 1986, p. 1a and C23.

McGuigan, Cathleen, et al. "A Word from Our Sponsor: Increasing Ties between Big Business and the Art World Raise Some Delicate Questions." *Newsweek* (25 November 1985): 96-98.

Mendonça, M. *Lei de incentivo à cultura: uma saída para a arte.* São Paulo: Carthago & Forte, 1994.

Mescon, Timothy S., and Don J. Tilson. "Corporate Philanthropy: A Strategic Approach to the Bottom Line." *California Management Review* 29, no. 2 (Winter 1987): 49-61.

Meyer, Karl E. *The Art Museum: Power, Money, Ethics.* New York: William Morrow and Co., Inc., 1979.

Meyersohn, Rolf. "Culture in the Bronx—Minority Participation in the Arts." In *The Future of the Arts. Public Policy and Arts Research.* Edited by David B. Pankratz and and Valerie B. Morris. New York: Praeger, 1990, pp. 141-149.

Miceli, S., org. *Estado e cultura no Brasil.* São Paulo: DIFEL, 1984.

Miggiani, M.C. *Rassegna Veneta di Studi Musicali: Giovanni Bertati, Impressario al Teatro di San Moisè (1799-1781).* Rome: CLEUP Editore, 1988.

Ministry of Cultural and Natural Heritage. Bulletin, special issue on the Parliamentary Inquiry into the Italian Cultural Heritage, no. 26, September-October 1989.

Minson, Jeff. "Strategies for Socialists? Foucault's Conception of Power." In *Towards a Critique of Foucault.* Edited by Mike Gane. London: Routledge & Kegan Paul, 1986, pp. 106-48.

Monaldi, G. *Cantanti Celebri del Secolo XIX.* Rome: Nuova Antologia, 1920.

Moncrieff, Elspeth. "Smart Art (The Merits of a Corporate Collection)." *Apollo* 133 (March 1991): 196-99.

Morais, F. *Chatô: o rei do Brasil, a vida de Assis Chateaubriand.* São Paulo: Companhia das Letras, 1994.

Morris, Rupert. "Radical Change of Art." *Financial Times,* 7 January 1994.

Mukarofsky, J. Essays on Aesthetics (Greek translation). Athens: Odysseas, n.d., pp. 115-28.

Muschter, G. and R. Strachwitz, eds. *Privatinitiative für Kultur, Protokolle der Kulturstiftung Haus Europa und der Stiftung Neue Kultur 1991/1992.* Berlin, 1992.

Muylaert, R. *Marketing cultural & comunicação dirigida.* São Paulo: Globo, 1993.

National Endowment for the Arts (NEA). "Regional and State Trends for Artists: 1970-1990." Research Division Note #41. Washington, D.C.: NEA, 1993.

National Statistical Service. "Households Expenditures." 1987/1988, 313-25.

Nirenstein, S. "Venite a prendere un restauro da noi . . ." *La Repubblica* 3 May 1988, p. 20.

O'Brien, Rodney. "Japanese Artists Find Collectors Still Look Abroad." *New York Times,* 3 July 1988, pp. H27 and 34.

Ogmundson, R., and J. McLaughlin. "Trends in the Ethnic Origins of Canadian Elites: The Decline of the Brits?" *Canadian Review of Sociology and Anthropology* 29, no. 2 (1992): 227-242.

Oliveira, L.C. de, 1976. *AnotaçΣes para a história de uma época.* São Paulo: Pioneira, 1976.

OMEOO. Statute, p. 3.

OMMA. Annual Calendar. Athens, 1993.

Ornstein, Michael D. "The Boards and the Executives of the Largest Canadian Corporations: Size, Composition and Interlocks." *Canadian Journal of Sociology* 1 (1976): 411-37.

Ortiz, R. *A moderna tradição brasileira.* São Paulo: Brasiliense, 1988.

"Os novos mecenas." *Jornal do Brasil* (6 November 1994), Rio de Janeiro.

Palmer, Caroline. "Hidden Treasure." *Accountancy Age* (October 1993).

Patterson, Jerry. "Artmarket '86: A Period of Consolidation." *Institutional Investor* 20, no. 9 (September 1986): 396-406.

Peterson, Richard A., and Albert Simpkus. "How Musical Tastes Mark Occupational Status Groups." In *Cultivating Differences: Symbolic Boundaries and the Making of Inequality.* Edited by Michele Lamond and Marcel Fournier. Chicago: University of Chicago Press, 1992, pp. 152-86.

Plios, G. Moving Image and Artistic Communication (Gr.), Athens: Delfini, 1993, pp. 43-45.

Porter, Robert A., ed. *ACA Guide to Corporate Giving.* New York: American Council for the Arts Books, 1978, 1980, 1981, 1982, 1986.

Ramantsoa, B. "L'Autonomie Strategique de L'Enterprise." In *L'enterprise: Une Affaire de Societe.* Edited by R. Sainsaulieu. Paris: Presses de las Fondation Nationale des Sciences Politiques, 1992.

Rampino, A. "Uno Sportello Nella Storia." *Capital* (March 1988): 26-38.

———. "Il San Paolo per la Cultura." *San Paolo Notizie* (December 1987): 58-63.

Reif, Rita. "Auctions." *New York Times,* 17 November 1989, p. C33.

———. "A deKooning Work Sets A Record at $20.7 Million." *New York Times,* 9 November 1989, p. C22.

———. "Auctions." *New York Times,* 8 July 1988, pp. C17-19.

Ricci, C. *Figure e Figuri del Mondo Teatrale.* Milan: Fratelli Treves Editori, 1920.

Rider, Linda I. "Rationality in Corporate Philanthropy Decision-Making Procedures and Processes." Honors Thesis, Lafayette College, 1994.

Rigaud, J. "Mecenat, sponsoring, parrainage: une querelle semantique." *Cashiers Francais* (1993).

Roberts, Marion, Chris Marsh, and Miffa Salter. *Public Art in Private Places: Commercial Benefits and Public Policy*. London: School of Urban Development and Planning, University of Westminster, 1993.

Robertson, John. "Cultural Indicators from the Leisure Activities Survey." *American Behavioral Scientist* 26 (1983): 543-52.

Roitter, Mario. "El Mercado de la Beneficencia." In *Del dicho al Hecho: Las Organizaciones No Lucrativas en Argentina*. Edited by Andrés Thompson. Buenos Aires: Ed. Losada/UNICEF, 1994.

Romeo, N. "Patrimonio immobiliare, archeologico ed arte. Sintesi Realizzata a Palermo." *Mondo Economico,* 18 January 1992.

Roos, Johan, and Iojord Asbørn. "A Conceptual Model of Determinants and Indicators of Strategic Alliance Performance." *Working Paper*. Norwegian School of Management, 1992.

Rosselli, J. *Singers of Italian Opera. The History of a Profession*. Cambridge: Cambridge University Press, 1992.

Rossi, A. "Gli Eredi del Magnifico." Mondo Economico, January 18, 1992.

Salamon, Lester M., and Helmut K. Anheier. *The Emerging Sector: An Overview*. Baltimore: Johns Hopkins University Press, 1994.

Sallum, B., Jr. "Por que não tem dado certo: notas sobre a transição política brasileira." In *O Estado da transição: política e economia na nova república*. Edited by L. Sola. São Paulo: _____.

Scanlon, Rosemary. *The Arts as an Industry: Their Economic Importance to the New York-New Jersey Metropolitan Region*. New York: The Research Center for the Port Authority of New York and New Jersey, The Tourism and Art Project, 1993.

Schuster, J., and Mark Davidson. "Government Leverage of Private Support: Making Grants and the Problem with 'New' Money." 1989.

——. "Supporting the Arts: An International Comparative Study." Washington D.C.: U.S. Government Printing Office, 1985.

——. "Tax Incentives as Arts Policy in Western Europe." In *Nonprofit Enterprise in the Arts: Studies in Mission and Constraint*. Edited by Paul DiMaggio. New York: Oxford University Press, 1986.

Scott, John. "Networks of Corporate Power: A Comparative Assessment." *Annual Review of Sociology* 17 (1991): 181-203.

Seigi, S. "A Perspective of Japanese Fine Art World." in Annual of Japanese Fine Art, Tokyo, Japan: Bijutsunenkansha, 1993a.

——. "A Critic of International Art Market." In *Annual of Japanese Fine Art*. Tokyo: Bijutsunenkansha, 1993b.

——. *A Whitepaper of Japanese Art Economy*. Tokyo: Bijutsunenkansha, 1991.

Shaw, Bill, and Frederick R. Post. "A Moral Basis for Corporate Philanthropy." *Journal of Business Ethics* 12 (1992): 745-51.

Shefter, Martin, ed. *Capital of the American Century: The National and International Influence of New York City*. New York: Russell Sage Foundation, 1993.

Simon, Herbert A. (1982). "From Substantive to Procedural Rationality." In *Models of Bounded Rationality: Behavioral Economics and Business Organization*. Edited by Herbert A. Simon. Cambridge: MIT Press, 1982.

Simpson, Colin. *Artful Partners*. New York: Macmillan Publishing Company, 1986.

Smith, Charles. "Investment: The Art of Yen." *Far Eastern Economic Review* 139, no. 9, (3 May 1988): 56-57.

Smith, Dinita. "Art Fever." *New York Magazine,* 20 April 1987, 38-43.

Stanley, Christopher. "Justice Enters the Marketplace: Enterprise Culture and the Provision of Legal Service." In *Enterprise Culture.* Edited by Russell Keat and Nicholas Abercrombie. London: Routledge, 1991.

Stokman, Frans N., and C.J.A. Sprenger, eds. *GRADAP: Graph Definition and Analysis Package* (Version 2.0). Groningen, The Netherlands: iec ProGAMMA, 1989.

Strachwitz, Rupert. *Vorträge und Beiträge 1988-1992, Berlin 1992, 1994. Stiftungen—nutzen, führen und errichten: ein Handbuch.* Frankfurt/New York 1994.

————. "Private Initiative in Public Affairs—A European Trend." Unpublished paper available at Maecenata Managment GmbH, Munich, 1992.

————. *Kunst und Geld. Uber private und offentliche Forderung von Kunst.* Munich: Maecenata Management, 1991.

Strachwitz, R., and S. Toepler, eds. *Kulturförderung, mehr als Sponsoring.* Wiesbaden, 1993.

Strakosch, M. *Memorie d'un Impresario.* Paris: private edition, 1887.

Stultz, Janice E. "The Decision to Give: Methods and Rewards of Corporate Philanthropy." *Directors and Boards* (Winter 1980): 6-20.

Sujo, Glenn. "The Arthur Andersen Collection." *Art Review Year Book 1990.* p. 53.

"Sunflowers." *Corporate ARTnews* 4, no. 3, (July 1987): 3.

Taft Group. *Taft Corporate Giving Directory.* Washington, D.C.: Taft Group, 1985, 1989, 1991.

Telegraph Weekend Magazine, 19 January 1991.

Thomas, Philip A., ed. *Law in the Balance: Legal Services in the Eighties.* Oxford: Martin Robertson, 1982.

Thompson, Andrés. "Sin Fines de Lucro." Buenos Aires: (separata) Boletin Informativo Techint: 272, 1992.

Thompson, James D. *Organizations in Action.* New York: McGraw Hill, 1967.

Thorncroft, Senn Antony. "Art Acquisition for Canny Companies."

Toepler, S. *Kulturfinanzierung: ein Vergleich USA—Deutschland.* Wiesbaden, 1991.

Toman, M. "Was leisten deutsche Landesstiftungen? Ein Überblick." In *Europäischer Kulturföderalismus—Positionenund Aufgaben der Kulturstiftungen.* Wiesbaden, 1991.

Turgeon, Normand, and Francois Colbert. "The Decision Process Involved in Corporate Sponsorship for the Arts." *Journal of Cultural Economics* 11, no. 1 (1992): 41-51.

UNESCO. "Convention and Recommendations of UNESCO Concerning the Protection of the Cultural Heritage." Paris: UNESCO, 1983.

————. "Convention Concerning the Safeguarding and Contemporary Role of Historic Areas." Paris: UNESCO, 1972.

Useem, Michael. "Corporate Support for Culture and the Arts." In *Corporate Support for Culture and the Arts.* Edited by Margaret Jane Wyszomirski and Pat Clubb. New York: ACA Books, 1989, pp. 45-62.

————. "Market and Institutional Factors in Corporate Contributions." In *California Management Review* 30 (1988): 77-88.

————. With Stephen I. Kutner. "Trends and Preferences in Corporate Support for the Arts." In *Guide to Corporate Giving in the Arts.* Edited by Robert A. Porter. New York: American Council for the Arts Books, 1987.

——. "Corporate Contributions to Culture and the Arts: The Organization of Giving and the Influence of the Chief Executive Officer and of Other Firms on Company Contributions in Massachusetts." In *Nonprofit Enterprise in the Arts*. Edited by Paul J. DiMaggio. New York: Oxford University Press, 1986.

——. "Corporate Philanthropy." In *The Inner Circle*. Edited by Walter W. Powell. New York: Oxford University Press, 1984.

——. "Government Patronage of Science and Art in America." In *The Production of Culture*. Edited by Richard A. Peterson. Beverly Hills: Sage Publications, 1976, pp. 123-42.

Useem, Michael, and and Stephen I. Kutner. "Corporate Contributions to Culture and the Arts: The Organization of Giving and the Influence of the Chief Executive Officer and of Other Firms on Company Contributions in Massachusetts." In *Nonprofit Enterprise in the Arts: Studies in Mission and Constraint*. Edited by Paul DiMaggio. New York, Oxford University Press, 1986, 93-112.

Veblen, Thorstein. *The Theory of the Leisure Class*. New York: New American Library, 1899/1953.

Vértice. 1988, pp. 118-144.

Villni, M., and Urbanet M. *Sponsorship and the Press: Concepts About Sponsors and the Press in Europe*. Athens, 1993.

Walker, Richard W. "The Power of the Yen." *ARTnews* 86 (September 1987): 25.

Watt, I. "Arts Sponsorship in the Mediterranean Area." In *Tehnew and Horigi*. 20 (1994): 15.

Weber, Nathan, and Loren Renz. 1993 *Arts Funding: A Report on Foundation and Corporation Grantmaking Trends*. New York: The Foundation Center, 1993.

Wellman, Barry, and S.D. Berkowitz. *Social Structure: A Network Approach*. Cambridge: Cambridge University Press, 1988.

Whybrow, Stephen. "A Toe in the Sponsorship Water." *Arts Review* (14 June 1991): 18-19.

Wiesand, A.J. "Kulturfinanzierung—Daten und Trends in Deutschland und Europa." In *Zweiter Bericht zur Kulturpolitik 1993/1994*. Bonn, 1994, pp. 75-105.

Williams, Raymond. *The Sociology of Culture*. New York: Schocken Books, 1981.

Wyszomirski, M., and P. Clubb. *The Cost of Culture: Patterns and Prospects of Private Arts Patronage*. New York: American Council of the Arts Books, 1989.

"Yasuda Denies Sunflowers' Regarded as Waste of funds." *Corporate ARTnews* 4, no. 1 (May 1987): 1.

Zaziak, Zbigniew. "New Challenges for the Revitalization and Management of Our Urban Heritage." In *Managing Historic Cities*. Edited by Zbigniew Zuziak. Krakow: International Cultural Centre/City Prof., 1993, pp. 9-24.

Zukin, Sharon. *Landscapes of Power: From Detroit to Disney World*. Berkeley: University of California Press, 1991.

Index

About the Editor and Contributors

EDITOR

MARTORELLA, ROSANNE, Ph.D., professor of sociology, has published several books and articles in the sociology of the arts. Her focus has been on the social and economic structure of performing-arts organizations, and the careers of artists. Her most recent book analyzed the extent and nature of corporate art collections in the United States. She also teaches in the area of health and illness. (Department of Sociology, William Paterson College, 300 Pompton Road, Wayne, New Jersey 07470)

CONTRIBUTING AUTHORS

ALEXANDER, VICTORIA D., Ph.D., received her doctorate from Stanford University. She recently completed a large study of how individual, corporate, and federal philanthropy affects American art museums. Her current research is on art museums in France, Great Britain, and the United States. (Department of Sociology, Harvard University, Cambridge, MA 02138 or vda@isr.harvard.edu)

CHITI, PATRICIA ADKINS, English-born dramatic mezzo-soprano and musicologist, is internationally recognized for her performances of Verdi operas and Russian contemporary music and for her pioneer work on behalf of women musicians. Founding member of the Italian National Commission for Musicology and member of the Italian State Council for the Performing Arts, she has produced programs for the RAI—Italian television—and has published extensively in Europe, Asia, and the United States on women composers and

singers and the contribution of women to music history. (Via Proba Petronia 82, 01136, Roma, Italy)

DURAND, JOSÉ CARLOS, Ph.D., received his doctorate in sociology of the arts from the Universidade de São Paulo. He is currently a full professor, and is executive coordinator of the CECC—Centro de Estudos da Cultura e do Consumo (Culture and Consumption Studies Center). He is the author of numerous articles in cultural consumption, the art market, and communications. (Department of Social and Juridical Foundations of Administration (FSJ) at the Escola de Administracao de Empresas de São Paulo Av, 9 de Julholo 2029, 01313 São Paulo, Brazil)

GLASMACHER, VIRGINIA, received her B.A. in 1992 from Brown University. As the project-manager of Maecenata Management GmbH, she serves as an independent consultant to the not-for-profit sector, assisting organizations in setting up and managing foundations in the areas of culture, social welfare, ecology, and international relations. (Maecenata Management GMBH, Barer Strasse 44, D-80799 Munich, Germany)

GONÇEBATE, RODOLFO S., Ph.D., graduate of Yale University, is an associate professor and a researcher and member of the Institute of Public Law, Political Science and Sociology of the National Academy of Sciences of Buenos Aires. He has published extensively on the political economics of Latin and South America. (Universidad de Belgrano, Graduados, Jose Hernandez 1820, Buenos Aires, Argentina)

HAJDUK, MARGO E., is an economist and graduate of the Universidad Nacional de Buenos Aires. She has published several reports and surveys on the relationship of private funding and the arts and culture in South America. (Universidad de Belgrano, Graduados, Jose Hernandez 1820, Buenos Aires, Argentina)

HALARIS, GEORGE, Ph.D., has been a researcher at the Foundation for Mediterranean Studies in Athens, and has also taught in the Departments of Sociology at the University of Crete, of Paria-Nanterre, and Johns Hopkins University. He has done extensive research in the fields of economic and cultural sociology. (Markou Evgenikou 24, 114 71 Athens, Greece)

HITTERS, ERIK, is a sociologist conducting research on the role of the private sector in arts and culture, and its relationship to the local government in shaping the cultural climate of the city of Rotterdam. He has previously published on private involvement in the performing arts, and financing, and the alliances between culture and capital. (Department of General Social Sciences, Urban Studies, Utrecht University, Aeidelberglaan 2, De Uithof,

Utrecht, The Netherlands)

KAWASAKI, KENICHI, Ph.D., professor at Komazawa University in Tokyo, has written extensively on modern culture in Japan. He has focused on youth culture, information scientists, and popular culture. (Komazawa University, 1-23-1 Komazawa, Setagaya-Ku, Tokyo, Japan 154)

KENYON, GERALD S., Ph.D., was a member of the faculty at the Universities of Wisconsin, Waterloo, and Lethbridge, and has taught and conducted research in the sociology of the arts, leisure, and sport. Research interests have included the multidimensionality of attitude toward physical activity; cross-national studies on leisure-role socialization; and taste. (Department of Sociology, University of Lethbridge, 4401 University Drive, Lethbridge, Alberta, Canada TIK 3M4)

KIRCHBERG, VÖLKER, Ph.D., is senior researcher at the Basica Institute for Social, Market and Arts Research in Hamburg, and an adjunct professor at the Universities of Luxemburg and Potsdam. He has done extensive social and policy research in the United States, as a Fellow for Urban Studies at the Johns Hopkins University Institute for Policy Studies and at the University of Baltimore. (Kohwitzstrasse 52, 20253 Hamburg, Germany)

KÖSSNER, BRIGITTE, is presently manager of the Austrian Business Committee for the Arts, and is pursuing her doctorate at the University of Economics in Vienna. She is an active advisor in the domain of marketing, especially in the area of advertising and counseling for leading Austrian and international patent undertakings. Since 1989 she has handled the Austrian art sponsorship award Maecenas. (Maecenata Management GMBH, Barer Strasse 44, D-80799 Munich, Germany)

KUSHNER, ROLAND, Ph.D. His dissertation research focused on management issues facing nonprofit organizations in the live performing arts. Subsequent research has been conducted on cultural markets, nonprofit organizations in other industries, and strategic alliances. He was administrator of a nonprofit arts group prior to his research career. (Department of Economics and Business, Lafayette College, Easton, Pennsylvania, 18042-1776; E-Mail: Kushner@Lafayette.edu)

PIPERNO, STEFANO, is deputy director of I.R.E.S. where he has conducted research projects on cultural economics in the performing-arts field financed by the regional authority of Piedmonte, Italy. He has held courses on cultural economics at the University of Turin and works as a private consultant. (Istituto Ricerche Economico Sociali Del Piemonte, Via Bogino 21, 10123 Torino, Italy)

PLIOS, GEORGE, is an hourly professor cf Culture at the Maraslio Academy, Athens. He also taught sociology of culture at the University of Crete and worked at the Research Institute of Sociology in Sofia. Author of *Moving Image and Artistic Communication* (1993), and several articles, his current work focuses on the civilization of image, and artistic structures. (Efthimias 2A 153 41 Athens, Greece)

STRACHWITZ, COUNT RUPERT, has had a distinguished career in the German Order of Malta Ambulance Corps. He has also been a consultant for the not-for-profit sector, assisting in setting up foundations and associations in the area of culture, social welfare, ecology, and international relations. He is the founder and was managing director of the Maecenata Management GmbH. (Maecenata Management GMBH, Barer Strasse 44, D-80799 Munich, Germany)

VAN DEN BOSCH, ANNETTE, Ph.D., is president of the Australian Art Critics Association. She has been a visiting scholar at the Centre for Research in Arts and Culture, Columbia University. She is undertaking comparative research on artists' careers and arts policy. She is co-editor of a publication of feminist perspectives on policy in the visual arts and media in Australia and Canada. (Department of Visual Arts, Monach University, Clayton, Victoria 3168, Melbourne, Australia)

VANHAEVERBEKE, ANN, was educated in the United States, Belgium, Italy, and Scotland. Since 1991, she has served as secretary general of CEREC, the Comite European pour le Rapprochement de l'Economie et la Culture, and also worked for Sotheby's in London in the modern and contemporary print department. She has also served as a journalist and researcher. (CEREC, Nutmeg House, Butlers Wharf, London, England)

WU, CHIN-TAO, is a doctoral student in the history of art at University College London. Her dissertation is on the comparative Anglo-American study of the relationship between the state, corporations, and contemporary art in the 1980s; it analyzes both survey responses and interview data. She is a native of Taiwan, and has had extensive travel and research experience in the United States and the United Kingdom. (University College London, Gower Street, London, WCIE 6BT)

ZAMBIANCHI, PATRIZIA, is an economist with Dunn & Bradstreet in Milan, and is a professor at the Universitá Cattolica del Sacro Cuore in Milan. She has written extensively on the art market and cultural policy in Italy. (Largo A. Gemelli 1, 20123 Milano, Italy)

ISBN 0-275-95000-X

90000>

EAN

9 780275 950002

HARDCOVER BAR CODE